6/07

HANDBOOK OF THE
GREEK COLLECTION

THE METROPOLITAN MUSEUM OF ART

HANDBOOK OF THE
GREEK COLLECTION

BY GISELA M. A. RICHTER

PUBLISHED FOR THE MUSEUM
BY HARVARD UNIVERSITY PRESS, CAMBRIDGE
MCMLIII

PREFACE

The *Handbook of the Classical Collection* first appeared in 1917 and was subsequently issued in several partially revised editions, the sixth and last appearing in 1930. The many important accessions since that date, the new installations, and the inevitable progress of our knowledge of Greek art have now made a thorough revision of both text and illustrations desirable. The present edition is, therefore, practically a new book, though occasionally I have freely drawn on the earlier text. The most important changes in installation are the segregation of the Etruscan objects in a separate gallery, and the removal of the Minoan reproductions to another room. This handbook deals only with the Greek objects (and Roman copies of Greek objects), specifically with those selected for exhibition in the main galleries. The Cypriote and Etruscan collections are described in separate volumes, and the Roman portraits in a separate pamphlet.

A new feature in this book is the notes giving accession numbers of the objects mentioned, references to descriptions and discussions of them in the Museum *Bulletin,* and, occasionally, references to articles in other publications, if these have added new information. No references to the previous editions of the handbook are included.

As objects in a museum are necessarily rearranged from time to time, no locations are given in this handbook. But the material has been divided chronologically, corresponding to the period rooms. The many illustrations should make it easy to find individual objects.

It is a pleasure to acknowledge the constant help given me by my colleagues—especially Miss Christine Alexander, Miss Marjorie J. Milne, and Mr. Dietrich von Bothmer. In the chapter on prehistoric Greek art I have had the expert advice of Mr. C. W. Blegen and Mr. A. J. B. Wace, both of whom have read the manuscript; the historical sketch on pages 7–11, 20–21 has in fact been largely written by Mr. Wace. I have also profited in this section from discussions with Miss Mary H. Swindler. It was fortunate that Professor Sir John Beazley's visit to New York in 1946 coincided with the preparation of this handbook. He helped us clarify many a moot point and in addition has read the whole manuscript and made corrections and suggestions that have improved the text. I am also much beholden to Mr. A. D. Trendall for revising my account of South Italian vases, pages 116–118.

Miss Deborah Hutchison helped me with the editing of the text and Miss Jean Leonard with the design and production of the book. Mrs. Edward S. Clark has done invaluable service in checking the references in the notes and in many other ways. Most of the drawings are by Lindsley F. Hall and most of the photographs by Edward Milla.

The majority of the drawings are of objects in our collection; those which are not have been introduced as designating typical ornaments of the period.

The writing of the book was completed in 1947. Since then descriptions of the more important new accessions have been inserted from time to time, but it was impossible to make major changes, especially in the illustrations, which, therefore, do not always correspond to the text (cf., for instance, pls. 105g, 121c).

June, 1951

G.M.A.R.

CONTENTS

LINE ILLUSTRATIONS

INTRODUCTION

THE COLLECTION AND ITS ARRANGEMENT

This handbook is intended to serve both as a guide to the Greek collection in this Museum and as an introduction to Greek art in general. The collection is shown in chronological sequence, objects in different materials being assembled according to their period. Each gallery, therefore, represents a chapter in Greek art. The larger sculptures, however, of all periods are shown together, and the objects of small size requiring special lighting—engraved gems, jewelry, and coins—are exhibited separately. As the visitor walks through these various galleries, several thousand years of Greek art will unfold before him. He will obtain a picture of the beginnings of Greek art, its enrichment by contact with the Orient, its gradual evolution, and its spread in Hellenistic and Roman times over the entire ancient world.

Our Greek collection—apart from the Cypriote—has been largely created during the last forty-odd years. Before 1906 the Museum owned only a few Greek objects, acquired from time to time in a rather haphazard way. In 1906, with the appointment of Edward Robinson as curator of the department and of John Marshall as its European agent, an era of systematic buying began. Within the next twenty years a representative collection of high caliber was developed, which included many masterpieces. Since the death of Mr. Marshall in 1928 and of Mr. Robinson in 1931 the purchases have been mostly single, outstanding pieces, or, occasionally, important collections, like the Gallatin vases, obtained in 1941, and a group of the Evans engraved gems, bought in 1942. From time to time during the last seventy years gifts and bequests have augmented the purchases.*

In studying our collection we must be aware of the gaps in the material that has come down to us, for only by realizing what is lost can we reconstruct Greek art as it once was. Practically all of the larger Greek paintings—the murals and the panels—have been destroyed, and we must derive our knowledge of that important branch of art from decorations on pottery and on a few gravestones, as well as from the copies and adaptations that were made during the Roman period. The many bronze statues which once adorned Greek sanctuaries have almost all disappeared, for metal is valuable and was melted down in antiquity, as it is today, in times of stress. For the same reason the gold-and-ivory cult statues and the vessels of gold and silver frequently mentioned by ancient writers and in Greek inscriptions are

* The accession numbers, in the notes and on the labels, indicate when each piece came to the Museum, the first two digits giving the year of acquisition. Objects acquired before 1906 generally had the initials GR (Greek and Roman) preceding a number, but new numbers conforming with the others have now been assigned.

for the most part gone. Even Greek marble statues have survived in only compara-
tively small numbers, for there has been much looting throughout the ages and
marble can be turned into useful lime. The beautiful wooden furniture represented
on Greek vases and reliefs, the wooden statues mentioned by Greek writers, the
textiles we know were woven and embroidered by Greek women have perished in
the comparatively damp climate of Greece; only a few examples here and there have
been preserved in the drier atmospheres of Egypt and the Crimea. Iron, too, which
was employed extensively for weapons and other implements and occasionally for
sculpture, has corroded.

Nevertheless, enough remains to give us some realization of the whole. There
have been, after all, a good many chance survivals of large sculptures, mostly re-
discovered after the earth had protected them for centuries; and the ancient custom
of placing offerings in graves has preserved a large number of smaller objects. More-
over, the Roman admiration of Greek art is responsible for much of our present
knowledge, for though the Roman conquerors looted and destroyed, their appetite
for Greek sculpture was such that the supply had to be augmented by copies and
adaptations. As some of these copies were made mechanically by the pointing
process, they exactly reproduce the originals in composition—as we learn from the
rare instances when both original and copy have survived, or from the frequent
instances when several identical copies are extant. Many of the famous statues of
antiquity are known to us from such Roman reproductions.

In addition, we derive much valuable information from inscriptions—temple in-
ventories and the dedications on statue bases, for instance—and particularly from
the ancient literature that has come down to us. We obtain from these sources the
names of some of the artists and, occasionally, descriptions and evaluations of their
works. Unfortunately, few of the ancient authors who wrote on art lived in the
great periods of artistic creation, and most of what they wrote has perished. We
should give much to have Polykleitos's *Canon* on the beauty of proportion in sculp-
ture, or the writings of Euphranor, Xenokrates, and Antigonos, who were them-
selves artists active in the fourth and third centuries B.C. We have, it is true, criti-
cisms of paintings by such eminent writers as Plato and Aristotle, but they were
philosophers, not practicing artists. Of the systematic works on art written in the
Hellenistic age—by Polemon, or Heliodoros, or Alketas—practically nothing is ex-
tant. We derive our literary knowledge of Greek sculpture and painting chiefly
from writers of the Roman age, who, however, had at hand much information that
has since been lost, in the form both of Greek writings and of actual works of art.
The two most important of these later authors are the elder Pliny (A.D. 23–79), who
in his *Natural History* included accounts of Greek sculptors and painters, arranged
according to the materials in which they worked, and Pausanias, who wrote a
Description of Greece in the second century A.D. The many temples, sculptures, and

paintings mentioned by them which have since disappeared make us realize the extent of our loss.

Our collection must be judged by the conditions we have described. It consists of comparatively few monumental sculptures in stone or bronze, a good many of them Roman copies of Greek works, and of a large number of smaller objects in metal, stone, and terracotta, among which pottery occupies a prominent place. Except for the vase decorations our only representatives of Greek pictorial art are a few paintings on archaic and Hellenistic plaques and gravestones. Jewelry and coins supply, with a few important exceptions, our only gold and silver specimens. Here and there some pieces in ivory, lead, wood, iron, glass, plaster, and wax remind us of the large choice of materials the Greek artist had at his command.

THE VALUE OF GREEK ART AND ITS APPRECIATION

Greek art, though produced long ago, is still a potent force. A primary reason is the close kinship between us and the ancient Greeks. Their intellectual outlook, their political institutions, their science, literature, and art have helped to mold Western civilization, to which America belongs. Greek art is therefore part of our heritage. Though the Greeks were the first people in history to achieve a naturalistic art—which made possible the subsequent development of European art—the evolution from the early, conventionalized forms to the later, naturalistic ones took place in several stages. Greek art is, therefore, many-sided. It comprises the early "abstract" and archaic products that appeal to our modernists, the idealistic creations of the fifth century, and the later, more realistic, figures that inspired the Renaissance. Throughout this long period, however, there are certain salient characteristics—a feeling for design and proportion, which, though strongest in the early works, is present also in the later ones, giving them distinction and style; and a sense of structure that imparts life and coherence. In addition there is—especially in the fifth and fourth centuries—an idealizing tendency that lifts each product from the individual to the typical and makes even a battle seem serene.

To appreciate Greek art we must understand what it represents, for what it was used, and, if possible, how it was made; for only with such knowledge can we fully comprehend the artist's intention. Above all, we must sense the spirit he has imparted to his work. No words or descriptions can convey this spirit, only the objects themselves; and they become eloquent if, by contemplation and study, we let them speak for themselves. Here it is possible only to offer a few remarks on their content, purpose, and technique.

The Greeks were humanists, and the chief theme in Greek art was the human figure. Gods assumed human shape, and monsters and animals, which played such a prominent part in the Oriental arts and were favored in the early Orientalizing period of Greek art, soon became subsidiary. The two principal subjects treated

were myths and the happenings of daily life. To interpret the scenes in Greek sculpture and in vase paintings we must therefore know the mythology of Greece, the legends about her gods and heroes. These legends are a mixture of fact and fancy—derived in part from past happenings, but transformed by the poets' and the people's imagination. They often served as symbols for actual events, but they were not abstract symbols. The contests of Lapiths and centaurs and of Greeks and Amazons on the Parthenon metopes, for instance, may have been intended to recall the war between Greece and Persia, but they did not symbolize, as they might have in another art, the triumph, let us say, of right over wrong. Such abstract concepts were mostly outside the scope of Greek art. When we see pictures of the birth of Athena from the head of Zeus, therefore, or of Herakles performing a mighty deed, we may enjoy them as they are presented—directly, perhaps naïvely, but with a refreshing zest in the telling of the actual story.

The scenes from daily life speak for themselves. They supply us with precious information regarding the customs of the Greeks—their athletic games, battles, household occupations, work in shop and field, dinner parties, dances, religious observances, and funerals. They supplement in vivid fashion what we learn from Greek literature and in their turn often elucidate the meaning of Greek writers.

Until Hellenistic times, the major arts of sculpture and painting usually served a public function. The creations of artists were used to adorn public buildings—the temples and their precincts, the "treasuries," and the halls erected throughout Greece. Much of this art was religious, for religion pervaded practically all Greek life. The sculptures served as decorations for the pediments, friezes, and akroteria of temples, as the cult statues of deities, and as the offerings made by the pious in sanctuaries. Commemorative statues for victories in war or in athletic contests were set up to honor the specific deities who had given aid or in whose precinct the games were held. Even the portraits of famous individuals were generally placed in sanctuaries. Practically the only private sculpture was sepulchral—the statues and stelai erected over tombs. In the late Greek and the Roman periods, however, when the importance of the state diminished, individuals became patrons of art. Private collections were formed and works of art created to adorn private dwellings. Portraits were no longer set up in sanctuaries only but in libraries and private houses.

When we pass to the "minor" arts the picture is different. Vases, whether of terracotta or bronze, served primarily a practical purpose in daily life. Though they have generally been found in tombs and sanctuaries, they were buried, in most instances at least, after they had served their owners during life. The shapes are therefore functional; and it is a pleasure to see how well they served their various purposes. But their gifted makers designed and executed them as works of art as well; that is why they have not merely an antiquarian interest, but are objects of beauty displayed in museums of art.

Bronze statuettes and reliefs often served as adjuncts to utensils—as handles and ecorative features of vases, stands, mirrors, and armor. The figures that are com-lete in themselves were offerings in sanctuaries, as we learn from the dedicatory iscriptions that are happily sometimes preserved, and occasionally, perhaps, pri-ate possessions. The terracotta statuettes found in sanctuaries were, of course, dedi-atory offerings. When they come from tombs we do not always know their original urpose.

Glass vases did not become common until the first century b.c., when the inven-on of glass-blowing revolutionized the industry. The earlier specimens served iiefly as containers of unguents and perfumes.

The technical processes of the Greeks were not very different from our own, ex-pt that work by hand played a more prominent part than it does today. Stone ulptures were produced in the earlier periods by cutting directly into the stone, ence their freshness and their lack of absolute symmetry. Later, in the Roman age, iany figures were made by mechanical transference from plaster casts of Greek iginals by means of the pointing process, still in use today (although some iodernists have returned to direct stone-cutting). Heads or outstretched arms were ten made separately and attached. Metal dowels and stone tenons were used for stening and were reinforced with poured lead as occasion demanded. The punch, ie claw chisel, the gouge, the flat chisel, and the drove were the standard tools, l manipulated with the mallet. The running drill was apparently not used until ie fifth century b.c. Both marble and limestone sculptures were painted either itirely or in part.

Larger bronze figures were at first made of plates hammered over wooden cores id fastened by rivets; but statuettes were cast solid from the Minoan and Geometric eriods down. Hollow casting must have been introduced sometime in the seventh ntury b.c. (there aré examples extant from that century), but did not become mmon until the later sixth century. The lost-wax and the sand-mold processes ere both employed. Often different parts were made separately and then attached. aults in casting were repaired with rectangular inserts. Metal reliefs were cast or orked in repoussé, or hammered over a die. Bronze vases were often hammered it of sheets of bronze, but handles, feet, and lips were mostly cast. Throughout, the onze was left in its natural golden-yellow color; the patinas which now cover e surfaces of ancient bronzes are not artificial (as are those of renaissance and odern times), but are due to the action of time.

In pottery, the process of building by coils and wads was used in the Early Bronze ge. After the introduction of the wheel, perhaps about 2000 b.c., throwing became e universal practice except for such things as cooking pots. For the more carefully ecuted vases the subsequent refining process of turning was employed. Molding as at first practically confined to "plastic" vases, that is, those made in the form

of heads and figures; but the relief ware of Hellenistic times was regularly mad
in molds. A single fire was the rule throughout antiquity; the glaze* was applie
while the vase was leather hard. Glass vases were made by hand over a core unt
the first century B.C., when the art of blowing glass was discovered.

The engravings on the sealstones—or gems, as we call them—were worked b
hand when the material was the relatively soft steatite and with bow-(or wheel?
run drills and emery when harder stones were used. Coins were struck wit
punches against dies in which the design of the obverse had been engraved; late
the punch was also provided with a design and became, so to speak, an upper di
In jewelry, gold was not used as a background for colored stones, as in later time
but was itself elaborately worked in filigree, granulation, and relief. Red and blu
vitreous pastes were inserted in the minute *cloisons* of the filigree to bring out th
design and to add a discreet color note, analogous to that of the decorative borde
of the contemporary architecture. Whether magnifying glasses were used in suc
minute work is still a moot question. The burning glass (τὴν λίθον... τὴν διαφαν
ἀφ’ ἧς τὸ πῦρ ἅπτουσι, "the transparent stone used to start fire") was known
Aristophanes (*Clouds* 766 ff.), and to Pliny (*Natural History* XXXVI. 67 and XXXV
10); and the elder Seneca (*Naturales Quaestiones* 1.6.5) speaks of "letters howeve
minute" appearing larger and clearer through a glass ball full of water. The princ
ple, therefore, of magnification was apparently understood, but we have no eviden
that lenses were used for magnifying by goldsmiths or gem-engravers. Modern gem
engravers have worked without them, even on very delicate work.

* I go on using the word "glaze" to describe the Greek application, for want of a better term, thou
Dr. Weickert and Dr. Schumann are of course right in pointing out that the Greek glaze is not a gla
in the technical sense (C. Weickert, *Archäologischer Anzeiger,* 1942, cols. 512 ff.; Th. Schumann, *Fo
schungen und Forschritte,* XIX, 1943, pp. 356 ff.). We cannot, however, use the old term varnish, f
varnish contains oil, not present in the Greek application, and cannot be fired. The term engobe is r
applicable, for an engobe has no gloss. The word semi-glaze (once employed by Professor Binns) or t
word pseudo-glaze (suggested to me by Dr. Schumann) would be more exact terms than glaze, but th
are awkward words for constant use; and so is glaze in quotation marks. And, after all, the Greek a
plication, whatever its chemical nature, served physically the same purpose as a modern glaze. Gla
therefore, seems still the best term, with the understanding, however, that the Greek glaze really co
sists of the finer particles of a peptized, red-burning clay plus a small quantity of alkali. (I am mu
indebted to Miss Maude Robinson, potter, and Miss Marie Farnsworth, chemist, for help in formulati
this statement.)

PREHISTORIC PERIOD

ABOUT 4000–1100 B.C.

Before the Hellenic people developed the civilization we know as Greek, another people had dominated the Aegean world for nearly two thousand years and had evolved an independent culture and an art of high standing. Our knowledge of this earlier civilization we owe almost entirely to the work of the archaeologist. There is no literature to help us, for the only written records are as yet undeciphered. Even the classical Greeks knew little of their predecessors; only a legend here and there harks back to this distant past. The gradual unfolding of this long-forgotten civilization is a story which reads like a romance. It has often been told, so we need here repeat only the salient points.

Heinrich Schliemann, convinced that Homer's Troy had really existed, conceived the idea of digging for its ruins. In spite of the skepticism of his contemporaries he started excavations in 1871. His faith and his enterprise were rewarded. He found Troy and later uncovered the Cyclopean fortresses of Mycenae and Tiryns. His discoveries, especially the famous shaft-graves at Mycenae with their treasures of gold, astonished the world. The heroic age of Greece had become a reality.

Soon other discoveries relating to the same epoch were made in Attica, the Peloponnese, Boeotia, Thessaly, the islands of the Aegean, Cyprus, Rhodes, the Levant, and Egypt. Thereafter the chief concern of archaeologists was to find the original home of this early civilization. Unmistakable clues, observed by Schliemann, pointed to the island of Crete. Since legends had proved to be such useful pathfinders, the stories of the Cretan sea king Minos, with his Minotaur and labyrinth, and of the birth of Zeus in the cave of Dikte assumed a new aspect. Isolated discoveries on the island pointed in the same direction.

In 1900 Sir Arthur Evans began excavations on the site of Knossos. Within a few years he had unearthed a large palace, with spacious courtyards and numerous living rooms, bathrooms, magazines, and staircases, of a plan so complicated that it might well be called a labyrinth. In its finished appointments and its advanced methods of sanitation it furnished many surprises to those who had pictured the prehistoric peoples of Greece leading a primitive existence. Even more important was the harvest of works of art—the paintings on the walls of the palace, the colored reliefs and statuettes, the pottery and sealstones, which all bore testimony to the originality and artistic sense of the early Cretans.

Other excavations, in southern and eastern Crete,* confirmed and enlarged the knowledge obtained at Knossos. Excavations in Greece proper† have made clearer the connections between Crete and the mainland. Since the soil of Crete, of the Greek mainland, and of the Aegean islands has by no means been exhausted, we may expect an extension of our knowledge in years to come; but we have enough at hand now to reconstruct on broad lines this early civilization in its various stages.

The Cretan civilization is essentially a product of the Bronze Age, that is, of the epoch when implements were no longer of stone and not yet of iron, but were first of copper, then of bronze. The remains that have come to light in many localities in Crete and on the Greek mainland, however, have shown that Greek lands were inhabited before the Bronze Age. No remains of Palaeolithic times have as yet been found, but the beginnings of Cretan civilization can at present be traced to the Neolithic or Late Stone Age of the fourth millennium B.C. By about 3000 B.C. the Bronze Age seems to have begun; and it was during the two thousand years covered by that era that this ancient civilization had its rise, its culmination, and its fall.

Like every other nation that has gained eminence, the Cretans passed through several stages in their development. Sir Arthur Evans' classification of the civilization into three main epochs, Early, Middle, and Late Minoan, each with three subdivisions, is a convenient skeleton on which to reconstruct the history of Crete as we know it. The word Minoan, derived from the name Minos, is, strictly speaking, only appropriate for the Late Minoan period, during which King Minos supposedly lived; but since his brilliant reign typifies what we understand by "Cretan" it would be difficult, in spite of this obvious anachronism, to find a more suggestive term for designating the entire civilization.

The relative dates of the Minoan periods and their chief characteristics have been established by the careful work of the excavators. Naturally not all periods are represented on all sites and there is an inevitable overlapping of styles. Knossos has provided a fairly complete stratification, however, and this has now been supplemented by the recent excavations on the Greek mainland and at Troy. The absolute dates, based on the minimum system of Egyptian chronology, are as follows:

Early Minoan I	about 2800–2600 B.C.
Early Minoan II	about 2600–2300 B.C.
Early Minoan III	about 2300–2000 B.C.

* F. Halbherr and L. Pernier discovered a palace at Phaistos and a villa at Hagia Triada; Harriet Boyd Hawes, the town of Gournia; D. G. Hogarth and R. C. Bosanquet, the towns of Zakros and Palaikastro; R. B. Seager, the settlements of Mochlos and Pseira; J. Hazzidakis, S. Xanthoudides, and S. Marinatos, various sites; the French excavators, the palace at Mallia.

† Especially those by C. Tsountas at Mycenae and Vaphio; by C. W. Blegen at Korakou, Zygouries, the Argive Heraion, and recently at Pylos; by A. J. B. Wace at Mycenae; by Hetty Goldman at Eutresis; by the Germans at Orchomenos; and by the Swedish expedition at Asine and Dendra.

Middle Minoan I	about 2000–1800 B.C.
Middle Minoan II	about 1800–1700 B.C.
Middle Minoan III	about 1700–1600 B.C.
Late Minoan I	about 1600–1500 B.C.
Late Minoan II	about 1500–1400 B.C.
Late Minoan III	about 1400–before 1100 B.C.

Recently, as excavations of prehistoric sites outside Crete have multiplied, the term Minoan has been restricted to objects found in Crete, and the terms Helladic and Cycladic have been applied to finds on the Greek mainland and the Islands respectively. All three civilizations apparently sprang from the same source, southwest Anatolia, but during the earlier periods the Helladic and Cycladic civilizations were more primitive than the Cretan. They have been divided into periods roughly synchronous with the Minoan, but their development was somewhat different.

In Crete there seems to have been a continuous evolution of culture from Neolithic days to nearly the close of the Bronze Age without any new racial admixture, but the mainland of Greece was twice overrun by newcomers. At the end of the Neolithic Age a race akin to the Cretans entered the mainland, perhaps from the Islands, and subdued and subsequently coalesced with the pre-existing inhabitants, who were of a different race. At the end of the Early Helladic period another new strain entered Greece—a people who introduced a new type of house, a new form of tomb, and a new style of pottery known to archaeologists as Minyan ware (see p. 14). The current view is that these people were of Indo-European stock and spoke an Indo-European language, an early form of Greek. They in their turn amalgamated with their predecessors, the Neolithic and Early Bronze Age peoples. By the end of the Middle Helladic period the mainland people had come under the influence of the Minoan culture of Crete, which they in part adopted. When, at the end of Late Helladic II, the power of Crete was overthrown, what is popularly known as the Mycenaean Age came into being on the mainland, and lasted until the Bronze Age closed.

The most important remains of the Early Minoan period—which is contemporary with the Old Kingdom of Egypt—have been found in the eastern part of Crete, especially at Gournia, Vasiliki, Palaikastro, Pseira, Mochlos, and Mallia. Conditions then were by no means as primitive as was once thought. Some of the people were rich and prosperous and lived in comfortable houses, and there was apparently communication with the outside world, especially with Egypt. The art of writing in a pictographic script was now first developed. In the crafts, some of which are of surprising technical or artistic excellence, may be noted certain marked characteristics that will distinguish Minoan work throughout its history—on the one hand,

a tendency to experiment, on the other, a readiness to utilize foreign products and transform them into independent creations.

In the Middle Minoan period, which is about contemporary with the Middle Kingdom of Egypt, Cretan civilization reached its first climax. Crete was now in active intercourse with foreign lands, and her increased trade brought greater wealth to her inhabitants, as is shown by the building of the first palaces of Knossos, Phaistos, and Mallia, and, toward the end of this period, of the second Knossian palace. A great advance was made in the various arts. The wall paintings and the polychrome pottery with its rich coloring and often eggshell thinness are especially remarkable. Work in metal and seal-engraving reflect the general advance. Remains of the period have been found not only at Knossos and Phaistos and on neighboring sites but also in the eastern part of the island, at Gournia, Pseira, Mochlos, Pachyammos, and other places.

In the Late Minoan period, which is parallel with the Empire of Egypt, the second and greater climax of Cretan civilization was reached. The ascendancy of Crete in the Aegean world was now complete. Her influence, or in some islands perhaps even her domination, was extended throughout the Cyclades and the mainland of Greece, and with Egypt, Anatolia, and Syria she had close and, it would seem, friendly connections. This is the period in which King Minos presumably lived, whose fame survived in Greek legends and to whose brilliant personality the greatness of Crete at this time may in no small measure be due. Both the mainland of Greece and the Aegean Islands have yielded valuable objects. Some of these may have been imported from Crete, while others are certainly of local manufacture. Whatever the provenience, the art of this period is more or less homogeneous.

The Late Minoan I period marks the height of prosperity of the smaller Cretan towns. An era of peace and quiet well-being is reflected in the delicacy of its artistic products. On the Greek mainland Minoan art was freely imitated and exercised great influence, as evidenced by the finds at Mycenae, Asine, Thebes, Tiryns, and elsewhere. Late Minoan II was an age of wealth and splendor. The centers of civilization were now the great Cretan palaces rather than the smaller places. The palace of Knossos, which had been rebuilt after a disastrous earthquake toward the close of Middle Minoan III, now took its final form through some remodeling and the second palace of Phaistos was built. The imposing ruins of these palaces are still standing; and their spacious courts, broad stairways, pillared halls, and luxurious fittings testify to the wealth and refinement which surrounded the life of the Minoan princes of this epoch. The influence of the Minoan style was still prominent on the mainland. Some vases of this date of obvious mainland origin have been found in Crete, as well as in Egypt. More recent discoveries even lend color to a suggestion that perhaps in this period Crete—Knossos for instance—fell under the political domination of the mainland, which developed new ideas and tendencies of its own

from this time onwards, no longer remaining in the spiritual subservience of Crete.

At the end of Late Minoan II came a sudden catastrophe. The palaces at Knossos and elsewhere were destroyed, and the island was overrun by conquerors. The evidence suggests an invasion from the Greek mainland, where the princes of the land had apparently been growing more and more powerful. Their success was complete. The power of Crete was broken, never to revive again. Although there are signs of a partial reoccupation of Knossos and other sites, this appears to have been of little consequence. The scepter had now definitely passed to Greece, and the kings of Mycenae and other Peloponnesian towns succeeded to the power of King Minos.

The epoch that followed the fall of Crete, when the Greek princes had risen to power—that is, Late Helladic III—may be identified with the heroic age of Greece pictured in the poems of Homer. Though the poems were not written down until considerably later, the historical events on which they were based clearly took place in these early times. The discrepancies in the Homeric poems that have given rise to so many discussions may be traced to this circumstance, as well as to the fact that the poems descend from a pre-existing body of epic and ballad full of suitable formulae and themes.

The greatness of this age in mainland Greece is reflected in the architecture. Recent discoveries show that some of the most important buildings at Mycenae and Tiryns—for instance, the Lion Gate, the Cyclopean Walls, and the so-called Treasury of Atreus—must be assigned to Late Helladic III in the second half of the fourteenth century b.c. And, since this is the time when the Greek-speaking Indo-Europeans are thought to have invaded the mainland, these monuments display the first manifestations of Greek architecture and of European as opposed to Eastern culture. The pottery, though technically of a high order, is not on a par with earlier Minoan products; in the decoration the gay, flamboyant ornaments of the preceding epoch are simplified, and a system of formalized pattern develops which tends to become stereotyped.

The objects in our collection which illustrate the two thousand years of the Minoan–Cycladic–Helladic civilization make a comparatively modest showing, consisting chiefly of pottery, stone vases, a few bronze utensils and weapons, small sculptures in bronze, marble, and terracotta, pieces of jewelry, and a collection of engraved sealstones. By themselves, they do not convey a true picture of this rich and buoyant civilization, and they should therefore be studied in conjunction with the important objects still in Crete and Greece, of which reproductions are displayed in another gallery—the gaily colored wall paintings and reliefs, the delicately wrought gold and silver vases and rings, the animated reliefs and statuettes of ivory, faience, terracotta, and bronze, and the beautifully ornamented pottery, including enormous storage vessels. The wall paintings and statuettes, in particular, have

taught us much about the appearance of the people of that time. When the Cup-bearer, for instance, was found at Knossos in 1902 the occasion was significant. It was the first picture of a Minoan that had come to light, and the excavators could suddenly visualize the men whose history they were bringing back from oblivion. Though the figure is conventionalized, it teaches several important facts—that the Cretans of that time were a dark-eyed, dark-haired race with regular, almost classical features and high, brachycephalic skulls, not unlike certain types still to be found in Crete today; that the men wore, at least sometimes, richly patterned loincloths and bracelets with sealstones; and that they let their hair grow long. Other representations have since added to this information. Some of the women have extraordinarily modern-looking costumes, with tight-fitting jackets and bell or flounced skirts. In appearance and bearing these men and women look worthy of their great history.

NEOLITHIC AGE

A few stone implements of the Neolithic, or Late Stone Age, mostly from Crete, bring to mind the time before the people of the Mediterranean had discovered copper and bronze, when all work had to be done with stone, bone, or wooden tools. They consist of a few celts,[1] a flint arrowhead,[2] a spearhead,[3] and a superb axehead of serpentine,[4] said to be from the Troad (pl. 1). A number of Neolithic potsherds[5] from Thessaly, Boeotia, the Peloponnese, and Crete show the primitive character of the pottery (pl. 1). It was hand-built and ornamented with geometric patterns, incised or painted, occasionally in several colors.

BRONZE AGE

POTTERY

Terracotta vases are the most copious and widely diffused products of an ancient civilization. Though a pot is easily broken, the fragments are almost indestructible; and sherds, found in successive layers, have been most useful in establishing a relative chronology.

The Minoan and Helladic pots in our collection have been acquired from various sources. Some come from Mrs. Hawes's excavations at Gournia and Vasiliki and were a gift of the Cretan Exploration Society of Philadelphia; others come from Knossos and were obtained from the Ashmolean Museum by exchange; still others, from C. W. Blegen's excavations at Zygouries, were a gift of the Greek government; a few were purchased. The vases fall into three categories—those from Crete, those from the mainland of Greece and the Islands, and those from Cyprus. They are supplemented by a collection of fragments from various sites.

CRETE. The Early Minoan examples are built, not wheel-thrown. They illustrate several different styles: a mottled red-and-black ware with a polished surface (see

pl. 2a)[6] found at Vasiliki, in eastern Crete, and a dark-on-light ware (see pl. 2d)[7] with linear designs painted in brownish black on buff clay, both Early Minoan II; and a light-on-dark ware (see pl. 2b)[8] with linear designs painted in white on a black glaze, Early Minoan III period.

The earlier Middle Minoan pots are still hand-built, but the later ones are made on the wheel. Apparently the art of throwing vases on the wheel was introduced sometime in Middle Minoan II and henceforth wheel-thrown vases became the rule. The influence of contemporary metalwork is seen in the delicate shapes, the ribbon-like handles, and the eggshell thinness of some of the vases of the period. Cups and jugs are the most popular shapes. Ornaments in white on a dark ground and a polychrome style in which white, red, and orange (see pl. 2c)[9] are applied on a blackish ground (sometimes turned reddish in the fire) are characteristic. Decorations in relief, applied in barbotine technique, also occur. Another ware has lustrous black designs sketchily painted, in large daubs and splashes, on buff terracotta. The most interesting example of this style in our collection is a large beaked jug from Knossos (pl. 2e)[10] decorated on each side with a bird; it was probably an importation from the island of Melos, where a number of similar vases have been found. Alongside these decorated vases occur plain ones in light buff terracotta.

Early in the Late Minoan period the light-on-dark decoration was abandoned, and thereafter the designs were regularly painted in brown glaze on a buff slip. Sometimes details were picked out in white. Naturalistic motives, which had been introduced in Middle Minoan II, became popular in Late Minoan I. They were taken mostly from plant and marine life and were executed in a free and graceful style, with feeling for selection and grouping. The shapes show considerable variety, the conical filler, one-handled cups, and flaring bowls being the most popular. One of the two fillers in our group has a fern pattern in red and black (pl. 2g).[11] A flaring cup from Phylakopi (pl. 2h)[12] has an attractive decoration of grasses. A fairly large three-handled jar with a design of spirals, leaves, and rosettes (pl. 2f)[13] is the only vase of the so-called Palace Style (Late Minoan II) in our collection. Late Minoan III is illustrated by several cups and jugs (see pl. 2i)[14] with somewhat stereotyped designs. All the Late Minoan vases are wheel-thrown.

GREECE. Among the specimens from Greece those from Zygouries, not far from Corinth, occupy an important place. They are Early Helladic III (about 2200–2000 B.C.) and Late Helladic III (about 1400–1100 B.C.), and consist of bowls, jars, jugs, goblets, and a ladle. The early ones are distinguishable by their sturdy proportions and hand-built technique, the later ones by their beautiful finish and wheel-thrown technique (see pl. 3c–f). An elongated bowl with a spout, of the so-called sauceboat form, is a characteristic Early Helladic specimen (pl. 3a)[15]; two goblets shaped like champagne glasses and decorated with conventionalized cuttlefish in

blackish glaze belong to Late Helladic III (pl. 3b).[16] The later vases were found in the basement of a large building filled with hundreds of pots, some in rows, some in high stacks set close together. Though many were cracked and shattered by the fire that destroyed the building, they have a fresh appearance, and obviously had never been used. The house probably served as a potter's shop with the wares stacked ready for sale.

Other Late Helladic pots include a two-handled goblet with a sprawling octopus on either side (pl. 3g),[17] a large three-handled jar with spirals (pl. 3i),[18] a jar with stirrup-shaped handles[19]—a characteristic Late Helladic III shape—and a vase on three feet, with a handle attached to the handle of its lid (pl. 3h),[20] which is said to be from Rhodes.

The collection of fragments ranging from Early Helladic to Late Helladic includes specimens of yellow and gray "Minyan" ware (Middle Helladic)—so called because this ware was first found at Orchomenos, the reputed center of the Minyans.

CYPRUS. In the Late Bronze Age there suddenly appeared in Cyprus typical Late Helladic vases, made of cream-colored clay, wheel-thrown, and decorated with blackish or reddish glaze (the red caused by oxidation in firing). A selection of such vases from the Cesnola collection are here included.[21] The forms are the familiar Mycenaean ones—pear-shaped, three-handled, and stirrup-handled jars, narrow-necked bottles, as well as bowls and cups (see pl. 4). The most important in our showing are a bowl decorated with fish (see pl. 4e)[22] and two large jars with human figures in two-horse chariots (pl. 4f, g).[23] The figures resemble the contemporary Helladic statuettes described below. An approximate date is furnished by the discovery of fragments of similar vases in the rubbish heaps of the palace of Akhenaten and Tutankhamen at Tel el Amarneh in Egypt (about 1375–1350 B.C.). Whether these vases were manufactured locally in Cyprus by Minoan and Helladic colonists or imported from the mainland is still an open question. The latter theory has recently gained some support by the discovery of a potter's kiln at Berbati, near Mycenae, with numerous fragments of vases in a similar pictorial style, some with chariot scenes. One theory, however, does not necessarily exclude the other.

SCULPTURES IN STONE, BRONZE, AND TERRACOTTA

The earliest original specimens of the Bronze Age in our collection are several Cycladic statuettes made of translucent Island marble, dating from about 3000 to 2500 B.C. (see pls. 5 a–c, 6). Their simplified forms and fine sculptural quality remind us of the cubist creations of the modernists. Most of them have been found in tombs, others apparently in sanctuaries. Whether they represent deities or votaries, or servants of the dead, like the Egyptian *shawabti* figures, is still a moot question. The majority are represented standing[24] with folded arms. The most important of our

examples shows a man seated on a high-backed chair, holding a harp in both hands (pl. 6).[25] He is nude except for a loincloth, his feet are off the ground, and his head is tilted back. The carving, especially of the arms, shows keen interest in natural forms, the swelling muscles, the bones at wrist and elbow, and even the fingernails being indicated. What looks like ancient red is preserved in the eyes and mouth. Similar statuettes are in Athens and Karlsruhe. One of the standing figures is said to have been found with a marble saucer and a fragment of a terracotta *kernos* (complex of connected offering jars). Three others, lent anonymously, were discovered in the island of Ios with two copper daggers.[26]

Enough Minoan and Helladic sculptures have been found to show that figures in relief and in the round, life size and over, were successfully produced. The "Priest King" and the bull's head from Knossos are superb works in painted relief; and a human head and several stone vases in the form of animal heads show considerable aptitude in sculptural work in the round. Reproductions of a few of them are in our collections. Only comparatively few such largish sculptures, however, have so far been found; the majority are small reliefs or statuettes, in various materials. Three small bronze statuettes[27] in our collection—a long-haired, standing youth, a female votary, and the upper part of a figure with the arms brought to the chest (see pl. 5d–f)—are typical Late Minoan works. The standing youth has the proportions and proud bearing of the Minoans—broad shoulders, narrow waist, and trunk bent slightly backward.

Several terracotta figures[28] with disk-shaped bodies, flaring bases, and pinched-up faces (see pl. 7a, b, d) are products of Late Helladic III (about 1400–1100 B.C.). Stylistically and technically they resemble the figures on Late Helladic pottery, being decorated with striped patterns in blackish glaze, sometimes turned reddish through oxidation in the fire. All are female; a diminutive one probably represents a child. In spite of their abstract forms they have a feminine charm and vivacity. Besides these standing figures there is one sitting on a chair[29] with both arms raised—either a votive figure or a deity (pl. 7c). A stylized ox is an attractive product in a similar technique (pl. 7e).[30] Such statuettes of human and animal figures have been found chiefly in tombs; they are sometimes found in children's graves, and may often have served as toys. Those which have been found in sanctuaries were of course votive offerings.

A gilt terracotta statuette of a goat (pl. 7f),[31] said to have come from Mycenae together with a gilt terracotta necklace (see p. 17), is perhaps also a Late Helladic product. It is more naturalistic than most of the terracotta and bronze animals of the later phases of this period, the body being modeled with considerable observation of nature. Stylistically it may be compared with the splendid bulls of Late Minoan I and II. The head of a similar figure, a gilt terracotta kid, was found at Asine during the Swedish excavations.

STONE VASES

The carving of stone vases was an art which attained a high level in the Aegean world. Our collection includes many fine examples. Two sturdy jars[32] made of the same translucent marble as the Cycladic statuettes are typical early Island products (see pl. 8a). Each has four "ears," pierced for suspension cords or tying on their lids. A number of bowls and cups in colored stones (see pl. 8b–h),[33] from Crete, are reminiscent of similar products from Egypt; but the shapes and materials are Cretan, and the colors show a greater variety. When we remember that these vases were ground out by hand, we realize the amount of skill and patience entailed. Our examples range in date from Early Minoan II and III, when the art reached its acme, to Late Minoan. Among the later ones are several handsome "blossom" bowls and a lamp.

GOLD AND SILVER VASES

Among the most sensational discoveries by Schliemann at Mycenae were sumptuous gold vases and rings, which brought to mind the Homeric epithet for that city, "rich in gold." The two famous embossed cups subsequently found at Vaphio and the rich gold deposits found by A. W. Persson at Dendra (the ancient Midea) have substantiated our picture of a wealthy mainland Greece in Late Helladic times. The Museum is fortunate in owning one complete cup and two handles of another cup in that precious material. The complete cup (pl. 11h)[34] is plain except for an embossed fern pattern on the two handles. The separate handles (pl. 11g)[35] have embossed rosettes; part of the rim of the silver cup to which they were attached by rivets is still preserved.

A Cycladic silver bowl (pl. 11 i),[36] decorated with incised shaded triangles, is an object of great rarity. Only a few metal vases of this type have survived, notably, two gold ones in the Benaki Museum in Athens. They throw new light on the early Cycladic civilization, which is known to us chiefly from the interesting series of marble sculptures and vases described above (see pls. 5, 6, 8).

METAL TOOLS, WEAPONS, AND UTENSILS

A selection of metal tools and weapons of the Bronze Age gives an idea of the forms current in Crete and the Aegean during the Minoan period. It consists of knife blades, chisels, tweezers, awls, needles, a weaving hook, a fish hook, axeheads, spear heads, and daggers (pl. 9).[37] Those of the Early Bronze or Chalcolithic Age are of copper; the later ones are of bronze. Some are said to have been found in the Dictaean cave, the reputed birthplace of Zeus, and must have been votive offerings, to judge by their flimsy character. Others are substantial and were doubtless actually used. The double axe was one of the chief religious symbols in Crete. Several miniature ones of the Late Minoan Age are similar to examples known to have been found

in caves in Crete; one is of gold and has an incised linear pattern. A steatite mold (pl. 9, top right)[38] was evidently used for making such small axes. Several spindle whorls or loom weights (pl. 9, right)[39] are of stone.

A bronze dagger blade (pl. 10c)[40] found in the Lasithi plain, bequeathed by Richard B. Seager, is one of the most important pieces in our collection. On each side is an engraved scene—a man spearing a boar and a fight between two bulls—in the lively style characteristic of Minoan representations. It is Middle Minoan, a predecessor of the famous ornamented dagger blades from Mycenae.

A bronze tripod (pl. 10a)[41] and the rim and handles of the cauldron (pl. 10b)[42] that perhaps rested on it were found in Cyprus and are part of the Cesnola collection. They are decorated with spirited reliefs in Late Mycenaean style (about 1200 B.C. or a little later). On the rim of the tripod are lions pursuing stags; on the rim of the cauldron are lions pursuing bulls; and on the handles are bulls' heads and monsters carrying jugs. This form of tripod is known also from other regions and continued in use for a considerable time.

JEWELRY

Minoan women, and also men, wore jewelry. Some attractive gold ornaments in our collection—a hairpin in the shape of a flower (pl. 11c),[43] a delicate spray of leaves (pl. 11b),[44] and various gold and stone beads and pendants—resemble similar objects found at Mochlos and were doubtless also found there. They must date from the Early Minoan period and suggest a surprisingly advanced culture and considerable wealth in these remote times. A number of glass beads of various forms (see pl. 11f)[45] belong to the Late Minoan period. Those in the form of "curled leaves," each with two transverse holes, probably were parts of necklaces (pl. 11e). Several gilt terracotta rosettes, each with two transverse holes, and a pendant in the shape of a conventionalized lily evidently belonged to a necklace or diadem (pl. 11d).[46] They are said to have come from Mycenae, together with the gilt terracotta goat mentioned above (see pl. 7f). Similar beads and pendants have been discovered in tombs of the Late Helladic period on the Greek mainland, and a necklace of thirty-six gold rosettes of this shape was found on the chest of a "princess" in the royal tomb of Dendra. A stone mold was evidently used for making gold or glass ornaments (pl. 8i).[47] The designs include several animals in the naturalistic Late Minoan style, similar to those on sealstones.

SEALSTONES

Of the many discoveries by Sir Arthur Evans in Crete none appealed to the popular imagination more than that of a written language. Schliemann had found no trace of writing at Mycenae, and people wondered how the highly civilized Mycenaeans of that time could have had no writing when the Egyptians and Meso-

potamians had long ago evolved a script. The many inscribed terracotta tablets and sealstones which later came to light at Knossos and elsewhere in Crete showed that the art of writing was well known to the Minoans. Subsequently, vases of clay and stone inscribed with "Minoan" signs were found at Tiryns, Mycenae, Orchomenos, Thebes, Eleusis, etc., and recently C. W. Blegen discovered several hundred inscribed tablets at Pylos. Evidently the art of writing was known in Greece as well as Crete in these early times. Long before the Greeks of classical times borrowed their alphabet from the Phoenicians, their predecessors in Greek lands had produced an independent native script. So far no bilingual inscription has supplied the clue necessary for interpretation, and in spite of much study and comparisons with the related Cypriote script of the classical period the language has not as yet been deciphered. However, we can trace its evolution from rude pictographs to developed hieroglyphic forms and finally to a linear script. The different stages can be studied on the sealstones, of which the Museum has an excellent collection of several hundred specimens, the majority bequeathed by Richard B. Seager.

The stones of the Early Minoan periods are soft steatites of different colors and shapes, engraved by hand with pictographs consisting of primitive renderings of human beings, animals, ships, floral patterns, branches, spirals, meanders, zigzags, and crossed lines (see pl. 12a).[48] Writing was clearly in an experimental stage without traditional forms.

In the course of time the three-sided, elongated bead became the popular shape, and the pictographs were transformed into less rude, more conventionalized forms (end of Early Minoan to Middle Minoan I and II about 2200 B.C. and later; see pl. 12b).[49] Several symbols generally occur together, showing that from a mere ideographic meaning they had acquired a phonographic value as syllables or letters. In other words the primitive pictographs have evolved into hieroglyphs. Pictographs evidently persisted for quite a while, however, and in the earlier examples they are sometimes found side by side with hieroglyphs. The material used was still the soft steatite.

By Middle Minoan III (1800–1600 B.C.) a further development had taken place. The stones are no longer steatite but harder varieties, such as carnelian, chalcedony, and green jasper, and the chief forms are three-sided, elongated and four-sided, equilateral beads (see pl. 12c).[50] The hieroglyphic script had reached its full development. The symbols appear in a highly systematized form, often executed with great nicety. Among those used are conventionalized flowers, heads of animals, implements, the human eye, and two crossed arms. A few, but only a few, resemble Egyptian hieroglyphs.

The next development in Minoan writing (Late Minoan I–II) was equally important, and incidentally affected the whole subsequent glyptic art of Crete. The linear script, of which there is some evidence even in the Early Minoan period (see

pl. 12d),[51] had been developed side by side with the more popular pictographic script, until it now gained almost complete ascendance. It is natural that, by constant repetition, pictographic symbols should in time be simplified into linear equivalents. Concurrently writing disappears from the sealstones, making way for purely ornamental designs. Representations of animals are favored and occur on stones and rings from both Crete and the mainland. Many of the engravings in our collection are of great beauty, for instance, a wounded bull (pl. 12f), a wounded lion, bulls resting in a meadow, a cow suckling her calf, a lion attacking an ibex, a lion attacking a bull (pl. 12g), an ibex hit by an arrow, two ibexes heraldically grouped, two birds, a ram, an octopus (pl. 12e), a man leaping over a bull, a monster, and two women in bell skirts.[52] One wonders whether the fine understanding of animal life which we admire in the representations of fifth-century gem-engravers was perhaps a quality inherited from an earlier age. The stones are mostly of lentoid and glandular shape; the materials are chiefly the hard quartzes, such as carnelian, agate, jasper, chalcedony, and rock crystal. In addition to these stones there is a red jasper ring (pl. 12i)[53] with a cult scene engraved on the bezel—three women approaching a seated female deity. It is from representations like this that we obtain what knowledge we have of Minoan religion.

In Late Minoan III or Helladic III, the naturalistic style tends to become mechanical. Gradually the representations become conventionalized into linear patterns (see pl. 12h),[54] foreshadowing the Geometric period.

GEOMETRIC PERIOD

XI–EARLY VII CENTURY B.C.

The period following the decline of the Minoan-Mycenaean civilization is called the Geometric period, from the decorative patterns characteristic of its art, or the Early Iron Age, from the increasing use of iron for implements. It is often referred to as the Dark Age of Greece, for in comparison with the splendor of past and future, the centuries between 1100 and 750 B.C. were in eclipse. Actually, we know little of this time. Except for what may be gleaned from the poems of Homer and Hesiod and from legends preserved by classical writers there are no literary records; we are again almost wholly dependent on archaeological evidence, and so far the period has been insufficiently explored archaeologically. Recently, however, new light has come from excavations in Crete, in Argolis, and in the Market Place (agora) and a cemetery in the Potters' Quarter (kerameikos) of Athens. Thus, gradually, the main outlines of this age are becoming more distinct.

We have seen that the first Greek-speaking people are believed to have entered Greece at the opening of Middle Helladic, about 2000 B.C. It is probable that after the arrival of this people other Indo-European tribes made their way southwards and so strengthened the Greek element from time to time. Mycenae succeeded Knossos as the center of authority and culture in the Aegean about 1400 B.C., and it was a great power for about two centuries thereafter. The downfall of the Minoan-Mycenaean civilization, however, did not begin until about 1400 B.C., when, as Thucydides relates, various Greek tribes after the fall of Troy (1196–1186 B.C.) began to move further down into Greece. This migration, known to us as the Dorian invasion, ended with the settlement of the Dorian Greeks in the Peloponnese and Crete. It is approximately contemporary with what the Greeks called the Return of the Herakleidai, the return of a princely family to the territory which had, according to legend, been taken from it by King Minos. Many of the Greeks already settled on the mainland were displaced by the invaders and forced to migrate overseas to the Islands and the coasts of Asia Minor and Cyprus, where they established Greek-speaking colonies. "The Isles were restless, disturbed among themselves," is the comment of the Egyptian chroniclers upon the situation.

It was formerly thought that the Geometric style was a peculiarly Dorian style, introduced by the Dorian invaders and imposed on the Greeks they overran. Thus, it was believed, there was a complete break between the end of Mycenaean and the beginning of Geometric culture. Recent excavations in Attica, however, which, according to tradition, was never overrun by the Dorians, have shown that this view must be modified. Archaeologists can now trace a gradual evolution of style from

the latest true Mycenaean to the earliest fully developed Geometric. There are two main steps in the transition, sub-Mycenaean, in which many Mycenaean elements still dominate, and proto-Geometric, the early, uncrystallized form of Geometric. Even when the Geometric style had been attained, certain elements of the older culture survived, and certain states, such as Athens, seem to have maintained their individuality throughout. There is no doubt, however, that the new style could not have been evolved without some vigorous outside force.

The phenomenon of Hellenic civilization is thus due to the influence of three groups of people: the Neolithic people, who, though primitive, had an artistic strain, as evinced in their pottery; the Early Helladic invaders, who were probably of a non-Hellenic, Mediterranean race akin to the gifted Minoans and were responsible for the introduction of the words ending in -ssos, -inthos, and -ene; and, lastly, the Indo-European invaders of Middle and Late Helladic—generally considered to have been the earliest Greeks—who instilled the new sense of logical order that eventually brought to fruition the miracle of Greek genius.

An outstanding feature of the Geometric period was the formation of a number of city-states and, later, the foundation by these states of colonies not only all over the Aegean, but far into the west, north, and south. Already in the late Bronze Age colonies of the Mycenean culture, which at first included some Minoan elements, had settled in Rhodes, Miletos, Cyprus, Cilicia, and the Levant, thus anticipating to some extent the Greek colonization of the early classical period. Since Greece is mostly a mountainous, rocky, and sterile country, it could only become prosperous by extending its frontiers through commerce and colonization. These facts determined the future history of Greece. Greece was never one country as we understand the word, but rather a group of city-states, each with intense local patriotism but with less feeling for the nation as a whole. National feeling was indeed fostered by the possession of a common language and religion and by the institution of common oracles and athletic games, but it was never strong and spontaneous, whereas loyalty to his city-state was a guiding principle in the life of every Greek.

Our evidence for the chronology of this period consists chiefly of the confused testimony of the Egyptian scarabs and faience statuettes occasionally found in Geometric graves; the traditional date of 776 for the foundation of the Olympic Games; and the traditional dates for the foundation of certain western colonies—733 for Syracuse, 688 for Gela, and 628 for Selinus. From this varied evidence we may deduce with some confidence the absolute dating of the later phases of the Geometric age, but not of the earlier ones. For further support we must again turn to archaeology.

The objects belonging to this epoch consist chiefly of statuettes of terracotta, bronze, and ivory; terracotta and bronze vases; jewelry; and bronze and iron weapons, utensils, and implements.

SCULPTURES IN BRONZE AND TERRACOTTA

Recent research has shown that temples were already being built in Greece in Geometric times. The foundations of largish shrines assignable to that period have been found in Samos, Sparta, Olympia, and Crete. One might therefore surmise that cult and other figures of considerable size also existed. So far, however, only statuettes and small reliefs of bronze, terracotta, and ivory have been found—but those in abundance. If monumental sculpture existed it was of wood and has disintegrated and disappeared.

Our collection of Geometric sculpture includes several bronze statuettes which illustrate the abstract, schematic art of this time. The forms are simplified, and there is little feeling for anatomical structure and movement, but there is a sense of design. Like their Cycladic predecessors, these sculptures remind us of the modernistic products. A group of a centaur and a man (pl. 13b; drawings of the bases of this statuette and of 13e and f are shown here)[1] perhaps represents Herakles and Nessos, for the end of what was apparently a sword held in the man's right hand is visible on the centaur's trunk. The forms are the characteristic ones of this age which occur also in the painted scenes on the vases: a more or less triangular trunk, a narrow waist, bulging thighs, and a flat face. A standing warrior (pl. 13a),[2] of similar proportions, is represented in a frontal pose with left leg advanced. He is a forerunner of the archaic kouros (see p. 47), but the arms are in action—the right one is uplifted, probably to grasp a spear, while the left is lowered, with the hand perforated, perhaps for holding his shield; both of these weapons are now missing. The face is turned upward, as often in Geometric figures. Part of the object to which the statuette was attached is still preserved; it looks like a bit of the rim of a large vessel or tripod of the type found, for instance, at Olympia, which had several such figures mounted on the edge of the rim (see p. 33).

A helmet-maker (pl. 13d)[3] is a particularly interesting piece. He is represented sitting on the ground, grasping a helmet by the cheekpiece, ready to strike it with a mallet (only the handle is preserved); his right foot is on the anvil support to keep it steady. He is forging the helmet, not decorating it; for he has no punch or chisel in his left hand. In spite of the summary execution, the action is nicely indicated. Instead of the stiff, erect posture usual in this period, the figure is shown in a complicated pose, and the movement of the limbs is successfully suggested. This is the earliest Greek helmet-maker known.

A hollow ball with transverse slits and with a seated bearded figure at the top acting as a finial (pl. 13c)[4] must once have served as a pendant, like the similar objects found in Olympia, Dodona, Macedonia, and elsewhere. Perhaps they served as

votive offerings and were hung up in sanctuaries. The seated figure is represented with his hands on his knees and his feet brought close together. The rectangular plate on which he sits has two holes for suspension and is connected with the ball by a cylindrical stem which has a disk at the end. Geometric ornaments are incised on the lower face of the disk and on the man's back. Whether the figure was intended for a deity or a votary it is impossible to say—the latter is more probable, since there are no attributes which could be of help in the identification of a particular deity.

Two statuettes—the upper part of a woman[5] and a man with outstretched arms and of rather crude workmanship[6]—were bequeathed by Richard B. Seager.

Animals were popular subjects with the bronze workers of the time. The examples in our collection include a stylized horse (pl. 13e)[7] with slim body, funnel mouth, and long tail; a cock or peacock with long sweeping tail (pl. 13f)[8]; and two quadrupeds (pl. 13g, h)[9] similar to those found in sanctuaries in Olympia and elsewhere.

Several of these bronze statuettes have openwork bases with engraved decoration on the under side. Their period is probably the late Geometric epoch, the late ninth and the eighth centuries, when human and animal figures first appeared also on the pottery.

Besides bronze, clay was a favorite medium for statuettes and reliefs in this period, and several examples are included in our collection. One of the most interesting is a seated divinity (pl. 13i)[10] with a small kneeling votary serving as a stretcher at the back of the chair. Geometric patterns in lustrous brown are painted on the pale terracotta surface. Several fragmentary plaques from Praisos, Crete (see pl. 15a),[11] have warriors in relief carrying spears and round shields and wearing crested helmets with nosepieces, similar to the one being forged by the bronze helmet-maker (see pl. 13d). A female figure carrying a large jar on her head (pl. 13j) comes from Cyprus (Cesnola collection).

POTTERY

As in other periods, terracotta vases are the most numerous extant remains. According to the locality in which they were found the pots of this period differ somewhat in technique and ornamentation, but essentially the style is remarkably uniform. Everywhere the free curvilinear lines and the naturalistic representation of plant and marine life popular with the Minoans and the Helladic Mycenaeans were evolved into systematized geometric patterns, consisting of zigzags, shaded triangles,

network, checkers, lozenges, straight and wavy lines, tangent and concentric circles, wheel ornaments, etc., and somewhat later by meanders and such derivatives as the swastika. Some of these ornaments had a long previous history, being derived from Minoan or Helladic prototypes; others were introduced by the Geometric potter and had, in their turn, a long subsequent history, forming part of the heritage of the classical vase-painters.

We are now able to distinguish four chief periods—the sub-Mycenaean, in which curvilinear Aegean elements are still common; the proto-Geometric, in which the Geometric repertoire is in formation; the full-fledged Geometric (subdivided into early, severe, ripe, and late), which is characterized by a profusion of Geometric designs and the introduction of figures of animals and human beings; and the sub-Geometric, which runs parallel with the early stages of the Orientalizing and proto-

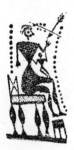

Attic. The decorations are executed in lustrous brown glaze on the light terracotta, as they had been in Late Minoan and Helladic times. Sometimes, through oxidation in the kiln, the brown glaze has turned reddish. The figured scenes are, of course, of special interest. The animals and human beings are drawn in silhouette, without incisions; occasionally the head is drawn in outline with a dot for the eye. The shapes of the vases are in part developed from those current in the Minoan and Helladic periods—the krater, the amphora (with handles differently placed), jugs, water jars, and cups. In general the vases are wheel-thrown (for exceptions see p. 26).

Geometric pottery reached its highest development in Attica and it is from this region that most of the examples in our collection have come. The most important are three colossal vases of the type used as grave monuments, formidable achievements in the art of pottery. They were worked on the wheel in sections, and the joins, sealed, of course, before firing, can be detected on the insides. There are holes in their bottoms for pouring drink-offerings to the dead. These vases are excellent examples of the Geometric style at its peak and are considered to belong to the second half of the eighth century.

On two the chief scene on the upper register represents a *prothesis* (pl. 14a, b).[12] A dead man is laid out on a bier, surrounded by his relatives (on one vase two hold branches), professional mourners, and domestic animals. Funeral processions of chariots and warriors wearing crested helmets and armed with swords, spears, and enormous shields occupy the other friezes. The human figures have the proportions typical of this art—triangular trunks, small waists, bulging thighs, and small, round heads. The horses have cylindrical bodies and funnel- shaped heads. All are schematized renderings, highly effective as patterns, but with little relation to nature. They are pieced together from full-front and profile views, without perspective or fore-

shortening. The three-quarter view is never attempted. It is noteworthy, however, that in inanimate objects the artist did not limit himself to the representation of the front plane, like his successors of the archaic period (see p. 56)—for instance, he indicated the horizontal surface of a chair or coverlet; the vertical surface of the back of a chair or couch, and the farther legs alongside the near ones; the two wheels and floor of a chariot. In other words, he tried to indicate every part of an object instead of a particular view of it.

A prothesis also appears on the third colossal vase, but in a compressed form, and in the lower frieze, instead of chariots, two lively sea battles are represented, separated by rows of marching warriors (pl. 14d).[13] The ships are long and narrow with a half deck at each end, hornlike objects at stern and bow, and a ram at the bow; they are, therefore, fighting ships. One ship is evidently beached, for there is no helmsman at the rudder; on the deck men are fighting with swords, spears, pikes, and bows and arrows. In the missing central portion there were doubtless more contestants. There are no rowers, presumably because all the men are fighting, for, as Thucydides tells us (1.104), in early times "all on board were at once rowers and fighting men." A bird sits at the stern. The second ship is at sea, with sail spread. A helmsman is stationed at the rudder and men are fighting on the deck; a man in the center may be wounded or attending to the sail. Probably the vase was erected on the grave of a sea captain who lost his life in the fight portrayed. Whether he was engaged in a regular battle or a piratical raid we do not know. (Piracy then was as common and as honorable a calling as in Elizabethan days.) In either case, the scenes indicate that in this early age Athens had formidable warships and that Athenian chieftains performed feats at sea which were commemorated at home in sumptuous memorials.

A fourth colossal vase (pl. 14c)[14] belongs to the Cesnola collection and was found in Cyprus, but it may originally have been imported there, perhaps from a Cycladic island, for it is different in character from the Athenian examples. It has a lid with a vase-shaped knob, and there is no hole in the bottom. The scenes are not sepulchral but consist of animals and geometric patterns. Some are survivals of the Mycenaean Age—the goat suckling her kid, the goats heraldically grouped browsing on a tree, the double axe, and the tangent circles—whereas the grazing horses, birds, meanders, checkers, and lozenges are the stock in trade of the Geometric age.

Two large Athenian jugs almost completely covered with patterns[15] may be assigned to the same period as the colossal vases, that is, the second half of the eighth century (see pl. 15b). Two handsome amphorae (pl. 15c, d)[16] said to have been found together, with chariots, warriors, mourning women, and Orientalizing patterns and plants probably belong to the end of the century; for the two pairs of lions on one of them herald the Oriental influence which was soon to become potent. Serpents appear in relief on the rim, shoulder, and handles.

Among the smaller vases of this general period is an amphora with an unusual representation on the neck—a man in a long chiton with a tasseled mantle over his shoulders (pl. 16b).[17] He is evidently a wealthy man of the upper class, such as Thucydides describes (1.6). The charioteers on the body of the vase likewise wear long chitons, as they did in later times. A dainty, two-handled cup (pl. 16d)[18] with a man leading two horses also probably belongs to a late phase of the Geometric style. A handsome pyxis, preserved with lid and knob, is completely covered with Geometric designs, dominated by a large running meander.[19]

A number of small vases[20] found in a dump heap during an American excavation on Mount Hymettos were given to the Museum by the Greek Government. They consist chiefly of one-handled and two-handled cups and jugs of different shapes and sizes (see pl. 16g, i). The inscriptions on some vases in Athens that were found with them are among the earliest extant examples of Greek alphabetic writing.

Two jugs, said to have been found together in Attica, have stamped instead of painted ornaments—evidently impressed by a cylinder (see pl. 16a).[21] Unlike most Geometric vases, they are hand-built instead of thrown.

Besides these Athenian vases, there are some from various other localities—two-handled bowls[22] decorated with concentric semicircles, of the type now identified as Cycladic (see pl. 16f); two small bowls from Sardis (see pl. 16e)[23]; and fragments of Geometric pottery from Laconia, Sardis, and elsewhere. Two jugs with conical bodies (see pl. 16c),[24] a round toilet box (pl. 16h),[25] a gift of Mrs. Bayard James, and two little jugs with globular bodies[26] exemplify Geometric proto-Corinthian ware. They are decorated with linear patterns of metallic precision, consisting mostly of continuous lines spaced close together encircling the body of the vase, single spirals and schematized birds.

TOOLS AND IMPLEMENTS

Although iron was introduced at this time—presumably by the northern invaders—bronze was naturally not discarded, and bronze and iron were used side by side for weapons and utensils. That relatively few iron objects have been preserved is, of course, due to the fact that iron corrodes more readily than bronze. The bronze fibulae, or safety pins, in our collection show two forms current at the time, when the introduction of the loose garment, which took the place of the tight-fitting Minoan one, made them useful adjuncts. One is a "spectacle" brooch with wire wound into two large spirals (pl. 17a)[27]; another has a large catch plate with an engraved design, perhaps a stylized bird (pl. 17b).[28]

A circular bronze handle of a tripod (pl. 17f),[29] of a type familiar from the discoveries at Olympia and elsewhere, reminds us of the sumptuous metal dedications current at this time (see p. 22). A bronze axehead (pl. 17e)[30] covered with a beautiful turquoise-blue patina is of the "winged" variety, with side flanges and stop-

ridge for fastening the handle. As it was bought in Rome, it was probably found in Italy; but the type also occurs in Greece. A bronze spearhead with leaf-shaped blade and tubular socket (pl. 17d)[31] comes from Cyprus (Cesnola collection). Another of the same form, also from Cyprus, is of the new metal, iron (pl. 17c).[32]

GLASS BEADS

Glass beads have been popular from Egyptian to modern times. A selection, ranging from about 1000 to 600 B.C. and later, is included in the Museum collection. They are of various types, the commonest being the plain, the melon, and the "eyed" varieties. The majority are from the Gréau collection, given by J. Pierpont Morgan in 1917 (see pl. 17g–j).[33]

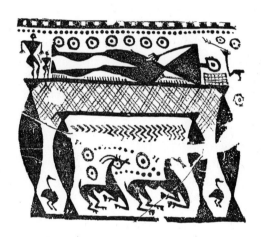

PERIOD OF ORIENTAL INFLUENCE

In the seventh century a great change came over Greek art. The Geometric style was transformed by new conceptions in which Oriental influence played an important part. The change came as a natural consequence of the conditions of the time. After the upheavals of the preceding period a new Greece was in formation. Navigation and commerce had received a fresh impetus with the formation of Greek colonies in near and distant parts (see p. 21), and the wealth of the city-states had thereby increased. The Greeks were continually coming into contact with the East. Oriental goods were brought to Greece by Phoenician traders, and the Greek colonists who had settled on the coasts of Asia Minor and in Egypt naturally felt the influence of their Oriental neighbors. The mature artistic experience of Egypt, Mesopotamia, Syria, etc. was thus made available, to some extent at least, to a young and comparatively unformed people. Greek appreciation of products peddled by the Phoenicians is reflected in the Homeric poems. It would not have been surprising under these circumstances if Greek art had assumed and retained a definitely Oriental character. Its vitality is shown by the fact that, instead of becoming Orientalized, the Greek artist merely selected the forms and ideas that appealed to him. With their help and under their stimulus the abstract Geometric art with its angular patterns and schematized figures was gradually transformed into a style with rounded forms and a wealth of new motives.

The late eighth, the seventh, and the early sixth centuries mark the beginning of many cardinal elements of Greek civilization. Coinage was introduced and doubtless stimulated industrial life. The alphabet had been brought to the Greeks by the Phoenicians, and by the seventh century the art of writing was in general use, each state, however, employing its own particular forms. The religion and myths of the Greeks had been crystallized into a coherent whole made up of Minoan-Helladic survivals, Hellenic traditions, and Oriental intrusions. The poems of Homer and Hesiod—which have been attributed to both the eighth and the seventh centuries—constitute their first common literature. The building of temples, which can now be traced back to the Geometric period (remains of a number of them have been found on former Helladic sites), had stimulated the arts; monumental stone sculpture seems to have been started in the seventh century, to judge at least by present remains (see p. 47). The Olympian games are said to have been instituted in the eighth century (the traditional date is 776 B.C.); the Isthmian, Pythian, and Nemean Games—the other great Panhellenic festivals that played so important a part in Greek life—were established in the early sixth century. All these elements tended to

unify the Greeks, while the diverse customs of the many scattered city-states fostered a love of local independence.

A rich and varied picture of the period is given by the objects that are in our collection. They enable us to see in concrete form the influence of the events of the time. A fresh, vigorous art is coming to life, touched by Eastern influence but independent in outlook. The objects consist of ornamented pots from various localities illustrating the development and the content of pictorial art in different sections of Greece from the eighth to the sixth century; and small sculptural works in terracotta, stone, ivory, silver, bronze, and lead showing the evolution of form during that period.

SCULPTURES AND UTENSILS IN VARIOUS MATERIALS

A terracotta head, just under life size, is a remarkable product (pl. 27a).[1] It has enormous eyes, a small slit for a mouth, a small, round chin, a large, beaked nose, and prominent ears. The hair appears like a band beneath the fillet, and a long lock frames the face on either side. Round the neck is a necklace with a pendant. The great width of the face is explained by the fact that the head was thrown on the wheel, as the marks on the inside show. The missing body was doubtless also thrown and was probably columnar. Traces of the original color are still visible. In spite of the slapdash execution the head has style and vivacity. It must precede the so-called Daedalid sculptures with their well organized features (see pl. 18e, g) and be a product of a more experimental stage. It recalls, in fact, some figures on proto-Attic vases of the first half of the seventh century which have the same large nose and eyes, flat skull, and vivacious expression (see p. 39 and pl. 27b). In the opinion of some it is Cypriote.

A number of early terracotta statuettes, heads, and reliefs from Praisos, Crete, are part of a rich deposit of votive offerings found by Federigo Halbherr in 1894. They are of great interest in that they reflect the sculptural styles current in Crete from the beginning of the seventh to the sixth century B.C. A woman in primitive style with a fragmentary inscription on her back (pl. 18a)[2] may be assigned to the early seventh century; two youths pressed from the same mold (see pl. 18b),[3] wearing belted tunics, probably date from the second quarter of the seventh century; a female figure with a tympanum hanging from her shoulder (pl. 18c)[4] may be assigned to the middle of the century. Two heads of the second half of the century were bequeathed by Richard B. Seager.[5] They have their hair arranged at the sides in horizontal layers, in the Daedalid fashion current throughout the Greek world at the time.

A terracotta head with hair similarly dressed (pl. 18e)[6] belongs perhaps to the middle of the seventh century. It was apparently once part of a statuette, as the somewhat rubbed fracture at the bottom indicates. It came to the Museum as a gift

of Alexander Boyd Hawes, in memory of his mother, Harriet Boyd Hawes, and is said to have been purchased in Crete.

Two terracotta female figures with flattened bodies, pinched faces, stumplike arms, high headdresses, tunics, and necklaces with pendants (see pl. 18d)[7] are votive figures of a type found in early Boeotian sanctuaries. One wears a mantle, shawl fashion. The type began in the late Geometric period and lasted into the sixth century.

Other examples, large and small, illustrate the many uses of sculpture in this period. They range in date from the late seventh to the middle of the sixth century. A terracotta antefix in the form of a female head (pl. 18g)[8] once decorated a temple at Matauros, a Locrian colony in South Italy. The modeling of the eyes and the triangular depressions at the corners of the lips point to a late seventh-century date. The hair, here too, is arranged in horizontal layers. A terracotta figure in high relief, perhaps from Sicily, represents a (female?) figure reclining, propped up on the left arm (pl. 19a).[9] The hand resting on the shoulder is evidently part of another figure, and the two presumably formed a group in a banquet scene. The modeling points to a date in the first half or the middle of the sixth century. A fragment of a large terracotta head (pl. 19c),[10] found at Matauros, near an archaic temple, dates from the middle of the sixth century. It was worked hollow, apparently in the round. The surface is covered with a white engobe; irises, lashes, and eyebrows are black. It is an imposing piece, perhaps from a temple statue. A fragmentary relief (in two pieces) with a rider and two horses (see pl. 18f for upper piece)[11] was found at Gela, in Sicily. The head of the near horse, which was turned to the front, is missing; that of the off horse is seen in profile. The rider himself turns his head to the spectator in a vivacious, lifelike manner. The thumb at the back of his long hair must come from another figure that was seizing the rider by the hair. This gives the clue to the identity of the figure—young Troilos seized by Achilles. The group may have been part of a metope and dates, perhaps, in the third quarter of the sixth century.

Four terracotta antefixes from Tarentum are decorated with masks of gorgons in relief. We must imagine such reliefs, gaily painted, adorning the eaves of temples. Two, with large, flat eyes and conventionalized ears (pl. 19d, e),[12] may be assigned to about 580–570 B.C. The two others are more developed in style and probably date around 540. One (pl. 19f)[13] has extensive traces of the original colors, applied over a white engobe: yellow on the face; red on the hair, beard, gums, lips, tongue, and snakes; blue on the background. The smaller one (pl. 19g)[14] evidently belonged to a series molded from one of the larger examples. The repeated dryings and firings caused considerable shrinkage.

A portion of a terracotta frieze is a delicate piece of work.[15] The design of sphinxes and chariots drawn by winged horses was produced in relief by a roller. The piece probably comes from the round stand of a cauldron, for it is finished at the bottom and could not have been part of a rim.

Four terracotta plaques, which probably decorated early Attic tombs, are important ceramic products. The two earliest, said to have been found at Olympos in Attica (pl. 26d, f),[16] have reliefs of women bewailing the dead (one is fragmentary). The mourning women wear long tunics and mantles and are represented tearing their hair in grief. The abrupt transition from full front or full back to profile view is a customary convention of the time. The figures are partly reserved in the buff color of the terracotta, partly painted in blackish glaze, with some incision and with some red as accessory color. The date of the reliefs should be some time in the third quarter of the seventh century, contemporary with the amphora from Kynosarges in Athens.

A third plaque (pl. 26h),[17] of which only the right side is preserved, has a representation in relief, originally painted, but now pale buff. Achilles (the name is inscribed), holding a shield with a gorgon's head as a device, is raising his spear against an opponent, now missing. The latter was evidently the queen of the Amazons, for part of a fallen Amazon, inscribed *Ainia* (?), is preserved below Achilles' shield. The vigorous, harsh style, the large features, and the rendering of the anatomy by grooves and ridges recall the marble kouros (see p. 47). We may date the relief, therefore, around 600 B.C. A fourth plaque, one dating from the end of the century, has a lion painted in black glaze (pl. 26g)[18] on the buff terracotta, with details incised. Lions were often figured on sepulchral monuments in Greece, perhaps as guardians of the tomb.

A fragmentary limestone sphinx (pl. 19b),[19] said to have been found in Attica, either was votive or served as the finial of a gravestone (see p. 48). She wore a *polos* on her head, of which the upper part was worked separately and is missing. The hair is rendered in front by horizontal folds, in Daedalid fashion. The colors are exceptionally well preserved—black on the hair, red and blue-green on the body and wings, white on the edgings. The date is probably the late seventh century.

A marble lamp (pl. 23g),[20] said to be from near Thebes, originally stood on an iron pedestal of which traces remain. The lamp is ornamented in low relief with griffins, sphinxes, sirens, lion's and ram's heads, and birds, worked with delicacy and refinement. It is probably of the second half of the sixth century. A piece belonging to it, in the Museum of Fine Arts, Boston, has been added here in a plaster copy.

An ivory plaque with two female figures in relief (pl. 20a)[21] is an object of rarity and importance. It probably once decorated a chest, for the back is flat and two holes show that it was once fastened by rivets. The ivory has split and peeled in places, and some parts are missing; but enough remains to make the intention clear. The two female figures are represented in frontal pose, with feet in profile. There were no other figures in the group, for the edges, right and left, are not fractured, but smooth. However, there may have been other figures or groups, right and left; indeed the turn of the head of one of the women suggests a continuation of the scene

at least in that direction. The long-haired woman has put one hand between her breasts, and with the other holds the edge of her mantle over her shoulder, letting the rest fall to reveal her body; her hair falls loosely down her shoulders. Her companion, whose head is missing, wears a long, belted tunic which is fastened on the left shoulder but not on the right, the loose material falling over the right arm and along the thigh but leaving the right breast bare (the splitting of the ivory accounts for the present distortion). She grasps her belt with both hands, and is tying or untying it.

The interpretation of the figures is not easy, for there are no obvious parallels. Aphrodite and Peitho; Arge and Opis; and Aphrodite and Helen (turning toward Menelaos) have been suggested (the last by Lady Beazley). The rendering of the face and of the foldless drapery with its incised ornaments brings to mind the limestone statuette once at Auxerre and now in the Louvre. We may assign the relief to the same period, that is, to the third quarter of the seventh century B.C. Nothing is known of its provenience except that it came to the Museum as the gift of J. Pierpont Morgan in 1917.

A fragmentary silver relief (pl. 20b),[22] which may once have ornamented a box, is another rare piece. The decoration is divided into panels in a metope-like arrangement, bordered top and bottom by a tongue pattern. The preserved panels are decorated with (1) Herakles shooting an arrow at (2) a centaur wielding a branch, (3) a *potnia theron*—a winged figure holding animals, (4) a flying gorgon with face frontal, and (5) a woman with one arm extended, the other held by a missing companion, evidently in a dance. The technique is interesting. The relief is in two layers of silver—a very thin surface layer, gilded front and back, and a thicker backing layer—both hammered in the same die and riveted together. The gilding was apparently applied by the mercury or amalgam process. For the most part only the backing layer remains; in the centaur, however, much of the gilded surface layer is also preserved, and of the gorgon only the surface layer is left. Other examples of such "plated" silverwork are the fragments from Perugia in the British Museum; our piece, however, is earlier in style and should date from the late seventh century. Nothing is known of its provenience except that it was purchased in Italy and so was presumably found there.

A number of bronzes, some of them utensils and parts of utensils, testify to the decorative instinct of the early Greeks. Several are from Cyprus. A substantial lampstand with lotus petals on the stem and a tubular socket for the insertion of a wooden shaft (pl. 21a)[23] must have supported a small lamp of the saucer type common in Cyprus during the sixth century. An animal's hoof (pl. 21b)[24] and a bull's head (pl. 21c)[25] with horizontal tubular sockets to which corroded fragments of an iron framework still adhere perhaps formed parts of tripods. An eagle (pl. 21d)[26] with outspread wings and eyes of stone (one is missing) probably decorated a tripod or

vase and dates from the seventh century. A two-handled bowl with reel-shaped knobs on the rim (pl. 21f)[27] is similar to one found in the famous Polledrara tomb (about 600 B.C.), to the one held by the ivory "hawk goddess" from Ephesos (early sixth century B.C.) and to several from Bayrakli (old Smyrna).

A griffin's head of unknown provenience is a fine example of the seventh or sixth century (pl. 21e).[28] Similar heads, found at Delphi, Olympia, and on the Athenian Akropolis, served as decorations on the rims of large tripod bowls (see p. 35) and were the successors of the statuettes which were perched on such rims in Geometric times (see p. 22). Our example may well have served such a purpose. The upper part of a bronze female figure (pl. 22i),[29] perhaps from Crete, has the hair arranged in Daedalid fashion, like the terracottas mentioned above. It was evidently part of a utensil, for on top of its headdress is a large dowel; perhaps it was one of several statuettes supporting a cauldron. The careful workmanship suggests that it was part of an important ensemble.

A bronze statuette of a long-haired youth wearing a loincloth (pl. 22c)[30] is said to have been found near Knossos. The large head, the thighs bulging out from a narrow waist, and the straight back recall kouroi from the Greek islands and suggest a date in the late seventh century B.C. The aristocratic bearing is in keeping with Minoan traditions.

A handle of a large hydria (pl. 22g),[31] decorated with sphinxes and reclining figures, probably belongs to the late seventh or early sixth century. A statuette of a walking horse[32] with a handsome topknot is said to be from near Lokroi in southern Italy; it may be dated in the first half of the sixth century, perhaps in the second quarter. A curved plaque (pl. 21h)[33] has two lions in low relief heraldically grouped on each side of a lotus flower. A similar example is in Berlin. Both may be assigned to the second half of the sixth century.

The material of ancient mirrors was not glass but burnished metal, generally bronze; a greenish patina now usually covers the surface, but originally the color was the golden yellow of the metal. The forms varied during different periods. The earliest date from the early sixth century and consist of a disk with a handle often in the form of a statuette. They were intended not to stand up, but to be held in the hand and when not in use to be laid down on chest or table. (For the later standing mirrors see p. 81.) The slight convexity of the disk was, of course, intended to diminish the image and enable the user to see the whole head. At a time when there were no large wall mirrors this was convenient.

Four examples of this comparatively rare type of mirror, dating from the middle and the third quarter of the sixth century, are included in our collection. One is practically complete (pl. 22a).[34] The disk is decorated on each side with a rampant griffin and supported by a slim, nude girl, wearing a necklace and a band of amulets and standing on a couchant lion; she holds a pomegranate by its stem in one hand and in

the other probably had a flower, now missing. In another example (pl. 22e),[35] without disk, a girl playing the castanets stands on the back of a frog, which, in turn, is sitting on a folding stool. Of a third specimen only the upper part of the girl is preserved.[36] All three figures may be interpreted as courtesans, votaries of Aphrodite. The girl in the fourth example, which has its disk (pl. 22b),[37] is of a sturdier physique (note the rendering of the rectus abdominis muscle); she is grasping two lions by their tails and has no necklace or amulets, but wears a loincloth. She is therefore not a courtesan but an acrobat. Girl tumblers were popular in Greece, as we know, for instance, from Xenophon's famous account in the Symposion. The disk is convex in front and concave at the back, reducing and enlarging the reflected image accordingly.

Another statuette of a girl wearing a loincloth (pl. 22f)[38] and of a similar developed physique served as the handle of a patera, as is indicated by the form of the attachment. The date is probably around 520 B.C. (near that of Deinagores' statuette in Berlin). A statuette of a nude girl holding a lotus bud (pl. 22d)[39] also supported some object, but not a mirror, for the hole on top of the head is squarish and hardly deep enough for a heavy disk. Perhaps it was part of an incense burner. The molded base is cast in one piece with the figure.

Bronze helmets were commonly used by the Greeks and a number of types can be distinguished. Three of our examples are of the "Corinthian" type, with long nosepiece. One is of the form current in the seventh and the early sixth century, with a straight back and small holes around the edge for the attachment of a leather lining (pl. 21g).[40] The two others (see pl. 21h)[41] are of the shapely sixth-century form with reinforced edges and no holes (doubtless a separate leather lining was used). Each has an attractive spiral border. A fourth example (pl. 21i),[42] with no nosepiece and two ridges along the bowl, is of the so-called Island type and dates from the late sixth century. Two confronting lions are delicately engraved on the frontal; between the two ridges running across the bowl from front to back are remains of an attachment for the crest, and the nail in front served the same purpose. The numerous dents and signs of wear on these and similar helmets show that they were made for use and were worn during actual fighting. Sometimes the nosepiece or the cheekpieces are bent upward, perhaps to show that the object was dedicated in a sanctuary.

A collection of lead figures in relief, cast in molds, comes from the sanctuary of Artemis Orthia at Sparta.[43] They represent deities, human votaries, monsters, and animals. The majority date from the seventh and sixth centuries; others are later, for the sanctuary enjoyed a long popularity. A few fragments of terracotta masks[44] are examples of another Spartan specialty. Such masks, often of grotesque appearance, were evidently votive, for they seldom have openings for eyes and mouth and could hardly have been actually worn.

POTTERY

The spirit of the new age is clearly reflected in the terracotta vases. All over the Greek world pots of this period in new shapes, techniques, and styles have come to light. Even if we had no other knowledge of contemporary events the sudden appearance of these many different, highly decorative wares would show us that something new was afoot.

The pottery best represented in our collection is the Corinthian. The proto-Corinthian vases—now recognized as early products of Corinth—consist chiefly of small, dainty perfume vases. They were made for suspension. Their neat forms and the astonishing minuteness and finish of the decoration give them a special attractiveness. Several styles can be distinguished which can be approximately dated from the traditional foundation dates of the Greek colonies in Sicily, where vases of this type have been found in quantity—Syracuse in 733 B.C., Megara Hyblaia in 728, Gela in 688, Selinus in 628. The earliest pots in our collection belong to the Geometric period of the ninth and eighth centuries and are decorated with linear patterns of metallic precision (see p. 26).

The "early Orientalizing" style of the late eighth century is illustrated in the cone-shaped bottom of a jug (pl. 23a)[45] decorated with an animated representation of a dog running at full speed after two horses, a large strutting bird, and what looks like a griffin-bowl (see p. 22); the background is strewn with fish, single spirals, a cross, and a checkered lozenge; above and below are patterned bands; on the underside is a swastika. The decoration is painted in brownish glaze on the buff terracotta; both outline drawing and silhouette are used for the figures, and the details are reserved, occasionally incised; white occurs as an accessory color. We have here the beginning of a style that was current all over Greece during most of the seventh century. The figures are no longer angular creatures of Geometric art but animated, expanded versions with rounded contours; the ornaments have become curvilinear, and several have Eastern prototypes.

In the next stage of proto-Corinthian—the first black-figured style (about 700–675 B.C.)—the decoration is painted in silhouette throughout and details are incised. Animals and occasionally human figures form the chief decoration. Two perfume vases of ovoid form decorated with running animals (see pl. 23b)[46] are characteristic specimens.

The second black-figured style (675–640 B.C.) is illustrated by an attractive vase (a gift of Edward Robinson) with a complex floral design and a frieze comprising three groups, a man and a woman, two warriors in combat, and a male and a female sphinx (pl. 23c).[47] It represents the acme of the proto-Corinthian ware and must be contemporary with the famous examples in London, Paris, and Rome with similar minute and spirited ornaments. A great change has taken place since Geometric times. The figures are now coordinated and have lost their former uncouthness. Not

only are contours more rounded and details richer, but there is more variety. The trunk, instead of always being drawn in full front view with head and limbs in profile, now appears sometimes in full front view, sometimes in profile, according to the direction of the arms; the head is turned to right or left; and the weight of the body is squarely on the feet. The first important steps toward a more naturalistic art have been taken.

Several perfume vases with black, incised scale patterns are late proto-Corinthian, of the second half of the seventh century. The shape has again changed, becoming markedly pointed. An example given by Mrs. George D. Pratt has red and brown accessory colors, which add to the richness of the effect (pl. 23d).[48] In another (a gift of Joseph Brummer) the glaze has turned reddish in the firing.[49]

Proto-Corinthian potters now and then made perfume vases in the shape of animals, birds, and human beings. A masterpiece of this type in our collection represents a little man (pl. 24a)[50] dressed in a short-sleeved tunic and a mantle, one end of which is thrown over his left shoulder; his hair, which is encircled by a fillet, is arranged in horizontal layers in front and tied at the back. The original color scheme can still be made out: the hair was black; the tunic the buff color of the terracotta; the mantle red with a border of black dots. The heavy, compact forms, the manner in which the little feet emerge from below the long tunic through an arc-like opening, reflect Oriental influence. The general style is paralleled in the limestone figure once in Auxerre and now in the Louvre. The figure may be dated, therefore, in the third quarter of the seventh century. It is noteworthy that on each side of the hair there are two string holes, for, like other proto-Corinthian vases, these plastic ones were made for suspension.

A bird, presumably intended to be a pigeon in spite of its large eyes and strongly curving beak, is one of the most engaging examples of proto-Corinthian art (pl. 24d).[51] Most of the tail and part of the beak are missing; otherwise it is in excellent condition. It was worked with loving care. The walls are extraordinarily thin. The form is compact, with wings and legs kept close to the body. The feathers are indicated by incisions on the body and wings, by dots on the head and neck, and at the beginning of the tail. The orifice was concealed by the tail, as is regularly the case in proto-Corinthian bird vases, and the legs are pierced for the insertion of a string, so the bird was evidently hung upside down. In that position it fits well into the palm of one's hand. Its date is probably the same as that of the fine partridge in Leyden—the second quarter or middle of the seventh century. Another bird, less carefully worked, and of somewhat later date, is covered with dots (pl. 24c).[52] It has no feet or base. The orifice, decorated with a rosette, is again under the tail, and the tail is pierced for suspension, so this bird, too, was carried upside down.

The Corinthian black-figured ware of the late seventh and the sixth century de-

veloped out of proto-Corinthian. Eastern ornaments, animals, and monsters are still the leading motives, but human figures in definite action also appear; the compositions are crowded with filling ornaments, among which the incised rosette predominates. Though the execution is often careless, the general effect is highly decorative; the designs give the impression of rich embroidery and were, indeed, doubtless inspired by Oriental textiles. Perfume vases—the aryballos and alabastron—were favored. The larger pieces, however, such as amphorae, mixing bowls, water jars, round boxes, and plates, which often have figured representations in a clear, sober style with little or no filling ornament, represent the best achievements of Corinthian potters.

That the city of Corinth was the center for the manufacture of this pottery is shown by the large quantity of vases of this style found there and by the inscriptions in the Corinthian alphabet which sometimes occur on them. The ware was evidently widely exported, for it has been found all over Greece and the Greek islands, Italy, Asia Minor, Egypt, and the Crimea. Its period is coincident with the tyrants of Corinth, under whom the city attained her political and commercial supremacy.

The examples in our collection have been arranged in five categories according to their period.

1. Transitional between proto-Corinthian and early Corinthian (about 640–625 B.C.). The decoration generally consists of animals arranged in rows and interspersed with dotted rosettes. Two jugs (pl. 23e, f)[53] and an alabastron,[54] all three with rows of animals, are characteristic examples.

2. Early Corinthian (about 625–600 B.C.). This ware has strong, bold designs, heavy, expressive forms, and a rich repertory of decorative motives. Human beings in concerted action and mythological scenes are now fairly common. The subjects on our examples include padded dancers—on a large krater from the Gallatin collection, where they are playing leapfrog (pl. 25c),[55] on an aryballos said to be from Tarquinia,[56] and on an amphora from Capua[57]—the winged Artemis,[58] and a winged male figure, perhaps a Boread,[59] both on alabastra. Two toilet boxes[60] are pleasingly decorative—note the handsome knobs on the lids. A jug with a conical body (pl. 25h)[61] shows precise, careful drawing.

3. Middle Corinthian (about 600–575 B.C.). The forms are more emaciated and there is a tendency to repeat stereotyped motives. A number of exceptionally fine examples are included in our collection. A large krater (pl. 25b, d)[62] with a continuous row of animals and with armed horsemen on one side and Helen and Paris on the other is an outstanding piece. Though the surface of the latter scene has suffered much, it could be reconstructed in a drawing from the traces that are left. Some figures have their names inscribed in Corinthian letters—Alexandros (Paris) and Helena in a chariot, Hektor (spelled Ektor) and Daiphon at the back, Automedousa at the side, Hippolytos in front, and Xanthos and Polypentha, two of the

horses. The scene probably represents the marriage procession of Paris and his bride after their arrival in Troy. A fragment of another krater (pl. 25e)[63] has a battle on the principal zone and, on the two subsidiary zones, horsemen and animals. The combatants are in battle array—crouching and lunging forward for the attack; some are in ambush behind, and one has fallen and lies helpless on the ground. The forms overlap, suggesting depth. Helmets, cuirasses, shields, greaves, swords, and spears are rendered with considerable detail and precision. Glaze diluted to a golden yellow is used as a wash on a helmet and cuirass to suggest the color of bronze. A plate, said

to have been found in Attica, has a Chimera painted in red and black, beautifully spaced in the circular field (pl. 25a).[64] On another plate,[65] said to be from Corinth, a man is represented lying on a couch, his lyre hung on the wall above, a footstool placed beneath for use in stepping down.

4. Late Corinthian I (about 575–550 B.C.). The subjects are often monotonous, the forms meager, and the drawing though it is more advanced is generally cursory. The pale ground of the terracotta is now often covered with a red wash to approximate the effect of the contemporary Attic ware (see p. 40)—perhaps an attempt to come into line with an increasingly successful rival. Our collection includes several tall, narrow-necked alabastra with lions, cocks, monsters, ably composed on the curving surface, and a number of small aryballoi with a horseman, marching warriors, animals, and monsters. A small alabastron (25i)[66] has a picture of Odysseus and his companions blinding Polyphemos. On a hydria[67] of spheroid form Herakles is about to thrust his sword into a centaur, who touches his opponent's beard in supplication. An oinochoe[68] with cocks and an owl has a well-preserved red wash on the background. Three toilet boxes with female busts in high relief on the handles (see pl. 25f, g)[69] are of special interest in that they supply sculptural types that can be approximately dated, since their painted decoration places them in the second quarter of the sixth century. On one the heads have their names inscribed in the Corinthian alphabet—Himero, Charita, and Iopa.

5. Late Corinthian II (after 550 B.C.). The decoration consists mostly of linear and floral ornaments. This is the last phase of Corinthian pottery. The ware was no longer widely exported, but produced principally for the home market, since Attic pottery had by now ousted its rivals. The most interesting specimen in our collection is a toilet box with female heads on the handles.[70] It is similar in type to those just described but later in style and decorated with floral ornaments.

Plastic vases—descendants of the dainty proto-Corinthian creations—were produced from the Early to the Late Corinthian periods. Our examples include a fish, two hares, and a crouching man.[71] The last—a particularly engaging piece—has rosettes painted on his back and hedgehogs and foxes on his arms and legs (pl. 24b). The holes in his hair served for suspension. It may be dated about 590–575 B.C.

The development of early *Athenian* pottery can be studied in several examples belonging to the three chief stages through which Attic vases passed from the late eighth to the early sixth century. (The later sixth-century examples are all discussed in the following chapter, which deals with archaic Attica.) In the almost complete absence of contemporary literary records these decorated pots assume special historical importance. They suggest an exuberance and a vigor that we should hardly have expected from our scanty information about contemporary Attic history—Solon's account of a harsh aristocracy and a downtrodden people, for instance.

We saw that in the late Geometric period Oriental motives had already found their way into the repertory of the Attic vase-painter (see p. 25). Gradually the shapes, technique, and style of drawing changed from Geometric to Orientalizing proto-Attic. At first the line between the two is difficult to draw; but soon the new outlook is unmistakable. The first stage is illustrated in our collection by several examples mentioned above (see pp. 24 ff.). Geometric ornaments predominate, but a few Oriental motives have intruded. A small, lidded jug, of the class formerly called Phaleron, since several examples of the type were found there, is decorated with "Boeotian" shields and a hare hunt (pl. 26a).[72] The decoration is painted in simple silhouette, without incision or accessory colors. Technically, therefore, it is a direct descendant of the Geometric age. In the forms of the animals and the shields, however, a new style is apparent. We may date these early proto-Attic vases around 700 B.C.

A magnificent amphora (pl. 27b),[73] about 3½ feet high, with a wealth of decoration, belongs early in the second stage—the full-blown proto-Attic, when the figures were drawn in a mixed technique, partly in silhouette, partly in outline, with a generous use of white and with occasional incisions. On the front of the vase are three scenes—a lion devouring a spotted deer, on the neck; two grazing horses, on the shoulder; and, on the body, a contest between Herakles and a centaur, probably Nessos. Behind Herakles is his four-horse chariot, with a woman—presumably Deianeira—sitting in it, holding the reins and turning around to watch the combat; a small man is running toward the horses; an owl flies above the centaur. Decorative bands frame the figured representations, and a great variety of fill-ornaments, derived from the Geometric, Oriental, and, perhaps, Minoan repertories, are sprinkled in the fields. A comparison between these scenes and those on Geometric ware is instructive. In spite of their crudity they have a force and a vitality not to be found in the highly systematized and orderly Geometric compositions. The figures are drawn with trunks in profile as well as in full front view, with rounded limbs, in which the joints are indicated. There is an attempt even at expression. The determined attack of Herakles and the beseeching attitude of the centaur are convincingly rendered. The four horses are spirited creations; the problem of representing them one behind the other is solved by placing their heads one below the

other with eyes glancing in different directions. The running man has a buoyancy never encountered in Geometric pictures. The lion and deer on the neck of the vase are also full of spirit, the deer being especially lifelike. The superb floral design at the back is not drawn in horizontal bands, but boldly over the whole available field. We may date the vase early in the second quarter of the seventh century.

In a later stage of this mixed technique the figures are partly reserved in the buff color of the terracotta, partly painted in blackish glaze, with some incision; but instead of a copious white, the principal accessory color is red. There are as yet no vases of this period in our collection, only a terracotta plaque with a relief representing a dead woman lying in state (see p. 31 and pl. 26d, f).

In the last quarter of the seventh century the black-figured style became established in Attica—as it had some time earlier in Corinth—and it remained the accepted technique for more than a century. The figures were painted in black glaze with red and white accessory colors and details were incised. At first the background was buff, as in proto-Attic; from the second quarter of the sixth century a reddish color was favored. Gradually the drawing became soberer and more disciplined.

The earliest example of Attic black figure in our collection is a fragment of a large vase with the head of a lion (pl. 26e).[74] It has the exuberant spirit of the preceding age, but also foreshadows the grandeur of the works by the Nessos Painter (named after his famous amphora in Athens with Herakles and Nessos). We may date it around 625 B.C.

A large amphora with the head of a horse in a panel on either side (pl. 26c)[75] dates from the turn of the century. A similar vase in Munich was found with bones inside. It is possible, therefore, that the purpose of such vases was sepulchral, as suggested also by the presence of sirens on a somewhat earlier amphora of this type in Athens.

A few Athenian black-figured vases of the second quarter of the sixth century are discussed here rather than with their contemporaries in the next chapter because Oriental influence is still potent in their designs. Animals and monsters in rows or confronted in pairs are the principal motives. An oinochoe from Sardis (pl. 26b),[76] decorated with two panthers, was made early in the sixth century. A curved plaque[77] of about 590–560 B.C., with two lionesses facing each other, has a suspension hole at the top and evidently served as a votive offering. A small, lidded box,[78] with water birds sketchily painted on the pale terracotta, without incisions, dates, perhaps, around 550. A handsome long-stemmed pyxis is decorated with patterns of lotuses, rosettes, and palmettes in effective combinations.[79] On several, mythological scenes are represented along with the animals—the combat of Herakles and the Amazons (one is inscribed Andromache), on a fragment of a "Tyrrhenian" hydria (or amphora)[80]; Herakles wrestling with the Nemean lion, on a hydria of the early ovoid form, from Cyprus (pl. 28a)[81]; and Achilles and Troilos, on another hydria

of this shape (pl. 28b),[82] from Vulci. The story of Troilos, in spite of its primitive rendering, is vividly conveyed. Achilles is crouching behind the fountain, unseen by Troilos and Polyxena, the young son and daughter of King Priam, who have come to water the horses and fill a pitcher (note the lifelike rendering of the thirsty white horse). On the fountain is a bird, a raven or a crow, perhaps sent by Apollo, in whose sanctuary the boy is said to have been killed. Behind Troilos are three armed warriors, evidently the Trojans who tried too late to come to his aid. They are balanced on the other side by the supporters of Achilles—his mother Thetis, Hermes, and a draped, bearded man holding a spear.

Three kylikes illustrate the pottery produced in *Laconia* during the sixth century. One, of heavy make,[83] with a floral decoration on the inside and palmettes and bands of lotus buds on the outside, has been assigned to the first half of the sixth century; the other, of lighter make (pl. 28g),[84] with bands of pomegranate, lotus, and net on the outside and a black-figured sphinx on the inside, to the middle of the sixth century. This ware was formerly called Cyrenaic, for on a kylix found at Vulci Arkesilas, king of Cyrene, is depicted, and on another, found at Tarentum, the nymph Cyrene appears. Excavations at Sparta, however, have shown that it was produced there in continuous sequence (see the potsherds from Laconia in our collection) and Sparta must, therefore, have been the center of its production. Exclusive attention to military affairs had not yet killed the early promise of her artistic creations.

Several examples illustrate the *Boeotian* ware of this period. One is an aryballos with a rider (pl. 28e)[85] in black-figure, showing strong Corinthian influence and dating probably from the first half of the sixth century. A bowl on a high foot (pl. 28f)[86] and several dishes (see pl. 28d)[87] belong to the late phase of Boeotian ware, of the middle and second half of the sixth century; the decorations consist of floral motives and animals, executed in a bold, spirited style. A large kantharos[88] of about 550 B.C. has a row of horsemen, front and back.

The so-called *Chalcidian* ware is sparsely represented in our collection. Three kylikes (see pl. 28h)[89] with apotropaic eyes flanked by satyr's ears have the characteristic low foot with concave edge (one foot is restored). One has a satyr and a maenad between the eyes, the others the wrinkled nose of a satyr or a gorgon. They may be dated about 540–530 B.C. An amphora with two splendid animal combats (pl. 28c)[90]—lions attacking a bull and lions attacking a boar—belongs to the so-called *Polyphemos* group, an offshoot of Chalcidian. Where this ware was manufactured—in Chalkis on the island of Euboea, or in Italy—is still a moot question.

The East Greek wares of this period comprise several varieties. The so-called *Rhodian* vases have been found extensively in Rhodes, as well as elsewhere in East Greece, in South Russia, Egypt, Sicily, and Etruria. They were evidently produced

in several centers in East Greece and widely exported. In contrast to the Corinthian ware (see p. 37) they are painted, partly in silhouette and partly in outline, in dark brown glaze on a creamy slip, without incisions—except in .the later examples, where the incision technique and the outline technique appear side by side. Dark red is used here and there as an accessory color. Animals and floral patterns form the chief motives. Human beings in concerted action, which on the mainland were rapidly becoming the chief preoccupation of the artist, are comparatively rare. Our collection includes several early examples of the late seventh and the early sixth century—two plates decorated with floral and other motives (pl. 29h, j)[91] and two jugs (pl. 29e, f)[92] with rows of wild goats, deer, and water birds, as well as a number of fragments. The animals, in spite of obvious conventionalization, are full of life. Postures and essential features are accurately rendered, though in a more generalized manner than on the contemporary Corinthian ware. Troops of such wild goats, deer, and wild birds can still be seen in Asia Minor today.

The later examples, of the second half of the sixth century, are called *Fikellura* after a cemetery in Rhodes where many of them were found. The decoration was applied without incisions on a white slip, and consists chiefly of floral and animal representations, arranged in friezes. Rows of crescents were popular. Our examples include several amphorae, large and small (see pl. 29a, b).[93] One has an attractive water bird, another, large spirals and palmettes (pl. 29g).[94]

Several vases which are also identifiable as East Greek have a simple decoration of horizontal bands and wavy lines, painted in brownish black glaze on the pale buff terracotta (see pl. 29c, d).[95] Here and there is an additional touch, such as a three-leaf ornament. An attractive amphora has panels front and back with foreparts of cocks.[96] Three of our examples are said to have been found in Tarentum, two in Cyprus.

A fragment of a dish cover[97] with a dainty siren and parts of two water fowl is our only example of a ware assigned to *Klazomenai,* near Smyrna. It is in the black-figured style of the mid-sixth century. The decorated rim of a terracotta sarcophagus[98] is probably also a product of Klazomenai, for a number of such sarcophagi have been found there and an actual cemetery has been located within recent times. The decorations on our example are typical in content and technique—friezes and panels, painted in black glaze on a white slip, with details reserved instead of incised and with white and red accessory colors. A handsome guilloche pattern and panels of sirens and centaurs are on the sides of the rim, a group of two lions and a boar at the foot, and at the head is a combat of warriors, bordered at top and bottom with friezes of sphinxes and animals. The battle scene, so far as it can be interpreted in its present state of preservation, includes a central group of two combatants, flanked on each side by a two-horse chariot into which a warrior is about to step; a charioteer is guiding the rearing horses. Such heroic battles are

not unusual on contemporary Attic and Ionic monuments. To judge from the style of the decorations these sarcophagi were in use during the last third of the sixth and the first third of the fifth century. Ours may be dated in the last quarter of the sixth century.

A kylix[99] from Sardis, with an offset rim and concentric circles in the interior, belongs to a class of Ionian cups which are contemporary with the Attic little-master cups (see p. 60). Other East Greek kylikes, from Cyprus (see pl. 29i),[100] are East Greek counterparts of the Attic Siana cups (see p. 59).

Fragments of polychrome terracotta vases from Naukratis, Egypt,[101] are a gift from Miss E. R. Price. According to one theory, this gay polychrome pottery was produced on the island of Chios. Provisionally it has been called *Naukratite*.

Two aryballoi (see pl. 30a),[102] made not of clay but of a white, composed body and covered with a blue alkaline glaze, are examples of the so-called "faience" ware which probably was made at Naukratis. One with lozenges and various tongue patterns is particularly attractive. Both are said to have been found in Italy. A few plastic vases in the same faience ware—two hedgehogs (see pl. 30b),[103] a fish (pl. 30c),[104] and a helmeted head[105] were also probably made at Naukratis. Such blue-glaze vases enjoyed a vogue in the seventh and the early sixth century, and examples have been found in various localities. Later the production stopped and blue glazes do not reappear on classical vases until the late Hellenistic and Roman periods.

A number of terracotta plastic vases molded in various forms are probably of East Greek origin. Those in the form of warriors' heads (see pl. 30d, e)[106] have been dated in the late seventh and the early sixth century, since some have been found with Early Corinthian pots. One of our specimens has a delicately worked gorgoneion on the frontal of the helmet. A bust of a young woman (pl. 30f)[107] with large eyes and prominent nose belongs in the same category. Her undulating tresses are painted black; her disk earrings are black with red and white rosettes; eyebrows, eyelids, and irises are purple-brown. The terracotta has turned greyish. The other shapes include a pomegranate from Sardis (pl. 30g),[108] two sandaled feet (pl. 30h, j),[109] and a right leg with a sandaled foot and a handsome rosette on the calf (pl. 30i),[110] all perhaps of the early sixth century. The leg and one of the feet may be Corinthian rather than East Greek, for the color of the terracotta is greyish instead of pinkish, but the color of the terracotta is not always a safe criterion. A vase in the form of a swimming duck (pl. 51l)[111] with incised feathers and red and white as accessory colors belongs to a group that has not yet been localized. The date may be around 530 B.C.

A collection of terracotta architectural revetments and vases found by Howard Crosby Butler and his associates at Sardis, in *Lydia,* was presented by the Turkish Government to the American Society for the Excavation of Sardis which gave them

to this Museum. There is no comparable collection elsewhere, for the material left behind in Sardis at the outbreak of the 1914–1918 war has almost all disappeared. The pots were found in tombs, the revetments among the remains of houses. On the latter the prevailing designs are the lotus, the palmette, spirals, meanders, and rosettes, in a variety of effective combinations (see pl. 31).[112] Copious remains of red, black, and white make these architectural friezes highly decorative. They may be assigned to the middle of the sixth century. A remarkable representation of Theseus killing the Minotaur (pl. 31a),[113] however, seems earlier, perhaps dating from the end of the first quarter of the century. Theseus has grasped the monster by its horn and is plunging his dagger into its body. The group is one of the earliest mythological scenes from East Greece. On one side are remains of a winged goddess holding two lions by their tails (a complete example of this figure is in the Louvre). Another fragmentary piece has a rampant lion (pl. 31b),[114] evidently part of a heraldic group.

The pottery from Sardis covers a wide range, from the Geometric to the Hellenistic periods.[115] We have already dealt with the Geometric examples (see p. 26) and with Laconian and Attic imports (see pp. 40 f.). The local wares of the seventh and the sixth centuries (which include a number of fragments) show a variety of techniques (see pl. 32). Those of the seventh century are mostly local imitations of Orientalizing East Greek wares; a few have figures in relief. Some examples of the first half of the sixth century have a blackish or greyish body, produced by reduction in the firing, like the Etruscan bucchero ware. A small jar of this type contained a hoard of gold staters of King Croesus (560–547 B.C.), four of which are in our collection[116] (the others are in the Istanbul Museum). Some vases are covered with black glaze (applied thinly in places and there reddish), with decorations occasionally added in white. Others have a white slip with ornaments in blackish or reddish glaze. In still others the red color of the clay is retained and white or blackish-brown decorations are added.

The same diversity is noticeable in the shapes. A few seem to have enjoyed special popularity—the two-handled skyphos, for instance; but as a rule the potters apparently liked to experiment and they created several effective forms of new outline—high-stemmed dishes, small jars with tiny conical feet, bowls with spouts, lekythoi with concave bodies, and so forth. A two-handled jar is ornamented on each side with the face of a man with a protruding tongue and two tusks (pl. 32i).[117]

The decorations show that the Geometric tradition was still strong in Lydia, most of the designs, though in new color schemes, being linear. Occasionally new motives appear, such as an effective marbled pattern. Scenes from daily life and mythology, which appear in contemporary Attic and Corinthian pottery, or animals, such as decorate the contemporary East Greek vases, are almost completely absent, the only instances being on a few fragments with horsemen in relief (see pl. 32h)[118] and on local imitations of "Rhodian" ware. It is evident that in the period of King Alyattes

(617–560 B.C.), before the advent of Croesus, Lydia had her own local artists. Hence the strong individualism of her pottery.

GLASS BEADS

A collection of glass beads,[119] ranging in date from about 1000 to 500 B.C., are of various types—the plain and "eyed" varieties, some with drops of glass protruding from the surface, others with spiral zigzag patterns, and still others in the form of grotesque masks. Their vivid colors—yellow, blue, red, and white—give them great attraction. As much the same types were used for a considerable period it is difficult to assign definite dates to them. Those assigned on our labels are largely based on information given us by Dr. Gustavus Eisen. Most of the examples come from the Gréau collection, presented to the Museum in 1917 by J. Pierpont Morgan.

ARCHAIC PERIOD IN ATTICA

VI CENTURY B.C.

In the last two chapters we have studied early Greek art in two formative stages—the primitive Geometric, with its orderly, systematized abstractions and its angular ornaments, and the exuberant Orientalizing, with its more rounded forms and freer compositions. During the sixth century, Greek art, which had been revitalized but not submerged by Oriental influence, assumed a definite pattern. Content and repertory changed. The fierce monsters and beasts of prey which had been paramount during the seventh century gradually withdrew to second place. In their stead, gods in human form and heroes were depicted enacting their parts in Greek myths; and presently human beings were represented in the activities of everyday life. The ornaments which had filled empty spaces and had sometimes produced a cluttered effect were relegated to definite areas.

Naturally the past left its mark. Some hybrid creatures—the centaur, the sphinx, the siren, and the griffin, for instance—became permanent members of the Greek repertory endowed with special functions; and some Eastern motives—such as the palmette, the lotus, and the guilloche—eventually became the stock in trade of Greek ornamentation.

More important even than changes in content and repertory was the increasing interest in naturalistic form. Instead of endlessly repeating the conventions which had obtained in the Orient for thousands of years, the Greek artists became absorbed in the representation of form as it is in nature and as it is seen by the human eye. At first the changes in the accepted conventions were minor and tentative (see p. 56); in the second half of the sixth century they became increasingly important; a century later sculptural and pictorial form had been revolutionized. This quest for naturalism was directed, not only to the structures of human beings and animals, but to the rendering of every object in a picture—furniture, buildings, drapery, etc.—as well as to the composition and the relation of the objects to one another. To watch this progression from convention to naturalism, from faulty anatomy to an accurate comprehension of form, from a two-dimensional to a three-dimensional concept, is an artistic education of the first order, for the Greek artist combined an intellectual approach with artistic genius.

The material discussed in this chapter is primarily from Attica and illustrates the important role played by Attica in archaic times. A few outstanding large Attic sculptures are described in another chapter (see pp. 134 ff.); and a few terracotta and bronze statuettes that may be Attic are placed with related material (see pp. 66 f., 70 f.). But the material here assembled sufficiently conveys the range and the

splendor of archaic Attic art. The rule of the aristocratic Eupatrids, the reforms of
Solon, the tyranny of Peisistratos and of his sons, and the beginnings of the democ-
racy form the historical background.

SCULPTURES IN STONE

Monumental stone sculpture made its appearance in Greece, as far as we now
know, around the middle of the seventh century B.C. The inspiration doubtless came
from the imposing creations of the Orient and especially of Egypt, which had been
opened up to the Greeks at that time. The chief uses of monumental sculpture in
Greece during the archaic period were religious and sepulchral. The increase in
temple-building caused a demand for large cult statues as well as for sculptures to
decorate the pediments, metopes, and continuous friezes; and the greater wealth of
individuals enabled them to erect important votive and funerary monuments. Three
chief types of statues became current—a nude standing youth (kouros), a draped
standing girl (kore), and a draped seated figure, male or female. In architectural
statues and in reliefs we encounter, besides these types, a variety of others—striding,
running, falling, recumbent figures, combined sometimes in lively combats.

One of the earliest and best preserved statues of the kouros type that have sur-
vived from antiquity is the marble kouros in our collection (pl. 33). He is repre-
sented in the characteristic frontal attitude with left foot advanced, arms held to
the sides of the body, and hands clenched. The body is four-sided, flat in front and
in back, with broad shoulders and a long, narrow waist. The proportions display
many obvious deviations from nature, the head being too large, the neck too long,
and the thighs too short. Anatomical details are indicated by grooves, ridges, and
knobs and indicate only a primitive knowledge of anatomy. The ideal of the art of
the time was not realism, but a simplified presentation of the human figure as a
solid, harmonious structure in which essentials were emphasized and generalized
into expressive patterns. On the body, for instance, the shallow upward curves of
the clavicles are contrasted with the deep downward curves of the pectorals; the
pointed arch beneath the thorax is counterbalanced by the pointed pelvic arch; at
the back the swing of the shoulder blades makes a design with the girdle of the
pelvis and the perpendicular groove of the spine. The indications of the bones and
muscles on the arms and legs likewise form effective patterns. And crowning the
figure, set on a long, slender neck, is the massive head, carved in large simple planes,
with almond-shaped eyes, patterned ears, and schematized hair, consisting of long,
beaded tresses. (There are traces of red on the hair, fillet and bands tying the lower
ends of the tresses, on the necklace, and inside the nostrils.) This architectural con-
ception, based on keen though naive observance of nature, gives to these early statues
their distinctive character. In the phrase Pausanias used to describe the works of the
legendary sculptor Daidalos, "there is something inspired in their appearance."

If our present chronology of early Greek sculpture is correct, the date of the statue should be around 600 B.C., perhaps a little before—the time of the kouroi from Sounion and the Dipylon, which are closely related in style. Whether the New York kouros was sepulchral, like the Dipylon one, or votive, like the group from Sounion, is not known.

A head from another kouros (pl. 34a)[2] is said to have been found at Sounion. It is fifty years or so later than the statue just described and shows considerable progression in naturalism. The form is more rounded than before, and features are separately emphasized; the eyeballs protrude, the sharp-edged lips curl upward into an "archaic smile," and the cheeks form a concave curve with the cleft chin. The hair is carved in beaded tresses, aligned horizontally, and is tied with a fillet; over the forehead and temples is a broad band, decorated with flame-like members and perhaps originally with rosettes, since there are holes for attachment. The effect is decorative, and yet the head has a remarkably lifelike quality. The surface, however, has suffered from having been cleaned with acid.

The draped female type is represented by a small statue of a girl (pl. 34e)[3] said to have also been found near Sounion. She holds a hare and a pomegranate as offerings to a deity and wears a tunic, girt at the waist and pulled out at the sides. The lower part of the tunic is not allowed to hang freely, but is drawn tight, with a fold of drapery tucked through the belt. The rippling folds of the upper part contrast with the broader, oblique ones below. It will be noticed that there is a discrepancy in style between head and body. The former is not archaic in features or headdress; the rear view of the statue shows that the hair originally hung down the back. The present head, however, is neither modern nor one of the familiar archaizing works of the Roman period. The only plausible explanation is that the statue was damaged in Greek times and was supplied with a new head in the fifth century B.C., to which period the style of the headdress points. At the same time a new left arm holding an offering was supplied; originally it was brought down to grasp the drapery, as indicated by the evident reworking of this portion (note its concavity).

The gravestones erected in Attica during the sixth century rank among the finest sculptures of their time. They consisted of decorated stelai or shafts, mounted on bases and crowned by finials. There were, to judge by available evidence, two chief types. The earlier one, prevalent about 600 to 530 B.C., had a capital carved in a separate piece and surmounted by a sphinx. At first a cavetto capital, derived from Egypt, was used, but later, apparently through Ionian influence, a capital of lyre—that is, double-volute—form was adopted. The later type, prevalent from about 530 to 500 B.C., had a volute-palmette finial carved in one piece with the shaft.

The evolution can be followed in the examples and fragments of examples in our collection. The earliest is a sphinx seated on a cavetto capital and cut in one piece with it (pl. 35a).[4] The feathers on the breast and on the sickle-shaped wings are

incised on the front and were originally painted red and black, of which traces remain. In style it is related to the early kouros. It has the same four-sided structure, a similar flat, voluted ear and flat eye with a ridge at the outer corner, and similarly rendered hair—flat, globuled strands with pointed ends. A date, therefore, not later than the early sixth century is likely. On the plinth is an inscription in early Attic letters: "I am the monument of [Phi]linos" (or Thalinos). The underside of the capital has a large socket into which a tenon on the top of the missing slab must have fitted. A pour hole for the molten lead that helped to hold the two is partly preserved at the back. A torus molding doubtless formed the transition between capital and shaft, as in similar Egyptian pilasters.

A later stage in the development of this type of monument is seen in a cavetto capital with lotus and palmette designs incised on the front and side faces and rosettes on the abacus (pl. 35c).[5] It too must have been crowned with a sphinx and mounted on a slab—as remains of fastenings at the top and bottom show. The shape of the capital is more graceful than in the preceding example, less thickset, higher in proportion to the width, and with no return at the bottom. Whether this capital crowned a sepulchral or a votive monument is uncertain. The same form was evidently used for both purposes. Thus an example decorated with mourners, from Lamptrai, in Attica, and one with crowning sphinx preserved that has recently been unearthed in the Kerameikos must have served as gravestones, whereas an example found on the Akropolis of Athens must have been a dedication.

A fragment of a limestone sphinx (pl. 35b),[6] said to be from Attica, may once have surmounted a similar capital. It was turned to the left like the sphinx shown in plate 35a, instead of to the right, as is more common. The wing divisions were incised as well as painted (remains of the original red and black are preserved). The breast feathers are compass-drawn arcs, all of the same circle, with the mark of the compass leg in the center of each. The abrupt transitions between the planes and the indication of the muscles on the haunch by grooves point to a date in the second quarter of the sixth century.

A beautiful marble relief with the lower part of a youth (pl. 34c)[7] must have belonged to a gravestone of this period. He is represented standing with the left leg advanced, holding a staff or spear in one hand, while the other hangs loosely by his side. The surface is well preserved and copious traces of red are on the background. It is possible that we have the base of this stele. The candidate is a limestone block (pl. 34d)[8] of which only the front side remains; the inscription, giving the names of the dedicator, of the youth commemorated, and of the artist, is composed as an elegiac couplet: "on the death of Chairedemos his father, Amphichares, set up this monument, mourning a good son; Phaidimos made it."* The restraint and adequacy

* In order to force the name Chairedemos into a hexameter the poet was obliged to violate the quantity of one of its syllables. Violations of quantity in proper names are not uncommon in epigrams on stone.

are typical of Greek epitaphs. Phaidimos is known from two other inscriptions, one on a three-stepped limestone base in Athens that supported the statue of a maiden. Only her sandaled feet have survived, but they are remarkably similar in style to those of the youth described above. Moreover, there is some evidence that our base and relief were found together. If the two really belonged together the youth would be a signed work of the sculptor Phaidimos.

A splendid example of the second stage of the earlier type of gravestone, complete with decorated slab, capital of double-volute form, crowning sphinx, and dedicatory inscription, and the lower part of another important monument of that period, with the legs of a warrior and a chariot scene on a panel, are discussed with the larger sculptures (see p. 134).

The head of a gently smiling youth in relief (pl. 34b)[9] is also a fragment of an Attic grave monument. The surface is admirably preserved, with traces of red color on the background and the hair (the wavy surface above the fillet probably had strands rendered in color). The boy was apparently represented not as a warrior but as an athlete, for there is no trace of a spear. The rounded skull, the short, curly hair, the still somewhat primitive ear, with knobby antitragus, the eye with the inner corner marked by an incised line and the lips which do not meet at the corner suggest a date around 530–520 B.C.

A capital with two double volutes[10] delicately carved in intaglio on the front face perhaps also belonged to a grave stele. The underside was tooled, evidently in ancient times, but so roughly that the surface cannot be the original one which fitted on the shaft.

The simpler type of gravestones with the finial in the form of palmette and volutes carved in one piece with the slab was introduced into Attica, apparently from Ionia, around 530 B.C. At first this form had double volutes, later single ones. It is represented in our collection by three examples. One consists of part of a shaft and a finial with a double volute (pl. 35d).[11] The latter is mostly missing but has been reconstructed in plaster with the help of the two fragments that remain. Between the volutes is an inverted palmette, and, below, a band of vertical zigzags. The volutes and horizontal lines are incised; the rest was merely painted in red and black, of which traces are preserved.

The second example consists of a shaft set in a rectangular base and crowned by a finial with a palmette and single volutes (pl. 35e).[12] Though a piece is missing between shaft and palmette there can be little doubt that the two belong together, for marble, dimensions, weathering, and provenience correspond. On the shaft was painted the figure of a man, of which only the lower part remains. The red on the background and on the alternate leaves of the palmette is still surprisingly well preserved; but the contours and inner markings of the figure, which now appear white, were originally black. The form of the palmette is that current in vase-paint-

ing during the late sixth century. On the base is an inscription in two lines, from left to right and right to left: "Panaisches set this up to Antigenes." Panaisches was presumably Antigenes's father.

A fragment of a third stele has only parts of the feet of a youth preserved.[13] Here, too, the background is red and the contours and markings were originally black.

SCULPTURES IN BRONZE

In addition to these stone sculptures several bronze statuettes of the sixth century show the decorative sense characteristic of the period. They are not necessarily Attic —the place of manufacture is not known—but they are included here to enlarge our picture of archaic Greek sculpture. The figures are in a variety of poses. Three are in the half-kneeling attitude popular for flying, running, and crouching figures. The earliest is a runner with arms held to the sides (pl. 36a)[14]; another, bequeathed by Richard B. Seager, is apparently an archer (pl. 36b)[15]; a third somewhat later figure was perhaps intended for Herakles, for he has a lion's skin wound around his waist (pl. 36c).[16] Whereas in the two earlier figures the upper part of the trunk is still in full front view, in the later one the torsion is successfully indicated. A statuette of Apollo (pl. 36d)[17] has boots, a mantle over the shoulder, shawl fashion, and a bow in one hand; it is said to be from Arcadia. A standing youth is of the kouros type (pl. 36f),[18] like the marble statue (see p. 47), but about a century later, as the more naturalistic rendering shows.

A long-haired warrior (pl. 36e),[19] bearded, but without mustache, and wearing a helmet and a cuirass, is a particularly interesting piece. He is represented marching; both hands are clenched and must have held something; the right evidently grasped a spear over the shoulder, preparatory to lowering it for attack (as described in Xenophon's *Anabasis* VI.5.25), and the left probably a shield (worked in a separate piece). The style is archaic Greek of the third quarter of the sixth century, as is indicated by the muscular limbs, the comparatively narrow arch for the lower boundary of the thorax, the long hair with horizontal markings, and the form of the palmette engraved on the cuirass. The cuirass is of the early metal type, turned out at the waist; it is provided with lappets (*pteryges*) for the protection of the hips, a feature probably borrowed from a type which was introduced into Greece from Ionia at about this time.

A centaur (pl. 36g),[20] given by J. Pierpont Morgan, is in full gallop, swinging a clublike branch in both hands for the attack; the body is modeled with masterly understanding of the essentials, and the engraved lines on the hair and beard are incised with great delicacy. The slightly curving horizontal base, cast in one piece with the statuette, suggests that it once decorated a utensil—perhaps a lebes or a tripod. A beautifully conventionalized goat (pl. 36h)[21] is represented leaping forward with head turned back.

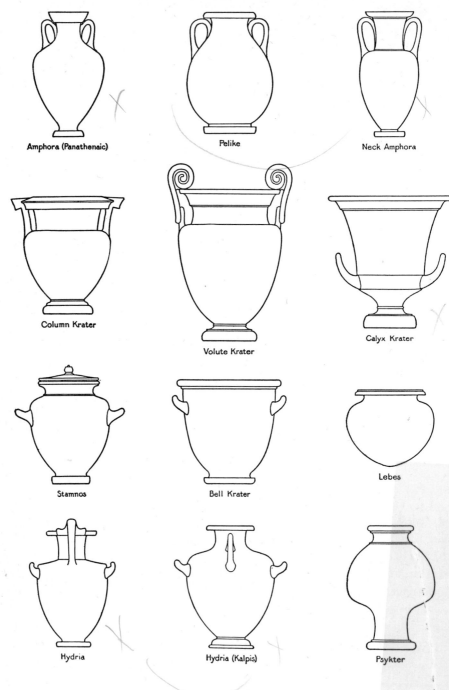

Amphora (Panathenaic)

Pelike

Neck Amphora

Column Krater

Volute Krater

Calyx Krater

Stamnos

Bell Krater

Lebes

Hydria

Hydria (Kalpis)

Psykter

SHAPES OF GREEK VASES

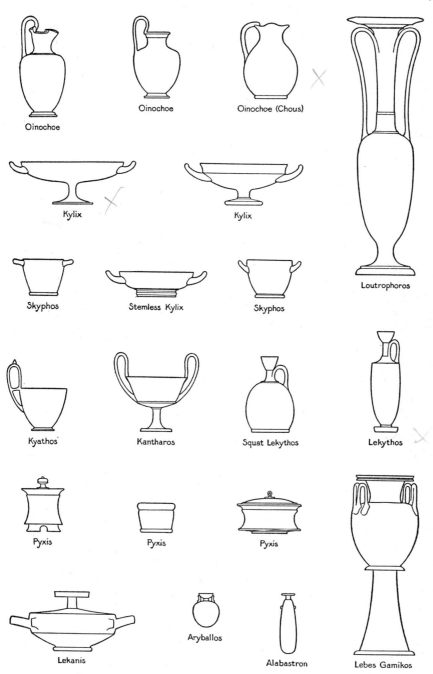

Oinochoe

Oinochoe

Oinochoe (Chous)

Loutrophoros

Kylix

Kylix

Skyphos

Stemless Kylix

Skyphos

Kyathos

Kantharos

Squat Lekythos

Lekythos

Pyxis

Pyxis

Pyxis

Lekanis

Aryballos

Alabastron

Lebes Gamikos

SHAPES OF GREEK VASES

POTTERY

One of the most remarkable phenomena in the history of Greek pottery is the absorption of the "world" market by Athens in the middle of the sixth century. Athenian vases had been exported previous to that time, but not in quantity; for during the seventh and early sixth centuries many ceramic centers had produced their individual wares, and Corinthian products were favored everywhere. In the second quarter of the sixth century a great increase in the number of Athenian vases is noticeable in the tombs and sanctuaries all over the Mediterranean world. Soon afterwards other wares, including the Corinthian, began to disappear and Athenian vases took their place. This distribution of the products of one community over an area which included Greece proper, the Aegean islands, North Africa, Asia Minor, Italy, Sicily, and even France, Spain, and the Crimea is eloquent testimony to the artistic and commercial importance of Athens. The wise statesmanship of Peisistratos and the sudden collapse of the Corinthian tyranny, which helped to eliminate a powerful rival, doubtless contributed to this success. Primarily, however, it must have been the excellence of the Athenian vases that secured preference for them—the well proportioned and well finished shapes, the jet black glaze of velvety texture, and the lively narrative scenes.

We have seen that in the last quarter of the seventh century the black-figure style, which had been current in Corinth for a considerable time, was introduced into Attica. In this chapter Attic black-figured and early red-figured vases of about 590 to 500 B.C. are discussed, arranged in chronological sequence and by painters. Before looking at the vases individually let us look at them as a whole, noting briefly their forms, techniques, ornaments, inscriptions, subjects, and style.

The number of the shapes is relatively small, for the Greek potter, like the Greek sculptor, did not continually create new forms, but adhered to a few types and evolved significant changes within this framework. Since the pots were for actual use, their forms had to correspond to the functions they performed. In our description we shall use the Greek names current among archaeologists for the various shapes: amphora and stamnos for two-handled containers; hydria for a three-handled water jar; krater for the vessel used for mixing wine and water; psykter for a vase in which the wine was kept cool; kylix, skyphos, and kantharos for various forms of drinking cups; oinochoe for a wine jug; lekythos for an oil jug; aryballos and alabastron for oil and ointment vases; pyxis for a toilet box; and so forth (see pp. 52 f.). Each shape changed somewhat in the course of time, yet retained its essential characteristics. Thus the early lekythoi have not a set-off shoulder, whereas the later ones have; the early kylikes have a low, conical foot, most of the later ones a high-stemmed foot; the hydriai have at first an ovoid body, a little later an offset shoulder, and presently a continuous curve from mouth to foot. There are two chief types of amphorae, one with the neck offset from the body—the so-called neck-amphora—the other with the

neck and body in a continuous curve, and four chief forms of kraters—the volute and the column, the calyx and the bell krater. The favorite shapes during the sixth century were the amphora, the hydria, the column krater, the kylix, the oinochoe, and the lekythos. In the last quarter of the sixth century a number of new forms appear—the stamnos, the pelike, the kalpis, and the psykter.

All these vases were thrown and turned on the wheel—except of course the molded portions of the plastic vases (see p. 75). In black-figure the decoration was painted in black glaze on the red ground of the clay, with incised details and red and white as accessory colors. The scenes were composed either in panels or over the whole surface of the body. About 530 B.C. red-figure was introduced, in which the figures were reserved in red against a black background, with the details no longer incised but drawn in glaze often standing out in slight relief. The red and white accessory colors popular in black-figure were mostly abandoned and a new color note—golden brown, produced by diluting the black glaze—was used for the less significant details. The red of the terracotta was enhanced by a red-ochre wash.

The ornaments, which during the seventh century were often scattered over the whole surface of the vase, were relegated to certain definite areas and assumed definite functions. They divided the surface into component parts, framed the chief scenes, and decorated spaces not occupied by the figured scenes or the black glaze; occasionally they were the sole decoration. These ornaments were reduced to a few motives—the lotus, the palmette, the meander, ivy and laurel wreaths, rays, tongues—which were used again and again in different combinations. Some had been borrowed from the East, but all had become thoroughly Greek compositions of remarkable elegance.

The occasional inscriptions, in the old Attic alphabet,* give the names of the makers or the figures represented, or they describe the action, or the person using the vase. Sometimes they are meaningless and introduced merely for decorative effect. Occasionally trade memoranda are inscribed on the underside of the foot. The most precious inscriptions are the signatures of potters and vase-painters, the names occurring either with *epoiesen,* "made it," or with *egrapsen,* "decorated it." Though comparatively few vases are signed, it has been possible, through a study of the different styles, to attribute unsigned vases to painters whose names are known, or, when no signed vases of a particular style exist, to form groups and invent names for the painters. The interest of Greek vase-painting has been greatly enhanced by such stylistic studies.

Naming a favorite youth or girl on a vase is another interesting Athenian custom. The usual formula was to give the name, followed by *kalos* or *kale,* "fair." Occasionally the name mentioned is known from other sources, and thus gives valuable

* See Roberts, *An Introduction to Greek Epigraphy,* 1, p. 384 f., and Larfeld, *Griechische Epigraphik,*[3] Schrifttafel; Meisterhans, *Grammatik,* p. 3.

chronological data. Sometimes no definite name is given, and the inscription reads *ho pais kalos,* "the boy is fair," or simply *kalos* or *kale.*

The scenes themselves are of absorbing interest. They present a series of illustrations from Greek life and mythology, and, since larger murals and panels have disappeared, they are an important source for our knowledge of Greek painting. At first the subjects were taken largely from mythology. The time-honored legends of the Olympian gods, of Herakles and Theseus, of the Trojan war, were favorite themes. As time progressed the artist drew his inspiration increasingly from the life around him. He depicted the youths at their exercises in the gymnasiums, riding, arming, departing for battle, and fighting; he painted the gay banquets with men reclining on their couches, drinking, and making music; he represented men and women making love and getting married; he depicted the women busy with their household and other occupations and the children at play; he showed the dead being taken to burial and mourners at graves. Everything the artist saw around him he drew with the same frank and eager interest.

The rendering of the figures reflects the significant changes which took place in Greek painting during the sixth century. Up to about the middle of the sixth century the pictures are two-dimensional throughout, in accordance with the scheme which the Greeks had inherited from the Orient. Human and animal figures are pieced together according to a set of formulas based on mental conceptions rather than visual impressions. Different aspects of the figure, separately conceived, are combined into one whole. Thus full-front bodies are attached to profile heads and legs; eyes in front view are drawn on profile heads; draperies are rendered as stiff encasing envelopes without any indication of folds. Depth is suggested merely by an overlapping of forms. If rectangular shapes in furniture or architecture are introduced, only the front planes are indicated. The colors are applied in flat, undifferentiated washes, without any attempt at modeling by light and shade. It did not occur to the artist to reproduce a scene as it appeared when looked at from one point of view. Composite renderings of many aspects of things were combined into rhythmic designs, and a decorative silhouette predominated.

Around the middle of the sixth century came the beginning of a change. Occasional attempts were made to show the human figure and its component parts not only in full front and profile views, as heretofore, but in three-quarter views. The artist gradually learned to turn away the farther side of the chest, abdomen, and back, to foreshorten clavicles, shoulder blade, shinbone, foot, and hand, and to suggest folds, first by differently colored areas, presently by oblique lines with zigzag edges. The full development of the new manner of drawing did not come until the succeeding periods; for the old concept was only slowly superseded and for a considerable time both methods were combined in the same picture. In fact, it took Greek artists almost two hundred years to change the time-honored two-dimensional

designs into three-dimensional representations; but once mastered, the new concep-
tion was adhered to throughout antiquity and became the basis of later European
painting.

Keeping in mind these many aspects and points of interest, let us now look at
some of the vases individually. We may begin with the examples of the first half of
the sixth century and note the early shapes of the vases, the two-dimensional render-
ings of the figures, draperies, and objects, and the variety of subjects represented. All
have a refreshing directness and vivacity, coupled with a fine decorative sense.

On a lekythos of the second quarter of the century, two women are seen talking
to each other, wrapped in one cloak (pl. 37g) [22]; on another of the same period a man
is fighting a centaur (pl. 37h) [23]; on two lekythoi (see pl. 40f) [24] of the third quarter
of the century (evidently companion pieces by the same artist) Herakles is fighting
the Amazons, and a charioteer is mounting his chariot; on a kylix (pl. 37b) [25] of
about 590–570 B.C. padded revelers, or komasts, are dancing (see p. 37); on another
kylix of the middle of the century, the birth of Athena from the head of Zeus is de-
picted (pl. 37a), [26] the diminutive new-born goddess standing fully armed on the
lap of Zeus, who sits on a folding stool holding his scepter, while on either side a
birth goddess opens her hands in the accepted gesture of facilitating a birth; in the
field are meaningless inscriptions.

A small amphora by the Taleides Painter is a famous vase, known for over 140
years (pl. 39b). [27] It is said to have been found in Agrigento, Sicily, and was for-
merly in the Hope and Viscount Cowdray collections. The decorations are painted
in a finished, lifelike style. On one side Theseus is shown killing the Minotaur in
the presence of onlookers, presumably Athenian youths and maidens; on the other
is a weighing scene with men putting bales on a pair of scales. The inscription
Taleides epoiesen, "Taleides made it," appears twice, *Klitarchos kalos,* once. Taleides
seems not to be an Attic name, so that we might here have an instance of a "foreigner"
working in an Attic pottery. Klitarchos is a misspelling for Kletarchos (later
spelled Kleitarchos), like Klitias for Kletias (see below). Several other vases signed
"Taleides made it" are known, some of them lip cups, and a number are evidently
by the same painter as our amphora.

Several small vases belong to about 560–540 B.C. A stand with the head of a gorgon
(pl. 37c), [28] exquisitely drawn, is inscribed in dainty letters "Ergotimos made it,
Kleitias decorated it" (Kleitias here spelled correctly for this period, Kletias). The
names are those of the potter and painter of the famous François vase in Florence
(Kleitias there misspelled Klitias). An aryballos (pl. 37d) [29] is signed by Nearchos,
a distinguished painter of the mid-sixth century, who also signed two fragmentary
kantharoi in Athens. The decoration is a masterpiece of miniature drawing; along
the edge of the mouth is a combat of pygmies and cranes, as many as eighteen
figures occupying a band about five inches long and half an inch high (pl. 37f);

on the handle are figures of satyrs, Perseus, and Hermes, and on the shoulder and body are crescents in four colors. On a lekythos of a little before the middle of the sixth century are two representations—women dancing (all in a row, holding hands) and women working wool (pl. 37i).[30] The latter shows the several steps in the production of cloth: two are weighing large balls of wool on a pair of scales; another is spinning with distaff and spindle; two are weaving on an upright loom—opening the shed to pass the shuttle across the warp and beating the weft threads up into place with a batten; other women are apparently engaged in making roves, twisting the wool between their fingers; still others are folding the finished products and putting them on a stool in a neat pile. The scene gives a vivid picture of the busy life of women before the machine age, when they provided the household with clothes and performed by hand the various operations now done in factories. Woman's place then was truly in the home. A small amphora (pl. 38f)[31] showing Dionysos, a dancing satyr, and a maenad, and a somewhat later pyxis[32] with youths putting on their armor (pl. 37e) are dainty, spirited products.

A number of larger vases may be assigned to about 550–530 B.C. An amphora, complete with lid, has a marriage procession with a man and woman in a chariot on each side, combats of warriors on the shoulder, and decorative spirals beneath the handles (pl. 38b).[33] The paintings are by Exekias, one of the leading artists of the time, who signed the well-known amphora in the Vatican with Achilles and Ajax playing a board game. An amphora with scenes of Theseus and the Minotaur and of Kassandra and Ajax at the statue of Athena (pl. 38d)[34] has been assigned to an artist of the so-called Group E (predecessors of Exekias). Another amphora (pl. 38a),[35] with warriors arming, is by the Amasis Painter; and still another, with a row of male figures (pl. 38c),[36] perhaps Dionysos received by Ikarios, is by the Affecter, so called because of the affected archaisms of his renderings.

A battle scene on a kylix of about 540 B.C. is particularly interesting (pl. 38e).[37] It is attributed to the vase-painter Lydos, whose signature is preserved on a large bowl in Athens and on fragments of an amphora in Paris. Our scene consists of only four warriors, in two groups of two, and yet it eloquently conveys the stress of combat. The archaic Greek vase-painters did not, like the Assyrian artists, for instance, attempt to depict complicated compositions, such as the manifold incidents on a battlefield, but instead contented themselves with representing excerpts from such scenes. Perhaps they felt that, until they had solved, to some extent at least, the problems of perspective, complex representations were premature; at all events, it is not until they began to cope in earnest with these problems that such representations occur. It may be noted that two of the warriors on our kylix wear tunics with zigzag edges in step formation, suggestive of stacked folds. This rendering is an early instance of what was to become an effective and popular convention.

A large krater, on a separate pedestal, is decorated with a picture of the return of

Hephaistos to Olympos, escorted by Dionysos and a gay band of satyrs and maenads (pl. 39a).[38] It is perhaps the most important extant work by the painter Lydos and is a masterpiece of rhythmical spacing. Animals and gorgoneia adorn the lip and handle plates. The vase is one of the largest of its kind known and represents a great achievement in the art of pottery. We may imagine that it evoked much admiration during the lively banquets at which it served as a wine container.

Several amphorae dating from about 530 B.C. are works by the Swing Painter, who is named after his picture of a girl in a swing, in the Boston Museum. One has a scene of the departure of a warrior in a chariot (pl. 40b),[39] a favorite subject at the time; on another, Poseidon is represented fighting a giant, and Hermes is escorting the three goddesses (pl. 40a)[40]; on a third,[41] heroes are seen quarreling while their friends try to separate them, and men are dancing to the music of the lyre. The scene on a neck-amphora of a woman pouring a liba- tion for departing warriors (pl. 40c)[42] has recently been attributed to the Painter of Munich 1411.

A hydria of ovoid form (pl. 40d)[43] has two representations, Herakles struggling with Triton on the main part of the body, and a warrior pursuing a horseman— probably Achilles and young Troilos—on the shoulder; it is noteworthy, however, that the latter is bearded, though in the story he is a young boy. Two large, particu- larly handsome and well-preserved amphorae[44] have chariot scenes; one, a gift of Mrs. Leonard A. Cohn, has on the other side a departing knight (pl. 40e). In all these pictures we note an advance in style in the direction of naturalism. The render- ing of the drapery in differently colored areas to suggest folds has now become the rule, and zigzag edges are not uncommon.

There are several distinct types of kylikes which belong to the period from about 575 to 525 B.C.

1. The Siana cups (so called from a place in Rhodes where two examples now in London were found) have a stout, flaring foot, a deep bowl, and an offset lip. They belong to the second quarter of the sixth century and are a development of the "komast" cups (see p. 57). A regular scheme is observed: both inside and outside are decorated; the outside picture either is restricted to the handle zone, in which case the lip is patterned or black or reserved, or else it spreads over both handle zone and lip. Bands, reserved or patterned, are placed in specific areas. Even the foot is treated in an accepted scheme; it is painted black outside but reserved inside except for one or more circular black bands and a central black dot at the top of the cone. The subjects on our specimens[45] include Herakles fighting an Amazon, a caval- cade, a chariot race, contests of warriors, Achilles pursuing Troilos at the fountain, a satyr pursuing a maenad, and a cock (see pl. 41a, b). A small kylix, cursorily made, approximates a band cup in shape, except for the short, broad foot and the deep

bowl.[46] It has a rider in the interior (pl. 41f) and meaningless inscriptions on the outside.

2. The little-master cups, popular during the middle and third quarter of the sixth century, have a high-stemmed foot, a deep bowl, and miniature pictures. There are two chief types: (a) the lip cups, which generally have a picture on the reserved, offset lip and an inscription and palmettes on the handle zone; and (b) the band cups, which have a black lip, less sharply offset, and a picture on the handle zone. In the interior of the cups there is often merely a red reserved disk with black concentric circles, though figures also occur—frequently on the lip cups, occasionally on the band cups. The inscriptions on our cups comprise exhortations, such as, "hail and drink well,"[47] meaningless letters, and signatures by Xenokles,[48] Tleson,[49] Epitimos,[50] and Hischylos.[51] On Epitimos's cup are two heads, drawn in outline, perhaps of Dionysos and Ariadne or Semele, and, on the inside, two horsemen, one of whom is dismounting (pl. 41d, e). On Hischylos's cup two four-horse chariots, each with a charioteer and a warrior, are drawn in front view (pl. 42b). The cup signed by Tleson ("Tleson, the son of Nearchos, made it") has a cock on one side (pl. 41c), a deer on the other. Two other lip cups[52] in our collection, one with a siren (pl. 41g), the other with sphinxes, a siren, and a panther, have been attributed to Tleson, who may be called the little master par excellence. A cup[52] has lively pictures of the marriage of Dionysos and Ariadne (pl. 42a), and of the return of Hephaistos to Olympos.[53] It is one of the best band cups known.

There are two other varieties of little-master cups, (c) the "Cassel" cup, and (d) the "Droop" cup. Each of these types is represented in our collection. The "Cassel" cup[54] has lip and bowl covered on the outside with pattern work and no figured scenes; the "Droop" cup (pl. 42c)[55] has stout walls, thick stem, and scenes on the lower part of the bowl of a lively battle of Greeks and Amazons.

3. Eye cups, with stout foot, bowl in a continuous curve, and two large apotropaic eyes on the exterior, became popular in Attica about 540–530 B.C. Figured scenes are often introduced between the eyes and sometimes at the handles. Our subjects include Theseus fighting the Minotaur, satyrs, battle scenes, and revelers.[56] An inscription is incised on the foot of a well-preserved example (pl. 42d)[57] said to have been found at Tarentum: "I am Melosa's prize; she won the girls' carding contest." It is in the western Greek alphabet and in a western (or "Doric") dialect, probably Tarentine (the name in the Attic and common dialects would be Melousa).

The style of black-figure during the last quarter of the sixth century may be studied in many fine examples in our collection. Diversified draperies with zigzag edges in decorative schemes have now become the rule. The movement of the figures has become freer, though the figures themselves are still mostly pieced together from profile and full-front parts, separately conceived; only occasionally are there attempts at foreshortening the farther portion of the body. The subjects on our vases include

several adventures of Herakles—his struggle with Triton, on a hydria (pl. 42f), his visit to the centaur Pholos, on an amphora, and his roping of the Cretan bull, on another amphora.[58] On the last the glaze has turned red in one spot through oxidation —a convincing argument for the theory that the blackness of the glaze is due to reduction in the kiln (see p. 6). A large amphora (pl. 43e)[59] has Dionysos, Ariadne, Hermes, and satyrs on one side and, on the other, a chariot with a bearded man and a woman—perhaps Herakles and Athena. The style is in the manner of the Andokides Painter, the artist who is credited with having invented red-figure (see p. 63). Two other chariot scenes are depicted on a large amphora[60]; in one the charioteer is mounting a four-horse chariot, in the other a warrior and charioteer are inside the chariot, which is drawn in full front view, as if coming toward the spectator (pl. 42e). Such frontal chariots are particularly common at this time (see also p. 60) and show the preoccupation of the artist with this difficult problem. The scheme is almost always the same: the chest of each horse is drawn in full front view, the head and neck in profile, the legs in front view, the hoofs in profile, the warrior's head is drawn in profile in one direction and the charioteer's head in profile in the other direction; only the front edge of the chariot wheels is indicated. The result is a composite picture made up of separately viewed parts. A large kylix (pl. 45a)[61] with another frontal chariot and a Dionysiac scene is signed by the maker, *Nikosthenes epoiesen*. An amphora[62] with a maenad riding on a donkey and with a man dining (pl. 42g) is by the Acheloos Painter, one of the best artists of late black-figure, named after his picture of Acheloos and Herakles, in Berlin. Two lively scenes on a pelike are by the same artist (pl. 38g, h).[63] One represents boxers practicing to music, the other the henchmen of King Midas lying in wait for Silenos, who is drinking wine from a fountain.

A large loutrophoros (pl. 43b)[64] of the late sixth century is a fine example of an uncommon type of amphora. Vases of this shape were used by Athenian maidens for bringing the water for the nuptial bath from the spring Kallirrhoë, and were also placed on the tomb of a maiden or youth who died unmarried. Our example must have been sepulchral, for a prothesis, or lying-in-state, is represented on it. A dead youth, with closed eyes, is lying on a bier, his head propped up on a pillow. He is surrounded by wailing women raising their arms and tearing their hair. Mourning men, their hands raised in a farewell gesture, are on the neck and back of the vase. Beneath is a cavalcade in slow advance—the funeral procession. The vase has no bottom, having evidently served as a tomb monument into which libations were poured, like the colossal Geometric vases of earlier times (see p. 24).

We know from Greek literature that a special amphora containing olive oil was used as a prize at the Panathenaic games which were held at Athens every four years. Two magnificent examples of these prize vases, belonging to the late sixth century,

are included in our collection.[65] Athena, the presiding goddess of the games, is painted on one side; she is represented in a striding attitude* between two columns, on each of which a cock, symbol of conflict, is perched (see pl. 43c). An inscription— *tōn Athenēthen athlōn,* "one of the prizes from Athens"—is painted along one of the columns. On the other side of the vases the contest for which the prize was awarded is shown—a foot race on one (pl. 43a), a horse race on the other. The former is by the Euphiletos Painter, the latter by an artist of the Leagros group. (For two early fifth-century examples see p. 71.) A smaller amphora,[66] likewise decorated with a striding Athena and an athletic contest, in this case a boxing bout (pl. 43g), has no inscription; it was apparently not given as a prize at the games but used for general purposes. It must, however, have been considered a precious object; for when broken in many pieces it was carefully mended, as the ancient rivet holes testify. The pictures are by the Antimenes Painter, one of the outstanding vase-painters of his time.

Among the smaller late black-figured vases several have interesting subjects. Athletes practicing in the palaestra are depicted on a lekythos (pl. 43f)[67]; two hold jumping weights, one is preparing to throw the discus, and another is poising a javelin with its head resting on his left hand and the fingers of his right inserted in the thong. Another lekythos (pl. 43h)[68] is decorated with four warriors crouching behind an archer—a vivid excerpt from a battle; the painter, whose hand has been recognized in other vases, has been called the Ambush Painter after this scene. Two musical contests are depicted on a neck-pelike[69]—a youth with a kithara, and a boy singing to the music of the flute (pl. 43d). Another musical scene—a youth playing the kithara to three women—appears on a jug[70]; the name Euphiletos and *kale* ("fair" in the feminine) are inscribed in front of one of the women. A ladle[71] with a high ribbon handle—a shape evidently borrowed from metalwork— has a seated Dionysos and two maenads dancing with castanets (pl. 44d). Three skyphoi (pl. 44a–c)[72] have unusual representations—lions under trees, guinea fowl, and men and women dancing.

An oinochoe with a scene on a whitish ground (pl. 44e)[73] is noteworthy for several reasons. The shape, with its ovoid body, trefoil mouth, and arched handle—on each end of which a female bust in relief is applied—is highly decorative, the ornamental bands and the principal scene are beautifully organized, the subject of the picture is of unusual interest, and the quality of workmanship is high. Potter and painter have here combined to produce a beautiful ensemble. The preservation is comparatively good—only a few parts are missing. The picture illustrates an episode in the life of Peleus that is not often represented in vase-painting, though it was a familiar one, to judge from ancient literature. He is on Mount Pelion, where he has been

* For the possibility that this striding, armed Athena reproduces the statue of Athena Polias, see Bieber, *AJA,* 1944, pp. 125 ff.

abandoned by the vengeful Akastos to be devoured by wild beasts, and he has climbed a tree to escape from a fierce lion and boar, which wait for him beneath. Ultimately he was saved by the help of the centaur Cheiron and by the gift of a magic knife (as both hands are missing in our picture, we cannot tell whether he was depicted holding it). The myth is also represented on an amphora in the Villa Giulia Museum (no. 24247), where the centaur Cheiron is added and Peleus is shown holding the knife. A companion piece to our oinochoe, in the British Museum (no. B620), has a picture of another episode in Peleus' life—the bringing of his son Achilles to Cheiron. It was painted by the same artist as our jug. Several other white-ground jugs of the same type have been attributed to this artist by Beazley, who has named him the Painter of London B620. He must have been active in the last quarter of the sixth century.

Red-figure—in which the figures appear red on black instead of black on red—was introduced around 530 B.C. Ultimately, it ousted black-figure, but at first the two methods were used concurrently—sometimes even on the same vase, as, for instance, on a kylix with Dionysos in black-figure on the inside and a hoplite and a long-distance runner in red-figure on the outside (pl. 45b).[74] The artist of this vase has been identified as Pheidippos, whose name is known from his signature on a kylix in London. Another intermediate stage is seen in a krater with a flying Iris in black-figure under each handle, and masks of Dionysos and a satyr drawn in glaze lines, front and back, on the red background (pl. 45d).[75]

Our examples of early red-figured vases comprise several by noted artists. A kylix with a running warrior[76] has been attributed to the great vase-painter Epiktetos, but as a late, minor work. A kylix (turned greyish in the funerary pyre) is signed by the potter Hegesiboulos[77]; it has scenes of revelers and of a bearded man, perhaps an Oriental, going for a walk with his dog—an extraordinarily individualistic rendering (pl. 45e). It is instructive to compare this scene with a graffito of an Oriental on a limestone fragment (pl. 45f)[78] from the Tachara of Darius at Persepolis. A small, dainty pyxis,[79] inscribed *Lysikles kalos,* "Lysikles is handsome," has a crouching satyr by the Thaliarchos Painter, called after the *kalos* name on two pyxides by him in Athens and Paris. A psykter[80] of about 520–510 B.C. has a scene of athletes practicing—a jumper, a discus thrower, a javelin thrower, a boy being crowned for a victory (pl. 45c), trainers, and a flutist; some of the names are inscribed, and near the jumper is painted *haloumenos eisi,* "he is going to jump." The picture is by Oltos, one of the best-known and most prolific artists of his time. A kylix[81] with an archer in Oriental costume on the interior (pl. 45g) and a battle scene on the exterior is by Psiax, who, with the Andokides Painter, perhaps initiated the red-figured technique. He was evidently interested in the new system of drawing, for on this cup we find some of the earliest attempts at three-quarter views: in a warrior attacking a fallen opponent and in a fallen warrior, the abdominal muscle and the shin are shifted to the farther

side, and the shield is represented tipped to one side. The other warriors, however, are still ingeniously pieced together from separately conceived parts and their shields are in full front, full back, or profile views. Another kylix[82] has a dainty Pegasos between two apotropaic eyes. It is inscribed *Psiax,* but without a verb, so the name is not necessarily a signature.

LATE ARCHAIC PERIOD

ABOUT 515–475 B.C.

In the late archaic period the history of Greece continued to be that of a number of separate states, but among these two—Sparta and Athens—had emerged as the most powerful and had become the leaders of the rest. Sparta was the head of the Lacedae-monian League, supporting everywhere aristocratic regimes, while Athens, in the concluding decade of the sixth century, had changed from a tyranny to a democracy and had adopted the constitution of Kleisthenes. Much of subsequent Greek history is taken up with the rivalries between these two cities, one with a militaristic out-look, the other the champion of individuality and democracy. At the beginning of the fifth century, however, a great danger from outside overshadowed all else—a threatened invasion by Persia. In the course of the sixth century Persia had become the most powerful empire in the East, and had conquered one nation after another, including the Greeks of Asia Minor and the Islands. After quelling the Ionian Re-volt in 493, Persia sent an expedition against Greece proper, allegedly in reprisal for the help the latter had given to Ionia. The unexpected happened. The victories of Marathon (490), Salamis (480), Plataea (479), and Mykale (479) saved the Greek mainland, and the battle of the Eurymedon (in the early sixties) freed the East Greek cities. Greece, instead of becoming part of an Asiatic empire, was free to work out her own destiny.

Whereas in the preceding chapter the sculptures and vases that were discussed were almost exclusively Attic, those described in this chapter illustrate the late archaic art of various regions of the Greek world.

SCULPTURES IN BRONZE

A large bronze statuette of a horse (pl. 46)[1]—one of the most important objects in the collection—sums up in an eloquent way the achievements of the Greek sculp-tor in this period. The modeling is naturalistic, or almost so, but it is simplified, with no detail allowed to obtrude, and the stylizing tradition is still in evidence. The re-sult is an astonishing combination of vivacity and rest. We feel the animation par-ticularly in the front view, as the horse steps gaily toward us. This is no abstraction of a horse, but a living animal, with a body that can function; and the artist's con-ception has endowed it with an additional quality which is essentially Greek—a quiet beauty which removes it from the individual to the typical and makes it curi-ously restful compared with later creations, even with such masterpieces as Col-leoni's horse by Verrocchio, Donatello's Gattamelata, or the horses of Degas. For-tunately, the preservation is excellent, the only serious loss being the tail. The eyes

are hollow and must once have been inlaid in another material. The horse is repre-sented walking with head erect. There is no trace of a rider, but the rendering of the mouth shows that it was being pulled by reins and the hole part way down the neck suggests that there was a bridle. It was, therefore, part of a dedicatory chariot group like a similar horse recently discovered at Olympia. We may date it about 480 B.C., midway between the Akropolis horses from the Persian débris and the horses of the Olympia pediment, and somewhat earlier than the bronze statuette from Olympia.

The three chief types of statues which had been current all over Greece during the sixth century—the standing nude youth, the standing draped female figure, and the seated draped figure, male or female—were retained until the end of the archaic period, that is, until about 480 B.C. During this period of more than a century the Greek artist, by a sustained effort, attained a knowledge of the structure of the human body; at the end of it he was able to abandon the strictly frontal attitude of the human figure and its symmetrical construction and to face new problems. The examples of the three types that can be seen in our collection are, therefore, the last of their kind, and in some we already see the scheme in dissolution.

The best preserved example of a nude standing youth is a fairly large bronze statuette (pl. 47a)[2] dating from the very end of our period, about 480 B.C. It repre-sents an athlete standing with his right leg advanced, holding up a discus in his left hand; he is about to raise it above his head with both hands, and then to swing it downward and backward, preparatory to the throw. The statuette is a masterpiece of simplified modeling. The advance toward naturalism has made great strides since the time of the archaic kouros (pl. 33). Though the stance remains frontal, the weight of the body is distributed slightly unevenly, so that the two sides are no longer symmetrical; the back and front of the thorax curve outward and the vertebral column has assumed its characteristic S curve; the lower boundaries of the thorax and of the abdomen form semicircular arches; the *serratus magnus* is indicated; the abdominal muscle has no longer three, but two divisions above the navel, and they are sensitively modeled; the flanks are differentiated; and the bulge of the external oblique over the iliac crest is well developed. Nevertheless, the formalizing tendency of archaic art has been retained and imparts precision and style. The hair is short and is rendered in a solid mass, like a close-fitting cap.

A life-size bronze torso of a man (47b)[3] is about contemporary with the statuette. Whereas the horse and the discus-thrower were cast solid, this statue is hollow. Con-sidering the rarity of life-size bronze statues—only accident has preserved some from the melting-pot—the piece has great importance. We may note several ancient re-pairs of defective casting—rectangular pieces, some of which have fallen out.

Several attractive bronze statuettes show the variety of poses current at this time. The most important is a bearded, striding Herakles (pl. 48a).[4] In his right hand he

wields a club, and in the left he probably held a bow. The muscles bulge and contract under the strain of the action, and the face, with its large, glaring eyes, shows intense absorption. The maplike rendering of the abdominal muscle with two transverse divisions above the navel and with the upper boundary forming a semicircular arch, the indication of the interlacement of the *serratus magnus* with the ribs, the accentuation of the muscle bulging over the iliac crest, all point to a date in the last decade or so of the sixth century. The statuette is said to have been found at Mantineia in Arcadia and well illustrates the Peloponnesian ideal of sturdy strength and bold structure.

Another striding figure (pl. 48b),[5] said to have been found at Cyrene and datable in the first quarter of the fifth century, represents, perhaps, a giant hurling a stone; but since the attributes are missing, the identification is uncertain. A long-haired man with extended right hand wears his mantle shawl fashion around his shoulders (pl. 48d).[6] A satyr with arms outstretched, one leg lifted, and head raised (pl. 48e),[7] is evidently dancing (the exertion has made his ribs protrude). In his rhythmical movement he recalls the dancing figures by the Brygos Painter (see p. 73).

The head of a youth (pl. 47c)[8] with hair rolled up at the back, from Sicily, is finished at the bottom and so cannot have been broken from a statuette. A hole in the center of the bottom appears modern (that is, it was presumably enlarged in modern times); a perforated attachment at the top suggests that the head was used for suspension, perhaps as a weight. The date is probably around 480–470 B.C.

Several statuettes of bearded men belong to a well-known group of Arcadian bronzes which were evidently produced by local artists to serve as offerings in sanctuaries. They have a rustic, spontaneous character and give a good picture of the shepherds who roamed the mountains of Arcadia in the sixth century. Each figure wears a pointed hat and a heavy mantle, sometimes fastened in front with a long pin. One—a gift in the name of Thomas K. Schmuck—holds a small feline animal (pl. 48f).[9] Another has a ram and a mug (pl. 48h)[10] perhaps filled with milk, which he is bringing to a local deity; the inscription on the base is much corroded, but apparently read "Aineas to Pan." The third was also an offering to Pan, the chief god of Arcadian shepherds and peasants, for an inscription on its base reads "Phauleas dedicated it to Pan" (pl. 48g).[11]

A statue of a man playing the lyre (pl. 48c)[12] is inscribed on the back, in the Attic alphabet and dialect, "Dolichos dedicated me." It, too, was clearly an offering to a deity. A little horseman (pl. 49f)[13] wearing a cuirass and a Corinthian helmet with a large crest is extraordinarily lifelike—the rider sits easily on the walking horse holding the reins with both hands, his head turned a little to one side. A votive bull (pl. 49d)[14] has an inscription in large letters on its body: "Thaletas dedicated me to the Kabeiroi"; it was evidently dedicated by a pious Boeotian in the sanctuary of the Kabeiroi near Thebes mentioned by Pausanias in his description of Greece. The

excavation of this particular sanctuary was made in the eighties of the last century.

As we have pointed out (see p. 33), bronze utensils often had sculptural decorations on their handles, and, since the latter were cast solid and hence were substantial, they have often survived, whereas the vases themselves were hammered out of thin sheets of metal and have mostly perished. Several bronze handles of the late archaic period in our collection are decorated with female heads, lion's heads, palmettes, or other motives, incised or in relief (see pl. 49).[15] One is in the form of a long-haired girl with her body bent backward (pl. 49a),[16] and her feet resting on a gorgon's head, which forms the lower attachment. She is wearing a loincloth (the surface is corroded) and is therefore an acrobat (see p. 34). A beautifully worked handle with a ram's head at each end (pl. 49g)[17] evidently belonged to a foot bath (see p. 82). It is said to have come from Dodona and is a gift of Mr. and Mrs. Henri Seyrig. Two similar handles,[18] less well preserved, belong to the Cesnola collection and so probably come from Cyprus. Another handle has a guilloche pattern in relief, with silver inlay.[19]

A bronze spear butt is of great interest (pl. 49h).[20] It is beautifully designed. The dodecagonal socket is decorated at its lower end with an ivy-wreath ornament, chiseled out to receive an inlay, perhaps of silver. Along one of the sides it is inscribed in the Arcadian dialect, "Sacred to the Tyndaridai from the Heraeans." The

I E R P Σ T V N Ω A R I Ω Λ I V Ξ Λ Π E R Λ E □ N

piece was, therefore, evidently dedicated to the Dioskouroi after having been taken, with other spoils, from the people of Heraia, a city in western Arcadia. As the dedicators are not named, we may assume that they offered the spear, not in a Panhellenic place like Olympia, but in a sanctuary of their own city; that they were Arcadians, like the Heraeans they vanquished, is indicated by their use of the Arcadian dialect. Dissensions among cities of the same district were, of course, frequent in ancient Greece. We know from vase representations and from the accounts of ancient writers that, in case of need, spear butts, or "shoes," were also used in Greece for attack.

SCULPTURES IN STONE

A marble head of a youth (pl. 50b)[21] can be identified as Harmodios from its similarity to one of the Tyrannicides in Naples. Like them, it is a Roman copy of the lost Greek group by Kritios and Nesiotes which was set up in Athens in 477 B.C. in place of an earlier group by Antenor which had been carried off by the Persians in 480–479. The protuberance at the back of the New York head is an important clue for the reconstruction of the raised right arm of Harmodios.

Another marble head of a youth (pl. 50c),[22] dating from about 500–490 B.C., is

broken from a statue of a kouros. As in the Harmodios, the short hair is kept in a close mass, bringing out the spherical shape of the skull; originally the individual locks were, perhaps, painted.

A head in relief (pl. 50d),[23] said to have come from Megara, once formed part of the gravestone of a youth. The eyes were inlaid in another material and are now missing; the surface of the hair was merely worked with the punch. The stele was similar in type to the late sixth-century Attic examples (see p. 50). The form of a tall, narrow shaft with a youth carved in relief on the front face evidently continued in use outside of Attica during the first half of the fifth century.

A marble statue of a woman (pl. 50f),[24] a gift of John Marshall, exemplifies the kore type of the late sixth century. In spite of its mutilated condition, we can reconstruct the action. She wears a tunic and over it a mantle. The right arm was bent at the elbow and presumably held an offering; the left was lowered and grasped a fold of the drapery, drawing it tight across the legs. The oblique, radiating folds thus created make a pleasing contrast with the vertical rippling folds of the upper part of the tunic and with the stacked folds of the mantle. The long hair originally fell down the back in a mass, ending below in a curving line, and four tresses are brought to the front on each side. The statue was found on the island of Paros, but the type is the same as that of the korai from Attica (see p. 48), for the scheme was not confined to one locality but was used, like that of the kouros, all over the archaic Greek world.

A much battered marble lion from Sardis (pl. 50e) dating, perhaps, from about 500 B.C., must once have been a fine example of animal sculpture.

SCULPTURES IN TERRACOTTA

A life-size terracotta head[25] (pl. 50a) perhaps came from a cult statue. Red and black colors, applied on a whitish slip, have survived in part. She wears a diadem and (painted) disk earrings with pendent pyramids. The style places it in the first quarter of the fifth century.

A number of terracotta statuettes of female figures, said to be from western Sicily, are executed with unusual care and finish. Some of them served as perfume bottles. A double statuette of a woman holding a pigeon (pl. 51c)[26] is a masterpiece of ceramic art. Two front views, made in different molds, are joined back to back, and the lip of an alabastron is added at the top. Each of the figures wears a chiton arranged in stacked folds with zigzag edges. One holds a bird in the left hand and a fold of the long chiton in the right; the other grasps a bird with both hands. The narrow, obliquely placed eyes, broad nose, and full lips are crisply and delicately modeled. Other, single, statuettes are variations on this theme (see pl. 51a, b, d).[27] Several of them are represented seated and wear mantles drawn up over their heads (see pl. 51e, f). Traces of the original bright colors remain. All may be dated in the

concluding decades of the sixth century. Similar terracotta statuettes have been found not only in Sicily but on various other sites, especially in East Greece. Some may have been intended for votaries, others, especially the sitting ones, probably represent divinities.

Other figures of various types and from various sites include seated goddesses[28] (two with their coloring exceptionally well preserved, pl. 51g, h); a crouching satyr (pl. 52l)[29]; a sphinx (pl. 51j)[30]; a deer and a goat (both said to be from Tanagra)[31]; a reclining dog and a pigeon sitting on a pomegranate—both from Sardis (pl. 51k)[32]; and a dog with red markings holding what looks like a piece of red meat in his mouth (pl. 51i).[33] A large statuette from Tarentum (pl. 52a) represents a goddess seated on a throne (the lower part is restored).[34] On the front is a little Nike in relief, evidently intended as a decoration on the dress. A head broken from a similar statuette (pl. 52d)[35] and apparently pressed in the same mold is a bequest of Richard B. Seager. Two statuettes—a woman with a child on her lap,[36] and a woman sitting on a stool in front of a round table and rolling out cakes (pl. 52h, i)[37] belong to a delightful class of Boeotian statuettes of this period representing men and women in everyday occupations. They are worthy predecessors of the dainty figures from Boeotian Tanagra.

A few archaic and early classical masks (see pl. 52c, e, f)[38] are from Athens, Rhodes, Ephesos, Sardis, and elsewhere. Some have holes at the top for suspension. A head in the round, wearing a pointed cap (pl. 52g),[39] was broken from a small statue. A relief from Crete (pl. 52j),[40] of the early fifth century, shows a warrior dragging a female captive—an unusual representation.

Several antefixes in the form of palmettes (see pl. 52k)[41] come from the collection of Viscomte de Moüy, who was French minister at Athens from 1880 to 1886. They are said to have been found on the Akropolis, in Athens, and evidently came from a small building or buildings dating from around 500 B.C.

POTTERY

The terracotta vases included in this chapter are mostly Attic; for Athens commanded the world market in pottery. The majority are red-figured, the new technique having found favor with most vase-painters. Black-figure, however, lingers through the first half of the century, especially in the smaller vases, and is used even later for Panathenaic amphorae—the vases given as prizes at the Panathenaic games.

It is noteworthy that some of the best work of Attic vase-painters belongs to this period. There is an unmistakable quickening of spirit in the representations. The bodies bend, turn, twist more easily than before; the draperies have become more expressive of the action of the figures; and the attitudes are more varied. The feeling for design is still a determining factor, however. As in contemporary sculpture, the increased interest in nature is shown in a more detailed obser-

vation of the anatomical structure of the human body; for instance, the *serratus magnus* is indicated, the *rectus abdominis* is no longer rendered merely by adjacent ovals, and the shape of the oblique muscle is shown bulging over the iliac crest. In the understanding of foreshortening, also, great progress is made. The set of formulas which served the preceding generation is enriched and enlarged. The full profile view becomes rarer. The artist gradually learns to indicate the three-quarter view of the human body by contracting the farther side of the chest, clavicle, abdominal muscle, and shoulder blade. Occasionally a leg, foot, or hand is attempted in three-quarter view. The profile eye becomes unsymmetrical, the iris being moved to the inner end. The former schematic renderings of the draperies are gradually loosened; the lower edges of tunics, which are at first drawn in groups of zigzags on either side of a central pleat (see p. 58), are presently rendered by a wavy line, or a series of arcs, or a curving line. The folds of the mantles, instead of being drawn in straight, radiating lines, are diversified, and their zigzag edges gradually become more rounded. The draperies thereby become a separate entity, expressive of the action of the figure. Side by side with these innovations, naturally, the old renderings persist, especially in the earlier years of the period.

In the technique also there are changes from the preceding period. Thinned glaze is used increasingly for drawing the muscles, hair, and folds of chitons, and even occasionally as a wash. This brown color note gives a pleasing variety, taking the place in this respect of the former red and white accessories, which now fall more and more into disuse (though red is retained for such things as inscriptions, fillets, wreaths, and strings). Moreover, this soft brown, being less conspicuous than the black, helps the artist to distinguish between the more and the less prominent parts of his picture. The black relief line is used with great effect and ability. Incisions are used only occasionally—for marking the contour of the hair, for instance.

The vases in our collection have been grouped according to their painters. Works of many artists of the time are included. Though we know the real names of comparatively few, many have been recognized by their individual styles and have had names assigned to them. The painters may be conveniently divided into three classes—those who decorated chiefly large pots, those who decorated mostly small pots, and those who specialized in the decoration of cups.

The Kleophrades Painter—the name is derived from the potter's signature on one of the kylikes he decorated, but his real name must have been Epiktetos, since he signed a pelike in Berlin with that name—is represented by several examples. Two are black-figured Panathenaic amphorae, with the goddess Athena on one side (see pl. 53a),[42] on the other a contest, in one case a chariot race, in the other a pankration—a contest combining boxing and wrestling (pl. 53b).[43] A well-preserved red-figured amphora[44] with twisted handles has a single figure on each side of the body—Herakles making off with the Delphic tripod on one and Apollo pursuing

him on the other (pl. 53e). A splendid calyx krater (pl. 53d),[45] only partly preserved, has warriors arming. The work of the Kleophrades Painter reflects the vigorous and exalted spirit of the time. His paintings have grandeur and spaciousness and are drawn with a firm, flowing line.

The Berlin Painter derives his name from one of his best works—the amphora in Berlin with Hermes and two satyrs. His lithe, graceful figures contrast with the more massive types of the Kleophrades Painter. The examples in our collection are all red-figured. The earliest is a hydria (pl. 53g)[46] with Achilles spearing the Amazon Penthesileia, who falls back fatally wounded. The artist has attempted to give a three-quarter view in the Achilles by placing the *rectus abdominis* muscle on one side of the trunk, but it is not foreshortened. A youth playing the lyre, a boy attendant holding his master's stick and listening, and a dog form an attractive group on an oinochoe (pl. 53h).[47] The composition has the easy balance of this painter's work. His late, less careful phase may be seen on a lekythos[48] and two Nolan amphorae[49] (so-called from Nola, in South Italy, where many examples of this type have been found).

Other red-figure pot-painters of the time are represented by one or more works. Myson painted a column krater (pl. 53f)[50] with Dionysos and a youth moving as if in a rhythmic dance; the Nikoxenos Painter, an amphora[51] with an angular but impressive picture of the death of Priam; and his pupil, the Eucharides Painter, an amphora[52] with monumental figures of Apollo and Artemis on one side (pl. 53c) and a young athlete and his trainer on the other. The Geras Painter decorated a pelike[53] with Dionysos (pl. 54c) leaning on a knotted stick and holding out his cup to have it filled by a satyr on the other side of the vase. A particularly interesting specimen is an amphora[54] showing Theseus and the Minotaur and Theseus and Skiron (pl. 54a), by the Gallatin Painter; in the second scene Theseus has seized Skiron by one leg and is about to hurl him over the cliff; the foot bath in which the victims had to wash Skiron's feet is on the ground (see the bronze foot bath, pl. 62f). Several pictures are by the Syleus Painter—Herakles strangling the Nemean lion, an early work on a hydria; and youths in statuesque poses, on an amphora and a hydria (pl. 53i).[55]

On a Nolan amphora (pl. 54b)[56] a Greek hoplite is seen running his long spear into a Persian, who is ready to deal a blow with his sword. The Persian wears a tiara, a long-sleeved tunic, trousers, and shoes, and has a bow and quiver. This is one of the few pictures of historical happenings on Greek vases. It dates from about 480–470—the very time when the struggle with Persia was occupying the mind of every Greek citizen. The artist perhaps had actually fought in the war—hence his somewhat realistic rendering of the enemy.

Several of the greatest vase-painters of the time specialized in the decoration of cups, particularly kylikes. The Panaitios Painter, the Brygos Painter, Douris, and

Makron are ▮▮▮▮▮ best known names in Greek vase-painting. Cups painted by them were, we may be sure, in great demand for the Greek symposia. Works by all four artists are included in our collection.

The Panaitios Painter, named after the *kalos* name which frequently occurs on his works, decorated a large kylix[57] signed by the potter Euphronios, *Euphronios epoiesen*. Though in bad condition, it gives a good idea of this painter's style. On the interior Herakles is represented walking with a little companion (pl. 54d); on the exterior is the fight between Herakles and the sons of Eurytos, which took place at a banquet, as indicated by the couches. Striding figures and the draperies thrown hither and yon admirably convey the confusion of the combat. A superb kylix[58] is painted by a contemporary of the Panaitios Painter and is related to his style. On the inside is a warrior leaning on his spear (pl 54e); on the outside are groups of boxers with their trainers.

The Brygos Painter is represented by several works. Two satyrs are painted on the broad rim of a cup (pl. 54h)[59] molded in the form of two female heads. One is playing the double flute—a picture of comfort and contentment—the other is playing the krotala (the ancient equivalent of our castanets) and is turning around as if to call to his companion. Another attractive picture is on a skyphos[60]—a maenad playing the double flute while a companion dances to her music; the landscape is indicated by tall crags. A majestic goddess, perhaps Hera or Demeter, on a lekythos,[61] is a good example in a quieter mood. Two pictures of Athena, on two lekythoi (pl. 54i, g),[62] show the artist's manner of drawing in his earlier and his later periods respectively. The individual forms are strikingly similar, but in the later work the lines are thin and delicate and the draperies, with their long parallel lines, appear stiff and lifeless compared with the earlier, more varied renderings. The same tame and delicate late style appears in a Thracian woman on a kylix.[63] She is probably part of a representation of the death of Orpheus. A scene of boys singing to a flute, on a kylix,[64] is by the Briseis Painter, a follower of the Brygos Painter.

The earliest of the kylikes decorated by Makron has a lifelike picture of a youth leaning on a stick watching a slim young girl dancing (pl. 55c).[65] Others with maenads dancing, or pursued by satyrs; banquets; men, youths, and women in balanced compositions (see pl. 55d),[66] show Makron's mature style. All are drawn with an unhesitating brush. The draperies especially, with their long, equable lines, are admirably rendered. Three of the cups are signed by the potter, *Hieron epoiesen;* one is inscribed, *Naukleia kale.*

Douris was a prolific painter and passed through several stages in his long career. Our collection, however, includes only two examples of his work; one, a fragment of a kylix[67] with a satyr's head, belongs to his middle period. The other, one of his latest and best works, belongs to the Early Free Period (see p. 87).

Among the less prominent cup-painters represented in our collection are the

Euergides Painter, the Epeleios Painter, and the Paint████████268,[68] all of whom worked in the late sixth century and so are contemporary with the latest examples described in the preceding chapter. Their subjects include athletes, revelers, youths with horses, and a man in Oriental costume (pl. 55b). Apollodoros, the Colmar Painter, and the Antiphon Painter were active about 500–480 B.C. Their chief theme is youth, preferably in action, such as practicing athletes (see pl. 55a) and revelers returning from parties.[69]

Among the painters who specialized in small vases—Nolan amphorae, lekythoi, and oinochoai—the Dutuit Painter is one of the most appealing. He decorated a lekythos (pl. 54f)[70] with a Nike holding an incense burner and perhaps another lekythos (pl. 56c)[71] with a woman standing in front of an incense burner, a flower in one hand and a spray in the other. Two lekythoi,[72] one with Athena holding an Attic helmet (pl. 56b), the other with Hermes speeding on some errand, are by the Tithonos Painter, whose style recalls the Berlin Painter's. The Providence Painter, who is also close to the Berlin Painter in style, is represented by four examples. On a lekythos[73] inscribed *Hippon kalos* a flying Nike is bringing a hydria, presumably a prize for a victorious athlete; on another (pl. 56a),[74] Artemis is seen rushing through the woods, a deer by her side. These two paintings rank among the artist's best works. A satyr pursuing a maenad, on a Nolan amphora,[75] and a woman running with a torch in each hand, on a lekythos,[76] are of average workmanship. A typical work by the Bowdoin Painter appears on a lekythos[77]: a woman is sitting on a chair making skeins of wool, and Eros is flying toward her with a fillet; a tame quail walks on the floor; on the wall hangs an alabastron.

Several painters continued the black-figure technique—on a red or a white ground—and adapted it to the newly developed style of drawing. On the white ground they occasionally depicted their figures not wholly in silhouette, but partly in outline with black diluted glaze, and sometimes they used red as an accessory color. The favorite shape was the lekythos. The subjects are often of special interest. The Diosphos Painter is represented by several works. On one side of an amphora Herakles is seen taking the dog Kerberos from the house of Hades, and on the other side are Athena and Hermes (pl. 56d)[78]; on a white-ground lekythos (pl. 56e)[79] Perseus is flying off after having beheaded Medusa, from whose neck springs the winged horse Pegasos; on a red-ground lekythos Achilles is dragging Hektor's body past the tomb of Patroklos (pl. 56h).[80]

A remarkable group of four white-ground lekythoi,[81] said to have been found in one tomb, are decorated by the Sappho Painter. On one Helios rises from the sea in his four-horse chariot while Night and Dawn disappear enveloped in streaky clouds and Herakles is sacrificing at an altar; on another are a Nereid driving over the sea, Athena fighting a giant, and Herakles escorted by Athena and Iris into the presence of Zeus in Olympos (pl. 57c–f). A satyr sitting on a rock, on another lekythos by

the Sappho Painter, is in an unusual technique, being incised in the black glaze, with red and white colors added.[82] A lekythos has a scene, on a red ground, showing the struggle of Apollo and Herakles for the Delphic tripod in the presence of Leto and Artemis; it is attributed to the Marathon Painter.[83]

A white-ground lekythos, perhaps from the workshop of the Marathon Painter, has a picture of Herakles with the centaur Pholos.[84] The Athena Painter, a prolific painter of the time, decorated several white-ground lekythoi and a red-ground jug[85] with scenes of a gigantomachy, Dionysos, a hare hunt (pl. 56f), and a satyr dancing with a goat. Two skyphoi[86] have scenes by the Theseus Painter—Poseidon riding a sea horse (pl. 57b) and athletes boxing and wrestling; under the handles herons (or cranes) are delicately painted in white. Still another interesting subject appears on a white-ground lekythos (pl. 56g)[87]—Herakles clubbing the sleeping giant Alkyoneus; it is a work by the Haimon Painter. A lively picture of horses being harnessed, on an oinochoe,[88] is by the Gela Painter. Two alabastra are worthy of note—one has a gorgon's head at the bottom (pl. 57g),[89] the other, a gift of Welles Bosworth, has a beautiful all-over pattern of palmettes, increasing in size from top to bottom (pl. 57h).[90] A small lekythos (pl. 58i)[91] with a lively, sketchily drawn lion hunt is probably of Boeotian make. The black glaze has turned reddish in the fire.

Several vases are covered entirely with black glaze except for a few reserved bands or patterns introduced to enliven the effect. A particularly handsome piece is a stamnos (pl. 57a),[92] the sole decoration of which is a lion on one shoulder. There is no doubt that the shape as such and the relation of the different parts to one another can be appreciated best in these relatively plain vases.

We saw that plastic vases were used in Corinth and East Greece a century or more before this time (see pp. 38, 43). The technique was not common in Athens before the late sixth century, but once introduced it was practiced continuously for two centuries. A favorite form was that of a woman's head, either single, or two-faced. Several small examples in our collection belong to the late sixth century (see pl. 58)[93]; one, the head of a girl, is worked with great care—it is, in fact, a little masterpiece (pl. 58b). A jug with trefoil mouth has the head of a negro boy (pl. 58h)[94]; another vase has two negro heads (pl. 58g),[95] back to back. An aryballos, inscribed on the lid, "the boy is handsome, yes," is formed to imitate a group of cockle shells.[96] A few larger pieces may be assigned to the early fifth century; one (pl. 54h) is decorated by the Brygos Painter (see p. 73); another—a mug—belongs to the so-called London group[97]; a kantharos in an exceptionally good state of preservation has the heads of a satyr and a maenad (pl. 58e)[98]; an attractive head of a woman (pl. 58d),[99] datable around 480 B.C., probably belonged to a jug (the top is missing).

Fragments of vases, both black- and red-figured, ranging in date from the sixth to the fifth century B.C., are included in the collection. The late archaic examples

comprise several attributed to specific painters,—the Hischylos Painter, [100] the Kiss Painter, [101] the Brygos Painter, [102] the Foundry Painter,[103] Douris,[104] the Triptolemos Painter (Douris II),[105] and the Antiphon Painter[106] (or his manner), Makron,[107] and the Eucharides Painter.[108]

GLASS

Glass vases of a type evidently derived from Egypt are frequently found in Greece and Italy in tombs of the sixth century and later. They are not blown—the invention of glass blowing not having been made until shortly before the Christian era—but modeled by hand over a core. The variegated patterns of zigzag, wavy, and horizontal lines (see pl. 57i, j) were produced by applying threads of colored glass to the surface of the vase while it was still hot, incorporating them by rolling, and then—for zigzag and other patterns—dragging the surface in different directions with a sharp instrument. The favorite shapes are the alabastron and the oinochoe; the commonest colors yellow and blue. The examples here exhibited, mostly from the Gréau collection,[109] belong to the sixth and fifth centuries, a few perhaps to the early fourth; the later ones are discussed in a subsequent chapter (see p. 118).

EARLY CLASSICAL PERIOD

ABOUT 475-440 B.C.

The second quarter and the middle of the fifth century—the period immediately after the Persian War—were significant in the history of Greek art. By about 480 B.C. the artists had learned to understand the anatomical structure of the human body and were ready for fresh problems. Moreover, the need of repairing the devastations wrought by the enemy, the stimulus derived from the momentous victories, the increased power and prestige of Athens, which had become the head of the newly formed Delian Confederacy, created a fresh outlook. A new spirit begins to pervade Greek art—a spiritual quality which shows itself not in a new choice of subjects but in a larger treatment of the familiar themes. According to the descriptions by ancient writers the great murals by Polygnotos—now lost—had this new nobility and amplitude. The metopes and pediments of the temple of Zeus at Olympia are the most conspicuous extant examples of this idealistic trend in the field of sculpture. Many more modest creations—statues, statuettes, reliefs, and vase paintings—can acquaint us with the spirit of the time.

SCULPTURES IN STONE

Some of the sculptures of the period are original Greek works, others are Roman copies and adaptations.* For we have come to the developed period of Greek art which later appealed especially to the Roman conquerors of Greece (see pp. 119 f.). The distinction between a Greek original and a Roman copy is not always easy to draw, for the copying was often faithful—sometimes executed mechanically by the pointing process—and the sculptors who executed the copies for the Romans were frequently able Greek artists. Moreover, extensive weathering can obliterate details of modeling and make it appear softer and more fluid. Nevertheless a certain hardness of execution generally differentiates the copy from the more delicately rendered Greek original; and, when possible, we shall try to make the distinction in our descriptions.

The treatment of the nude male figure can be studied in several examples in our collection. They show the larger yet subtle modeling characteristic of the second quarter and the middle of the fifth century. The human anatomy is now rendered in greater detail, but with a tendency toward broad planes, each passing imperceptibly into the next, without undue accentuation of any particular part.

* We use the expression "Roman copy" and "Roman adaptation" to signify a copy or adaptation made in Roman times (during the late Republic and the Empire), not the work by a Roman sculptor, for the sculptors who worked for the Roman conquerors were mostly Greeks.

A life-size marble torso of a man (pl. 59a)[1] recalls in its conception the Olympia pediments. It is a beautiful example of simplified modeling. The twist of the body suggests that the figure was once in a half-reclining position.

A marble statue of a young athlete (pl. 59d)[2] in a quiet, standing pose is preserved with its head. It is, however, not a Greek work, but a Roman copy. The original must have been popular in Roman times, for several other copies and variations exist: for instance, two heads in Copenhagen and a marble statuette in Berlin. In the last the left arm is held to the side of the body and the hand once grasped what appears to have been a fillet. Perhaps we can reconstruct the missing parts in our figure accordingly.

Several heads, large and small, may be assigned to this period. A life-size marble herm of a bearded man (pl. 59f),[3] considerably restored, comes from the Giustiniani collection. The formal treatment of the hair and beard is appropriate to the architectonic character of the herm. The fame of the original is attested by the large number of Roman copies and variations that have survived, of which the best known is one found at Pergamon inscribed, "you will recognize Alkamenes' beautiful statue, the Hermes before the gates; Pergamios dedicated it." Another slightly different version, from Ephesos, has the name "A[lka]menes" preserved. Whether all these variations go back to only one Greek original is a disputed question. Two small bronze herms and a marble one (pl. 59g, h, i),[4] in our collection, are adaptations of the same general type. The Greek original must have been created in the middle or the second half of the fifth century, for Alkamenes was a contemporary—some say a pupil—of Pheidias.

A large marble head (pl. 59b)[5] is likewise one of several Roman copies of a Greek work. The rendering of the hair and the severe face, with its dignity and repose, suggest a date soon after the middle of the fifth century. It may represent Zeus; but besides the fillet in the hair there is no attribute to help in the identification.

A marble head of a woman (pl. 60a),[6] trimmed in modern times, is a Roman copy of a work of about 460 B.C. The simple planes, the fine oval face, in which each feature is sharply outlined, and the beautifully designed hair—slightly varied on the two sides—impart to it a quiet grandeur. Our head was found between 1769 and 1773 near Rome and was for a long time in the Lansdowne collection. The missing body must have resembled a figure in the Museum of Candia, Crete; that is, it was clothed in a garment with ample folds, recalling the sculptures from the temple of Zeus at Olympia.

A headless marble statuette of a woman wearing a tunic and mantle (pl. 60f)[7] is a reduced copy of a Greek work of the second quarter of the fifth century. The Greek original must have been popular, for a number of copies exist. One recently discovered at Hama has the head preserved; on another, in Berlin, a Roman portrait has been substituted for the Greek idealistic head. Ours may also have been a por-

trait, for on the base of the statuette are engraved the name Europé, in Greek letters
of Roman date, and a palm branch, a Christian symbol of victory; the name could
then be that of a Christian lady. On the other hand, as Beazley has suggested, the
original statue may have been an ideal figure of the heroine Europé (see Aischylos,
Carians, frgt. 99). The missing head and left hand were attached with iron dowels,
evidently after having been accidentally broken off.

The type of gravestone which had been popular in Attica during the sixth century
—a tall shaft generally decorated with a single figure of a youth and crowned with
a finial (see p. 48)—was changed in the fifth century to a broader and usually
shorter slab, decorated with one or two figures in relief, and crowned by a finial. Two
excellent examples belonging to about 450–440 B.C. are in our collection. One was
found in Paros (pl. 60c)[8] in 1775 and for a long time was in the collection of Lord
Yarborough at Brocklesby Park. A girl clothed in a peplos is represented standing
quietly, holding two pigeons—one perched on her hand, the other clasped to her
breast, its beak touching her lips. It is a subject directly observed from life—a
momentary action, and yet not transitory, but epitomizing the playful child who
died so early. The disproportionately large head, the chubby arm, and the fact that
the peplos is open down one side are the only factors that convey the tender age of
the girl. A realistic rendering of children was not attempted until later. The slab
was once surmounted by a finial—probably in the form of a palmette—as indicated
by the two holes on the upper edge.

The other gravestone—which has a rounded top—is decorated with a relief of
a young girl holding a pomegranate in one hand (pl. 60e).[9] In its graceful, unaf-
fected pose and in the composition of the folds, the figure recalls the maidens on
the eastern frieze of the Parthenon, with which it is no doubt contemporary. It is
said to have been found at Liatani in Boeotia.

SCULPTURES IN TERRACOTTA

Several small figures exemplify the rendering of the drapery in this period. The
most important is a fragmentary terracotta figure (pl. 60g),[10] much larger than the
ordinary statuette, wearing a peplos, with an overfold that falls in simple, dignified
folds. It is undoubtedly a Greek original, and its similarity to the Olympia sculptures
suggests a date around 460–450 B.C. It is said to have been found on the Aventine. A
smaller terracotta statuette (pl. 60h),[11] complete with head, helps us to reconstruct
the missing parts of the larger figure. Another attractive terracotta figure represents
Europa riding on the bull (pl. 60d).[12]

The so-called Melian reliefs (many are said to have been found in the island of
Melos) of the second quarter and the middle of the fifth century are among the
most attractive Greek products in terracotta that have survived. They presumably
served as decorations on wooden caskets.

Our most important example represents the return of Odysseus (pl. 62a).[13] Odysseus, scantily clothed in the guise of a beggar, is leaning on a stick; a wallet, an oil bottle, and a gourd hang from his arm. He is grasping the arm of Penelope, who sits with bowed head in the attitude of mourning, her wool basket under her chair. Behind her, her son Telemachos starts back in surprise at the sight of his father; the herdsman Eumaios, sitting on the ground in the manner of humble folk, eagerly watches the scene; and Laertes, supporting himself on his stick, looks quietly on in the detached way of the aged. The whole epic of the arrival of Odysseus at his home is brought before us, not in any one particular incident as told in the Odyssey, but as an integral whole. The chief participants are combined in one picture, each in his characteristic attitude. Traces of the original colors—white, blue, and various shades of red—remain here and there. The two holes near the top of the relief were not for suspension, because they are not centered, but for fastening it to a wooden casket. The subject on another Melian relief is also taken from the return of Odysseus (pl. 62d).[14] The hero is sitting on a stool while his old nurse Eurykleia washes his feet, and Telemachos and Penelope stand by.

On a third relief Phrixos is seen being carried across the sea by a ram (pl. 62c).[15] The subject on the fourth (pl. 62b)[16] is taken from daily life. A girl is sitting in a chair playing the double flute; originally another girl was dancing to its music with outstretched arms, but only the right arm and a small piece of the drapery are now preserved; a youth on his way home from the palaestra is watching the pretty scene. The missing figure can be reconstructed from similar, better preserved reliefs in Paris and Athens.

In contrast to these Melian reliefs, which apparently served to decorate chests, the Locrian ones were evidently votive offerings to Persephone; at least many are known to have been found in her sanctuary at Locri. Some of the subjects relate to the cult of the dead. The only example in our collection is a fragment with Hermes carrying a woman who presumably has died and is being taken to the lower world.[17] He is hardly Hades with Persephone, for he is represented as a beardless youth. The scene is preserved in several examples, for, like the Melian reliefs, those from Locri were made in molds and were often repeated.

Tarentum has yielded rich deposits of terracottas, ranging from the sixth century to the Hellenistic period and illustrating the local cults. Many were apparently votive offerings to nether deities, dedicated in the worship of the heroized dead. Male figures reclining at banquets or riding various animals were popular subjects. A youth reclining[18] is probably a banqueter; the little head at his armpit must have belonged to the couch support. A reclining bearded figure holding a kantharos[19] was presumably intended for Dionysos. Both figures date from about 460 B.C. Two heads[20] bequeathed by Richard B. Seager, of about the same date, are of reddish clay and are probably Locrian.

SCULPTURES AND UTENSILS IN BRONZE

A large bronze statuette of a youth (pl. 59c)[21]—on its ancient base—is an outstanding piece. He is represented raising his right hand to his lips in the attitude customary in saluting a divinity. The figure may, therefore, have been a votive offering in a sanctuary. The somewhat stiff pose, the exaggerated broadness of the shoulders, and the rather primitive rendering of the ears and hair suggest a date not later than 470 B.C. The position—with the right leg slightly advanced and the weight unevenly distributed—shows the gradual dissolution of the archaic kouros type.

A bronze statuette of a youth leaning backward in a somewhat precarious position, his feet gripping the ground and both arms held before him (pl. 59e),[22] may represent an athlete finishing a jump. Such momentary poses were popular in the mid-fifth century. We may recall Myron's Diskobolos and Marsyas, and the bronze statuette of a falling warrior in Modena. The excellent preservation of our statuette enables us to enjoy to the full the composition and the fine, restrained modeling.

A bronze head (pl. 60b)[23] broken from a large statuette is probably a Greek original of about 450 B.C., and though the surface is corroded we can sense the refinement of the workmanship. The hair, in particular, is crisply and sensitively rendered. The provenience is said to be northern Macedonia.

A number of bronze female statuettes which served as mirror supports have the same quiet bearing as the terracottas described above, and similarly rendered drapery —a peplos with overfold. One mirror is of rare completeness (pl. 63a),[24] retaining not only the disk, but the decorative figures around it—two flying Erotes on either side of the attachment that connects disk and support, two hounds pursuing a fox and a hare along the edge of the disk, and a siren as the crowning member. The statuette is mounted on a tripod base, as is regularly the case in this period, for the standing mirror now takes the place of the hand mirror prevalent in archaic times (the latter, however, is never entirely abandoned; see p. 96). Another example has the support and disk preserved, but lacks the subsidiary decoration (pl. 63b)[25]; and of a third only the support remains (pl. 63e).[26] Though female figures are the most common supports, male statuettes occasionally occur. One such example (pl. 63d),[27] a bearded figure wearing a mantle, is included in our collection.

A bronze statuette of Athena from the Elgin collection (pl. 61)[28] is related in style to the mirror supports. She wears a peplos with a long, belted overfold and a Corinthian helmet, on which a crest was once fastened (only the attachment now remains). In her extended right hand she holds an owl and in her left was doubtless a spear. Related figures appear on various monuments of different periods; for instance, on a marble relief in the Lanckoronski Palace in Vienna, on a fourth-

century Panathenaic amphora, and on Athenian coins of the Roman period. All apparently reproduce, more or less freely, a famous statue of around 460 B.C. The Elgin bronze appears to be a contemporary product. The execution, as in some of the mirror supports, is uneven; some parts are summarily rendered (we may note the disproportionately long arms and the cursory feet and right hand), whereas others, the striations of the hair, for instance, are delicately marked. The figure as a whole has the freshness of a Greek original, and we sense in it, more perhaps than in any of the other copies, the regal quality of a major work.

Several bronze vessels illustrate the sturdy, harmonious proportions prevalent at this time. A foot bath (pl. 63f),[29] consisting of a two-handled, shallow bowl on a tripod base, is a beautifully interrelated composition. It is said to have come from a tomb in South Italy and is excellently preserved, for instead of being hammered out of a sheet of bronze, it was cast. The decoration is confined to the rim, handles, and feet. Not many such entire bowls have survived, but they appear in footwashing scenes on vases (see pl. 54a) and reliefs (pl. 62d). For handles from such foot baths see page 68. A sturdy oinochoe (pl. 64d)[30] with trefoil lip and engraved palmettes on the handle attachments is said to have been found with the complete foot bath; whether in the same tomb or merely in the same cemetery is not known. Its date is about 550 B.C.

A bronze hydria (pl. 64a,h)[31] is another outstanding example of Greek design. It too was cast, not hammered, and is in an excellent state of preservation. The simplicity of the decoration suits the robustness of the shape. Above the vertical handle is the upper part of a woman, clothed in a peplos; there is a tongue pattern on the shoulder, and ribbing on the foot, and the handle attachments are decorated with palmettes and rosettes. All are worked with great delicacy and finish. Of the many bronze water jars that have survived, this, perhaps, is the finest. And it served, in-

ΠΑΡΘΕΡΑΣ : ΑΡΛΕΙΑΣ : ΘΑΓΕΘΗΟΝ

deed, on a special occasion. On the inside of the rim is an inscription stating that it was a prize at the games of the Argive Hera. It is said to have been found in the Peloponnese.

A hydria with leaf-shaped attachments for the handles (pl. 64b)[32] is inscribed, "of Sopolis," evidently the name of the owner. It is said to have been found with the Argive prize hydria, so Sopolis may have been a winner at the Argive games. Another hydria,[33] perhaps from Galaxidi, in Phokis, has a leaf-shaped thumb rest. A large lebes (pl. 64c)[34] of the late sixth or the early fifth century is an imposing piece in good condition.

Three handles of a hydria further testify to the high quality of bronzework in this

period. The elegantly curved vertical handle (pl. 64e,f) [35] is shaped like a serpent, the head of which served as the thumb rest and so is much worn. Its upper attachment has a lion's head framed by a stylized mane; the pendent tongue in the wide-open mouth is curved like a spout—as if to supply the jar with water from a fountain. On the lower attachment is the familiar motive of a siren with an openwork ornament of scrolls and palmettes, only partly preserved. The horizontal handles have palmette attachments and beaded collars similar to those on the foot bath. Strikingly similar handles are in other collections. All must belong to about 460–450 B.C. A handle of a jug (pl. 63c) [36] has a siren and a design of scrolls and palmettes on its lower attachment, like the handle just described. A strainer (pl. 64g) [37] shows the good taste in household implements, as well as the use of bronze for all manner of utensils for which we now employ other materials.

POTTERY

The vase paintings of this period, like the sculptures, show a new breadth in the treatment of forms. The conception becomes ampler and the feeling for space more pronounced. The old tradition of putting all the figures along one line in the front plane is not always followed; though they are still all drawn the same height, some are occasionally placed higher than others to suggest a farther plane, and, moreover, the two feet are no longer always drawn along one and the same line. Three-quarter views of trunk, head, and limbs are increasingly popular, and the farther side is convincingly foreshortened. The use of diluted glaze as a wash to indicate roundness of form becomes more common than before. In profile heads the eye, instead of being drawn in full front view, as before, is now generally more or less in profile, with the inner corner open and the iris moved back. The old schematic rendering of the drapery is abandoned except in the works of the archaizing mannerists; the folds assume natural shapes, they go in a number of directions, and they have depth. Occasionally bold foreshortenings involving the whole figure are attempted, but they are not as yet very successful, and the old procedure of piecing together different parts of the figure into one whole is generally retained. If rectangular shapes in furniture and architecture are introduced, only the front planes are indicated; in the rare instances when the farther leg of a chair is added, it is merely placed alongside the front ones, seemingly on the same plane. Artists only gropingly try to reproduce the visual appearance of things. Through these attempts, however, vase paintings gradually change from decorative designs into three-dimensional pictures.

In the choice of shapes a change is also apparent. The kylix, so popular with vase-painters in the preceding periods, remains as a prevalent form. The stamnos, pelike, and various forms of amphorae are popular, and, of course, the different kraters for the more ambitious compositions. The column krater and, among the smaller vases, the Nolan amphora and the lekythos, enjoy a special vogue.

We can distinguish several groups of vase-painters with different tendencies: (1) the mannerists, who cling to the formulas of the preceding age but develop them into a new, flowing style with graceful affectations; (2) an individualistic school, reaching out boldly in the direction of naturalism; (3) a group of artists who are strongly influenced by the contemporary murals of Polygnotos and Mikon; and (4) painters who favor quiet compositions, foreshadowing the classicism of the Periclean period. In addition, there are painters who combined several of these tendencies.

1. The Pan Painter is the protagonist of the mannerists, carrying on the style of Myson (see pl. 53f), but in a new, individualistic way. He is one of the most engaging of Greek vase-painters, delighting in scenes of movement and dramatic incident, consciously archaizing, and yet with a taste for the unusual and untried. Several good examples are in our collection. On a column krater (pl. 65a)[38] Dionysos is represented walking in stately fashion, dressed in a long tunic and voluminous mantle; he is followed by a satyr decorously carrying a cup, a stool, and an ivy branch; another satyr—painted on the other side of the vase—is coming toward them, bringing a cup filled with wine. On an amphora of Panathenaic[39] form a man is depicted playing the kithara in a contest, stepping forward, his head thrown back in rapture over the music he is making, while the judge (on the other side of the vase) listens quietly. Ganymede, on an oinochoe (pl. 65b),[40] is especially attractive; he is running at full speed, in one hand a cock, in the other a hoop and stick; his head is turned, as if toward a pursuing Zeus. Theseus and the Minotaur, on a skyphos,[41] are not drawn with great care, but are well characterized; the rapid pursuit of Theseus, the flight of the monster, and the rocky landscape are suggested with a few deft touches.

The other mannerists, though they are not of the same caliber as the Pan Painter, appeal by their rhythmical compositions and by the graceful attitudes of their figures. Most of the scenes are on column kraters. A satyr pursuing a maenad,[42] and a youth and a boy,[43] are typical works by the Pig Painter. A lively scene of youths returning from a banquet[44] is by the Leningrad Painter. The picture of Herakles and Busiris (pl. 65d)[45] by the Agrigento Painter is vividly rendered. Herakles, who was about to be sacrificed at the altar by the order of the Egyptian king Busiris, is turning on his enemies; he has seized one of the Egyptians and is clubbing him so that the blood runs down his face; the others are fleeing right and left, carrying the paraphernalia for the sacrifice. The Nausikaa Painter is represented by three works— a hydria (pl. 65c)[46] with the child Herakles strangling the serpents, a pelike[47] with Kronos and Rhea, and a column krater[48] with a Nike driving a chariot.

2. The Penthesileia Painter was one of the chief exponents of the new naturalistic trend. He made the old familiar stories live in vivid fashion. Two of his best works, painted in polychrome on a white ground (see p. 88), are in our collection. The

Judgment of Paris, on a toilet box (pl. 66a),[49] is treated in a light, humorous vein; Paris, a boy with pouting lips, is seated on a rock looking up at Hermes, who has brought Hera, Athena, and Aphrodite to him. Each is skilfully characterized—Hera, with scepter and veil, turns to the others as if eyeing her rivals; Athena is in full array; Aphrodite adjusts her mantle while Eros looks up at her admiringly. The varied colors, the finely designed shape, the careful execution, and the exceptional preservation combine to make this an outstanding piece. Zephyros and Hyakinthos, and Nike crowning a victorious youth, are represented on a double disk (pl. 66b),[50] which served, perhaps, as a bobbin or a toy. The compositions have a bold rhythm running through them; the design of the Nike and youth in particular—both figures placed diagonally across the circular field—is singularly vivacious, a happy solution of a difficult problem.

Several less imposing works show the Penthesileia Painter's ordinary output. On either side of a stemless kylix[51] a lively Eos pursues a reluctant boy—Tithonos on one side, as we see from the lyre, and either Tithonos or Kephalos on the other. Men and youths with armor are depicted on a skyphos[52]; if we may judge by the dejected look of the older men, the scenes represent soldiers departing. A large kylix[53] has athletes on the exterior and on the interior a man in a rocky glen attacking a boar with sword and club—a well spaced composition within the circle.

The Penthesileia Painter's broad and lively style appealed to his contemporaries and he had many imitators. Several of these are represented in our collection. Vivacious groups of girls by the Painter of Bologna 417 are seen on a large, well preserved kylix.[54] Nike and a boy, a winner in a school contest, are represented on a kylix[55] by the Splanchnopt Painter. A particularly interesting rendering of the Birth of Aphrodite, by the Wedding Painter, occurs on a pyxis.[56] The goddess, represented as a young girl, is welcomed by Eros and surrounded by excited nymphs bringing sashes, a perfume vase, a branch, and a chest. On a similar scene in Ancona Aphrodite's name is inscribed.

3. The Niobid Painter and his associates are the most important representatives of the group that was influenced by the contemporary murals of Polygnotos and Mikon. Two comparatively slight works by the Niobid Painter himself are in our collection: on a hydria[57] Triptolemos is represented seated in a winged chariot, holding a scepter and the ears of grain which he is about to bring to mankind; and on a tall neck-amphora[58] two libation scenes with figures in statuesque poses are rapidly drawn, without great finish. A beautifully composed picture of Kadmos and the dragon, on a calyx krater,[59] is "in the manner of the Niobid Painter." Compared with some of the Niobid Painter's more grandiose scenes—for instance, the Death of the Niobids on the krater in the Louvre from which he derives his name—these pictures are modest creations.

We obtain a good idea of the imposing products of the vase-painters of this group

from two other large vases—a volute krater (pl. 67a)[60] decorated by the so-called Painter of the Woolly Satyrs with contests of Greeks and Amazons and of Lapiths and centaurs; and a calyx krater (pl. 67b)[61] with a picture of Greeks fighting Amazons, by the Painter of the Berlin Hydria. It is interesting to study the bold foreshortenings of the figures on these vases. In the Amazon on horseback, riding out of the picture toward us (pl. 67b), the head is in full front view, whereas the head and body of the horse near a three-quarter view, and her legs and the horse's go in different directions. One of the centaurs has the equine part of his body in three-quarter back view, his human trunk in full front, the legs, one arm, and the head in profile. In spite of the new conception of space, the old tradition of piecing together separately viewed parts of the body is still strong. The crowded composition and the suggestion of shadows in the draperies by washes of thinned glaze were doubtless inspired by the larger paintings of the time. That the vase-painters, however, did not directly copy from those paintings is indicated by the fact that there are no repetitions of groups, or even of single figures, in his representations. An Amazon on horseback, an Amazon lifting an axe with both hands, an advancing Greek, a collapsing Greek or Amazon appear again and again, but always in different attitudes and groupings.

4. The Villa Giulia Painter is the chief representative of the academic group, which, flourishing side by side with the Niobid Painter and his associates, preferred calm, harmonious scenes to the latter's ambitious compositions. His paintings consist mostly of quiet, serene figures with little animation. Apollo, Artemis, and Leto on a bell krater (pl. 68a)[62] and a youth arming, surrounded by his family, on a stamnos,[63] are typical products.

Two hydriai[64] have pictures of Peleus pursuing Thetis by the Chicago Painter, a follower of the Villa Giulia Painter. The two vases were evidently made as a pair. A magnificent bell krater (pl. 68b)[65] has a Dionysiac scene by the Methyse Painter. Though the subject is a revel, the figures march in a dignified procession: a maenad, inscribed Methyse, playing the lyre, her head raised in ecstasy; Dionysos holding a kantharos and thyrsos, his uncertain steps supported by a little satyr; another maenad playing the flute; and a satyr holding a kantharos and a wineskin. When we contrast these stately figures with the ecstatic maenads by the Brygos Painter we can gauge the change of outlook. Greek art has lost the exuberant spirits of youth and is assuming the serene outlook of the "classical" period.

A boy, on a kylix (pl. 68c),[66] is an attractive product by the Akestorides Painter; he is depicted sitting on a stool in front of an altar, playing the lyre and singing to its music as if inspired; we have few pictures in which such grace and feeling are expressed by means so simple. Attractive scenes of schoolboys with writing tablets and rolls of manuscripts, on a stemless cup,[67] are by the Painter of Munich 2660. Another stemless cup,[68] has a satyr stoking the fire in an oven, by the Euaion

Painter. Though slight, the scene has a pleasing vivacity often absent in this artist's rather academic paintings. Two vases have decorations by the Painter of Louvre CA1694, an artist "near the Euaion Painter." One is a jug[69] with two satyrs, the other a mug (pl. 68f)[70] with a satyr putting on a wreath in front of a tree, under which stands a basket, no doubt filled with fruit. The latter, particularly, is an engaging piece, comparable to two mugs in London and Boston with similar scenes by the same painter. A well-preserved skyphos (pl. 68e)[71] has pictures by the Euaichme Painter—who also belongs to this group. There are two male figures on either side; the writing case on the well suggests a schoolroom. The inscription reads, "Isthmodoros is fair."

The cup-painter Douris was evidently active for a long time—about 500 to 470 B.C. (see p. 73). One of the best extant works of his last period is on a kylix in our collection. On the exterior are scenes of youths and women in conversation; on the interior are two women putting away their clothes (pl. 68d).[72] The undulating contours and quiet poses show the elevation of spirit characteristic of this great period. An attractive scene of women working wool, on a well preserved pyxis (pl. 68g),[73] has recently been attributed to the school of Douris (to the Hiketes group).

5. Several painters that do not fall specifically into one of the four preceding groups are represented in our collection. We may mention especially a maenad (pl. 65e), and a maenad and a satyr, on two lekythoi[74] by Hermonax; satyrs, and satyrs pursuing maenads (pl. 65f), on two Nolan amphorae[75] by the Oionokles Painter; the story of Danae and Perseus, a pursuit, and a youth arming (pl. 65h), on three stamnoi[76] by the Deepdene Painter; and pictures of an orchard, of Jason seizing the golden fleece (pl. 65g), and of pursuits, on three column kraters[77] by the Orchard Painter. The Painter of Bologna 228 painted departing warriors on the neck of a loutrophoros,[78] and two scenes on a column krater[79]—a two-horse chariot (pl. 65i), and Dionysos with two maenads. The latter was never finished; the relief lines for the contours and for the inner markings of the figures are lacking throughout. The vase was evidently removed for firing before the artist had completed his work. Also, the vase itself did not come out well. The body was not set straight on the foot, and leans to one side; consequently, neck and handles had to be shaped irregularly to produce a level top. In spite of these faults, the pot was not discarded, but must have been used for some time, for it shows considerable wear.

A number of Nolan amphorae and small lekythoi[80] have decorations by minor artists of the time—the Painter of the Yale Oinochoe, the Nikon Painter, the Carlsruhe Painter, the Aischines Painter, and the Ikaros Painter. The last is named after the unusual scene on the lekythos by him, probably depicting the fall of Ikaros.

The practice of molding vases in the form of heads and diverse objects continued through this period. The examples in our collection include heads of rams (pl. 69d,f),[81] a bull (pl. 69h),[82] and a lamb (pl. 69e),[83] a vase in the shape of a large

knucklebone (pl. 69g),[84] and a cup in the form of a cow's hoof (pl. 69i).[85] On the latter an unusual scene is depicted. A herdsman, clothed in a tunic, shoes, furry pelt, and cap, is sitting on a rock watching a herd of cows, two of which are wandering in different directions; at the other end a wolflike dog is emerging from a cave; in the center is a tree under which a hare is crouching; a little to one side is a shrub. The whole is a sensitive picture of rural life, concisely told. Thinned glaze is ingeniously used to suggest the various surfaces of cave, rock, herdsman's pelt, coats of dog and hare, foliage, bark; on the vase itself the texture and color of the horn are rendered by brown striations.

White-ground vases, which we saw were in use also in the preceding period, become increasingly popular during the second quarter of the fifth century. By the addition of mat washes for the garments—red, brown, and yellow—colorful effects are obtained. The technique is employed on various shapes, but especially on lekythoi. The subjects now often relate to death, in which case the vases must have served as offerings to the dead. One by the Sabouroff Painter represents the lying-in-state, with mourners surrounding the bier (pl. 69b).[86] Another, by the same artist, depicts Charon in his yellow boat, ready to ferry a youth across the river Styx (pl. 69c)[87]; the youth, wrapped in a red mantle, has been escorted by Hermes to the river bank. In an exceptionally well-preserved picture by the Vouni Painter mourners are represented standing by two gravestones, holding offerings (pl. 69a)[88]; the shafts are bound with numerous fillets; one of the graves, at least, must have been that of an athlete, for jumping weights, a strigil, and an oil bottle are suspended from the right-hand platform; in the background is the funeral mound. Scenes of mourners at graves occur also on two lekythoi—one by the Inscription Painter,[89] the other also probably by him.[90] The picture on a small lekythos[91]—drawn in glaze lines but without colored washes—represents a warrior cutting off a lock of his hair, presumably to put it on a tomb, like Orestes at the grave of Agamemnon; it is a work by the painter of the Yale lekythos.

SECOND HALF OF THE V CENTURY B.C.

The Periclean administration and the Peloponnesian War are the two outstanding historical events that affected Greek art during the second half of the fifth century. After her victory over Persia, Athens had founded an empire by converting the Delian Confederacy into a league of states subject to herself, with its fleet an instrument of her power and its treasury at her disposal. Increase of trade had brought her additional wealth, which meant more leisure and greater opportunities for many of her citizens. The state was further democratized so that every citizen took a direct share in the government of his country; and this in its turn raised the general intelligence of the community. The occasion for great achievements had come, and with it, fortunately, came great men. Pericles, a member of the Alkmeonid family (see p. 135), rose as a distinguished statesman, as a leader of the people, and as a patron of the arts. During his administration the rebuilding of the temples and porticoes sacked by the Persians was undertaken on a magnificent scale, and Pheidias was made chief overseer of all artistic enterprises, with eminent men like Iktinos and Mnesikles as architects. The most famous of the new buildings was the Parthenon, which, even now, in its mutilated and fragmentary condition, is accepted as one of the highest standards of art, both in architecture and in sculpture. In this temple is achieved the perfect expression of the idealistic art of the time.

Pheidias had many distinguished contemporaries and pupils, and though we know little more than the names of many, the praise bestowed on them by the people who saw their works makes us realize their stature. And many a product by a nameless artist shows in spirit and execution how widespread the influence of the great masters had become. Nor was artistic production confined to Athens. Polykleitos, the Argive sculptor, was hardly second in fame to Pheidias and had an important and permanent influence on the art of his own time and on that of subsequent ages.

The Peloponnesian War, the life-and-death struggle between the two rival states of Sparta and Athens, broke out in 431 B.C., and was not brought to a close until the year 404. It resulted in the breakdown of the Athenian empire and the reduction of Athens to a second-class power. Nevertheless she long remained the intellectual center of Greece. The sculptures of the Erechtheion, of the temple of Athena Nike and its parapet, of the temple at Phigaleia, the Nike of Paionios at Olympia, and many a private monument and offering illustrate the sculptural art of this time. And again a host of vase paintings have survived to give us at least some idea of the pictorial art evolved by the great Polygnotos and by Apollodoros and Zeuxis.

SCULPTURES IN STONE

Several large marble sculptures of this period in our collection are discussed in a later chapter (see pp. 136 ff.); a number of smaller examples likewise show the various trends in the art of the time. There are several beautiful male figures.

The torso of a boy in violent action (pl. 70a)[1] was intended perhaps for a Niobid defending himself from the arrows of Apollo and Artemis. The anatomy is rendered with perfect understanding, but, as in the preceding period, there is a tendency toward broad surfaces rather than detailed elaboration. The sculptor's aim was to represent the harmoniously developed human body, without undue accentuation of its parts. This feeling for moderation and pure beauty gives Greek art of this epoch its distinction.

A fragmentary figure of a seated man (pl. 70b),[2] considerably less than half life size, is another important piece. Whereas the torso of the boy is represented in movement, this figure is in repose. The modeling, however, shows the same subtlety and restraint and the same sensitive differentiation between the hard and soft surfaces of the body. The identity of the figure is not certain. The proportions are those of a man of mature age and of ideal type. The figure evidently formed part of a group, perhaps from a small pediment. On each side the drapery is interrupted by an angular cutting, which was apparently made for the reception of another figure or object, and on the left side there is a small rectangular dowel hole, which must have served for attachment. The body, moreover, is turned to the left, as though toward another figure.

A third male figure (pl. 70c),[3] again without its head, and about two-thirds life size, represents a delicately formed boy. It is possible to reconstruct the original attitude. He was standing with his weight on his right leg, the left hand brought to the back, the right hand resting on a pillar (the place where the pillar was attached is marked on the right thigh by a fractured surface, and the left hand is preserved above the left buttock; the hole above the right knee is not ancient). The statue is a Roman copy (reversed) of a Greek work of the later part of the fifth century, preserved in many copies and known in modern times as "Narkissos," although the original probably represented a boy athlete.

A small marble torso of a youth (pl. 70d),[4] bequeathed by Richard B. Seager, is another example of quiet, restrained modeling. It, too, is probably a Roman copy of a late fifth- or early fourth-century type.

The most important marble head of this period in our collection represents a a youth (pl. 71a)[5] wearing a fillet—the badge of victory in athletic contests. Though it, too, is of Roman workmanship, the sculptor has caught much of the spirit of the Greek original. It illustrates the Greek conception of the beauty of young manhood, a beauty both physical and intellectual, in which the dominant note is serenity. A small projection on top of the head—probably part of a support—

suggests that the youth stood with one arm resting on his head. He may be inter-
preted, therefore, as a victorious athlete after a competition. Other copies of the
same lost original exist in several heads, but the body is not known. Who the sculp-
tor was it is impossible to say. Kresilas, a Cretan sculptor who worked in Athens,
has been suggested, but the evidence is slender.

A head of a youth (pl. 71b)[6] is a rather hard Roman copy of a lost Greek work
probably by Polykleitos. The long, angular skull, the flat locks, the narrow brow,
and the heavy eyelids are in his manner. The fact that more than twenty other
copies exist (all more or less fragmentary) shows that the original was famous.
From various clues, it has been reconstructed as a nude youth standing with his
weight on one leg and holding a discus in his left hand.

Two heads of youths are Roman copies of Greek works of the later fifth century.
One, with heavy-lidded eyes and wavy locks (pl. 74c),[7] is said to have come from
Rome; the other (pl. 74b),[8] with its oval face, foreshadows fourth-century types.

It became customary in the fifth century to erect portraits of prominent men.
Though the likeness was still generalized, the impetus given to the study of in-
dividuals paved the way for the realistic conceptions of the Hellenistic age (see
pp. 119 ff.). The best known example of the Periclean age is the Pericles, pre-
served in several Roman copies—for instance, in London, Rome, and Berlin. In
this Museum a portrait herm of Herodotos (484–430 B.C.), "the father of history,"
is a Roman copy of a Greek work that has been attributed both to the late fifth
and to the early fourth century B.C. (pl. 74a).[9] Though the execution is somewhat
hard and mechanical, the figure brings before us in a sympathetic way the per-
sonality of the great, imaginative historian. The inscription "Herodotos" and the
similarity to the famous portrait on the double herm in Naples make the identifica-
tion certain. The head is said to have been found at Benha, in Lower Egypt, and
was presented to the Museum by George F. Baker in 1891.

The draped female type of this period is best illustrated in a statue of an Amazon
(pl. 72a),[10] from the Lansdowne collection. Though it is a Roman copy, it is an
exceptionally fine one, and it reproduces a famous Greek work of about 440–430 B.C.
Pliny tells the story that four eminent sculptors—Polykleitos, Pheidias, Kresilas,
and Phradmon—competed in making a statue of an Amazon for the temple of
Artemis at Ephesos and that the prize was awarded to the statue which each
artist placed second to his own, namely, that of Polykleitos. Copies of four distinct
types of Amazons datable in the period of Polykleitos have survived, and there
has been much discussion as to which type is to be assigned to which sculptor. The
type here shown has been attributed both to Kresilas and to Polykleitos. Judging by
its rhythmical composition and its superiority in this respect to the other three
extant types of Amazons this one is quite possibly a copy of Polykleitos's prize-
winning work. She is represented leaning on a pillar, her right arm raised to her

head, a wound at her right breast. The stance is similar to that of the Doryphoros and the Diadoumenos of Polykleitos, with the weight of the body on the right leg and the left placed backward and sidewise; but the curves of the body are accentuated by the fact that she leans against a pillar. The balanced drapery is also characteristic of Polykleitos, who we know was particularly interested in design. The folds of the tunic, though arranged with studied symmetry, are varied slightly on the two sides; their sharp contours would be particularly effective in bronze, presumably the material of the original. Several other Roman copies of this type of Amazon are known—for instance, in Berlin, Copenhagen, and the Vatican. Our statue preserves most of the right arm with part of the hand and the upper portion of the pillar—essential clues for the reconstruction of the composition. Some of the marble restorations added in the eighteenth century, when the statue was found, have been removed, and plaster casts of preserved ancient portions have been substituted—the nose and the feet from the statue in Copenhagen, the lower legs from that in Berlin.

A statue of the "Venus Genetrix" type (pl. 72b),[11] one of the most graceful creations of antiquity, illustrates the transparent drapery that became a characteristic of late fifth-century sculpture. The type was also popular in Roman times, for many copies and variations exist, of which the most complete is in the Louvre. Ours, though headless and armless, and discolored by fire, brings us near to the original, for the execution is sensitive.

The upper part of a statue of Athena (pl. 74f)[12] is a Roman copy of a pleasing Greek work of the late fifth century. Again a number of Roman copies exist. In our figure both arms and the top of the head—now missing—were worked in separate pieces and attached. On one side of the head the protruding lining of the helmet is indicated.

Several Attic gravestones are excellent examples of Greek relief-work during the late fifth century. The slab is now broader and less high than in the archaic period and the finial is generally in the form of a pediment. On a tall stele a young woman is represented leaning against a pillar, while a little attendant holds a jewel box (pl. 72c).[13] A woman with her maid is a common subject on Greek grave reliefs, for it served the purpose of showing the dead in an ordinary incident of daily life. But the action in our relief is subsidiary; the thoughts of the woman are far removed from it. She looks neither at the box nor at the girl, but seems lost in thought. By this detachment the Greeks tried to convey the idea of death in their sculptures. The name of the woman was doubtless inscribed on the missing portion of the architrave.

A fragment from another grave relief (pl. 71d),[14] with the head of a woman, belongs to about the same period. The monument must have been an important one, for the head is practically life size, and beautifully executed. Its forward in-

clination and its place in relation to the pediment show that the woman was seated and that there was probably a second figure standing at the left. The inscription on the architrave reads: . . . *omeno(u)s thuga[ter]*, ". . . , the daughter of . . . omenes." The fragment was known to be in Athens in 1837; later it passed into the collection of Lord Lansdowne.

A woman seated on a cushioned chair (*thronos*), her mantle wrapped around her, is part of still another gravestone of this time (pl. 119b).[15] The large scale and high relief (the figure is practically in the round) show that it was an important monument, comparable to that of Phrasikleia in Athens. The missing left half of the slab was probably occupied by a standing handmaiden, as in the approximately contemporary stele of Phainerete in Athens. Like the fragment from the Lansdowne collection this piece is not a new discovery. It was found in 1811, or soon after, at Acharnai in Attica and was for a long time in the collection of the Earl of Lonsdale in Lowther Castle, in Westmoreland, England.

A fourth gravestone (pl. 73d)[16] of about the same date has a relief of a woman seated on a stool (*diphros*). The head is missing. The pose and the graceful folds of the tunic and mantle recall the well known stele of Hegeso in Athens.

Two small reliefs probably also served as gravestones. One represents two contestants in a battle (pl. 73a).[17] A bearded warrior, evidently a hoplite, in a belted tunic, with a shield on his left arm and a dagger or sword hanging from his shoulder, has placed one foot on his fallen opponent and is about to deal the death blow with his spear. The opponent has unsheathed his dagger and is holding it point upward, aimed at his enemy's heart. This momentary action, full of movement and tension, is rendered even more dramatic by the alert expression of the fallen warrior; he knows that his end is near, but as his last act he will try to kill his enemy. The relief is evidently a grave monument erected to a soldier who died in battle, probably sometime in the last quarter of the fifth century, during the Peloponnesian War. As the relief is said to have been found in Athens, the two contestants may represent a victorious Athenian and a vanquished Spartan.

The other relief also has a battle scene (pl. 73b).[18] Only the right end, with three figures and part of a fourth, is preserved; we do not know how far it continued toward the left. A fallen youth is lying on the uneven ground, one arm limp at his side, the other still clutching a sword; behind him a warrior flees to the right; his clenched left hand probably grasped a spear (which was indicated in color only); to the left another warrior is collapsing under the onslaught of an opponent; the latter, of whom there is very little preserved, has one knee against his victim's side and has seized him by the hair with his left hand; a wavy ledge above the shield is perhaps the outline of a tree or rock which was indicated in color. Similar crouching and fallen figures appear on the friezes of the temples of Athena Nike and of Apollo Epikourios at Phigaleia. Our relief has a molded edge along the top,

a plain one at the bottom. Presumably, therefore, it was not an architectural frieze, but a grave memorial, perhaps of soldiers killed during the Peloponnesian War. Originally the slab was thicker, but it was cut down with the saw in antiquity, perhaps in Roman times.

A fragment, delicately carved, was evidently broken from a so-called hero relief (pl. 71c).[19] We see the upper part of a woman who is holding out a circular object —originally perhaps painted with leaves and flowers to represent a wreath—to another figure of which only the right hand is preserved. The woman wears a chiton and a mantle, one end of which she holds up in a gesture characteristic of the time. Behind her are traces of a small figure, and behind her head is part of a rectangular depression with a horse's head in it (note the two grooves of the mane and the creases at the neck). To judge by better preserved reliefs of this type, the figure receiving the wreath was the hero, who was reclining on a couch, while his wife sat on the foot of it. The little figure at the back must have been a servant, perhaps a cupbearer. A table with food and offerings was presumably in front of the couch. On the molding above the relief was a dedicatory inscription, of which five letters, *kallo,* are almost completely preserved; there seems to have been no letter before the *k,* but after the *o* are three dots (signifying the end of the word) and what looks like the beginning of an *a.*

A large relief (pl. 72d)[20]—only the lower part is preserved—showed Demeter and Persephone sprinkling incense on a small, round altar. The attitudes of the figures and the arrangement of the draperies resemble those in the large Eleusinian relief in Athens (see p. 136), the chief variation being that the altar takes the place of Triptolemos. The provenience is also Eleusis, but the workmanship is evidently Roman, or it is a copy of a similar relief. The rough portion at the left end of the plinth indicates that the block was sawed from right to left to within a few inches of the end and then broken apart.

A small votive relief (pl. 73c)[21] represents a woman seated on a stool (*diphros*) in evident exhaustion, a maid holding a baby, and two larger figures, clearly intended for deities (of one, only a small portion, including the left hand holding a staff, is preserved). Presumably the seated woman has given birth to a child and the relief is a thank offering. The two deities were, perhaps, Asklepios and Hygieia. The sticklike object in the latter's left hand is difficult to interpret. The surface of the relief was at one time cleaned with acid, hence the unpleasant sheen.

Two marble fragments with egg and dart moldings are from the Erechtheion of Athens (about 420 B.C.) and were obtained by this Museum from private owners. One, with a corner palmette (pl. 74e),[22] comes from an anta capital of the east portico, the other from the *epikranitis* (pl. 74d).[23] Even these small pieces can help us to appreciate the delicacy and crispness of Greek architectural carving during its best period.

A fragment of a marble inscription[24] has historical interest. It is part of a tribute list (other fragments exist elsewhere) recording the payments to Athens by members of the Athenian confederacy. Our piece lists the assessments of Paros, Naxos, Andros, Melos, Siphnos, Eretria, and Thera. The date is 425 B.C., when the Peloponnesian War had lasted six years and Athens was sending out the first Sicilian expedition. She was beginning to be hard pressed, and we note that the tributes are double the amounts of former times.

SCULPTURES AND UTENSILS IN BRONZE

Several important bronze statuettes belong to this epoch. One of a youth (pl. 75a),[25] from Cyprus, recalls the style of Polykleitos. The stance, the square build, the rendering of the abdominal region, the shape of the skull, and the treatment of the hair and face are in his manner. The modeling is fresh and careful; even such details as nails and knuckles are indicated. A superbly modeled youth in a praying attitude (pl. 75b)[26] is a votive figure of the same period. The influence of Polykleitos is again apparent, in the square build and the broad shoulders. Other bronze statuettes include a satyr (pl. 75f)[27] in an animated pose; a youth in Oriental costume (pl. 75d),[28] evidently part of a support, perhaps of an incense burner; a draped female figure (pl. 75c)[29] said to be from Egypt; two bulls (pl. 75g,h),[30] a doe (pl. 75e),[31] and a delicately worked head of a calf (pl. 76g).[32] The latter is hollow, but is evidently not a little vase, for it is rough inside.

A beautifully proportioned bronze hydria (pl. 76a,d)[33] may be assigned to the last quarter of the fifth century. The vase itself was hammered and is plain; the handles, foot, and mouth were cast and richly decorated with relief work, enlivened by silver inlay. On the lower attachment of the vertical handle is a group of a winged figure, perhaps Artemis, seizing a deer. She has jumped on the back of the animal, and placed her left arm firmly around its neck, and with her right hand grasps one of its antlers. The delicacy of the work, the clinging drapery, the lively pattern of the bunched mantle, the features, the coiffure, and the sense of movement in the composition recall the reliefs of the Nike parapet in Athens (410 B.C.).

A pair of handles (pl. 76c)[34] from a large volute krater, a handle of a jug (pl. 76e)[35] with a sensitively modeled bearded head on the attachment, and an oinochoe with trefoil lip (pl. 76b)[36] are further good examples of bronzework of this period.

The high quality attained by the Greeks in embossed metalwork at this time is seen in a number of bronze mirrors. They are examples of a type that was introduced in the second half of the fifth century and remained in favor for more than two centuries. It consisted of a disk with a projecting rim, into or over which a hinged cover fitted; the cover was ornamented with a relief; the upper side of the disk was polished for reflection, the back ornamented with concentric moldings. Five fine examples are said to have been found at Vonitza, in Akarnania. On the

cover of one is a female head in profile (pl. 77a)[37] (the eye, however, is not in profile); her curly locks are bound with a band at the back. On another is a bust in three-quarter view (pl. 77c),[38] with long, wavy hair; the nobility of the features

suggests that a divinity was intended, probably Aphrodite, for she would form an appropriate decoration on a mirror, and the action of the right hand, which holds a lock of hair, is found in representations of her. A third mirror (pl. 77b),[39] of exceptional quality, is ornamented with a female head in full front view with hair flying in wavy locks; heads of the same general character appear on Greek coins of the end of the fifth century and belong to different deities and local nymphs, according to the place for which they were struck.

Occasionally the mirror cover was ornamented not only with a relief on the outside but with an engraved scene on the inside. To show both decorations of one such example (pl. 77f)[40] we have mounted the relief on a separate, modern disk. It consists of a male figure, identified by the lion's skin tied under his throat as Herakles, in violent struggle with a woman—perhaps Auge, the mother of Telephos; though the piece is fragmentary enough remains to show the beauty of the modeling and the spirited composition. The engraved design represents Herakles and Atlas: Herakles has placed his club and quiver on the ground and is on the point of taking the weight of heaven from Atlas. The fifth example (pl. 77e)[41] has on its cover a beautifully composed floral pattern in *à jour* relief. Every leaf and petal is minutely modeled, without impairing the freedom and animation of the whole. A sixth mirror of this period, not from Akarnania, has a relief of a female Pan's head (pl. 77d)[42] in three-quarter view; note the animal ears and horns.

In addition to mirrors with covers, those with handles were in vogue throughout the sixth, fifth, and fourth centuries. Part of a handle from such a mirror (pl. 76f),[43] decorated with scrolls and palmettes, belongs to the Cesnola collection and is said to have come from Cyprus. The type is often represented in contemporary sculptures and vase paintings.

SILVER AND GOLD

Little Greek embossed work in gold and silver has survived. A pair of silver phialai (pl. 78a,b)[44] or libation bowls dating from the late fifth century are rare examples from the period when the art of embossing metal was at its height. Though bent, discolored, pitted, and corroded, their extraordinary beauty can still be appreciated. The decoration on the two bowls is identical. It consists of two figured friezes, framed by ornamental borders. The outer, wider one represents the Apotheo-

sis of Herakles. Four chariots in three-quarter view are driven each by a Nike and occupied by Herakles, Athena, Ares, and Dionysos respectively. The inner, narrower frieze consists of groups of figures reclining at a banquet. Dionysos and Ariadne, Papposilenos, Herakles, and perhaps Hebe may be distinguished. The subject is probably the celebration of Herakles's wedding to Hebe at a banquet of deities. Several instances of double-striking in the design indicate that the bowls must have been hammered over a mold. There are no toolmarks on the face of the bowls, that is, no chasing was done after the hammering. All the exquisite details must have been cut in the mold.

A third phiale (pl. 76h),[45] of massive silver, is cast and chased and has effective parcel gilding. Such bowls were used for libations and must once have been common. Many are listed in temple inventories.

A gold plate from a sword sheath (pl. 78c)[46] is another remarkable example of Greek work in embossed metal. It belongs to a class of Greek antiquities which have been found exclusively in southern Russia and were evidently made by Greeks for Scythian chieftains. Our example is the only one of its kind outside the Hermitage in Leningrad, which contains a rich collection of gold and silver objects found in Scythian tombs. The projection at the side of our plate served to mask the attachment of the sheath to the belt. The sheath itself was made of perishable material and has disappeared. The plate is decorated in relief with two contests of animals— a lion attacking a deer, and a lion-headed griffin killing a doe—and with a battle of Greeks and barbarians. The contestants are recognizable by their costumes and weapons—the Greeks by their chitons, mantles, helmets, cuirasses, greaves, swords, spears, and shields; the barbarians by their long-sleeved jackets, trousers, Oriental caps, shoes, bows, axes, and short swords or spears. The figures are beautifully modeled in a rich variety of postures—attacking, defending, falling, and prostrate; one is being dragged by a frightened horse. They are effectively designed in closely knit groups, and yet the melee of the battlefield is successfully conveyed. The style of the reliefs points to the period around 400 B.C., the nearest parallels being the friezes of the Phigaleia temple, of the Gjölbaschi Heroön and of the Nereid monument, where there are the same vigorous, compact, and lively groups, the same decorative draperies, and the same restrained, maplike modeling of the bodies. The battle scene is identical with that on the famous sheath from the Chertomlyk tomb, excavated in 1859–1863, the two plates evidently having been hammered into the same mold or die; only in the subsequent chasing, which was free hand, are there variations. The animal groups, however, are different in the two pieces. That duplication by the use of the same die was practiced in Greek metalwork is shown in other examples—for instance, by two gold plates of a quiver with identical representations, one found at Ilyintsy, the other in the Chertomlyk tomb, both now in Leningrad, and by the two silver phialai mentioned above.

SCULPTURES IN TERRACOTTA

The most important terracotta sculpture of this period in our collection is a large statuette (pl. 79a),[47] representing a youth with both arms raised to tie a fillet around his head, an ancient adaptation of the Diadoumenos of Polykleitos (see pp. 137 f.). The robust, somewhat severe style of Polykleitos has been softened by lengthening the body, by making the head less square and the neck less short, and by imparting to the eyes an expression of tenderness. In other words, the artist has retained the rhythmical composition of Polykleitos but has added the gracious elements introduced by Praxiteles and Lysippos in the fourth century. The statuette is the most important example of a group of terracotta figures, found mostly in Smyrna, which reproduce famous statues of different periods and were probably made in the first century B.C. Originally they were gilded. A few remains of gold leaf still adhere to the fillet of our statuette.

Several terracotta figures and reliefs illustrate some of the numerous types produced in Tarentum; they served as votive offerings in sanctuaries of the nether deities (see p. 109). A reclining banqueter was probably intended for a heroized dead man. A youth is shown riding a centaur, another a swan (pl. 79e,f,g).[48] Of some figures only the heads or upper portions are preserved[49]; a bearded one is perhaps Dionysos (pl. 78d)[50]; two represent women (pl. 78e,f),[51] one of whom is holding a child. A relief (pl. 79b),[52] once part of a small altar, shows Aphrodite being driven over the sea in a chariot, by two Erotes. A small mold (pl. 79c)[53] for the lower part of a male figure, evidently taken from a metal relief, shows the largeness of treatment characteristic of the best work of this period. On the back are the fingermarks of the potter, impressed while the clay was still soft.

A female bust (pl. 79d),[54] from Sardis, has much of its original polychromy preserved. She is represented with her hands brought to her breasts and was probably intended to be a goddess, presumably Aphrodite.

POTTERY

As no major paintings of this period have survived, we are again dependent on vase decorations to visualize the pictorial art. They reflect the spirit of the time. Something of the grandeur of the Parthenon sculptures appears in the simple compositions which now come into favor. The figures are drawn with a new freedom; they are no longer composites of separate formulas, but are realized as a whole, and the contours suggest the volume of the shapes enclosed. Three-quarter views no longer present difficulties. The rendering of the eye in profile becomes more natural, being more or less triangular in shape, with the iris hiding the inner corner. The hair has lost its former compactness. The garments are drawn in flowing lines which vary in direction, suggesting the round forms of the body underneath. As in the preceding period, thinned washes are occasionally used

for shadows in the folds to indicate depth, or alongside the anatomical markings to give plasticity to the figures. And, gradually, linear perspective, which had for some time occupied the minds of philosophers, penetrates the consciousness of the vase-painters. By the end of the century shrines, altars, furniture are drawn not always in front view, but with receding sides.

The color scheme in red-figure remains the same as before, but accessory colors —white and red (generally, it seems, on an undercoating of white)—become fairly frequent and, toward the end of the period, gilding on applied clay appears. Relief lines for the contours of the figures are often dispensed with.

The white-ground technique is restricted more and more to lekythoi used as offerings to the dead. The subjects accordingly deal chiefly with mourning and death. The figures are drawn in outline, first in glaze, later in dull paint, and solid washes are added on the garments; applied white, which in the preceding period was often used for women's flesh, occurs only occasionally.

The most prominent painters of this period represented in our collection are the Achilles Painter, the Mannheim Painter, Polygnotos, the Eretria Painter, Polion, and the Meidias Painter.

The work of the Achilles Painter reflects more, perhaps, than that of any other vase-painter the serene spirit of Periclean sculpture. Most of his pictures are on Nolan amphorae and lekythoi and consist of one or two figures doing the simple things of everyday life, but with a quiet poise that gives them distinction. In his early, formative years he learned much from the Berlin Painter; and he drew his forms in a rather summary manner. Among the examples of this phase is an interesting scene on a bell krater[55] of an old soldier and another man engaged in lively conversation (pl. 80a); the old warrior's face is drawn in a remarkably realistic way, with a hooked nose, strongly curving eyebrows, and wrinkles on the forehead and cheek. Other early examples show Eos pursuing Tithonos,[56] and a woman pouring a libation for Athena.[57] The mature style of the Achilles Painter is remarkably uniform. The same poses and motives occur again and again with but few variations. A woman pouring a libation for a departing soldier on a squat lekythos (pl. 80b),[58] and several lovely, quiet figures on white-ground lekythoi[59] are typical works. The subjects on the latter include a mistress waited on by her maid (pl. 83b), a woman and a youth about to clasp hands (pl. 83a); two women preparing to take offerings to a tomb; and a youth holding out a fruit to a woman (the youth's flesh is painted a light brown). The delicacy of the line drawing in these pictures is extraordinary.

Some followers and associates of the Achilles Painter were artists of high standing. A scene of Poseidon pursuing Amymone, on a tall lekythos (pl. 80f),[60] and a youth pursuing a woman, on a Nolan amphora,[61] are attractive works by the Phiale Painter. An impressive picture on a large bell krater is by the Persephone

Painter, who takes his name from this work (pl. 8oc).[62] Persephone is rising out of an opening in the ground, her hand raised in a gesture of surprise; her guide, Hermes, stands by her side, holding his herald's staff; Hekate lights the path with two torches, while Demeter awaits her daughter, scepter in hand. The picture suggests the miracle which the story symbolizes—the return of life to earth with the coming of spring.

A number of white-ground lekythoi have scenes by the Bosanquet Painter, the Thanatos Painter, and the Painter of Munich 2335; on one a mother is taking her child to Charon's boat (pl. 83d)[63]; the child stands on the bank, his toy cart at his side, waving farewell to his mother, who is wrapped in her himation; Charon stands expectantly at the prow of his boat. On another, given by the Julius Sachs Estate, two mourners are shown at a tomb (pl. 83c),[64] one pouring a libation on an altar; behind rises a high mound hung with red fillets. On a fragmentary lekythos evidently broken on the funeral pyre, Sleep and Death are seen carrying a dead youth (pl. 83h).[65] An Amazon throwing a stone with a sling,[66] by the Klügmann Painter, has well-preserved white pigment which was added on top of the flesh areas.

The Mannheim Painter is represented by one of his best extant works—three Amazons going into battle, on an oinochoe (pl. 8oe).[67] They are drawn in a formal style, with a fine sense for composition and movement. Their names are inscribed: *Penthesileia, Antiopeia, Iole.*

Musical scenes were popular at this time and several—on bell kraters—are in our collection. On one, by the Danae Painter, a woman is seen sitting on a chair playing the lyre, while two young women stand before her listening (pl. 8oi)[68]; on another, Orpheus is playing the lyre among the Thracians (pl. 82c)[69]; and on a third,[70] a man is playing a kithara to three listeners (pl. 8og). The last is by the vase-painter Polygnotos—a namesake of the famous mural-painter of Thasos. More distinguished pictures by that artist, on a large pelike,[71] show a king (inscribed *Polypeithes*) standing between two women, and—on the front of the vase—Perseus (inscribed *Perreu[s]*) cutting off the head of the sleeping Medusa in the presence of Athena (pl. 8oh). The Gorgon is not a terrifying monster, as she was in earlier days, but a beautiful woman, stretched out on the rocky hillside; Perseus has rays around his head (originally painted white or red), perhaps to mark him as a hero.

A tall neck-amphora (pl. 8od)[72] has a picture of a departing warrior named Neoptolemos. It is a masterpiece by the Lykaon Painter, a follower of Polygnotos. The washes of thinned glaze in the folds and in the grooves of the anatomical markings are characteristic of this group of painters.

Several paintings are especially interesting for their subjects. A remarkable one of the Lower World is on a calyx krater (pl. 82b)[73]: Herakles, who, with Hermes as escort, has gone down to Hades to fetch Kerberos, finds Perithous and Theseus,

condemned to punishment for their daring attempt to carry off Persephone; the scene continues with Elpenor, Ajax, and Palamedes, three heroes who died tragic deaths, and Persephone in her chamber. The story of Circe changing the companions of Odysseus into animals appears on a calyx krater (pl. 82a)[74] given by Amelia E. White. Odysseus has come to Circe's house to rescue his friends and draws his sword against the sorceress; in alarm the latter drops the cup in which she has prepared the poison. Another rare subject—Tydeus and Melanippos—is represented on a fragment of a bell krater.[75] According to the story, when Tydeus was lying at the point of death from a wound inflicted by Melanippos, Athena came to bring him immortality, but when she appeared, she saw him eating the brain from the severed head of Melanippos, and in horror and disgust withheld her gift. On the fragment we see Tydeus seated on a rock, leaning his head on one hand, and at his feet the head of Melanippos; in front of him are Athanasia, Immortality (her name is inscribed), and the goddess Athena. It is characteristic of Greek art that the most gruesome part of the story is not actually depicted. The Argive king Adrastos (his name is inscribed) is depicted driving a four-horse chariot on a small, pointed red-figured amphora (pl. 82i)[76] which was without doubt used as a vase for perfume.

A large volute krater (pl. 81a)[77] with deities, signed by the vase-painter Polion, and a volute krater on a stand (pl. 81b),[78] with a spirited Dionysiac scene, perhaps by the Coghill Painter, are also outstanding achievements in pottery. Another work by Polion, on a bell krater (pl. 81e),[79] has satyrs inscribed *odoi Panathenaia,* evidently costumed singers at the festival of the Panathenaia. Two horsemen by the Marlay Painter, on a column krater,[80] recall the riders of the Parthenon frieze. The same painter decorated two stemless cups[81] with symposia in a slovenly but vivid style.

The Eretria Painter is one of the most attractive artists of the period around 430 B.C. Most of his products are on the smaller vases. Three masterpieces by him are in our collection: a dainty picture of the Return of Hephaistos to Olympos (pl. 81c),[82] on an oinochoe of *chous* form (see below); a woman dressing, on a squat lekythos (pl. 81f)[83]; and, on a large squat lekythos (pl. 81d),[84] three representations —a fragmentary chariot scene, a lively battle of Greeks under Theseus and Amazons under Hippolyte (both in red-figure), and Patroklos, Achilles, and Nereids (in polychrome on a white ground). Some of the figures are identified by inscriptions. Patroklos is shown lying on a bier, covered with a cloth; his friend Achilles sits beside him with bowed head, both hands folded in his lap, while his mother Thetis and her Nereid sisters ride on dolphins across the sea to bring him the armor made by Hephaistos. The motion of the sea is suggested by the wavy outlines of the dolphins. The shields and the other objects in applied buff clay were originally gilded. Other pictures by this painter, on a kylix (pl. 81g)[85] and on two lekythoi

(pl. 81h),[86] are drawn with comparatively less care and serve as examples of his average output.

A scene by the Painter of London D 14, on a pyxis (pl. 83g),[87] shows six women in a house engaged in dressing, putting away their clothes, and playing with a pet bird. Their names are inscribed: *B . . ., Galene, Kymodoke, Akteie, Glauke,* and *Psamathe.* They are evidently Nereids, not ordinary Athenian women; but instead of riding the sea on dolphins, as in the other pictures, they are at home. A kantharos (pl. 82g)[88] in the form of heads of a satyr and a maenad has libation scenes for two departing warriors—dainty products by Aison, who signed a kylix in Madrid.

The Washing Painter, so called from his pictures of women washing, decorated several nuptial vases with wedding scenes, some of which are in our collection. On two the bride is depicted seated, playing the harp, while her friends approach with their presents (pl. 84a,b).[89] The three-cornered harp, the Greek *trigonon,* though less popular than the lyre or the kithara, enjoyed a vogue in the late fifth and the fourth century—to judge by vase representations.

The Shuvalow Painter decorated many small vases in a miniature style. Two typical works are in this Museum—two boys standing before an incense burner, on an oinochoe,[90] and two women with a casket, on a hydria.[91]

A jug of the *chous* shape (pl. 82f)[92] used during the festival of the Anthesteria in honor of Dionysos has an interesting subject. A man is coming home late from the festival (as we see from his wreath and lyre) and is pounding on the door with the butt end of his lighted torch. On the other side of the door is a woman with a lighted lamp. She has been roused by the noise and must let in her drunken husband. Her timid manner makes it probable that she is his wife rather than a hetaira. The rendering of the house shows an early attempt at linear perspective. The door, floor, and tiled roof are shown as slanting or receding into the background, but the parallel lines are not made to converge toward a common vanishing point.

The Meidias Painter, who decorated the famous hydria in London signed "Meidias made it," is one of the last great figures in Athenian vase-painting. He carried on the tradition of the Eretria Painter, but in a softer, more luxurious form. He is represented in our collection by two excellent works. One is a painting, on a large pelike (pl. 82d),[93] of Mousaios, with his wife Deiope and his son Eumolpos, making music in the presence of Aphrodite and the Muses. The other, on an oinochoe (pl. 82e),[94] shows women perfuming clothes in preparation for the feast of the Choes; it is inscribed *Ganyme[des] kalos.* Several other pictures, mostly on vases of small dimensions, illustrate the Meidian style, for that artist evidently had many followers.

A typical example, on a pyxis,[95] shows Aphrodite with her attendants, including a girl balancing a stick on her finger. A maenad riding a panther, a torch in each hand, and the Theban sphinx carrying off a boy appear on a vase with two plastic heads of a satyr and a maenad, back to back (pl. 82h).[96]

A number of diminutive jugs of *chous* form with scenes of children may also be connected with the Choes festival; for we know that children played a part in it. The subjects include a child crawling on all fours toward a jug (pl. 84f),[97] a child with his cart (pl. 84d),[98] a revel,[99] and children imitating the ceremonial wedding of Dionysos (pl. 84e).[100] In the latter the boys have placed the god (presumably one of their number) in a cart, with a canopy over his head; he stiffly holds his cup and thyrsos; an attendant motions the small bride to mount; three little fellows bring up the rear with a standard hung with fillets. As such small jugs have been found in children's graves, they may have served as toys—like the other diminutive vases in our collection, for instance, a hydria[101] with a girl holding a casket, and a loutrophoros or marriage vase (pl.84c)[102] with a scene of women bringing gifts to the bride. It is noteworthy that the children on these diminutive vases are often depicted, not as little grown-ups, but as real children with rounded forms. In sculpture such realism does not become the rule until much later, in the Hellenistic period (see p. 124).

Several white-ground lekythoi are late examples, datable in the last two decades of the fifth century. The lines are now always drawn in mat colors—red or black—and a large palette is often used for the colored washes—blue, purple, green, mauve, yellow, and different shades of red; applied white is discontinued. Our collection contains works by the Triglyph Painter,[103] the Carlsberg Painter,[104] the Quadrate Painter,[105] the Woman Painter or one of his associates (pl. 83f),[106] and a member of Group R (see pl. 83c).[107] A change in the representations is noticeable. The artists of the preceding period suggested the pathos of death subtly, by attitude and gesture; those of the late fifth century often show the sorrow of parting more directly. As before, the scenes generally consist of figures at a tomb and the dead are often represented sitting or standing by their graves, with one or two mourners bringing offerings; but the attitudes and expressions are no longer detached. Instead of resignation, actual grief is suggested by the restless poses and the sad, almost rebellious expressions. It was the time when the Peloponnesian War was drawing to a close and Athens' long struggle was ending in defeat.

Vases entirely covered with black glaze are very popular in the later part of the fifth and in the fourth century. Two Attic examples in our collection are a late fifth-century amphora (pl. 84h)[108] with a pointed, ribbed body, doubtless used as a perfume vase, and a skyphos (pl. 84g)[109] of delicate make with a reserved band at the base decorated with vertical lines. Cups of this type were popular during a fairly long period, from about 500 to 425 B.C.

A terracotta vase, said to have come from Rhodes (pl. 84i),[110] has as its only ornament two inscriptions, one on each side, in blackish glaze on the terracotta ground: "Zeus, Hermes, Artemis, Athena," and "the Brasian region is the fairest in the land, it seems to me." We know from other inscriptions that there was a "Brasian" region in Rhodes. The date is uncertain, but might well be in the late fifth century.

For South Italian vases of the second half of the fifth century, see page 116.

IV CENTURY B.C.

The Peloponnesian War had ended in the year 404 B.C. with the downfall of the Athenian Empire. Sparta had championed the Greek states in their fight for independence and had been successful. It soon became apparent, however, that she had done so only to humble her rival Athens and that she now regarded herself as in control of the former Athenian dependencies. The latter found that they had exchanged one master for another; and Spartan rule was much more offensive than the Athenian had been, for Spartan garrisons were placed in many of the cities and the democratic parties were deprived of their power. Moreover, Sparta did not even have the excuse of protecting the Aegean world from Persian aggression; for, in exchange for Persian recognition of her leadership, she abandoned the Greek cities of Asia Minor to Persia.

The power of Sparta was not long-lived. She was defeated by Thebes in the battle of Leuktra in 379 B.C., and the leadership of Greece passed to Thebes. But Thebes was no more successful, and when Epaminondas, the Theban general, was killed, in 362 B.C., she was no longer able to maintain her position. It was clear that the unification of Greece could not be evolved from within. Love of autonomy among the individual states was too great, their jealousy of each other too strong to make the formation of a United States of Greece possible. Constant strife had, moreover, weakened the country, and, when at last a formidable enemy from without appeared in the person of Philip of Macedon (359–336 B.C.), she could offer no effective resistance. A league of Greek states was formed under Philip's protection.

Happily, the Macedonians, though looked upon as "barbarians" by the Greeks, were a people of kindred stock to whom Greek civilization readily appealed. Macedonian suzerainty of Greece, therefore, was not entirely an overthrow of Greek civilization. When Philip's brilliant successor, Alexander the Great (336–323 B.C.), conquered the old Oriental kingdoms one by one and brought the whole of western Asia and Egypt under his sway, he spread Greek influence over a much vaster area than the most ambitious Greek could have thought possible. This extension of Hellenic culture far beyond the boundaries of Greece itself resulted in the "Hellenistic" age, which we shall consider in the next section.

The effect of these events on the outlook of the fourth century was profound. The ideal of the state, which had been fostered by the local independence of the city states, lost much of its force. Moreover, the teachings of poets and philosophers like Euripides, Sokrates, and the Sophists had tended to increase the interest in the individual. The change of outlook is reflected in the art of the time. Instead of the idealism and impersonality of the fifth century, we find a personal, individualistic element. This individualism is not yet marked, for the traditions of the Pheidian

period remained strong for a considerable time, but it is unmistakable. Art is on a different plane.

Whereas Pheidias and Polykleitos were the outstanding sculptors of the preceding period, Praxiteles, Skopas, and Lysippos dominate the fourth century. Their widespread influence can be seen in the graceful, lithe, sensitive figures which now come into favor. The works of the mural and panel painters—of the great Apelles, for instance—have all perished. The vase paintings of the time and the later Graeco-Roman wall paintings from Pompeii and Herculaneum can give us only a faint glimmer of those famous creations.

SCULPTURES IN STONE

The marble sculptures of this period in our collection consist of heads, fragmentary statues, and reliefs (the larger pieces are discussed in a separate chapter). A bust of a youth (pl. 85a)[1]—evidently part of a statue made into a bust—is related in style to Praxitelean works. It may be identified as an athlete from the swollen cartilage of the ears, the distinctive mark of the boxer. The rounded skull, the oval face, the forehead protruding in its lower half, and the dreamy, half-closed eyes recall the Hermes at Olympia and the athlete in the act of pouring oil, in the Glyptotek, Munich. The modeling shows considerable delicacy where the marble has not suffered from the cleaning with acid which it underwent at some time—on the forehead, for instance, and the graceful little curls crowning it. The head is evidently an excellent Roman copy of a Greek original.

A head of a youth (pl. 85c),[2] broken from a relief, recalls the works associated with Skopas, in the overhanging brow, the sketchy hair, and the deep-set eyes, turned slightly upward; but the shape of the head, though broad and short, is not so square as the Skopaic ones from Tegea. The modeling is fresh and spirited, and undoubtedly Greek.

A head of a young goddess (pl. 85b),[3] considerably larger than life size, was evidently made for insertion in a statue. It is a product of the late fourth century, combining dignity and simplicity with delicate charm. Its colossal size indicates that it represented a goddess, and its youthful character shows that a maiden, not a matron, was intended. The choice therefore appears to be between Persephone and Hygieia.

A head of a girl (pl. 84d),[4] the gift of James Loeb, must have been part of a relief, for there is a fracture at the back, and the left side is only roughly worked, indicating that it was to be seen in profile. A dreamy expression is imparted by the delicate modeling of the surface and the deep-set eyes, with the lower lid only slightly protruding. The head presumably came from an Attic grave monument. Another female head (pl. 85e)[5] broken from a statue, perhaps of Aphrodite, is a charming product of the Praxitelean school. The type is related to that of the Aphrodite Anadyomene. A head

of a woman (pl. 85f)[6] wearing a kerchief is a Roman copy of a Greek original—a gift of Francis Neilson; other copies of the same work are known. The upper part of a satyr (pl. 85g)[7] broken from a statue is a Roman copy of a work attributed to Praxiteles; it must have been famous, for many copies exist, some in good preservation. From them we learn that the satyr was in the act of pouring wine. Our fragment, though summary in execution, conveys some of the evanescent charm of Praxiteles's work.

Several attractive small marble heads were broken from statuettes and reliefs. One, with remains of a hand on the chin, perhaps represented a Muse (pl. 85h).[8] A head of a youth,[9] from Tarentum, may have been part of a metope. A head of another youth (pl. 85i),[10] with remains of a hand, was also broken from a relief. A small head (pl. 85j)[11] resembles the Hermes of Praxiteles; though the workmanship is sketchy, the artist has caught something of the charm of his master's style.

Several figures—Roman copies of Greek originals—show the treatment of the male body in this period. The earliest is a torso (pl. 86a)[12] with the weight resting lightly on the right leg. Another (pl. 86b)[13] recalls the work of Praxiteles in its easy attitude, rounded forms, and harmonious curve. A third (pl. 86c)[14] is in the pose of the Apollo Sauroktonos of Praxiteles but has wings at the back and so represents Eros. Another replica of this type was found at Baiae and is now in the Naples Museum. The Greek original may well have been by Praxiteles.

A statuette of a boxer (pl. 86d)[15] is a beautiful Greek original. The lively pose, with its graceful curves, and the soft play of light and shade on the surface give it great attraction. The modeling of the back is especially fine. That the youth was a boxer is indicated not only by the swollen ear but by the action, which we can reconstruct from the traces of the right hand on the left chest and of the left hand on the left ear. He was evidently pulling tight the straps that pass over the head, around the ears, and under the chin. A similar arrangement of straps can be seen on a head in the Capitoline Museum in Rome.

The nude female form became a special interest of Greek sculptors in the fourth century. It had, of course, been studied for a long time in figures only partly covered with drapery. But now completely nude statues became common, the delicate proportions and flowing lines of the female body appealing to the softened taste of the time. Praxiteles seems to have been a pioneer in this direction, and his Aphrodite of Knidos greatly influenced contemporary and later art. A number of large marble statuettes of Aphrodite—Roman copies and adaptations—are in our collection (for bronze examples, see below). All are more or less fragmentary. One, a gift of Francis Neilson, reproduces the Knidian Aphrodite, in which the left hand was held in front of the body (pl. 86h).[16] Another, a bequest of Mrs. Francis Neilson and said to have been found in Alexandria, shows a later type, in which a garment is loosely draped around the body and held in the left hand (pl. 86i).[17]

A third is of the well-known Aphrodite Anadyomene type, in which the goddess raises both hands to her hair, as if to arrange it or to wring out the water after the bath (pl. 86g).[18] A fourth shows Aphrodite bending down to loosen her sandal (pl. 86e).[19] We can reconstruct the original composition of this one from a terracotta in our collection (pl. 86f).[20] In our marble version an Eros must have been added, to judge by the traces preserved at the left breast. All of these graceful poses are familiar from many other examples and were evidently popular in the Roman period.

Two marble gravestones exemplify the form current in Attica at this time, consisting of a slab decorated in relief and framed by a pilaster on each side and a pediment or cornice above (see also p. 92). One of them (pl. 87b)[21] was erected, we learn from the inscription, to Sostratos, the son of Teisandros, of the deme of Paiania. He is shown in the act of scraping his body with a strigil to remove the dust and oil from his skin; a little boy is holding his master's garment and oil bottle. A certain solemnity is imparted to this simple scene by the dreamy expression of the youth and the wistful look of the boy. The cornice over the slab is decorated at each angle with a sphinx, and in the center with a mourning siren, beating her breast and tearing her hair. The execution is not highly finished. In the fourth century, gravestones were produced in Attica in large numbers, often for people who could not afford a costly work.

The second gravestone is decorated with a farewell scene—the commonest subject on these monuments (pl. 87g).[22] A young woman seated on a chair is clasping the hand of an older woman, who stands before her; between them is another woman carrying a casket. The seated woman is evidently the deceased; the woman holding her hand, with hair cut short as a sign of mourning, is perhaps her mother; and the one with the casket must be the maid. On the entablature above the relief the names Lysistrate and Panathenais are inscribed. We may note the skillful way in which the various planes of the relief have been handled and how the figures take their places in a somewhat crowded composition.

In addition to decorated slabs the Greeks used marble vases as grave monuments. A marble lekythos (pl. 87a)[23] in our collection has on its body a relief with a man and a woman clasping hands, and a seated woman holding out a bird to a little girl. The execution is delicate and careful. See also pages 138, 141.

A limestone relief (pl. 87c)[24] shows a young warrior and a woman standing by an altar. Their sad expressions denote them as mourners. In the background hang arms, a cuirass, a helmet, and a sword, presumably those of the dead warrior. It has been suggested that the two mourners represent Elektra and Orestes at the tomb of Agamemnon, in which case the scene would be symbolical; the helmet of *pilos* form, however, hardly seems appropriate for Agamemnon. The style recalls that of the group of Hermes, Thanatos, and Alkestis on the column from Ephesos in the Brit-

ish Museum, datable around the middle of the fourth century. Our relief is said to have been found at Tarentum, doubtless a correct statement, for the material is like the limestone of that region and a number of such reliefs have been found in the ancient cemeteries of Taranto and Lecce. Ours is one of the finest and most impressive so far discovered.

Several small marble reliefs are noteworthy. One of a youth on horseback (pl. 87e)[25] recalls that shown in plate 97 in subject and style but is probably somewhat earlier. A fragment with a pensive female figure sitting on a pillar (pl. 87f)[26] was broken from a larger composition with Aphrodite persuading Helen to join Paris, which exists in several other Roman copies. Our figure is Peitho, Persuasion. A relief of the river god Acheloos and Hermes escorting three nymphs is a freshly worked Greek original (pl. 87d).[27] A tiled roof with a pilaster on either side marks the locality as a shrine and an *omphalos*-like mound stands for the rustic altar. The inscription on the architrave reads "Sacred to Hermes and the nymphs and august Acheloos." On the under side of the stone is a rectangular tenon for attachment. Such votive reliefs with dedicatory inscriptions to rural divinities have been found in considerable numbers. Grottoes all over Greece were made sacred to the nymphs and springs.

A marble vase (pl. 87h)[28] from Athens is a rare piece, worked in two parts, the body shaped like that of a pyxis, the neck and mouth like those of an oinochoe.

ARCHITECTURE

A finely carved architectural fragment,[29] a gift of Philip Lydig, comes from the frieze which decorated the circular wall of the Tholos at Epidauros.

An Ionic capital and parts of a column[30] from the temple of Artemis at Sardis (middle of the fourth century) is one of the most beautiful examples of Greek architectural carving that have been preserved. The decorative members—the egg-and-dart on the abacus, the palmettes and leaves of the echinus, the graceful scrolls and deep channels of the volutes, and the leaves on the bolster—are freshly and precisely carved. The temple, one of the largest known, was octastyle and pseudo-dipteral, with three columns in front of the antae—a unique feature. Two entire columns are still standing (there were six until about 1750), rising to a height of over 56 feet, including the plinths, and thirteen more exist in truncated form. All are from the east end of the temple. The column from which our capital is derived 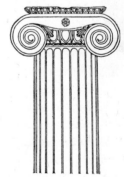 is one of two that stood on each side of the main axis in the colonnade of the porch. They were the only two completed ones; all the others have unfluted shafts and unfinished bases. The shaft and torus combined with our capital are not necessarily

from the same column, but have been added—with the missing portions restored in plaster—to give an idea of the whole composition. The capital was found by Howard Crosby Butler and his associates and presented by the Turkish Government to the American Society for the Excavation of Sardis in recognition of his work, and that Society gave it to the Museum.

SCULPTURES AND UTENSILS IN BRONZE

A large bronze statuette (pl. 88a)[31] of Aphrodite—represented, perhaps, as lifting a necklace to put it around her neck—is a distinguished Greek original. The modeling is extraordinarily subtle; the lovely curves of the girlish figure, the soft flesh, the gentle expression are sensitively rendered. The statuette is a gift of Mr. and Mrs. Francis Neilson; it once belonged to the French sculptor Paul Dubois and, after his death, to Charles Haviland, the well-known china-maker of Limoges. In the Providence Museum is a similar, though not identical, statuette, probably of Roman date.

Another large bronze statuette (pl. 88b),[32] also of Aphrodite, is a good Roman work, inspired by Praxiteles's Aphrodite of Knidos. A smaller statuette, also of Roman date, is an adaptation of the same famous work.

A bronze statuette of an athlete (pl. 88d)[33] in a rhythmic pose is an outstanding Greek original. The action was probably that of a *diadoumenos;* in his right hand he held the short end of the fillet, while he wound the long end around his head with the left. The depression made by the fillet in the hair is clearly marked, especially at the back, and in the front is a hole for fastening it. The proportions of the slim body, the long legs, and the small head suggest the influence of Lysippos.

Another beautifully worked statuette (pl. 88c)[34] represents a bearded man standing with his right arm raised. The attributes are missing, but the general type is that of Poseidon. Originally he probably held a trident in one hand and perhaps a dolphin in the other.

A bronze hydria (pl. 90a)[35] is a distinguished piece, comparable in quality to the two fifth-century examples described in preceding chapters (see pp. 82, 95). The shape is that prevalent in the fourth century—with high neck, flaring mouth, elongated body, strongly curving handles, and foot forming an ogee curve (compare the terracotta hydria (pl. 95a). The relief under the handle (pl. 90c) is a sculptural work of importance, assignable to the second half of the fourth century. A winged Eros is represented arranging his hair; he holds a mirror and leans against a small female statue of archaistic style. The hydria belongs to a well-known class which is often referred to as East Greek, since several examples have been found in Asia Minor and the near-by islands; other specimens, however, come from Greece proper; ours, for instance, is said to be from Eretria, and a relief in our collection which evidently came from a similar hydria was found in Akarnania (see p. 111,

pl. 90b). The subjects of the reliefs generally refer to love (Eros, Eros and "Psyche," Dionysos and Ariadne, Boreas and Oreithyia) and it is possible that these precious water jars were given as wedding presents. Some have been found with ashes and bones inside them and so ultimately served as urns for the dead.

—In the preceding chapter we described bronze mirrors with covers ornamented with repoussé reliefs and, occasionally, with engraved scenes. Fine examples belonging to the fourth century are included in our collection. One has a relief of two Pans engaged in a quarrel, with Eros intervening (pl. 89c).[36] One Pan has seized the other by the arm and is pulling him away; Eros, who has apparently just arrived on the scene, is about to strike a blow at the remonstrant. The locality is indicated as a mountain side by the rocky ground and the flowering plants. The thick-set bodies of the Pans and their coarse-featured faces form an effective contrast with the slender figure of Eros; the physical exertion and intentness of all three are well rendered.

Another mirror (pl. 89b)[37] is decorated with a relief of Marsyas and the Scythian slave who flayed him alive as a punishment for his presumption in challenging Apollo to a musical contest. Marsyas is shown seated on a rock covered by a lion's skin, and playing the double flute; he has the usual snub nose and animal's ears. The Scythian wears long trousers and a pointed leather cap. The reliefs of two other mirrors—both said to have been found in Akarnania (see p. 110)—represent Dionysos and Ariadne (pl. 89a),[38] and a female head in profile (pl. 89d).[39] That of a third shows Aphrodite seated on a rock, and Eros holding a large cornucopia (pl. 89f).[40] A relief which originally belonged to a mirror also represents Aphrodite sitting on a rock, with two Erotes (pl. 89e).[41] A delicately engraved toilet scene appears on the under side of a mirror cover (pl. 91e),[42] given by J. Pierpont Morgan. Two women are sitting opposite each other; one is doing her hair, while the other holds up a mirror for her. The lines of the garments and the hair and all of the details are engraved with great freedom. As is often the case in mirrors of this type, the figures were silvered. The relief that decorated the outer side of the cover is missing.

Several small bronze reliefs once formed parts of utensils. We have already referred to the relief (pl. 90b)[43] that probably decorated a hydria (see p. 110). On it Eros is represented standing in an easy, graceful pose, with a jug in one hand and a bowl in the other. A Nereid riding a sea goat is an attractive ornament (pl. 91d)[44] from another object. Two bronze plaques (see pl. 91c),[45] perhaps from a vase, have effective palmette motives. Two disks (pl. 91a, b)[46] with heads of satyrs in relief, found at Elis, must once have belonged to a bridle, for three disks now in the British Museum are said to have been found with them, and a bridle, found at Alexandropol in South Russia, has five similar disks, at the four points where the side straps crossed and on the front of the head, indicating that bridles were decorated with five such disks. The date can hardly be earlier than the late fourth century.

A bronze jug (pl. 91h)[47] is decorated with a beautiful *à jour* relief—an inverted anthemion rising from akanthos leaves. Two bronze helmets show the form prevalent in this period. One (pl. 91g)[48] is of conical shape, resembling a pilos or felt cap (compare the one in the limestone relief); the other (pl. 91f)[49] is a late version of the Attic type with a small, shapely nosepiece and cheekpieces in the form of rams' heads.

TANAGRA STATUETTES AND OTHER TERRACOTTAS

The changes inspired by the individualism of the fourth century are reflected in the terracotta statuettes generally called Tanagras, after the cemetery at Tanagra in Boeotia where they were first found. The lofty remoteness of the fifth century has given way to a purely human charm. The figures are not divinities whose sublimity evokes worship. The women, youths, and children portrayed are as human as ourselves; and it is probably this quality that has made them so popular today. They require no complicated explanation; what story they have to tell they can tell themselves, for they represent the people of their time as they might have been seen any day, but transformed into works of art by their exquisite grace.

Our collection includes many excellent examples, assignable to the fourth century and the first half of the third. The most successful are the figures of women and girls. They stand in restful poses, sometimes leaning against a pillar, occasionally walking or sitting, but always quiet and serene. Only rarely are they portrayed in a definite action, such as doing their hair (pl. 92g),[50] sitting by a tombstone,[51] or playing games (pl. 92b, e, i).[52] The garments consist of a tunic (chiton) and a mantle (himation), generally wrapped completely around their bodies and arms. Some wear a pointed hat, or a hood formed by pulling up the mantle. Leaf-shaped fans are popular, and baskets, tambourines, and other objects sometimes appear. There is little individual interest; but it may be said without exaggeration that womanly gentleness and grace have never been expressed more simply and more truly than by the artists who made these clay figures. The children are equally charming, and among them we must include the little Erotes, with their merry, mischievous faces, for there is nothing godlike in their conception; they are like human children except for their wings. Occasionally an old nurse is represented holding a child (see pl. 92h).[53] The youths are not so common, and as a rule, less successful; but some, in statuesque poses (pl. 92d),[54] were evidently inspired by contemporary sculptures.

One of the most attractive of our examples (pl. 92a),[55] a gift of Mrs. Sadie Adler May, represents a woman wearing a ring on her left index finger; originally she held a fan in that hand. Several others of high quality—among them a woman with a child (pl. 92c)[56] and a woman holding a fan and a wreath (pl. 92b)[57]—were presented by J. Pierpont Morgan in 1917.

Fourteen actors (see pl. 93a–f),[58] said to have been found together in a tomb in

Greece, form an unusual group. The figures show a great variety of types and poses, but all have the conventional insignia of the comic actor, the mask, generally bearded, and the protruding stomach. The men wear trousers, a short chiton, sometimes made of an animal's skin, and, occasionally, a mantle and cap; the women (whose parts were taken by men according to the Greek custom, and who are clearly recognizable as such in our statuettes) wear long tunics and mantles. A few of the figures are identifiable as specific characters; for instance, a ludicrous Herakles with his finger in his mouth, an old nurse and a baby, a weeping man, and a slave. There seem to be two sets in the group, distinguishable by the the color of the terracotta, one pink, the other yellow. The types have been identified as belonging to the Middle Comedy and dated about 380–330 B.C. Whether such figures were used by children as puppets, like the *burattini* in Italy, or whether they were votive offerings, placed, perhaps in a playgoer's or an actor's grave, we have no means of knowing.

Occasionally, instead of single figures, groups are represented in relief. An excellent example, said to be from Tanagra, shows a youth and a girl in an arbor with Eros hovering over them (pl. 93h).[59]

To appreciate the original appearance of Greek terracottas we must remember that they were painted and that instead of their present often drab surface they had a varied color scheme. On a few the original tempera (unfired) colors—applied on a (fired) white engobe—are fairly well preserved. The predominating colors were blue, yellow, and different shades of red; mauve was also common, and gilt was used for accessories. A few of the statuettes are modeled and therefore solid, but the majority were made in molds and are hollow. The vent hole at the back allowed the moisture in the clay to evaporate in the firing. The rectangular stand, generally made in a separate piece and attached before firing, is often missing.

It has been said of the Tanagra figures that they are all sisters, but few of them are twins. And this is true. Considering that they were mostly made in molds, it would be natural, from our point of view, to reproduce the same types over and over again. But the love of diversity, so characteristic of the Greeks, prevented such mechanical production. Though the same mold was used many times, variety was achieved by attaching the arms in different ways, changing the pose of the head, adding different attributes, painting them different colors, and by retouching. These slight differences introduce a fresh element and save the statuettes from ever being monotonous.

What, we may ask, was the purpose of these little figures? Were they used merely as bric-à-brac, had they a religious significance, or did they play a part in funeral ceremonies? We must admit that we do not know. The majority have been found in tombs; but whether they were placed there because they were familiar household articles, or for a religious or sepulchral purpose, is difficult to say. That they were, at least in the majority of cases, purely *genre* figures, without any mythological import,

seems to be an obvious conclusion from the general character of the representations.

A word must be said about modern forgeries of Tanagra statuettes, which are prevalent in many private and even public collections. When the Tanagra figures were first found, in the seventies of the last century, they became popular immediately. As the supply was soon less than the widespread demand, a flourishing industry of forgeries grew up, which deceived even experts for a considerable time, until the truth came out. The Museum has a large collection of such forgeries, acquired in the last century. There is no better way to appreciate the simple beauty of the Greek statuettes than to compare them with such modern imitations. Even when the latter copy the ancient figures fairly closely, a certain affectation and sentimentality betray their non-Greek character.

Terracotta was used for many purposes in ancient times, for instance, for antefixes on the roofs of buildings, to mask the ends of tiles. Two terracotta heads in relief from Tarentum once ornamented such antefixes. One (pl. 93g),[60] with a cow's ears and horns, represents Io; another (pl. 93i),[61] Herakles wearing the lion's skin over his head.

POTTERY

The Peloponnesian War and its disastrous ending had seriously crippled the export of Athenian vases. Though Athens retained a few of her markets in Italy for a decade or two, the local South Italian wares presently took the place of the Athenian (see pp. 116 f.). For a while Athens continued to send her red-figured pots to South Russia and elsewhere in the eastern Mediterranean, but by about 320 B.C. their manufacture practically stopped; apparently only Panathenaic amphorae continued to be made for several generations.

During the first quarter of the fourth century the Attic vase painters developed the styles of the preceding period; and naturally some of the artists who were active at the end of the fifth century also worked in the early fourth. A florid and a somewhat plainer style flourished side by side.

The decline in popularity of Athenian vases is seen in the comparatively sparse representation in this Museum. Three amphorae, said to have been found in one tomb at Suessula, near Naples, belong to the turn of the century; two (pl. 94a,b)[62] have battle scenes, on the third (pl. 94c)[63] is a soldier leaving home. The copious additions of white and yellow, the richly ornamented garments, the uneven thickness of the lines show the so-called ornate style of the period. Violent foreshortenings and three-quarter views, which fifty and sixty years ago were boldly but unsuccessfully attempted, are now convincingly rendered. A fragment of a volute krater with a combat of Lapiths and centaurs in the same ornate style belongs to the early fourth century. Several small lekythoi[64] of about 400 B.C. and a little later have their applied colors fairly well preserved. The subjects relate to Aphrodite and

Eros; on one an omphalos-shaped object appears (pl. 94h).[65] The plainer style is illustrated by several interesting pictures—Herakles in the garden of the Hesperides on a pelike (pl. 94d),[66] Poseidon greeting a youth, who may be Theseus or Pelops, and a woman burning incense on an altar, on two small hydriai.[67]

By about 370 B.C. the Kerch style—so-called after the place in South Russia where many of them were found—was evolved. It represents the last phase of Athenian vase painting. Instead of delicate curves and strongly marked contours many short, very thin lines are used to indicate the actual structure of the folds and the plastic shape of the bodies. The subjects are largely taken from the life of women, but mythological and cult scenes are also common. White, pink, and gold leaf, and occasionally blue and green, are added to enrich the red-and-black scheme. Inscriptions, so frequent in the early days, and popular also in the late fifth century, occur only rarely. The vases are slenderer, more elongated than before, with a tendency to ogee curves. An oinochoe (pl. 94e)[68] in our collection has an interesting scene beautifully executed. A woman, identified by an inscription as Pompe, "Procession," is turning toward Dionysos, who is sitting on a chair (*klismos*); on the ground is a processional basket in applied, gilded clay, and beside it Eros is tying his sandal. The occasion is evidently a Dionysiac festival. The scene is drawn with very fine lines and with copious additions of white, pink, and gold. Another processional basket, also rendered in applied clay and gilded, is on a skyphos (pl. 94g)[69] of about the same period; a seated woman holds it on her lap. As a satyr is present, the subject presumably is also the preparation for a procession at a Dionysiac festival. A hydria with Herakles and the Hesperides (pl. 95a)[70] is exceptionally well preserved. The tree with the apples and the serpent occupy the center of the scene; Herakles stands at one side, leaning on his club; the other figures represent Hesperides, perhaps Iolaos, Pan, and a satyr; on the ground is an omphalos-shaped object. A fragmentary, squat lekythos[71] has a cult scene representing the celebration of Adonia. Other subjects include Arimasps fighting griffins, on a pelike (pl. 95b)[72]; Poseidon and Amymone, on a hydria[73]; Greeks fighting Amazons, on a pelike (pl. 95c)[74]; Dionysos and Ariadne, on an oinochoe.[75] A beautifully preserved hydria,[76] said to be from Kerch, has a wreath of vine leaves applied in clay, and gilded.

Several vases from the end of the fifth century and later can be identified as Boeotian. On a skyphos (pl. 94i)[77] is a lively scene, painted in black glaze without incisions, perhaps a caricature of the story of Herakles, Eurystheus, and the Erymanthian boar. On an oinochoe is an attractive picture, in the same technique, of two youths, one reaching for a lyre, the other with a flute.[78] A bell krater (pl. 94f)[79] is ornamented with the head of a woman (a favorite decoration on these vases) and a palmette, both in red-figure. Another bell krater[80] has a woman before a wash basin and a hippocampus. On a small calyx krater,[81] all over black-glazed, are stamped palmettes.

In the last decades of the fourth century vases with applied reliefs had a short vogue. Several examples of such vases are included in our collection. The scenes are applied in red clay—in barbotine or appliqué technique—against the black-glaze background, and painted in tempera over a white engobe. Telephos at Argos is represented on a squat lekythos (pl. 95d).[82] He has taken refuge on the altar and grasps the child Orestes, threatening to kill him with his dagger; a woman, perhaps Klytaimestra, extends both arms to the frightened child. On a small oinochoe (pl. 95f)[83] is an attractive scene of Aphrodite and her retinue; she is sitting on a rock, with a dove on her shoulder, and extends one arm to a little Eros, who is about to fly toward her, assisted by a young, shaggy Pan; the Eros is evidently a baby learning to fly; two older Erotes are behind Aphrodite. It is a pretty scene in the intimate, playful vein of the late fourth century. Considerable traces of the original colors remain—white engobe, gilding on the figures and the tree, and blue on the rocky ground.

A few vases have bodies in the form of statuettes. One represents an Eros holding an incense burner (pl. 95g)[84]; another a sphinx (pl. 95h).[85] On still another, said to be from Athens, Boreas, the North Wind, is carrying off the king's daughter Oreithyia (pl. 95i)[86]; on a diminutive one the infant Dionysos is sitting in an arbor (pl. 95e).[87]

In addition to these Athenian and Boeotian vases the Museum has an extensive collection of red-figured South Italian ones, made by Greeks in Italy—the earliest perhaps by Athenian immigrants, for the style is often close to the Attic. They range from the second half of the fifth through the fourth century B.C. Among the earlier examples (about 440–380 B.C.) are one by the Pisticci Painter,[88] several by the Amykos Painter (see pl. 96a),[89] and one by the Tarporley Painter with a scene from a comedy of a thief being tried for a theft (pl. 96b).[90] A fragment of a bell krater shows an actor in front of a building, by the Dolon Painter.[91] A large bell krater by the Sarpedon Painter has on one side the apotheosis of Sarpedon or Memnon (pl. 96c),[92] on the other perhaps Thetis's visit to Hephaistos. A lekythos, a little later in date than the others, has an attractive picture of a girl in a swing.[93] Two fragments of a calyx krater[94] are examples of an interesting technique with polychrome decoration on black glaze and with figures incised in the black glaze. They may be regarded as the precursors of Gnathian ware.

Of special interest for its subject is a scene, on a column krater, of an artist painting a statue of Herakles in encaustic (pl. 96e).[98] He holds the instrument in his right hand, a small bowl in his left, and is evidently engaged in painting the mane of the lion's skin that hangs from the left arm of the hero. The figure itself is painted white, so it must be intended for a marble statue. Herakles himself, not nearly so heroic a figure as his statue, is standing by watching the process. There is of course plentiful evidence, both literary and archaeological, that Greek statues were colored

(see p. 5). The scene on our krater gives valuable evidence of this practice in actu-
ally representing the process. The date is early in the fourth century, not far removed
from the time of Praxiteles, who, according to Pliny, valued most those of his statues
to which Nikias, the painter, had put his hand. Our piece may be attributed to the
Ariadne Painter, an artist distinguished by his choice of unusual subjects.

South Italian vases from about 380 B.C. may be divided into four main categories—
Apulian, Lucanian, Campanian, and Paestan. The Apulian are by far the most
numerous. They show a great variety of shapes. On the smaller vases the popular
subjects are: exchange of gifts between lovers, funerary scenes, single figures of Eros
and Nike, and female heads. On the larger vases mythological subjects and theat-
rical representations are favored. The most representative pieces in our collection
are two vases of large size, one an amphora with a picture of the dispute of Per-
sephone and Aphrodite about Adonis,[95] the other a hydria with a scene of Hades
carrying off Persephone (pl. 96f).[96] Another noteworthy piece is a nuptial vase
with a bride and groom attended by Erotes and companions, as the principal scene
(pl. 96d).[97]

The Lucanian ware is characterized by a comparatively simple, somewhat clumsy
style, and restraint in the use of accessory colors. It flourished under the Choephoroi
and Primato Painters during the middle and third quarter of the fourth century,
lapsing thereafter into something that may best be described as barbaric. Of this
ware there is a four-handled vase (nestoris)[99] in our collection and warriors in
Lucanian costume may be found on two column kraters,[100] one with a scene of the
departure of two warriors, the other with youths and a woman.

The Campanian ware is characterized by crowded compositions, with a profusion
of ornaments. The favorite shapes are the hydria, the neck-amphora—sometimes
with a handle across the mouth—the skyphos, the bell krater, and the "fish plate."
There are several tendencies observable in the style of the representations. One,
Apulianizing, is seen on a large hydria (pl. 96g),[101] and on a large "bail amphora."[102]
The principal scenes consist of mourners bringing offerings to a tomb; the latter is
in the form of a shrine with a representation of the deceased, similar to contem-
porary marble tombstones. Other vases show brilliant coloring with copious washes
of yellow, white, and various shades of red. A hydria with the departure of a
warrior[103] is a typical example.

Closely related to Campanian wares is the fabric of Paestum, interesting because
we know its two chief artists, Asteas and Python, by name from their signatures.
They established a substantial workshop which flourished during the third quarter
of the fourth century and from which over three hundred vases have survived.
Their work is characterized by the frequency of Dionysiac and theatrical repre-
sentations, including a number of *phlyax* plays, and particularly by the use of
upright palmettes to serve as a frame for the pictures. Their followers, like their

contemporaries in Campania, soon lapsed into barbarism, and the fabric dies out very early in the third century. No examples are as yet in the Museum.

Generally speaking, these fourth-century Graeco-Italian vases present an increasing divergence from the Athenian. The black glaze is more metallic and has not the same rich, velvety quality; the shapes lack precision; and the drawing is more florid. In the better examples the subjects are frequently of considerable interest as representing rare myths or scenes from lost tragedies; there is often a pleasing sense of movement and life and the elaborate shapes give an impression of splendor; but the average output is of poor workmanship.

GLASS

A number of glass ointment jugs of the hand-modeled type belong to this epoch. The technique is the same as in the earlier examples (see p. 76), but the shapes and decorations have changed. The necks of the alabastra are now somewhat longer than before and the handles are mere eyelets without the lower attachments; fern patterns are particularly common. The majority of our specimens come from the Gréau collection.[104]

HELLENISTIC PERIOD

LATE IV—EARLY I CENTURY B.C.

Through the conquests of Alexander the Great and the foundation of Greek cities over a large area Hellenic culture had been extended far beyond the confines of Greece. Greek history is henceforth bound up with that of the Hellenized—or Hellenistic—world which Greece had created. This new world she was unable to control politically. After Alexander's death (323 B.C.) there ensued a long struggle among the Macedonian generals who succeeded to his empire. Three separate kingdoms, Macedonia, Syria, and Egypt, were finally established, and in Greece proper a number of leagues of cities were formed, among them the Achaean and the Aetolian. It was not long, however, before quarrels arose among these also. Finally Rome, which had steadily risen in importance, conquered both Greece and Asia and became the controlling power in the Mediterranean.

Even though politically Greece had been unable to become a unified nation her civilization conquered the world. Under the Seleucids, Attalids, and Ptolemies new centers of Greek art and learning arose in Syria, Asia Minor, and Egypt. Rome herself eagerly adopted Greek culture and modeled her literature and art largely on those of Greece. Through this extension in all directions Greek art acquired a new lease on life. Its character, however, changed. The aim of the artist was no longer idealism or pure beauty but a closer adherence to nature, which showed itself in more detailed modeling and in a larger variety of subjects. Old age, childhood, and even deformity, were studied with new insight, and individualistic portraiture received a fresh impetus. Here and there, however, and especially in Greece proper, the old idealistic tendencies remained. Moreover, though in conception the works of this period do not reach the former lofty standards, they often exhibit great vigor and skill. Their vitality is shown in their independence. Though the types were often borrowed from earlier works, they were transformed and given new aspects.

Hellenistic art had a paramount influence on the art of subsequent periods. It dominated the Roman world and was adopted throughout all its vast domains. The term Roman is, in fact, merely a political term used to distinguish the art that was produced after the establishment of the Roman conquest from what preceded it. The artists who worked under Roman rule were mostly Greeks who carried on the Greek tradition, whether they lived in Asia Minor, Greece, Africa, or Italy. Works of the Hellenistic period, as well as those of the fifth and fourth centuries B.C., were either copied mechanically or adapted to form new compositions. Gradually this "Graeco-Roman" art was changed first into what we call Roman art—that is, Roman in content and form—and then into Early Christian, Coptic, Sasanian, etc. Though

Byzantine art is something seemingly new, its types too go back, in large part, to the Graeco-Roman. After the Middle Ages the Graeco-Roman tradition in its secular form was revived and developed by the artists of the Renaissance, who handed it down to our modern world. Only comparatively recently has earlier Greek art become familiar through excavations, more extended travel, and a new appreciation of simpler forms.

In this chapter we shall discuss the Hellenistic objects in our collection that are essentially Greek in style and content. Some are certainly of late Greek workmanship, others were copied in Roman times from Hellenistic originals. Those pieces in which the subject and conception are Roman are placed in the Roman section as illustrating Roman art—a Lar, for instance, or a Camillus, a portrait of a Roman individual, a Zeus copied from the Jupiter Capitolinus, a painting from a Roman villa, a stucco or terracotta relief from Roman times. Even here, however, the style is often directly derived from late Greek art and should be studied in conjunction with the material in our Hellenistic section.

The different trends in Hellenistic art are well exemplified in our collection. The smaller works are described in this chapter, the larger pieces in the next (see p. 149).

SCULPTURES IN STONE

A marble relief of a young horseman is one of the most attractive objects in our collection (pl. 97).[1] He holds a staff, or part of a spear (continued in paint), in his left hand, which also held the reins (originally painted), and with his right is caressing the horse's head as if to calm it. The spirited bearing of the animal and the firm, easy seat of the rider remind us of the horsemen on the Parthenon frieze, but the detailed modeling of the body and the individualism of the face place the relief not earlier than the latter part of the fourth century. There was originally a second rider on the missing left portion, as is shown by the presence of such a figure on two similar reliefs in the Barracco Museum in Rome and the Medinaceli collection in Madrid. Our example is superior in execution to the other two, but, like them, it is probably also a Roman copy rather than the Greek original from which the two other reliefs were copied.

A fragmentary relief (pl. 99e)[2] shows a youth sitting backward on a horse, one leg extended, the other bent under. The tension of the muscles indicates that he is fighting an assailant, presumably the centaur on whose back he is perched. Probably, therefore, the fragment was part of a frieze representing the battle of Lapiths and centaurs. A somewhat similar group occurs in the frieze of that subject from Phigaleia, in the British Museum (no. 528). Whereas there, however, the modeling is in the patterned style of the fifth century, the realistic, fluid carving of our piece suggests Greek work of the third to second century B.C. The provenience is said to be Athens.

A tendency toward pictorial effects in sculpture, which began in the Hellenistic period and became popular in the Roman, is illustrated in a charming relief (pl. 101c),[3] a fragment of a larger composition. A flying Eros, with a fringed, long-poled parasol, is shown against a high wall on which two shields are hung; in the foreground is a little shrine with an image of Priapos; a tall vase is displayed within arches; a cloak hangs over the buttress.

Several heads, broken from statues, continue the idealistic style of the fourth century. Indeed the only criterion for the later date is the lack of definition in the modeling and the greater softness in the general effect. One female head (pl. 98b)[4] of Praxitelean style, of the late fourth or the third century, is said to have been found in Rome. It is unfortunately in a mutilated condition and the back, which was worked separately, is missing. Another female head (pl. 98c),[5] also from Rome, was evidently not intended to be seen from behind, as it is only roughly worked at the back, and there is a large dowel hole, perhaps for fastening it to a niche. A bearded head (pl. 98d)[6] may have represented Zeus. Here too the back was made in a separate piece, probably in stucco, as was often done in Alexandria.

A number of heads, of the same idealistic style, were broken from statuettes. One, delicately carved and with gentle expression, has a quadrangular hole at the top in which a separately carved piece must have been inserted (pl. 98a).[7] The limestone head of a youth with a dreamy expression (pl. 98f),[8] said to be from Tarentum, is Praxitelean in style. In the same class are the marble head of a woman[9] wearing a headband; a small head of Aphrodite[10] said to be from Alexandria; and two heads of children, one characterized as Dionysos (pl. 98e),[11] the other perhaps representing an Eros.[12]

Other marble heads, also evidently broken from statuettes, show the new realistic trend. The modeling is now more restless than before, with a multitude of different planes, and the types are individualized. A barbarian (pl. 99c)[13] with deep-set, expressive eyes, and a sensitively modeled female Pan (pl. 99d),[14] with head thrown back and eyes half closed in ecstasy, are among the most attractive. A bearded male head with bushy hair can be identified as a satyr (pl. 99b)[15] by his pointed ears; a small head of square build[16] probably represents an athlete. The statuette of a man[17] with a long beard and protruding paunch may have been intended for a philosopher; it and a grotesque head[18] show the popularity of caricatures in this period. A marble head of an old woman (pl. 99a)[19] comes from a statue similar to the old market woman (see p. 143), but it is smaller in scale and probably a Roman copy rather than a Greek original, for the execution is hard.

The realism of the new age is reflected in its portraits, the forerunners of those of Republican Rome. The individual is studied with a new sympathy and penetration, but always with a certain idealizing tendency. Some of the finest portraits of the period may be seen on Hellenistic coins, which bring before us in Greek originals

(see p. 154) the traits of contemporary rulers. Several stone examples in our collection are Roman copies of famous Greek works. (A few belong to the fourth century.)

A head of Epikouros (pl. 100b),[20] the founder of the Epicurean philosophy, is perhaps the best of his numerous portraits that have been preserved and probably goes back to an original executed soon after his death in 270 B.C. He is shown in advanced age and bears signs of the long physical suffering which we are told he underwent in later life. The head is characteristic of the Greek conception of portraiture. It is individualized to represent the features of a certain person, but it could serve to typify a man of thought and intellect. Though the philosophy of Epikouros was founded on the belief that happiness is the chief end of man, this happiness he conceived as meaning the peace of mind attained by independence of physical conditions, not the sensualism practiced by some of his later followers. And this ideal is well brought out in our portrait.

The head of a bearded old man (pl. 100a)[21] with hollow cheeks and sunken eyes is another portrait in the late Greek manner. The individual traits are faithfully rendered, but beyond the individual we are made to see the Greek thinker and philosopher. The head bears some resemblance to the type identified by Studniczka as Aristotle (384–322 B.C.), but there are also important differences: in our head the forehead is less high, the skull shorter and narrower, the mouth smaller, and the eyes closer together. Moreover it represents a man at least seventy years old, whereas Aristotle was sixty-two when he died.

The head of an Egyptian or Libyan princess (pl. 100c)[22] with generalized features is a Roman copy of what must have been a Greek work of considerable note, since there are other copies in Florence, Paris, Budapest, and Venice. Our example was in the Giustiniani collection in Rome. The hair is arranged in a highly decorative manner.

Another head[23] from the Giustiniani collection, also a Roman copy, represents a youth wearing a fillet. The style recalls the Lysippian school, but the individualistic cast of the features suggests that a portrait was intended. The fillet would then presumably be the diadem of a Hellenistic ruler. Otherwise we must interpret the head as an athlete with the badge of victory.

The head of a helmeted Greek general (pl. 100d),[24] a little over life size, was evidently made for insertion in a statue. As there are other copies of the type—in the National Museum of the Terme and in the Vatican—the man must have been famous. The style points to the fourth century. The helmet is decorated with reliefs of griffins on the crown and rams' heads on the cheekpieces; the eyes are hollow and were inlaid in a different material; the missing end of the nose was once attached with an iron dowel; the hole at the top of the helmet served for inserting a crest.

The "basalt" (diabase) head of a man (pl. 101a)[25] is probably a late Hellenistic

work. He is shown as a man full of energy and force but of a rather somber tempera-
ment. The delicate modeling of the lower part of the face, with its sensitive treat-
ment of the fleshy surfaces, is especially noteworthy if we consider the difficulty of
working so hard a stone as diabase.

Several of these heads may have been broken from statues; for the custom of
erecting portrait statues—begun in the fifth century—was common also in the Hel-
lenistic period (see p. 143). A portrait statue, about half life size, of a seated, draped
man (pl. 101d)[26] is a characteristic example. Four other replicas are known—in the
British Museum, the Barracco Museum, the Vatican, and the Albertinum. As the
head is missing in our example we have supplied it with a plaster cast from the
practically complete bronze figure in London, which is about the same size as ours.
From this bronze we also learn that the right hand was brought up to the face and
that the sandaled feet were crossed. The quiet composure of the figure is suited to
the calm physiognomy of the face. The few significant folds of the mantle bring
out the forms of the body. The identity of the person is not known. The philosophers
Aristippos and Zenon have been suggested.

A head, approximately half life size (pl. 101b),[27] must have belonged to a
similar seated statue and can be identified as the philosopher Chrysippos. The type
is well known from many other examples—heads, headless statues, an inscribed
headless herm, and reliefs on coins of Soli, the birthplace of Chrysippos. The large
number of extant portraits of Chrysippos is in line with the well-known popularity
of this philosopher, in his own and later times, and with Juvenal's remark (11.4)
plena omnia gypso Chrysippi invenies, "you will find [their houses] full of
plaster casts of Chrysippus." Our example is an admirable likeness of the eager,
argumentative exponent of the Stoic philosophy. Since he died in 207 B.C., at the age
of seventy-three, the original Greek statue may well have been a contemporary
portrait of the end of the third century, perhaps by Euboulides.

The statue of a dead kid lying on a slab with its legs tied together (pl. 99f),[28] is an
attractive piece of animal sculpture, presumably a Roman copy of an early Hel-
lenistic work. Goats were commonly used for sacrificial purposes and it is probable,
therefore, that this is a votive offering to some deity. The helpless little body with
its drooping head, the sunken eyes, and the shaggy hair are skillfully and sympa-
thetically rendered. The muzzle (now restored), the ears, and the horns are missing.

SCULPTURES IN BRONZE

The bronzes in our collection include a number of excellent examples. A life-size
figure of Eros (pl. 102)[29] is a piece of great rarity, for few ancient bronzes of that
size survived the melting pot. The provenience is said to be the island of Rhodes,
which was an important commercial and artistic center in Hellenistic times. Eros
is shown asleep, stretched out on a piece of drapery. The artist has tried to represent

the complete relaxation of a sleeping child, and he has admirably succeeded. The soft little body, the chubby legs, the drooping arm, the face with its closed eyes and parted lips, and above all the easy attitude convey the abandon of sleep. We almost hear the child breathe, so lifelike is the rendering. But it is not a direct copy from life. The stylizing tendency of earlier Greek art is still evident, as shown in the all-over composition and the studied designs of feathers and locks. The preservation is fortunately excellent, the only important missing parts being the left arm from the shoulder and parts of the drapery. The baldric across the chest suggests that there was once a quiver on which the head rested; a curious little remnant with sharp projections adjoining the hair may be explained as the feathered ends of arrows inside the quiver. The rock on which the figure probably lay is missing; it was presumably of bronze but has been restored in stone. The statue was cast hollow, by the lost-wax process, with thin walls, and was made in several pieces: 1, the head; 2, the right arm; 3, the right wing; 4, most of the drapery, as preserved; 5, the remainder of the figure including the left wing and the edge of the drapery below it; the missing left arm was apparently also cast separately. The joins of the several parts can be seen on the inside.

The figure belongs to a familiar type. There are similar marble statues and statuettes in Italy, Spain, France, England, Denmark, Germany, Austria, Greece, Turkey; and a bronze statuette in our collection shows the same motive reversed (pl. 103b).[30] All are evidently of the Roman period and must be copies and adaptations of a famous Greek original of the middle Hellenistic period, about 250–150 B.C. The superiority in execution of our statue over the other known examples makes it possible that it is a Greek original. The sensitiveness of the modeling, the crispness in the rendering of hair and feathers, and the feeling of life that pervades the figure are the very criteria by which we distinguish Greek originals from Roman copies. If, however, the statue is still another Roman copy, it must be so close to the original Greek work that it helps us to visualize it as we never have before. We can appreciate why this composition became popular throughout the Roman Empire.

A statuette of a standing, bearded man (pl. 103a),[31] to be identified perhaps with Hermarchos, is one of the finest Greek portraits on a small scale that have survived. Again the subject is treated with a mingling of idealism and realism. The features are individual, the skin is represented as shriveled by age, and the prominence of the abdomen is faithfully rendered. The conception of the whole, however, is full of force and dignity, and the arrangement of the drapery in a few sweeping folds contributes to the quiet simplicity. The figure was originally mounted on an Ionic bronze column of which only the capital and the core of the shaft remain. The resemblance of the head to a bust from Herculaneum in the Museum of Naples, which is inscribed with the name of Hermarchos, makes the identification of our statuette with that philosopher possible though not certain. Hermarchos succeeded Epikouros

as head of the Epicurean school of philosophy about 270 B.C., and this date would agree with the general style of our figure.

The statuette of a drunken Herakles (pl. 104d)[32] is another outstanding piece. He is represented reeling backward, his head thrust forward, his legs wide apart. Both arms are missing, but from a better preserved statuette of this type in the Museum at Parma we learn that the right arm was extended and held a cup, and that the left was lowered. The strong, muscular body is rendered with great ability. Drunkenness is suggested only in the pose; there is nothing in the expression of the face to indicate it.

A satyr (pl. 104b)[33] with a wreath of ivy leaves and berries is a fine Greek original unfortunately much corroded. He is shouldering a wineskin and holding a torch upside down, ready to accompany his master; or perhaps we may interpret him more specifically as a *dadouchos,* a torchbearer in the mysteries devoted to Dionysos, whose task it was to minister to the wine god, walk in the holy procession, and provide light where needed. The wineskin was cast separately as the seam shows. A marble satyr in Karlsruhe, about one third life size, is a Roman copy reproducing the same type. Our statuette was formerly in the Forman collection and afterwards in that of Sir Thomas Gibson Carmichael (later Lord Carmichael of Skirling). It has since been cleaned.

Another statuette (pl. 104c),[34] important for its large size (18 inches high), must be a Roman copy of a Hellenistic work, for the workmanship is rather hard. A satyr is represented dancing, and his missing arms perhaps held castanets. His wrinkled brow and arched eyebrows give an individual touch. This and the pointed ears are the only indication of his woodland nature, for there is no tail. The provenience is said to be Carthage. Two diminutive statuettes are freshly and vigorously worked; one shows Herakles struggling with the Nemean lion (pl. 104g),[35] the other a dancing satyr (pl. 104h),[36] of the same type as the well-known bronze in Naples.

The statuette of a negro boy (pl. 104f),[37] with a mantle twisted around his waist, illustrates the salient features of the race with refreshing naturalism—the relaxed gait, the wide mouth with thick lips, the short, broad nose, and the woolly hair. A striding satyr (pl. 104a)[38] is a good Roman copy of a vigorous Pergamene type. A nude bearded man (pl. 104e),[39] said to be from Chiusi, may represent Poseidon or a river god. The bust of a barbarian (pl. 105e)[40] wearing a mantle and sword is a sensitively modeled piece. The statuette of a seated woman (pl. 104i)[41] with a mural crown can be identified as Antiocheia, the personification of the city of Antioch founded in 300 B.C. It is a reduced Roman copy of a bronze statue made by Eutychides, a pupil of Lysippos, which was reproduced on Syrian coins of Tigranes (83 B.C.) and later. The type occurs in a number of Roman copies; the best-known is a marble statue in the Vatican where a youth symbolizing the river Orontes is added; he was doubtless also part of the original composition.

The statuette of a hunchback, wearing a tunic, sandals, and what appears to be a mask with large ears, large hooked nose, and protruding teeth (pl. 105a),[42] was perhaps intended for an actor in the Atellan farces of South Italy. It illustrates the care with which some small bronzes were worked and decorated. Both forearms, now missing, were made in separate pieces and inserted; the whites of the eyes are of silver; the irises and pupils are missing, but were probably of some other material; the two protruding teeth are of silver; the missing piece on the crown of the head was probably also of silver and indicated a shiny bald spot; the hair and whiskers are covered with a thin foil of niello, and the little buttons on the sleeves are also of niello. Though the black niello can now hardly be distinguished from the dark patina of the bronze, it must have made an effective contrast when the metal was its original golden color. The masterly execution suggests Greek workmanship perhaps of the second century B.C. The statuette formed part of the Ficoroni collection and has been known for two centuries.

The statuette of a stockily built man (pl. 105b)[43] is probably also a Hellenistic original, judging by the spirited execution; the earnest, upturned face, the dramatic manner in which both hands clutch the folds of the himation, and the declamatory pose, suggest either an orator or a singer. Similar statuettes are in the Petit Palais and in the Bibliothèque Nationale in Paris.

A dwarf (pl. 105c),[44] with a large tray of eatables from which he is helping himself, may be the caricature of a hawker. He wears an apron tied at the back of his neck and has a bag hanging by his side. The type is Hellenistic, but the execution is probably Roman.

A statuette of a female panther (pl. 105d)[45] is a remarkable example of animal sculpture. The catlike nature is well displayed in the grinning face, the uplifted paw, and the long, lithe body with its many curves and hollows. The conception is characteristic of the Hellenistic period, but the actual workmanship is probably of early Imperial date. The whole body, as well as the head, the paws, and the tail are covered with spots which were inlaid with silver. The base on which the animal rests is inlaid with silver and niello. It is rather too small for the panther (the right forepart protrudes) and probably was not originally made for it, though the two are said to have been found together in Rome in a deposit of Roman bronzes in 1880. A small figure of a greyhound (pl. 105f)[46] gnawing a bone is another attractive animal study observed directly from life.

UTENSILS IN BRONZE AND SILVER

A mirror with a cover ornamented with a repoussé relief is assignable to this period and shows that the type introduced in the fifth century (see p. 95) had a long life. The relief (pl. 105g)[47] represents Eros as a nude chubby infant, seated on a rocky ground. A relief, perhaps from a cuirass (pl. 105h),[48] has two warriors in

violent combat; the victor is about to plunge his sword or spear into his opponent; the latter draws his sword as he falls and holds up his shield with his left hand; each wears a helmet and a mantle, the billowing folds of which spread over the background. The face of the falling warrior is remarkable for the intensity of its expression. It is interesting to compare this Hellenistic combat of the third to second century B.C. with the fifth-century relief of the same theme (see p. 93). In each the end of the struggle nears; the victor is about to deal the death blow to his enemy who defends himself to the last; but the spirit in the two is different. The earlier relief is composed in the stately measure of the fifth century; the later one conveys the passion and vehemence of a real battle.

A mirror of an unusual type (pl. 106a)[49] is said to have been found at Olbia in South Russia. It consists of (1) a bronze disk with a loop or eye at the back, (2) a silver-gilt openwork frame with flange, and (3) a domed wooden back with punched circles on its face and with a wooden disk and bronze loop at the back. The wood was probably originally covered with some fabric which has now disappeared, but which would have made a richer and more appropriate background than the present disintegrated wood. (There is a double series of holes around the edges of the wood where the fabric was presumably tacked.) The form of the mirror is Eastern, similar examples having been found in Russia, Egypt, and Bulgaria. The openwork design of floral elements and birds, in four units, is Greek, of the late fifth century, and resembles those of the silver amphora and of the two-handled silver bowl, both from the Chertomlyk tomb, now in the Hermitage. But whereas they are worked in repoussé, our frame was cast from a repoussé original. It may therefore be considerably later than the lost original—perhaps Hellenistic or Roman since we know that in those periods fifth- and fourth-century metalwork was much prized and frequently copied.

Several bronze and silver cups (see pl. 107)[50] with long, slender, upturned handles and with attachments in the form of lanceolate leaves illustrate the graceful shapes prevalent in the early Hellenistic period (fourth to third century B.C.). Two cups of this type have a delicate engraved pattern on the inside (pl. 107d). They are part of a group of silver objects said to have been found together in northern Italy. The other pieces in the group are a jug (pl. 107g), a ladle with a handle ending in a swan's head (pl. 107e), a pail with swinging handles (pl. 107f),[51] and a bracelet made of a single wire coiled at both ends.

A bowl of hemispherical shape (pl. 106b),[52] said to be from Olbia, belongs to a group of Hellenistic metalware from the East, by some identified as Bactrian or Graeco-Iranian. It is decorated in relief with a pattern of scrolls and plant motives, among which flying Erotes are introduced at intervals. The same pattern is repeated on each side of the bowl with slight variations. The design covers the whole bowl except the rim, which is edged with an egg-and-dart border; the rosette of akanthos

leaves on the bottom serves as a bed from which the scrolls are made to rise. In shape and general scheme of decoration the bowl resembles the "Megarian" bowls of the third and second centuries B.C. (see p. 131), but it lacks their feeling for plant growth (note the fan-like palmettes). A gold bowl in Leningrad, also said to be from South Russia, is a similar product.

SCULPTURES IN TERRACOTTA

The custom of fashioning figures in painted terracotta, which, as we saw, reached its acme in the fourth century (see p. 112), was continued in Hellenistic times. The chief center of manufacture, however, shifted to regions outside Greece proper. The little town of Myrina in Asia Minor, for instance, has become famous through the extensive discoveries made there in the years 1880–1882. Our collection includes specimens from Myrina, Smyrna, Pontos, Herakleia, Greece proper, and Tarentum. A comparison between these and the examples from Tanagra and Athens (see p. 112) shows marked differences. Instead of the quiet, gentle women, youths, and children of the preceding epoch we have figures in lively poses. Even those which are copied more or less directly from the earlier types show a new striving for effect. Deities, especially Aphrodite and Eros, are common subjects.

Among our examples from Asia Minor and Greece one of the finest is a flying Victory (pl. 108a)[53] (the wings are missing) whose forward sweep has an almost sculptural grandeur. A flying Eros (pl. 108c),[54] a gift of W. S. Davis, with colors well preserved, is another noteworthy piece. These two and several female figures in statuesque poses are impressive also for their large size. In one, which is almost a foot high (pl. 108e),[55] the folds of the tunic are made to show through the thin mantle, a device that was in vogue in marble sculpture during the second century B.C. (see p. 143). The same scheme is used for a draped dancing woman (pl. 108f)[56] said to be from Trebizond. In both statuettes the Greek feeling for structure is apparent. In spite of the difficulty of representing two separate garments, one over the other, each fold logically connects with the next, while together they form an artistic whole. A statuette of a flying Eros (pl. 108b),[57] eighteen inches high, has the easy grace of early Hellenistic art; numerous traces of its original colors are preserved. The examples from Tarentum include draped female figures (see pl. 108d)[58] and semi-draped statuettes of Aphrodite (see pl. 109a).[59] Several dancing girls (pl. 108g, h, i)[60] almost rival their Tanagra sisters in delicacy and simplicity. Two groups —a boy with a cock (pl. 109b),[61] said to be from Pontos, and a woman with an Eros (pl. 109e),[62] from Smyrna—are charming creations.

The realistic trend that we noticed in the marbles and bronzes of the period is also apparent in some of the terracottas. One represents a teacher with his pupil (pl. 109c).[63] The bearded, bald man has a writing tablet on his knees and is absorbed in inscribing letters for a little boy who stands by his side; the old man with his broad

stooping back and Socratic, satyr-like face is ably modeled. A Priapos (pl. 109d),[64] protector of vineyards and gardens, is represented carrying an armful of fruit. The head of a smiling young satyr[65] with mischievous eyes was broken from a relief. A nurse,[66] with an infant on her lap, and a comic actor[67] are other good examples.

A terracotta antefix is decorated with a relief of two butting goats' heads rising from akanthos leaves and surmounted by a palmette (pl. 109g).[68] The surface of the leaves and the shaggy hair of the goats are particularly well rendered. Extensive traces of color remain.

SCULPTURES IN WOOD, WAX, AND PLASTER

A statuette of a triple Artemis-Hekate (pl. 109f)[69] is a rare example of sculpture in wood—a material that was widely used by Greek sculptors. Very little wooden sculpture has survived, only a few pieces from the dry climates of Egypt and the Crimea. Alexandria is said to be the provenience of our piece. The goddess is represented in three almost identical figures, each wearing a baldric and a quiver. A coating of gesso, once painted and gilded, originally covered the surface. The period is probably Hellenistic.

Another material which was employed by Greek sculptors but of which little has survived is beeswax. A wax head of a woman (pl. 109i),[70] once presumably part of a statue, is, therefore, a piece of considerable interest. The details were painted and traces of a dark color are still visible. The provenience is again said to be Alexandria.

A plaster relief[71] and fragments of two others[72] belong to a class of ornaments found in Egypt which were cast from metal originals—from utensils, vases, armor, and so forth. Sometimes they consist of a whole scene, sometimes merely of a portion of it. A circular relief shows a youth and a woman holding cornucopias and between them a woman who is being crowned by Eros (pl. 109h). In the field above are the caps of the Dioskouroi-Kabeiroi. It is evidently a cult scene. One fragment, from a shallow dish, has the upper part of a reclining woman; another the lower part of a man seated on a throne. The execution is fresh and delicate, perhaps of the late fourth century.

POTTERY

During the fourth century potters had walked more or less in the footsteps of their predecessors and had painted their vases in red-figure (see pp. 114 f.). After about 300 B.C. other techniques (which heretofore had had only a limited vogue) became popular. We may obtain some idea of the variety of Hellenistic vases by a study of the examples in our collection. Five different techniques are represented.

1. Several vases from a Greek cemetery at Hadra, near Alexandria, are painted in tempera colors on a white engobe. The unfired colors have largely disappeared; occasionally, however, they have been miraculously preserved, as in the beautiful tondo on a hydria with the head of Medusa (pl. 110a),[73] painted in a three-quarter view. The foreshortening is skilfully conveyed in planes and shadows against a blue and yellow background. The colors are black and various shades of pink, red, and brown. A jug from Cyprus (pl. 110c),[74] from the Cesnola collection, has black garlands with red fillets on a white engobe; another (pl. 110b)[75] is decorated in blue and red on the pink terracotta.

The tempera technique was popular also in Italy. It was used with great effect on the sumptuous Canosa vases of the third century[76] and on those from Centuripe, Sicily, somewhat later (see pl. 112a, b).[77]

2. A number of vases from Hadra (see pl 110d, e),[78] chiefly waterjars (hydriai), are decorated with designs in blackish glaze, applied directly on the terracotta body. Several come from the same cemetery as the vases painted in tempera. Ivy, laurel, grapevines, palmettes, and flowers are the favorite motives; occasionally Erotes, Pegasoi, and animals occur. Inscriptions give the names of the deceased and show that the pots were used for the burial of Greeks who died in Alexandria during the second and third quarters of the third century. Some of the jars still contain ashes of the dead.

Two jugs, of the so-called lagynos form, are decorated in blackish glaze on a cream slip. One[79] is from Cyprus and has an ivy wreath on the shoulder; the other (pl. 110f),[80] said to be from Athens, has three wreaths tied with fillets, a vase of lagynos shape, and an oval object that has been interpreted as a bag for provisions. All are popular motives in this ware. Such lagynoi were produced throughout the Hellenistic period from the third century B.C. on.

A deep bowl (pl. 110g), with foot made in a separate piece, and decorated with garlands, comes from the American excavations at Sardis. Inside it are fragments of bones.

3. A few vases are entirely covered with black glaze on which decorations are painted in various colors. This technique, though it also occurs elsewhere, was especially popular in South Italy during the fourth and part of the third century for the so-called Gnathian ware (see pl. 112c)[81]; an excellent example, recently acquired, is a calyx krater with a dancing *phlyax* (comic actor).[82] A ribbed black amphora (pl. 110h)[83] from Hadra has white ivy bands on neck and body; on the shoulder are appliqué reliefs representing Herakles holding his club and Eros with a cornucopia (see below).

A collection of nineteen vases[84] is of interest as having been found in one grave at Teano in Campania. They are ornamented with stamped, incised, and painted decorations, and consist of a large hydria, a number of plates, various jugs, and a

stand (or kernos) for condiments. These vases probably constituted a table service.

4. The most popular Hellenistic pottery has relief instead of painted decoration in imitation of metalware. The well-known "Megarian" vases of the third and second centuries are in that technique. These bowls are called Megarian because some of them were found at Megara. Others, however, have come to light elsewhere, for instance in Attica, Boeotia, Thessaly, Delos, Crete, Cyprus, and Italy. The actual place of manufacture is not known; probably they were produced in a number of different places.

The reliefs on these vases were either impressed with stamps on a mold inside of which the vase was thrown on the wheel, or they were appliquéd on a wheel-thrown vase before firing. The vases are generally covered with a blackish glaze that has often turned red in places. The commonest shape is the hemispherical bowl without handles. The decorations consist of floral ornaments and—rarely—of figured scenes. The latter are of particular interest, for they are sometimes taken from the epic cycle or from well-known tragedies. The plays of Euripides were evidently popular. One of our bowls has scenes from the Iphigeneia at Aulis (pl. 111a, c).[85] Inscriptions make the identification of the figures easy. Five episodes are shown: 1, Agamemnon, who has weakened in his resolve to sacrifice his daughter to Artemis, bids his old slave take a letter to Klytaimestra instructing her not to send her daughter to Aulis; 2, Menelaos has come upon the slave and is taking the letter from him by force; 3, Menelaos, with the letter in his hand, blames Agamemnon for refusing to go through with the sacrifice; 4, a messenger brings the news to Agamemnon that Iphigeneia has arrived; 5, the cart which has come from Argos, with queen Klytaimestra, Iphigeneia, and the little Orestes. We know that the story was continued on a second bowl—of which specimens are preserved—again with five episodes, the concluding one representing Iphigeneia's meeting with Achilles. Doubtless a third bowl—of which, however, no specimen is preserved—brought the story to its conclusion with Iphigeneia's sacrifice. Since the ending of the play preserved in our manuscripts is obviously a late substitution, it is to be hoped that a bowl showing the end of the story may some day be found. In spite of a rather cursory rendering, the figures on our bowl convey by their vivid attitudes something of the poignancy of Euripides's great drama—the anguish and futile sorrow of Agamemnon, the insistence of Menelaos, and the regal bearing of the unsuspecting queen.

Another of our "Megarian" bowls has fourteen figures (pl. 111e),[86] some identifiable: a Nike crowning a trophy; Poseidon with his trident; Ariadne (or a Maenad) with Dionysos, supported by a satyr; and Athena with spear and shield. There are several repeats, and the various stamps are combined in a haphazard manner as is

often the case in this ware. Other bowls have Erotes (pl. 110d)[87] and floral or other patterns.[88] One is signed by its maker, Demetrios (pl. 111f).[89]

Another Hellenistic ware with decorations in relief is called Pergamene, as it is thought to have been made in Asia Minor, perhaps in Pergamon. It is rather later than the Megarian, probably about 150–50 B.C. The glaze is red in some areas, black in others (red when fired under oxidizing conditions, black when fired under reducing conditions), the difference in color apparently being due to stacking in the kiln. Good examples are in our collection. One is a cup (pl. 111b)[90] with reliefs of Eros holding a torch or making music, the infant Herakles strangling the serpents, etc. The other is a high beaker (pl. 110 i)[91] with reliefs of Erotes holding thyrsoi or playing the syrinx, and a head of a Maenad in a medallion. A terracotta mold for an ivy twig[92] was used for the decoration of a "Pergamene" vase, since such twigs appear on extant examples. A fragment from a cup of this type is included in our collection.[93]

In addition to these relief wares found chiefly in the eastern Mediterranean there are others of Italian origin, black-glazed and polychrome. The most important are the Calene bowls and lampfeeders of the fourth to third century B.C., ornamented with reliefs which were sometimes impressed from earlier Greek silverware. The subjects on our examples include the Apotheosis of Herakles (see pl. 112d)[94] and a combat of Achilles and Penthesileia.[95] Several kylikes have a head of Arethusa as a central medallion,[96] reproduced from decadrachms by Euainetos (see p. 153).

5. As in the preceding epochs, vases were occasionally molded in the forms of heads or figures. A good example is a lively satyr sitting on a rock with an amphora by his side.[97] The blue, red, and white colors, applied over a white engobe, are still fairly well preserved. The date is perhaps around 300 B.C.

Vases in human and animal form were popular also in Italy. Our examples include a comic actor,[98] a negro boy sitting by an amphora,[99] and a negro boy with a goose (see pl. 112e),[100] all three covered with black glaze. Sprinklers of various forms comprise a bull[101] and a pygmy carrying a crane (pl. 112f).[102] They belong to the magenta class, so called because the terracotta body was covered with magenta color. Only slight traces of this color remain on our examples.

PAINTED GRAVESTONES

For our knowledge of the pictorial art of this period we are fortunately not altogether dependent on the decorations on pottery. A number of Hellenistic paintings on walls of houses and on gravestones have survived. Six painted limestone stelai[103] are in our collection. They were found at Hadra in Egypt in the same tomb as the vases described above (see p. 129), and they were erected for Galatians in the third century B.C., as we learn from inscriptions on the vases. The paintings were executed in tempera, in various shades of red, blue, yellow, and mauve, and are still

fairly well preserved. They represent the deceased either in scenes of daily life or of farewell, as in the fourth-century Attic gravestones (see p. 108). We see a youth calming a restless horse; a warrior standing with shield and spear; a man about to receive a drink from an attendant; a man saying farewell; and a reclining woman with two attendants.

LARGE SCULPTURES OF VARIOUS PERIODS

The larger stone sculptures discussed in this chapter should be studied with objects of the same periods described elsewhere, for the introductory remarks in each chapter apply also to them. The arrangement is roughly chronological—from archaic and fifth century to fourth century and Hellenistic. As we have said, the ancient Roman practice of making copies and adaptations of Greek works has saved much of Greek art from oblivion. When a Roman copy reproduces—as far as we can tell—the composition of the Greek original, it has been placed among the Greek works to which its style belongs. Unless otherwise stated, the material of the sculptures described in this chapter is white marble.

ARCHAIC PERIOD, VI CENTURY B.C.

An archaic Attic gravestone (pl. 113)[1] with capital, crowning sphinx, and inscribed base is the most complete example of this type extant (see p. 48). The shaft is decorated in relief with a youth and a little girl, probably his sister. He holds a pomegranate and has an oil flask hanging from his left wrist; the little girl holds a flower. The upper part of the girl, including the head and the hand, is a plaster copy of a piece which was acquired by the Berlin Museum at the beginning of the century. The crowning members placed on top of the shaft—the sphinx and the capital—are also of plaster; the marble originals are shown close by, at eye level. Traces of colors can still be seen—red on the background of the relief, red and black on the youth, red, black, and blue on the sphinx. The faded, painted design on the capital has been reconstructed in the cast. The now empty area below the relief probably had a design and perhaps also that above the youth's head; at least such areas are decorated in some extant stelai. The dedicatory inscription on the base is incomplete:

Μνεμα φιλοι με [. . .]
Πατερ ἐπεθεκε θανοντ [. . .]
Χουν δε φιλε μετερ

"To dear . . . his father and his dear mother set me up as a monument when he died [and to the sister . . .]."

The monument, as reconstructed, is almost 14 feet high (more than 4 meters) and is singularly impressive. The well-preserved head of the youth is an admirable example of archaic sculpture; each feature is carved in a precise, effective manner and the hair is beautifully stylized. Of the many archaic sphinxes in marble that have survived, this is the only one that is practically complete—with head, wings, paws, and even tail preserved. The four different parts of the stele—finial, capital, shaft, and base—were worked separately and fastened together by dowels and tenons reinforced with molten lead.

Stylistically the monument may be dated around 540 B.C. If, as has been surmised, the name Megakles appeared in the first line of the inscription and the stele was therefore erected by a member of the famous Alkmeonid family, the exile of that family some time between 541 and 537 would supply chronological evidence. We may also recall that, according to Isokrates (XVI.26), the tyrants not only destroyed the houses of the Alkmeonids but also dug up their graves. The report that some of the fragments of our monument were used to line other graves, and were thus protected from weathering while others were not, would account for the different preservation of various parts.

Another important Attic gravestone of this type has only the lower part preserved (pl. 114a).[2] It is decorated in relief with a warrior, of whom the greaved legs and part of the spear remain, and is flanked on either side by a guilloche border. Extensive traces of the original polychromy remain. The greaves and spear were blue, the background red; the guilloche was in four colors—red, blue, and green bands with black centers. At the bottom is a panel—incised, with parts slightly sunk—representing a warrior mounting a four-horse chariot while the charioteer holds the reins taut. The warrior has a chiton, cuirass, crested Corinthian helmet, round shield, sword, and spear. The charioteer holds a goad as well as the reins and wears a Corinthian crestless helmet and a chiton, which he has pulled over his belt to form a pouch; the pouch is represented in profile, the folds it causes in full front. The fine contours of the horses' bodies, the beautiful curves of their tails, the varied design of the legs and balancing intervals, the effective contrast of the quiet charioteer and the animated warrior, all contribute to the beauty of the composition. And this was further enhanced by the red and black coloring of which extensive traces remain. The horses recall those of Exekias and of the Siphnian frieze, and the rendering of the drapery is that current in Greek vase painting during the third quarter of the sixth century. We may assign our stele, therefore, to the period from about 535 to 525 B.C.

A warrior mounting a chariot is a common subject in archaic vase painting (see pp. 59 f.); and in one of these scenes the warrior is identified by an inscription as the hero Amphiaraos departing for battle. As it is unlikely, however, that a mythological scene was represented on a gravestone, the scene on our stele perhaps was intended for the warrior who died and who is likened to a mythical hero; or again he may be an *apobates*, that is to say, an armed runner in a combined chariot and foot race.

A fragment of a marble group with a lion attacking a bull (pl. 114b)[3] evidently came from the pediment of a small building, for the back is roughly finished. Only the foreparts of the two animals remain, but even in its fragmentary state the piece shows to an amazing degree the fierce strength of the lion and the limpness of the dying bull. The lion has sprung on its prey and is biting it in the back, one forepaw

on its shoulder, a hind paw on the head. The bull lies prostrate, head down, legs helplessly folded under; its dewlap is rendered by a series of wavy ridges; the horn, which was added in a separate piece, is missing. On the left we must imagine the rest of the lion, which was broken off. To the right another block of marble was fitted (note the roughened surface with smoothed edge), containing the rest of the bull and part of the second lion; it is now in the National Museum, Athens (no. 1673), and was found near the Olympieion almost a century ago. The composition thus resembled the famous pedimental group from the Akropolis in Athens. The style of the modeling places our piece in the late archaic period, around 500 B.C., about contemporary with the lions and bull from the temple of Apollo at Delphi (dated about 510 B.C.) and with the bull on the staters of Samos probably issued during the Ionian revolt (500–494 B.C.).

V CENTURY B.C.

The upper part of a female statue (pl. 118a),[4] over life size, is said to have been found in South Italy. The figure is represented standing and clothed in a chiton and a belted peplos; and though a mere fragment, it has retained its monumental character. The dignified posture, the simple folds of the drapery, the graceful locks, the quiet countenance, all contribute to the regal impression of the whole. The style recalls that of the pedimental figures of the temple of Zeus at Olympia in the heavy-lidded eyes and well-shaped lips, the undulating strands of hair, and the rhythmical folds of drapery. The probable date is, therefore, about 460–450 B.C. The face and the hair over the forehead—the workmanship of which is rather hard compared with the rest of the statue—is in a separate piece and must at one time have been broken off and later reattached; the top of the head was also made separately and is now missing.

If the statue is a Greek original, as seems likely, we may surmise that it was broken in Roman times and repaired. On the left side of the head, toward the back and above the fillet, the surface is left unfinished. That part of the head was therefore presumably covered by something, perhaps a helmet—in which case the statue must have represented Athena. In her left hand she probably held a spear, for there is an ancient hole on the upper left arm at the place where a spear might have been attached. Spear and helmet must have been of bronze. The large size of the statue suggests that it served as a cult figure in a sanctuary; and this would explain why, even after several centuries, the statue was so highly prized that, when broken, it was repaired instead of discarded.

A fragmentary relief (pl. 116a)[5] of Demeter, Persephone, and Triptolemos—a Roman copy of the famous Eleusinian relief in Athens of about 440 B.C.—was found in Rome more than a generation ago, embedded in an old wall. Only about one third of the composition is preserved, but it has been possible to restore the missing parts

from a plaster cast of the relief in Athens. Since known instances of the survival of a Greek original and its Roman copy are rare, it is a happy chance that a copy of so famous a work has been preserved. The close correspondence between the marble and plaster parts in our relief—furrow for furrow and ridge for ridge—indicates that the copy was executed not freehand but mechanically by the pointing process. In the execution there is, however, a great difference between the delicate carving of the Greek original and the drier, harder treatment of the Roman copy; we may note especially the renderings of the hair and the folds. But whereas the surface of the Greek relief is much weathered, the Roman copy—what is left of it—is well preserved and helps to reconstruct several portions which have become obscured or are missing in the original. Whether the Roman copy served to decorate a sanctuary in Rome or whether a Roman collector had the copy made merely as a decorative panel is not known. Among the fragments that came to the Museum is a sandaled right foot with folds of drapery in the background that could not be incorporated in our relief since it did not belong to any of the figures. As workmanship, style, and scale are similar to those of the other fragments, the piece may have belonged to a companion relief.

A statue of a young warrior (pl. 115a),[6] a little over life size, is a piece of considerable interest. He is standing on a slanting base, leaning slightly backward as if to acquire momentum for throwing his spear against an enemy. On his left arm is preserved the central strap of a shield he carried; the remains of his raised right hand indicate that he held a spear pointing in a downward direction. A sheathed sword is hanging from a tree trunk, which acts as a support. The Greek original of which our statue is a Roman copy was probably of bronze and so did not need the support. Another less well-preserved Roman copy in the British Museum has the slanting base worked in the form of a ship's ram. This gives a clue for the interpretation of our statue. It must represent the Thessalian hero Protesilaos, "the first man who dared to leap ashore when the Greek fleet touched the Troad," throwing his spear from the ship against an enemy on the shore. According to Philostratos (third century A.D.) there was a sanctuary of the hero at Elaious, in the Thracian Chersonese, with "a temple statue of Protesilaos standing on a base in the form of the prow of a boat." Our figure may be a copy of this or of some other Greek statue of the hero. The rendering of the hair by small, short ringlets, the simple planes of the body, the expressive mouth, the eyes with both lids strongly marked, and the quasi-parallel folds of considerable volume in the drapery, point to a date around the middle of the fifth century. This was, it will be remembered, a period in Greek sculpture when complicated poses in momentary action like those of our statue were popular (see p. 81).

A statue of a Diadoumenos (pls. 115b, 117a),[7] or youth tying a fillet round his head after an athletic victory, is a Roman copy of a work by Polykleitos of about

440–430 B.C. The Greek original was of bronze and one of the most highly esteemed works of antiquity, famous, as Lucian says, for its beauty, and, as Pliny characteristically remarks, for the large price paid for it (of course in Hellenistic or Roman times). Its popularity is also attested by the many Roman copies, large and small, that have survived (see below and p. 98). In our figure the whole torso and the upper part of the legs are missing and have been supplied from a plaster cast of the statue from Delos in Athens. The head may be considered the best of all extant copies. It is practically intact with the surface in beautiful condition (even the nose is unbroken), and the execution is unusually sensitive. The sharp-cut eyelids bordered by ridges suggesting lashes, the transverse incisions on the lower lip, the crisp curls indicate a faithful rendering of the Polykleitan bronze original. The supports which joined various parts of the body to one another (only one is preserved entire) were of course not part of the bronze original, but were, like the tree trunk, additions by the Roman copyist. Their large number (five in all) suggests that they were made for transport, and for some reason were not afterwards removed. As the statue was purchased in Rome it was presumably found in Italy.

Another Roman copy of the Diadoumenos (pl. 115c),[8] once in the Giustiniani collection, was given to the Museum in 1903 by Mrs. Frederick F. Thompson. The torso and parts of the legs are all that remain. A cast of the head of the other Diadoumenos has been added.

A gravestone with the relief of a woman (pl. 118b)[9] is a Greek original of about 430–410 B.C. The woman is represented seated in a chair, holding up an oil jug, and with a toilet box on her lap. She is evidently the person in whose memory the stone was erected, shown with objects she commonly used in her daily life. Her name was doubtless inscribed on the missing part of the pediment. The harmonious composition of the drapery with its multitudinous folds and the skillful treatment of the different planes recall the Parthenon pediments.

In our account of the fourth century (see p. 108) we had occasion to mention a type of gravestone in the form of a lekythos. An example, over five feet high (pl. 118c),[10] is one of the few of that size that have survived from the fifth century. The delicately carved relief shows three figures—a standing youth, named Kallisthenes, clasping the hand of a seated bearded man and a woman standing behind, her hand raised to her chin in the customary gesture of grief. There is a strange stillness in the scene. The father and mother are looking at their son in a dazed manner, and the youth has a detached look, as if already he belonged to another world. It is this quiet pathos—grief suggested rather than expressed—that makes these Athenian monuments so singularly moving. The awe and the gestures of the parents are more poignant than distorted faces could be. The poses of the figures, the treatment of the folds, the modeling, and above all the dignity of the composition recall the Parthenon frieze. A greater softness in the renderings, however, suggests a slightly later date—

perhaps about 430–420 B.C. To visualize the original appearance of the vase we must add in our imagination the painted patterns that originally decorated it—a tongue or maeander border above and below the figures, a design of palmettes and scrolls on the lower part of the vase, and perhaps scales on the neck. The handle must also have been indicated in color as a narrowish band along the edge. The abnormal height of the foot is explained by the fact that it was partly inserted in a quadrangular block; for that reason its lower part was left rough. The vase was probably set up not as a monument on a single grave, but as part of an ensemble in a family burial plot, with different forms of memorials combined in a group. Its provenience is not known, but it must have stood somewhere in Attica, for the type and style are Athenian.

A relief of a Maenad (pls. 116b, 117b)[11] is an excellent Roman copy of a late fifth-century Greek work. She is represented clothed in a diaphanous tunic and a mantle, leaning on her thyrsos as she pauses in her dance. A few portions are missing, but what remains is unusually fresh, the carving crisp and delicate, and the head miraculously entire. The composition, with the long, sweeping folds of the drapery following the sinuous curves of the figure, their recurving edges acting as an effective framework, must have been the creation of a great artist. Moreover the relief is not an isolated product. Many other examples, both of the figure on our relief and of similar figures, bear witness to the popularity of these ecstatic Maenads in the Roman age. At least eight types have been distinguished. They appear, singly or in groups, on marble bases, altars, candelabra, and vases, generally not more than a foot or two high. In addition, a few slabs as large as the New York one exist in Madrid and Rome, each with one Maenad, and one of these corresponds so closely to ours in dimensions, composition, and details that the two must have been copied directly from the same Greek original. The transparent, turbulent draperies point to the last quarter of the fifth century as the period of this original. If one were to name a specific sculptor of that time who might have created the Maenad types, the likeliest is Kallimachos, known for the grace, elegance, and elaboration of his works. Moreover, the dancing girls of Sparta, cited by Pliny as one of Kallimachos's works, can on good evidence be identified as the prototypes of the dancers with short tunics and high headdresses which enjoyed a vogue in Roman times, and they strikingly resemble the Maenads in style.

The statue of a lion (pl. 116c,d),[12] said to have been found in Rome, is a good specimen of Greek animal sculpture. It is shown in a crouching position, with mouth wide open, the tail (now missing) lashing its side; the four paws and parts of the legs are restored. Though the representation is conventionalized, the chief characteristics of the lion—its fierceness and the strength of its supple body—are well brought out. In general appearance the figure recalls the lions of the Nereid Monument in the British Museum.

IV CENTURY B.C.

A headless statue (pl. 115d),[13] from the Giustiniani collection, is a Roman copy of the Apollo Lykeios attributed to Praxiteles. It was described by Lucian (*Anacharsis,* 7) as leaning against a pillar, a bow in one hand, the other raised to the head, and a figure corresponding to this description appears on Athenian coins of the Roman period. That the figure became popular is shown by the many reproductions and variations in Hellenistic and Roman times.

A torso, slightly over life size,[14] is evidently a Roman adaptation of the same Greek work. It too came from the Giustiniani collection.

The statue of a draped woman (pl. 120c),[15] of which the head and both arms are missing, is a Roman copy of what must have been a famous Greek work, for we know of other Roman copies in Munich, Athens, and Dresden. The statue in Munich, which is more complete than ours, and an Athenian coin of Roman date with a reproduction of the statue, show that the head was turned to the left, that the right arm was extended and held a scepter, and that the left arm supported a child. The subject was doubtless Eirene, the goddess of peace, holding the infant Ploutos, the god of wealth. A statue of Peace with Wealth in her arms is referred to by Pausanias (ix.16.1), who says that it was made for the Athenians and was the work of Kephisodotos. The period of the original Greek work has been much discussed, the two dates suggested being 404 B.C., which marked the end of the Peloponnesian War, and 375 B.C., the year of the battle of Leuktra. The simple, massive folds of the drapery and the dignified posture are in line with fifth-century sculpture, but the gentle expression of the face and the turn of the head show the influence of the new ideas brought to fruition by Praxiteles. The later date is therefore likely. Our statue is said to have come from Rome.

Another large statue of a draped woman (pl. 120d)[16] belonged to the Giustiniani collection and is a gift from Mrs. Frederick F. Thompson. It too is headless and parts of the arms are missing. The drapery, consisting of a himation and a belted chiton with hands crossing at the back, has the heavy, dense quality typical of the middle and third quarter of the fourth century. It is difficult to say whether the figure is a Greek original or an excellent Roman copy. No replica exists.

Several grave monuments are original Greek works of this period (see also p. 108). A large relief shows a seated man grasping a staff, a woman of mature age holding a child by the hand, and a young woman with clasped hands (see pl. 121c).[17] The woman on the left is perhaps the person who died and the others her father, her mother or sister, and perhaps a little daughter. The last is represented as a diminutive adult, as often in the periods preceding the Hellenistic age (see p. 79). Sorrow is shown only in a quiet detachment. The relief must date from the early fourth century, the figures retaining much of the fifth-century majesty. It used to be shown inside a shrine consisting of two reconstructed pilasters and a partly

preserved pediment, inscribed on the cornice "Sostrate, the daughter of Thymokles of Prasiai." The pediment for it, however, although it is said to have been found in the neighborhood of the relief, cannot have belonged to it, for it is too wide.

A large sepulchral lekythos (partly restored) of the type described above (see pp. 108, 138) has on it seven figures in relief, evidently a family group (pl. 119a).[18] In the center is a woman seated on a chair (her head and parts of her right arm are missing); she is clasping the hand of a young girl who stands before her, presumably her daughter; behind her is a bearded man—the husband and father. To the right and left of this central group is a young woman in a pensive attitude, with a little attendant by her side holding a small chest. The names are inscribed (except those of the attendants); Leonike, below the seated figure, and, left to right above the respective figures, Stratokleia, Aiolos, Aristomache, Axiomache. To judge by the gesture of the father, Aiolos, it was Aristomache, the young daughter, for whom the lekythos was erected, not her mother, Leonike, seated in the center. The names of the parents and sisters were added without any implication that they too had died. The names Aiolos and Leonike, in fact, reappear on a sepulchral marble lekythos in the Louvre, Ma3446, and, as Aiolos is a rare name except in mythology, they probably were the same people as those shown on our lekythos. The rhythmical composition of our relief with the figures arranged in symmetrical groups, subtly varied, is typically Greek, and so are the detached, serene expressions. The delicate grace of the figures—bringing to mind early Praxitelean sculptures—and the rendering of the drapery suggest a date in the first half of the fourth century, near the time of the relief commemorating the alliance between Athens and Korkyra, dated 375 B.C. Closest in style is perhaps the exquisite group of husband and wife on the well-known sepulchral lekythos in Munich.

A relief of a woman from a grave monument (pl. 119b), formerly in Lowther Castle, is discussed on page 93.

Two statues (pl. 120a,b)[19]—a draped woman and a child looking wistfully up at her—were probably also part of a grave monument. The figures, however, are worked in the round instead of in relief, with the backs left unfinished. To give them the required architectural setting we have restored the missing shrine in wood. The woman wears a sleeved chiton and a peplos with belted overfold, as well as a mantle, which is fastened on both shoulders and falls down her back; the girl—represented as a small grown-up—has a peplos with long, belted overfold. Though the hands are missing we can reconstruct the action to some extent. The woman grasped a fold of her flowing mantle with her left hand and perhaps held an object in her right; the child's right arm was lowered and she had perhaps a casket in her left hand. Both woman and child wore earrings, for the lobes of their ears are pierced. The heads were worked separately from the bodies. The neck of the woman ends below in a large, rounded tenon, which fits a corresponding socket at the top of

the body. A similar socket is at the top of the child's body to receive the missing tenon (the child's neck is not preserved and had to be restored). The quiet loveliness of the group and particularly the charming head of the woman, with its delicate, oval face and serene expression, show the influence of Praxiteles. The date of our monument is probably the late fourth century, shortly before the anti-luxury decree of Demetrios of Phaleron which forbade the erection of sculptured gravestones in Attica and thus put an end to one of the most beautiful forms of artistic expression in Greece.

Another type of gravestone prevalent in Attica during the fourth century is a tall marble shaft with a finial in the form of an anthemion rising from a bed of akanthos leaves, and a flower in the middle (the stem was often painted). Two finials from such gravestones are in our collection. Though the design is formalized, the feeling of plant growth is admirably conveyed. One finial (pl. 121b)[20] is treated as a relief; in the other (pl. 121a)[21] the intention was evidently to repeat the ornament at the back, but it was only roughly blocked out. The shaft of the former, though not in this Museum, is preserved (see Conze, *Attische Grabreliefs,* no. 1539); it has an inscription recording that the stele was erected to Timotheos and his son Nikon, both of the deme of Kephale.

HELLENISTIC PERIOD, LATE IV–I CENTURY B.C.

A fragmentary statue of Herakles (pl. 122b),[22] seated on a rock and leaning on his club, illustrates the forceful modeling current at this time. The powerful relaxed frame of the hero is rendered with a thorough knowledge of anatomy and with an understanding for the soft texture of the flesh. The folds above the navel are a realistic touch typical of the age. The style is Lysippian of the third century B.C., and the statue is either a Greek original or an excellent Roman copy. It is said to have come from Valladolid, Spain. The polish on the surface is not original (it runs over the cuttings on the shoulders) and since such surface gloss is common in the sixteenth century, it has been suggested (by John Marshall, who acquired the statue for the Museum) that it was found centuries ago, perhaps in Rome, and exported to Spain.

A bearded Herakles (pl. 122a)[23] wearing a lion's skin over his head is a Roman copy of an early Hellenistic work (the legs are mostly restored). The same type appears, with the head of the Emperor Commodus, in a statue now in the Palazzo dei Conservatori in Rome.

In spite of its fragmentary condition, the statue of a fighting Gaul (pl. 122d)[24]— said to have been found at Cervetri—is full of vitality. Only the lower part of the torso, parts of both legs, and a piece of the base are preserved, but we can reconstruct the action from them. A Gaul is striding forward to attack an opponent, who was perhaps opposite him; he wears the tight-fitting trousers and belt of the Celtic

soldier; but the clothes in no way conceal the strong, hardy body; the muscles are shown at tension, and yet they are not emphasized. The effect is one of freshness and energy. We may date the statue perhaps toward the end of the third century B.C., the time of the dedications of Attalos of Pergamon on the Akropolis of Athens.

A seated man (pl. 124a),[25] wrapped in a himation, was a portrait statue of a poet playing the kithara, to judge by the turn of the body to its left and by the holes beneath the left shoulder. The lifelike rendering of the heavy material and the sweeping folds in which it falls give the statue great animation. The head was worked in a separate piece and is missing. The signature of the sculptor is engraved on the front of the seat: *Zeuxis epoiesen,* "Zeuxis made it," in letters of the first century B.C. or later. He was evidently a copyist of Roman times.

A headless statue of Aphrodite (pl. 122c)[26] shows her crouching in the bath. It is a Roman copy of what must have been a famous statue, for there are many copies and variations. The best known is a marble figure in the Louvre, found at Vienne, France. The lost original has with some probability been identified with a work which in imperial times adorned the temple of Jupiter in the portico of Octavia and which was executed by Doidalses, a Bithynian sculptor of the third century B.C.

Three statues from the Giustiniani collection are Roman copies of Hellenistic types. One represents a seated woman (pl. 123c),[27] probably a Muse, with torso and head inclined to one side. Figures of the same type are in Dresden, Rome, Lepcis, and Zagreb, but ours is the only one with the head preserved. In the second statue, a woman draped in chiton and himation (pl. 123d),[28] the folds of the chiton are made to show through the himation—a typical late Hellenistic rendering that we observed also in some terracotta statuettes (see p. 128). The third statue (pl. 123a),[29] a girl wearing a mantle over her chiton, may also be compared with Hellenistic terracotta statuettes. The head, of which only the face is ancient, does not belong to the statue.

A female statue (pl. 123b),[30] over life size, is said to have been found in Attica. She wears a chiton, girt above the waist, and a himation, which passes over her left shoulder and is wound around her left arm; the head was made in a separate piece and inserted. In the absence of attributes (both hands are missing) we cannot say whom the statue represented. The unfinished back suggests that it was placed against a wall or in a niche. The execution is fresh, though cursory, and Greek rather than Roman. The drapery, with the bunched folds gathered round the waist, recalls such mid-fourth-century works as the Artemisia of the Mausoleum at Halikarnassos; but the composition as a whole is tamer and less coherent.

An old market woman (pl. 124c,d)[31] illustrates the blending of realistic and idealistic styles common in late Greek times. A peasant woman, bent with age and toil, is offering her wares for sale; by her side are some chickens and a basket of fruits or vegetables. The ivy wreath encircling her kerchief may indicate that she is

celebrating a Bacchic festival. The stoop of the body, the wrinkled face (restored in pl. 124c), the shrunken skin on neck and chest are realistically rendered; the lower part of the figure, however, might be that of a young girl. The freshness of the modeling makes it likely that the statue is an original Greek work of the second century B.C. (For a head from a similar statue, see p. 121.)

The statue of an old fisherman (pl. 124b),[32] a Roman copy of a second-century work, is another example of the realistic trend in this period. His age is indicated by his shrunken skin and bent body, and he is represented as pursuing his trade. It is only in the drapery with its simple, effective folds that the old idealizing tradition is retained. Another copy, preserved with head, in the Conservatori Palace in Rome, has been restored with a net over the left shoulder and a stick in the right hand. Though we do not know that these were the original attributes, the figure can be identified as a fisherman by the characteristic round hat.

ENGRAVED SEALSTONES

VIII CENTURY B.C.—I CENTURY A.D.

Greek intaglio sealstones—or gems, as they are generally called—have a special attraction today. There is something intimate and personal in a seal used and worn by an individual for identification and for the safeguarding of his possessions. Moreover, a Greek seal is not uncommonly a great work of art; though of small size, it is often carved with nicety, and in conception it can be as monumental as a piece of sculpture. The representations are in fact sculptures in miniature. They reflect the development of Greek art through its many phases and give a comprehensive picture as regards both style and content.

The art of engraving semiprecious or precious stones to serve as seals goes back to Babylonia in the fourth millennium B.C. and was practiced in the Mediterranean countries from early Cretan (see pp. 17 ff.) to late Roman times and thereafter. We shall discuss in this chapter Greek sealstones from the Geometric age to the Hellenistic, as well as a few of the Roman Imperial period that have designs more or less directly copied from earlier Greek works.

The materials used are first the steatites, then the colored quartzes, later also the more precious stones. The soft steatite was worked by hand, the harder stones were cut with drills rotated by the bow (or wheel?). Glass gems also occur, especially in later times. They were mostly cast in molds made from engraved stones, sometimes with subsequent retouching. Sometimes the design was engraved directly on the bezel of a metal ring. The earlier stones are regularly perforated and were worn on metal swivel rings and perhaps cords; later, the stones were set in rings, as in modern times.

Whereas in the Roman period engraved gems were in common use, Greek gems are relatively scarce, presumably because only a limited number of wealthy people owned them. Sometimes they must have served as official seals, as we learn from inscriptions (see, *e.g. Inscriptiones Graecae,* second edition, II, 204, 40), from literary evidence (see, *e.g.,* Aristotle, *Constitution of Athens* 44.1; Strabo 9.31), and from the fact that the design on a gem is occasionally almost identical with one on a coin (see p. 149). We know the names of a few Greek gem engravers from references to them in ancient literature and from a few signatures.

The precious character of the gems made them favorite objects for collectors from ancient times until our own. The examples in this Museum have been derived—by purchase, gift, bequest, and loan—from many famous collections. As the designs were carved to be seen in the impressions, the enlarged photographs which we have placed with the stones are taken from such plaster impressions. These enlargements

will greatly facilitate the appreciation of the beauty and interest of the engravings.

GEOMETRIC PERIOD, VIII CENTURY B.C. The gems of the Geometric period are soft steatites of different shapes and are engraved with patterns, human beings, and animals, in the same "abstract," linear style as the vase paintings and bronzes of the time (see pp. 22 ff.). A few typical examples are in our collection: a glandular gray steatite with a man and ornaments (pl. 125a)[1]; a green translucent steatite[2] with two men in reversed positions on either side of an animal, perhaps a lion; and a green steatite disk[3] from central Crete with two wild goats on one side and a man sitting on a stool opposite a draped woman on the other. A large silver ring has a griffin-like monster engraved on the bezel.[4]

PERIOD OF ORIENTAL INFLUENCE, LATE VIII–VII CENTURY B.C. AND LATER. Greek contact with the Orient gradually transformed the attenuated designs of the Geometric age into more rounded forms. Hard stones worked on the wheel were now sometimes used, and Eastern motives became popular. A four-sided steatite[5] with linear patterns and two stylized monsters—a griffin and perhaps a sphinx—shows the intrusion of Oriental motives into Geometric ones in the late eighth century. An ivory disk (pl. 125b),[6] with a lion on one side and flying bird on the other, may be assigned to the early seventh century. Ivory seals with similar designs have been found at Perachora, near Corinth, and at Sparta. A green translucent steatite,[7] also of about 700 B.C., has a lion attacking a man, whose head is shown inside the beast's wide-open jaws.

The so-called Island gems show a revival of Mycenaean traditions in the glandular and lenticular shapes of the stones. They are products of the seventh century, chiefly of the second half. The subjects are mostly animals and monsters; human figures are relatively rare. The stones in our collection include several typical designs such as a sphinx on a gray stone[8] from Melos; a dolphin and the head and tail of a fish on a greenish white translucent steatite[9]; the front part of a warship with a sea serpent swimming alongside it (note its fins, pointed ears, and the teeth in its wide-open mouth), on a pale green steatite from Epidauros Limera (pl. 125d).[10] Beautifully cut designs appear on the two faces of a light green steatite—a monster with the body and tail of a fish and the forepart of a winged goat (pl. 125c),[11] and a winged horse with reversed hindquarters; both are skilfully composed to fill the circular space, the tails, wings, legs, and horns being used with good effect. Another stone of this class—a green translucent steatite from Perachora—has a remarkable representation of the suicide of Ajax (pl. 125e).[12] The hero has fallen on his sword which is stuck in a mound of earth, indicated by hatched lines; the sword has passed right through him (the tip appears above his back). The inscription in the field is probably to be read HAHIVAS, Ajax. The date must be in the second half of the seventh century, the

body being comparatively well constructed, while the head recalls the linear Geometric style.

Several gems, commonly called Graeco-Phoenician, belong to a class with a mixture of Oriental and archaic Greek elements. They have been found chiefly in the Carthaginian cemeteries of Sardinia and are mostly of green jasper and of the scarab, that is, the Egyptian beetle, shape (see below). A lion attacking a bull,[18] the Egyptian god Bes carrying a lion and a boar (pl. 125f),[14] Herakles (pl. 125g),[15] sphinxes,[16] and a figure with the forepart of Isis and the hindpart of a winged scorpion (pl. 125h)[17] are some of the subjects on our stones. They cover a long period, from the seventh to the fifth century.

ARCHAIC PERIOD, VI AND EARLY V CENTURY B.C. In the Greek gems of the sixth and the early fifth century the subjects are those current in the art of the period, and the style shows the same gradual development from stylization to naturalism as do the sculptures and vase paintings of the time (see p. 46). The favorite materials are the quartzes, especially carnelian, sard, chalcedony, agate, rock crystal, and plasma. The most popular form is the scarab, which had long been familiar in Greek lands from Egyptian imports; in Greece, however, it had presumably no religious significance but was purely ornamental. In addition, other shapes, such as a recumbent lion, a mask, a siren, are used for the backs of the intaglios. A plain, convex form called scaraboid, which was soon to become the favorite form, now makes its appearance. Occasionally the Oriental cone and cylinder occur. All these stones are perforated and some are still attached to their metal swivel rings. In some the engraving is cut directly on the metal bezel of a ring.

Most of the examples in our collection belong to the late archaic period. Only a few are earlier than the last quarter of the sixth century. A large carnelian scarab (pl. 125i)[18] with a youth kneeling and washing his hair in a basin, a carnelian scarab[19] with two lions, one on top of the other, and an agate[20] with two prancing ibexes may be assigned to about 550 B.C. A carnelian scarab (pl. 125j)[21] with Herakles wielding the club and holding a lion by the tail belongs to around 530; and a chalcedony scaraboid inscribed Charidemos in the Euboean alphabet and dialect also looks early.

Among the gems of the end of the sixth century we may mention several of high quality and special interest. Hermes, wearing a chiton, a himation, winged shoes, and a hat, and holding a flower and his herald's staff, appears on an eight-sided cone (pl. 125l)[22]; a dainty Nike, holding a flower and a wreath and with a snake rising behind her, is carved on a carnelian scaraboid (pl. 125m)[23]; a fierce lion attacking a bull is a powerful rendering of this popular subject on a large carnelian scarab (pl. 125k)[24] found at Gela in Sicily; a warship with soldiers on the deck, rowers below, and a steersman in the stern, is skilfully composed into the oval field

of a chalcedony scaraboid[25] from Phaleron; and a hunting scene appears on a black cylinder[26] bequeathed by Richard B. Seager. Like the other products of the period they show the refinement and decorative quality of Greek art at this time.

The end of the sixth century and the first quarter of the fifth seem to have been times of especially fine work in seal engraving, as in vase painting, if we may judge by extant examples. An archer testing his arrow, on a (discolored) chalcedony scaraboid (pl. 125n)[27] from the Southesk collection (about 500 B.C.), is one of the finest Greek gems extant; the delicacy of the long-drawn-out lines is remarkable. Also of first quality are a flying Eros carrying a girl to her lover, on a carnelian scarab (pl. 125o)[28] of the early fifth century, and a satyr, with trunk in three-quarter view, leaning against a wineskin, on a black jasper scaraboid (pl. 126b).[29] In the last the name Anakles is lightly incised in Ionic letters; it is perhaps the name of the artist rather than of the owner, for it is comparatively inconspicuous, like the signature of Epimenes on a gem in Boston. There was an Attic potter named Anakles who lived two generations or so before the time of our gem. A huntsman returning from the chase, on a gilt-bronze ring[30] of about 480 B.C., is a rather cursory work but interesting for the manner in which a complicated design has been fitted into a small space. The hunter is walking along, a gnarled stick in hand, his day's bag slung over his left shoulder; it consists of a small deer hanging down his back and a large, long-necked, long-beaked bird suspended in front, upside down. We may compare the returning hunters on Greek vases. A galloping centaur[31] surrounded by stars and shooting off an arrow (first half, perhaps second quarter, of the fifth century) is apparently the earliest representation in Greek art of the constellation Sagittarius, the Archer (we may compare, as an equally impetuous centaur, the fine bronze statuette, pl. 36g). A flying Eros (pl. 125p),[32] perhaps about to catch a bird; a youth holding two horses[33]; and a Herakles[34] with club, bow, and lion's skin, similar in type to that on coins of Kition, Cyprus, are other fine designs of this period. Several scarabs and scaraboids have engravings of lions, boars, and wild sows (see pl. 126c,d).[35] They recall the devices on coins of Methymna and elsewhere.

DEVELOPED PERIOD, ABOUT 450–330 B.C. The second half of the fifth century and the first half of the fourth are again periods of great achievement in the art of gem engraving. It is the time of Dexamenos of Chios, who signed several of his works (now in Leningrad, Boston, and Cambridge, England). The favorite shape is the scaraboid perforated and worn on a swivel ring. The commonest stones are the chalcedony and the carnelian. Metal rings with engravings on their bezels are also popular. The subjects, like those in vase paintings, are taken from mythology and daily life. Among the more appealing representations in our collection are a bearded Hades seizing the young Persephone, who has dropped her torch in her fright, on a chalcedony scaraboid (pl. 126a)[36] of about 450 B.C. or a little later, and a nude girl,

leaning back and stretching herself, on the bezel of a gold ring (pl. 126e),[37] of about 450–425 B.C. A chariot with two spirited horses driven by a long-robed charioteer, on a mottled red jasper scaraboid,[38] is comparable to chariots on Syracusan coins of the late fifth century. The subject on a large (discolored) carnelian or chalcedony[39] is unusual, a tall youth holding up a garment while a girl crouches in front of him and pulls at his cloak.

Birds and animals are popular themes at this time and some are of fine quality. A heron with a snake in its beak, on an agate barrel,[40] approximates, though it does not quite equal, Dexamenos's engravings. A quail looking for food, on a carnelian scarab set in its original gold ring,[41] a heron walking,[42] or spreading its wings (pl. 126g)[43] (on its other side is a woman standing by a wash basin), a horse preparing to lie down,[44] or grazing,[45] a bull[46] with head and hindquarters in three-quarter view, a fallow deer scratching itself (pl. 126f),[47] a hound tethered to a tree trunk,[48] gnawing a bone,[49] or caressed by a dwarf,[50] are some of the subjects freshly and vividly represented on our stones.

The engravings on several gold rings and on two gold scarabs once mounted on swivel rings, may be assigned to about 400 B.C. and later—a girl dancing, stick in hand (pl. 126j)[51]; a woman with Eros[52]; a woman seated in front of a herm[53]; Eros offering a bunch of grapes to a goose[54]; and a woman with a mirror and a wreath.[55] The graceful attitudes recall similar scenes on vases of the Meidian circle and later (see p. 102). A sard[56] from Catania, Sicily, has a well-knit group of Herakles strangling the Nemean lion; it is practically identical with that on gold coins of Syracuse by the artists Euainetos and Kimon; so it has been suggested that the gem served as an official seal. A chariot with four galloping horses, on a sard scaraboid (pl. 126k),[57] is one of the most spirited engravings of the second half of the fourth century (about 330 B.C.); it may be contrasted with the chariot group of almost a century earlier (see p. 149).

IONIAN AND "GRAECO-PERSIAN" STONES, ABOUT 450–300 B.C. The so-called Graeco-Persian stones are of great interest. The style is similar to that of contemporary Ionian gems, and the shapes (chiefly large scaraboids) and the material (mostly bluish chalcedony) are identical. Only the subjects differ, consisting, on the Graeco-Persian stones, of Persians instead of Greeks. Men in Oriental costume, on horseback and on foot, are shown hunting wild animals (lions, boars, foxes),[58] in combat with their enemies,[59] or standing at rest (pl. 126h)[60] and confronting long-haired women. The latter occasionally appear alone.[61] Sometimes only the hunted animal is shown (pl. 126i),[62] running headlong before its pursuers across the field of the stone. Except for the subjects and a certain "frozen" quality in the representations, they are difficult to distinguish from Ionian ones of the period, for instance, the walking lion,[63] or the deer,[64] or the ram[65] on three bluish gray chalcedonies in our collection.

This strong similarity is natural if we interpret the Graeco-Persian stones as made by Ionian Greeks for Persian clients.

HELLENISTIC PERIOD, LATE IV CENTURY TO ABOUT 100 B.C. In this period the perforated scarab and scaraboid of the preceding centuries were discarded, and an unperforated stone, intended to be set in a ring, became the accepted form. In addition to the rock crystal, carnelian, sard, sardonyx, and agate formerly used, hyacinth, garnet, beryl, topaz, and amethyst are now the favorite materials. Many of these beautiful stones were introduced into the Greek world from the East after the conquests of Alexander. Glass as a substitute for stone became popular. The designs, which are often cut on a convex face, show the wide range of Hellenistic art and include scenes from mythology and daily life, as well as portraits.

A female head, on a chalcedony (pl. 126m)[66] from Amisos, is an excellent portrait of the period. The lines of the hair especially are sensitively drawn. As she wears a diadem she may represent a royal personage. A massive gold ring (pl. 126l)[67] has on its bezel a head, maybe that of Alexander, with the lion's skin of Herakles; it is said to have come from Sovana in Italy. Several large glass gems, some set in their original gilt-bronze rings, have elongated figures of Apollo and of Aphrodite. Three come from the Gréau collection and were given by J. Pierpont Morgan in 1917 (see pl. 126n).[68] A Nike writing on a shield[69] and a seated woman with a lyre,[70] probably a Muse, both on glass ringstones, are typical Hellenistic compositions of considerable charm. A Dionysos,[71] wearing a chiton and a mantle and holding a kantharos and a filleted thyrsos, is in an archaizing style.

GRAECO-ROMAN, I CENTURY B.C.–I CENTURY A.D. Engraved gems enjoyed a special vogue in the early Imperial period and a large number of examples have survived. The carnelian, sard, and red jasper were especially popular; more precious varieties, such as the garnet, topaz, and peridot also occur. The ringstone, flat or convex, is the regular form, and the size is often small. The subjects and styles show the eclectic character of Graeco-Roman art, which borrowed freely from the large artistic store at its disposal. In our selection we have included only stones that show direct Greek inspiration, such as copies and adaptations of Greek statues, mythological scenes perhaps derived from Greek reliefs or paintings, and a few scenes from daily life.

The stones with designs evidently copied from Greek sculptural types (some occur in extant statues and reliefs) include a plasma[72] with the Athena Parthenos by Pheidias; a peridot with Apollo holding a bow and leaning on a pillar (pl. 126o)[73]; a garnet[74] with a youth standing before an image of Artemis; a carnelian[75] with Apollo resting his lyre on a female statue; a brownish chalcedony[76] with Nike sacrificing a bull; a sard[77] with Agave holding the severed head of Pentheus; a

beautiful peridot[78] with a mask of Medusa; and an amethyst with a bust of Dionysos, resembling that in the British Museum signed by Aspasios.[79] Among the mythological scenes are such interesting subjects as Priam begging Achilles for Hektor's body[80] (on a carnelian known since 1834); Hektor, Andromache, and their little son Astyanax[81]; Oedipus and the sphinx[82]; Perseus with the head of Medusa[83]; and the eagle carrying off Ganymede.[84] A moss agate (cut to a lozenge shape in modern times) has a man riding on a turtle,[85] perhaps a mythical founder of a Greek colony in Italy. When we remember that these stones were used for sealing by private owners throughout the Roman empire, we realize how widespread the knowledge of Greek legends had become. Two scenes from daily life are of special interest—a sculptor[86] working on a large vase with mallet and chisel, and a metal worker[87] sitting in front of an anvil and decorating a metal bowl with mallet and punch. Such illustrations of artists at work, which are comparatively rare, give us welcome information regarding ancient technical processes.

CAMEOS. Cameos, in which the representation is carved in relief instead of in intaglio, were introduced in the Hellenistic period and were popular in Roman times. They did not serve as seals, but as decorations in rings and other objects. The favorite materials are stratified stones, like the sardonyx, and glass, often in different colored layers. The subjects are mostly mythological scenes and portraits. A Nereid riding a Triton, in sardonyx,[88] and a head of Medusa, in translucent green glass,[89] are so fresh in execution that they are probably Hellenistic originals. Other fine pieces, Hellenistic in type but of Roman execution, are a Herakles roping Kerberos[90] (a gift from Milton Weil); Dionysos and Ariadne in a chariot drawn by two panthers[91]; Eos, the goddess of dawn, driving a two-horse chariot[92]; and a satyr with two Maenads, one of whom is suckling a panther cub.[93] All are of sardonyx.

COINS

Whereas engraved gems served in most cases as private seals, coins were issued by the state and their type or design was an official seal to certify correctness of weight or value. Coinage was introduced in Greece in the seventh century B.C. and quickly spread throughout the Greek world. Nearly every city adopted its own design; in fact, the wealth and variety of the types are an eloquent commentary on the independent life of the Greek city states. There were various weights and denominations; identity of standard suggests close commercial relations.

Gold, silver, electrum (a natural alloy of gold and silver), and copper with its alloys, were the chief metals used, the first two in a very pure state. Bronze was the commonest material, as least in later times, but owing to corrosion it has not often survived in good preservation. Greek coins are thick compared to modern ones and too irregular to be stacked. They were struck from dies (see p. 6). Each city chose an appropriate design, and mostly the fitness is clear: the owl or the head of Athena for Athens, the eagle for Elis. At other times the meaning escapes us; presumably in most cases the type had a religious significance.

The inscriptions and letters that occur on many of the coins enable us to assign them to specific cities. The absence of such inscriptions during the archaic period makes the early examples sometimes difficult to classify. But even when we can attribute the coins to different localities their styles are hardly distinguishable from one another, an argument in favor of the theory that Greek sculpture developed not locally, but more or less uniformly all over Greece, with artists traveling hither and yon. Occasionally, as in the gems, eminent artists signed their products. A few coins are dated by historical events, like the decadrachms of Syracuse, which were struck to celebrate the victory over Athens in 404 B.C. The designs on such coins supply valuable chronological evidence.

The Greek coins in our collection are mostly from the John Ward collection, which was presented to the Museum by J. Pierpont Morgan in 1905. They are arranged and numbered to accord with the catalogue of that collection by George F. Hill (published in 1901). The dates on the labels are those there assigned, except for some changes that were suggested by the late Edward T. Newell in 1924.

Like the engravings on the gems, the reliefs on the coins reflect the development of Greek art through its various epochs (only occasionally for commercial reasons is a type archaizing). Our collection does not contain many examples of the archaic period, but is fairly representative of the later epochs.

The early archaic coins generally have a design only on one side and an incuse

square on the other. Three gold staters of Croesus, king of Lydia (nos. 723–725*), have foreparts of a lion and a bull, like those from Sardis (see p. 44). Two early staters of Aegina (nos. 511, 512) have a tortoise, which remained the type of that city throughout its independent history. A stater of Corinth (no. 517; pl. 127a) shows an early version of the familiar flying Pegasos. In the South Italian coins of this period the design that appears in relief on the obverse is repeated in intaglio on the reverse. The Poseidon of Poseidonia (nos. 62, 63) is a good example of the striding figure in late archaic art. Taras riding a dolphin, on the coins of Tarentum (nos. 20–22), and the leaping dolphin on a drachm of Zankle (nos. 201–205) are beautifully stylized compositions.

The coins of the first half of the fifth century B.C. include many well-known types, such as the Pegasos of Corinth and the owl of Athens (nos. 518, 519; 499–501). The city of Syracuse was noted for its fine coinage. The horses of the chariot groups on several tetradrachms (see pl. 127b; nos. 239–246, 248, 249) may be compared with the large bronze statuette shown in plate 46. Other noteworthy designs are the river god in the form of a human-headed bull on the coins of Gela (pl. 127c; nos. 148–152) and the nymph Himera on those of Himera (no. 163). The ear of grain on the stater of Metapontum (nos. 48, 49) is an allusion not merely to the fertility of the region but to Demeter, the city's goddess. As in contemporary gems, fine representations of animals often appear—for instance, the eagle of Akragas (Agrigentum) (nos. 131–134), the hound of Segesta (nos. 227–229), and the hare of Methymna. Essential details are given, but they are not allowed to obscure the design as a whole.

Among the coins of the second half of the fifth century is a series of Syracusan decadrachms (nos. 290–295) struck soon after the triumph of the Sicilians over the Athenian navy. The female head surrounded by dolphins on the obverse (pl. 127e), and the quadriga on the reverse (pl. 127d), show the heightened sense for inter-related composition that artists then attained. The skilful manner in which four galloping horses are represented abreast in relief recall the similar achievements on the two silver phialai of this period (see pl. 78a,b). Two examples are signed by Euainetos (no. 293), four by Kimon (no. 297). The youthful river god on the tetradrachm of Selinus (pl. 127f; nos. 235–237) is in the easy, harmonious pose familiar from contemporary sculpture. A tetradrachm of Naxos (nos. 222–225) has a squatting satyr in front view, admirably composed in the circular field. The eagle devouring a hare, on the coins of Akragas (pl. 127g; nos. 140–142), is an excellent example of animal sculpture on a small scale. The reverse of the tetradrachm of Amphipolis shows the decorative use to which an inscription could be put. The krater on the Theban coins (no. 483) has handles similar to the bronze one described on page 95. The head of a lion on the Leontinoi series (nos. 188–192) is a punning allusion to the name of the city, a not unusual feature. The tetradrachm of

* The numbers refer to G. F. Hill's *Catalogue of the Ward Collection of Greek Coins*.

Ainos, in Thrace (nos. 415–417), with the head of Hermes and a goat, illustrates the excellent work produced in the distant North.

The coinage of the fourth century B.C. remained at a high level, as seen in such compositions as the youth on the dolphin from Taras (pl. 127h; nos. 25, 26) and the seated Nike from Terina (pl. 127i; no. 129). The range of subjects becomes wider, the treatment approaching occasionally even the *genre*. A stater of Aspendos (no. 731) has two wrestlers engaging, and one of Kelenderis (nos. 734, 735) has a rider sliding down from his horse. A stater of Herakleia (no. 44) shows Herakles strangling the Nemean lion by means of a hold well-known to wrestlers today. The heads on the coins of Rhodes (nos. 707–712) and Ainos (no. 417) are experiments in full-face renderings, which were soon abandoned, however, for the wear to which coins are subjected made such views impractical.

The Hellenistic coins with the head of Alexander the Great as Herakles (nos. 388–392) illustrate the great change that came in the later part of the fourth century. The loss of independence by the city states is reflected in the disappearance of their emblems. Henceforth the subjects are usually, though not exclusively, portraits of rulers on the obverse and divinities, sometimes copies of statues, on the reverse. The head of Ptolemy Soter on the gold stater of Egypt (no. 883) is the first instance of a direct portrait of a living man on a Greek coin. The heads of Antiochos II (pl. 127j; no. 777), Prusias I (pl. 127k; no. 592), and Philetairos of Pergamon (pl. 127l; nos. 620–622) make us realize the high quality of Hellenistic portraiture.

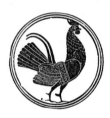

JEWELRY

VII–III CENTURY B.C.

Greek jewelry reflects the Greek taste for restraint and careful workmanship. It differs from the jewelry of most other peoples in that gold was used not only for settings of precious stones but as a vehicle for the expression of artistic thought. The great possibilities of this ductile material were developed, and modeling, casting, repoussé, cutting, granulation, filigree, plait work, and chasing were practiced with skill and delicacy.

Though silver was also used, perhaps extensively, comparatively little of it has survived, for it easily corrodes and disintegrates. Gold, however, is untouched by time and dampness, and Greek work in this medium can be appreciated in its pristine state, except for the absence of the enamel that once introduced a discreet color note. Electrum—a natural alloy of gold and silver—was popular in early times for jewelry, as it was for coins (see p. 152).

The Museum has an extensive collection of jewelry, which is shown in four categories—Greek, Cypriote, Etruscan, and Roman. We shall confine ourselves here to short accounts of the Greek and Cypriote displays, the Etruscan and Roman being outside the scope of this Handbook.

Little Greek jewelry of the Geometric age has been found in Greece, and comparatively little of the sixth century B.C. or even of the fifth. This paucity is not due only to accident, though naturally much gold and silver was melted down, but it reflects the condition of the times. Greece was never a rich country and in early days her citizens did not spend much money on personal ornaments, still less did they stow them away in tombs. The most flourishing time for the craft was the fourth century B.C. At least most extant Greek jewelry of high quality dates from that epoch. It is significant, however, that much of it was found outside of Greece proper —in rich Macedonia, the Propontis, and the Crimea. With the conquest of the East under Alexander the Great, Greece obtained easy access to a variety of stones, and Greek jewelry gradually lost one of its essential characteristics. Instead of the minute, accomplished work in the metal itself, more showy effects were obtained by the use of colored stones. Even then, however, Greek restraint generally prevented overladen, pretentious designs.

The changes in style and workmanship will be appreciated by the study of a few selected pieces of each period in our collection. (For the Minoan and Helladic jewelry of the Bronze Age see p. 17, and for gold and silver rings with engraved bezels see pp. 146 ff.)

Our display of archaic Greek jewelry contains a few choice pieces. The sturdy, yet

delicate work produced in the seventh century B.C. is illustrated in a six-petaled electrum rosette (pl. 128d),[1] said to be from Rhodes. Each petal is ornamented with a smaller rosette, and from the center rises a griffin's head; fine wire and granulation are used for decoration. The piece probably formed part of a diadem and was fastened to a band (there are small holes at the back). Similar ornaments have been found in other Greek islands, for instance, in Thera, Melos, and Delos. A pair of earrings (pl. 128b),[2] each in the form of a hook with a cage-like pendant, are said to have come from Tharros in Sardinia. They date from the seventh to the sixth century. Earrings of this type have also been found in Cyprus (several are in the Cesnola collection), Rhodes, and Carthage, and are generally referred to as Phoenician. An earring in the form of a spiral of gold-plated bronze has at each end a pyramid of gold globules and a collar decorated with tongues and scrolls in filigree (pl. 128a).[3] In the *cloisons* of the tongues are traces of blue and green enamel. Earrings of this form occur on coins and other monuments of the end of the archaic period and later. They must have been suspended from a ring which was inserted in the lobe of the ear. A pair of gold earrings from Naxos are boat-shaped, with one end elongated to form the hook (pl. 128c)[4]; beneath are two box-like pendants decorated alternately with spirals in filigree and with pointed bosses.

Our collection is rich in masterpieces of the fourth century and contains two magnificent ensembles. One group, said to have been found in a tomb in Madytos on the Hellespont, includes a diadem, a necklace, a pair of earrings, a finger ring, seven rosettes, and nineteen beads from a necklace.[5] The diadem (see pl. 129d) has a design in relief with Dionysos and Ariadne in the center, flanked by female figures playing various instruments—the lyre, the harp, the flute, and the lute; one holds a scroll and is singing; spiral arabesques stemming from a central acanthus flow through the composition, and flowers, birds, and grasshoppers are skilfully inserted at intervals. The necklace (see pl. 129b) consists of a woven braid of fine gold wire from which amphora-shaped pendants are suspended by chains (the ὅρμος ἀμφορέων listed in the inventories of Greek temples). Tiny rosettes and griffins' heads, each separately modeled, mask the points of attachment. The clasp at each end is decorated with filigree and granulation. The earrings (see pl. 129a) are equally elaborate and likewise worked with almost incredible minuteness. Sculptural ornaments are introduced here and there—winged griffins and Erotes at some of the junctures, and a Muse, playing the lyre, above the crescent-shaped pendant. In spite of the wealth of detail the all-over design stands out clearly.

The second set, which is said to have come from Macedonia, consists of a necklace, two bracelets, a finger ring, four brooches, and a pair of earrings.[6] It has been described by an expert in Greek goldwork as "one of the most magnificent sets known in the whole field of classical jewelry." The earrings (see pl. 129c) are particularly remarkable and have given the set the name of the Ganymede jewels. From

an elaborate palmette with two layers of leaves and a central fruit are suspended two figures, the eagle of Zeus carrying off young Ganymede. The figures are cast solid; Ganymede's drapery, the wings and tail of the eagle, and the palmette are hammered; the feathers of the eagle are chased; each leaf of the palmette is edged with beaded wire, and the fruit is covered with granulation. The bracelets are of rock crystal, spirally ribbed, and terminate in gold finials, each shaped like a ram's head with a profusely decorated collar (see pl. 129g); the ends of the horns are made separately and soldered on; the ram's wool is indicated by chased dots. The finger ring is a hoop of double-twisted wire soldered to a band setting, with a large, domed emerald. The four brooches, or fibulae, are of intricate design. Each is a semicircular bow strung with mill-wheel ornaments and has elaborate projections at the ends. The necklace is comparatively plain. It is composed of a plaited ribbon and pendants shaped like three-sided spearheads, a form often mentioned in inventories of Greek temples. A similar necklace was found at Corinth with a hoard of forty-one coins of Philip II and ten of Alexander the Great, assignable to about the time of Alexander's death, 323 B.C. The Ganymede set may well be of this general period. The type of the brooches points to northern Greece.

Several single pieces of this period are likewise outstanding; for instance, an earring in the shape of a siren with spread wings playing the kithara (pl. 128e)[7] and a pair of earrings of the disk and pendent pyramid type, ornamented with filigree and with lions' masks in relief.[8] A gold ornament of pediment shape (pl. 128g)[9] is decorated with scrolls and palmettes in filigree and with foreparts of winged horses at the corners; the Ionic capital at one side suggests that there was once a whole façade, and indeed parts of such shrines are extant. At the back are fastenings apparently for a pin.

Other necklaces, bracelets of silver and gold with lion's head attachments, a spool-shaped ornament with a Nereid in relief (pl. 128f),[10] fibulae, finger rings, and earrings with Erotes or birds or lions' heads show the rich variety of motives within the accepted types.

The same forms continued into the Hellenistic period; but gradually a change becomes evident. Colored stones are freely introduced; the jewelry becomes more showy, but the goldwork inevitably deteriorates. With simpler means for striking results at their command, the goldsmiths neglected the minute work of their predecessors. We need only examine the diadem with a garnet center (pl. 129e)[11] and the earrings with pendent birds[12] and female heads[13] to realize the change. The things are pretty and effective, but how different in quality is now almost every detail of the work!

Masterpieces, however, are not absent. A part of a set of the fourth to third century B.C.[14] is said to have been found at Eretria, in Boeotia, in the same tomb as the bronze hydria seen on plate 90a. It includes three pairs of disk-form earrings

with pendants, a superb bracelet, and two ornaments which were probably diadems, now bent out of shape. The bracelet has a hoop of spirally twisted wire and ends in lions' heads which emerge from richly ornamented collars (pl. 129f). The diadems consist of a central medallion, fastened by hinges to two bands that are decorated with reliefs and end in loops for tying to a ribbon. An elaborate necklace,[15] found in Tarentum, has as its chief feature a frontal head of Dionysos in relief—a sculptural piece of high quality.

The Cesnola collection of jewelry from Cyprus* contains examples from the Late Bronze Age of the second millennium B.C. down to Roman times. The discovery of the "treasury chambers" at Curium, filled with gold and silver ornaments, is vividly described by General Cesnola in his book on Cyprus. No subsequent explorer has been able to rediscover these particular tombs and no accurate information about them is now available. The objects are, therefore, shown not in tomb groups but as separate units in chronological sequence. They supplement our collection of Greek jewelry in a welcome manner, for several periods only sparsely illustrated in the Greek collection are here more adequately represented. Moreover they show in an interesting way the hybrid, semi-Greek and semi-Oriental, character of Cypriote art.

The Late Bronze Age section includes a gold frontlet with stamped concentric circles (pl. 130a),[16] a necklace with palmette pendants,[17] roundels with embossed rosette and lotus ornaments (see pl. 130c)[18] similar to those found in the royal shaft graves of Mycenae, a large silver pin,[19] and earrings of various forms (see pl. 130b).[20]

Among the examples of the Greek periods, the most remarkable are the heavy, gold-plated spiral earrings, with heads or foreparts of griffins (see pl. 130f,g),[21] perhaps of the fifth century B.C. Design and execution are of a high order. A pendant in the form of a sphinx (pl. 130e)[22] and a disk with clusters of bells hung on chains (pl. 130d)[23] are also outstanding. There are necklaces with semiprecious stones, gold, gold-plated, and silver bracelets with different-shaped terminals, gold pins, a great variety of earrings, mostly ending in animals' heads, and a large assortment of finger rings. A crystal scent bottle,[24] similar in form to Egyptian alabaster vases, has a gold cover decorated with granules and filigree.

It is a splendid display, eloquent of the wealth of Cyprus and of the love for personal adornment of Cypriote women. A comparison of these ornaments with those represented in Cypriote sculpture gives evidence of how and when they were worn.

* For a detailed description of it cf. J. L. Myres, *Handbook of the Cesnola Collection*, pp. 373 ff.

PLATES

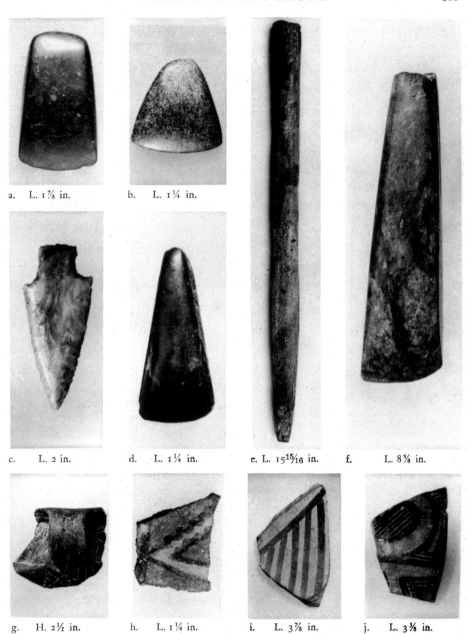

a. L. 1⅞ in. b. L. 1¼ in.

c. L. 2 in. d. L. 1¼ in. e. L. 15¹⁵⁄₁₆ in. f. L. 8⅝ in.

g. H. 2½ in. h. L. 1¼ in. i. L. 3⅞ in. j. L. 3⅜ in.

I. NEOLITHIC STONE IMPLEMENTS AND POTSHERDS

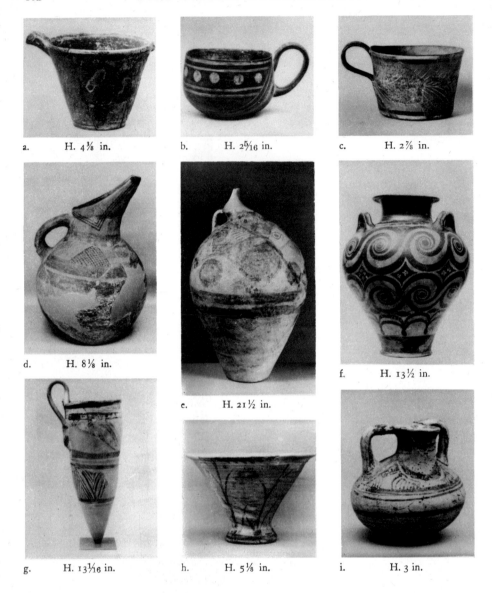

a. H. 4⅜ in. b. H. 2⁵⁄₁₆ in. c. H. 2⅞ in.

d. H. 8⅛ in.

e. H. 21½ in.

f. H. 13½ in.

g. H. 13¹⁄₁₆ in. h. H. 5⅛ in. i. H. 3 in.

2. POTTERY FROM CRETE. EARLY, MIDDLE, AND LATE MINOAN PERIODS

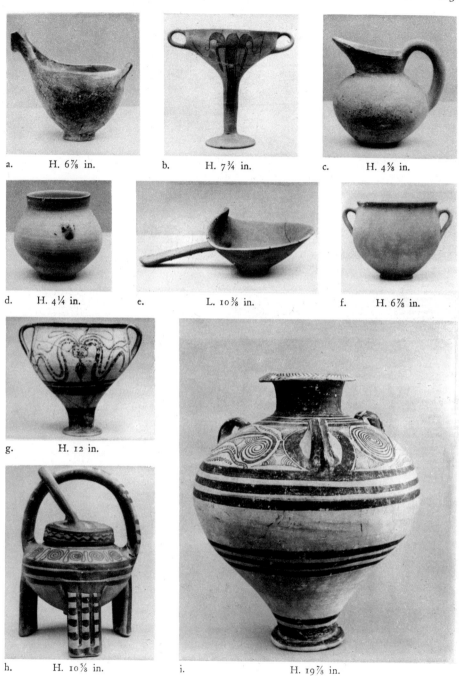

a.　　H. 6⅞ in.　　　b.　　H. 7¾ in.　　　c.　　H. 4⅝ in.

d.　　H. 4¼ in.　　　e.　　L. 10⅜ in.　　　f.　　H. 6⅞ in.

g.　　H. 12 in.

h.　　H. 10⅜ in.　　　i.　　H. 19⅞ in.

3. POTTERY FROM THE MAINLAND. EARLY AND LATE HELLADIC PERIODS

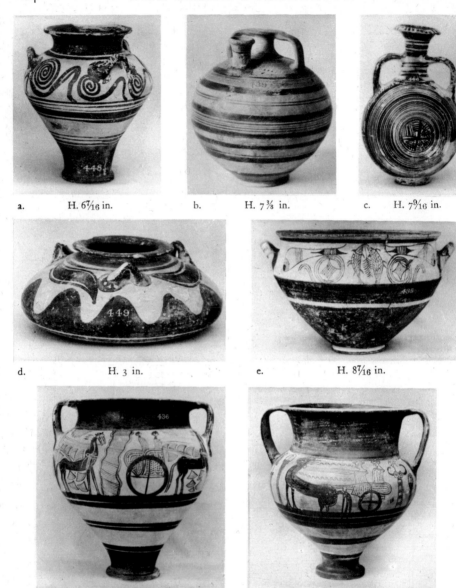

a. H. 6⁷⁄₁₆ in. b. H. 7⅜ in. c. H. 7⁹⁄₁₆ in.

d. H. 3 in. e. H. 8⁷⁄₁₆ in.

f. H. 14⁷⁄₁₆ in. g. H. 16⅜ in.

4. POTTERY FROM CYPRUS. LATE BRONZE AGE

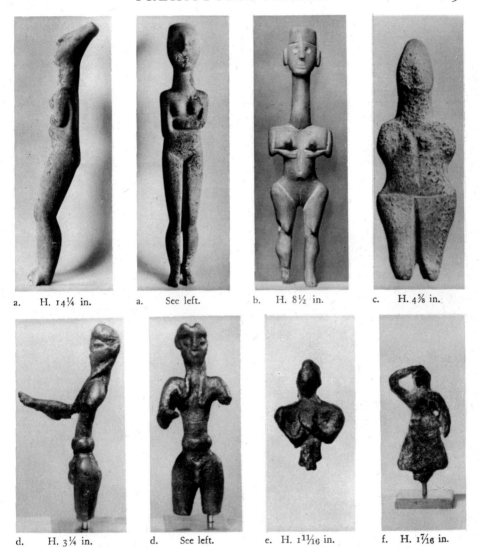

a. H. 14¼ in. a. See left. b. H. 8½ in. c. H. 4⅝ in.

d. H. 3¼ in. d. See left. e. H. 1¹¹⁄₁₆ in. f. H. 1⁷⁄₁₆ in.

5. MARBLE AND BRONZE STATUETTES FROM CRETE AND THE GREEK ISLANDS

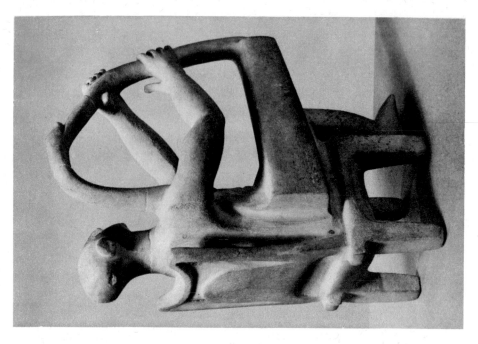

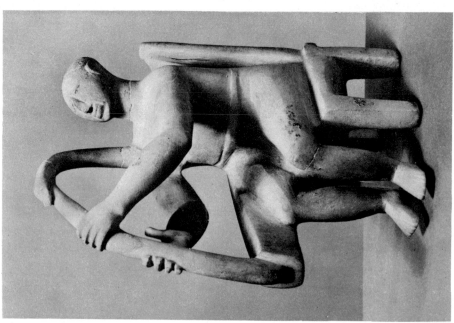

H. 11½ in.

6. CYCLADIC MARBLE STATUETTE OF A HARPER

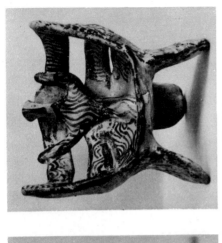

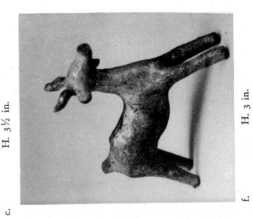

H. 3½ in.

c.

H. 3 in.

f.

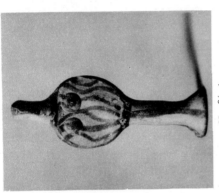

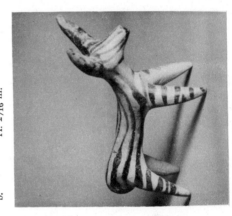

H. 2⁹⁄₁₆ in.

b.

H. 3¼ in.

e.

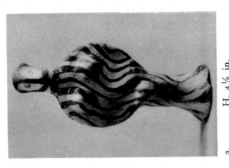

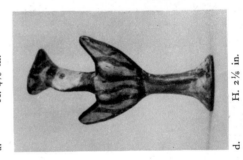

H. 4⅛ in.

a.

H. 2⅛ in.

d.

7. TERRACOTTA STATUETTES FROM THE MAINLAND

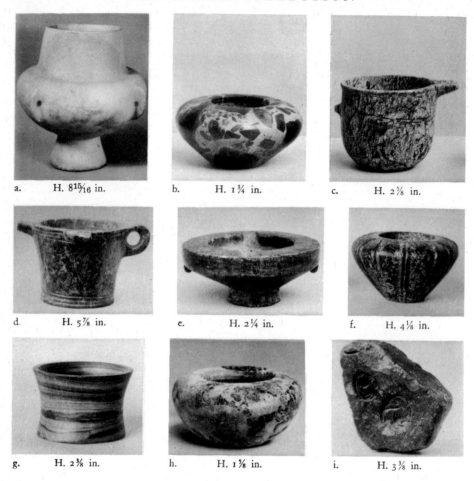

a. H. 8¹⁵⁄₁₆ in. b. H. 1¾ in. c. H. 2⅝ in.

d. H. 5⅞ in. e. H. 2¼ in. f. H. 4⅛ in.

g. H. 2⅜ in. h. H. 1⅞ in. i. H. 3⅜ in.

8. STONE VASES AND A MOLD FROM THE GREEK ISLANDS AND CRETE

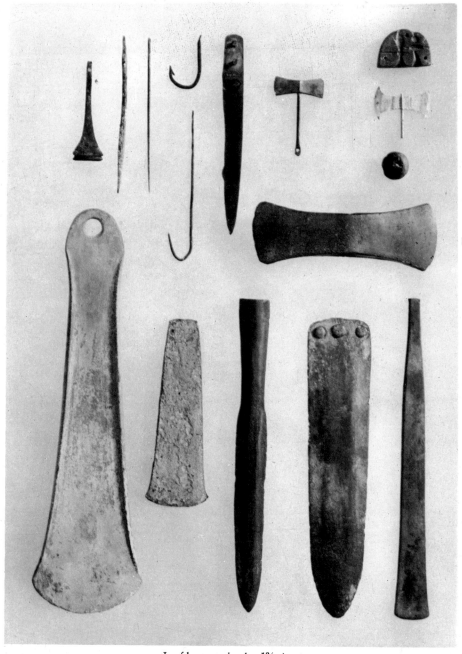

L. of large axe-head 12¹³⁄₁₆ in.

9. METAL TOOLS AND WEAPONS

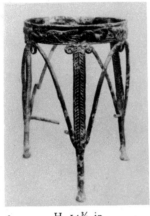

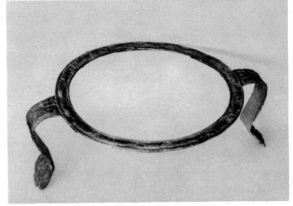

a. H. 14¾ in. b. D. 15¾ in.

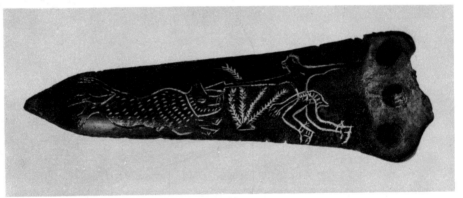

c. L. 6 in.

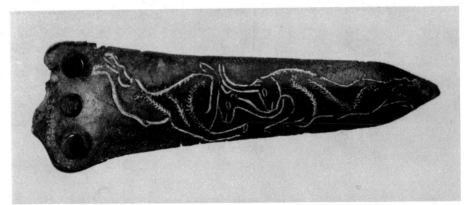

c. See above.

10. BRONZE TRIPOD, RIM OF A CAULDRON, AND DAGGER BLADE

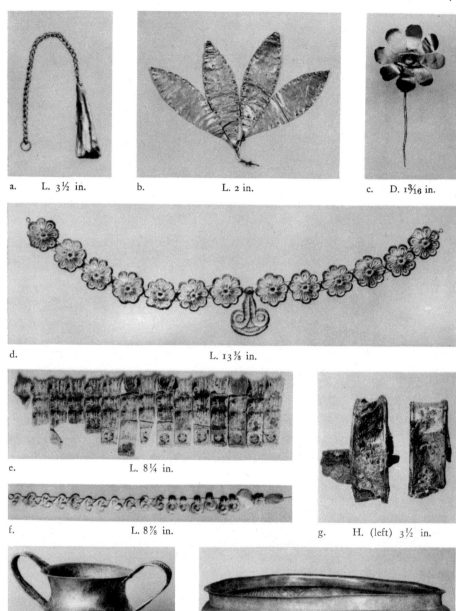

a. L. 3½ in.

b. L. 2 in.

c. D. 1³⁄₁₆ in.

d. L. 13⅜ in.

e. L. 8¼ in.

f. L. 8⅞ in.

g. H. (left) 3½ in.

h. H. 2⅞ in.

i. H. 2¼ in.

11. JEWELRY, CRETAN AND MAINLAND. GOLD AND SILVER VASES, MAINLAND AND ISLAND

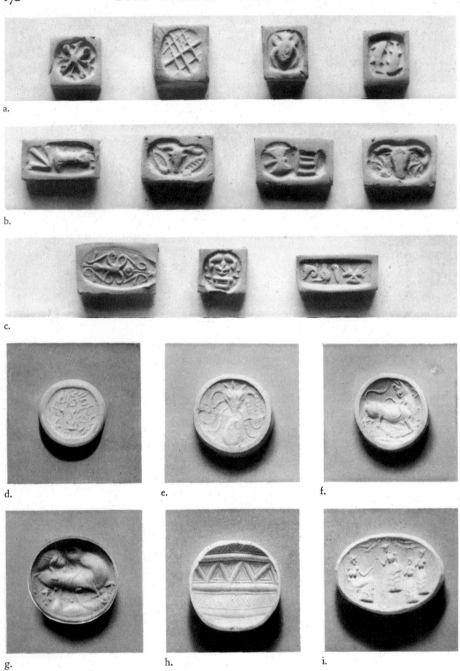

12. PLASTER IMPRESSIONS OF CRETAN SEALSTONES. EARLY TO LATE MINOAN

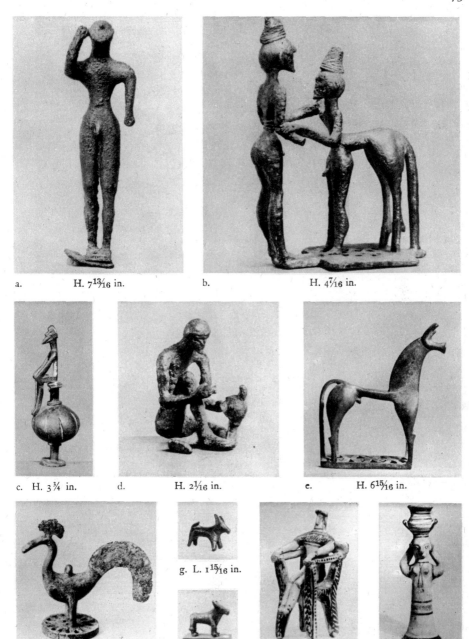

a. H. 7¹³⁄₁₆ in. b. H. 4⁷⁄₁₆ in.

c. H. 3¾ in. d. H. 2¹⁄₁₆ in. e. H. 6¹⁵⁄₁₆ in.

g. L. 1¹⁵⁄₁₆ in.

f. H. 4 in. h. L. 2⅜ in. i. H. 4⅞ in. j. H. 3 in.

13. BRONZE AND TERRACOTTA STATUETTES FROM VARIOUS SITES

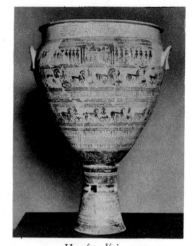

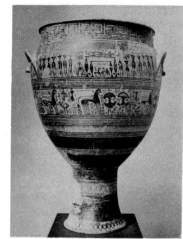

a. H. 4 ft. 3⅜ in. b. H. 3 ft. 6⅝ in.

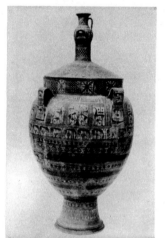

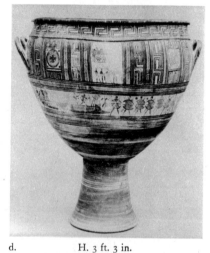

c. H. 3 ft. 9¼ in. d. H. 3 ft. 3 in.

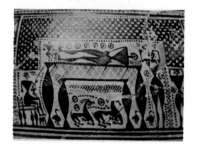

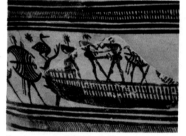

e. Detail of b. f. Detail of d.

14. COLOSSAL TERRACOTTA VASES

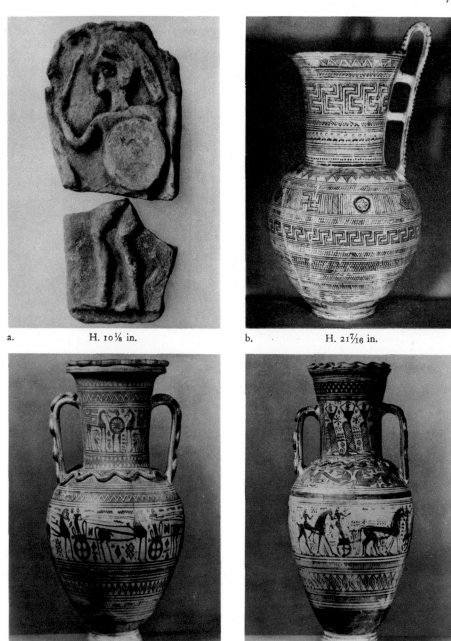

a. H. 10⅛ in.

b. H. 21⁷⁄₁₆ in.

c. H. 27 in.

d. H. 30⅝ in.

15. TERRACOTTA PLAQUE AND VASES

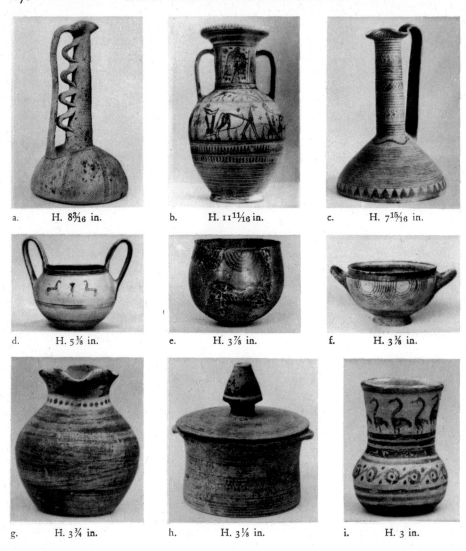

a. H. 8⅜₁₆ in. b. H. 11¹¹⁄₁₆ in. c. H. 7¹⁵⁄₁₆ in.

d. H. 5⅜ in. e. H. 3⅞ in. f. H. 3⅜ in.

g. H. 3¾ in. h. H. 3⅛ in. i. H. 3 in.

16. TERRACOTTA VASES

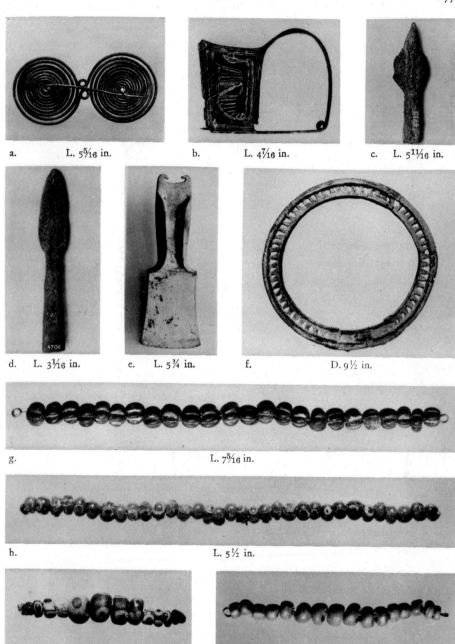

a. L. 5$\frac{5}{16}$ in. b. L. 4$\frac{7}{16}$ in. c. L. 5$\frac{11}{16}$ in.

d. L. 3$\frac{1}{16}$ in. e. L. 5$\frac{3}{4}$ in. f. D. 9$\frac{1}{2}$ in.

g. L. 7$\frac{5}{16}$ in.

h. L. 5$\frac{1}{2}$ in.

i. L. 2$\frac{3}{4}$ in. j. L. 3$\frac{13}{16}$ in.

17. BRONZE PINS AND OTHER METAL OBJECTS. GLASS BEADS

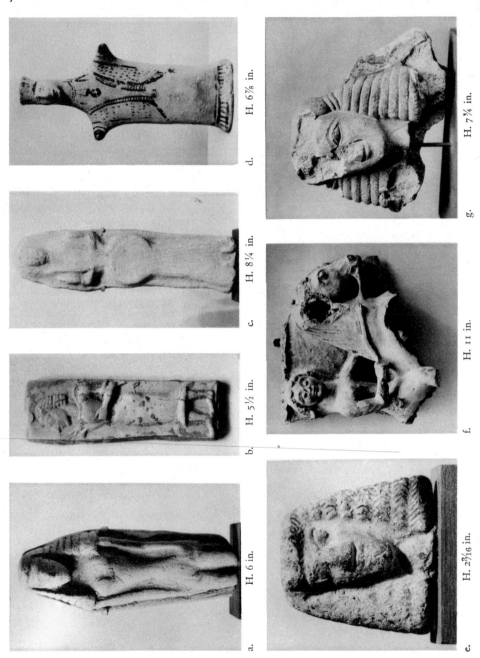

d. H. 6⅞ in.

g. H. 7¼ in.

c. H. 8¼ in.

f. H. 11 in.

b. H. 5½ in.

a. H. 6 in.

e. H. 2³⁄₁₆ in.

18. TERRACOTTAS FROM CRETE, BOEOTIA, AND ITALY

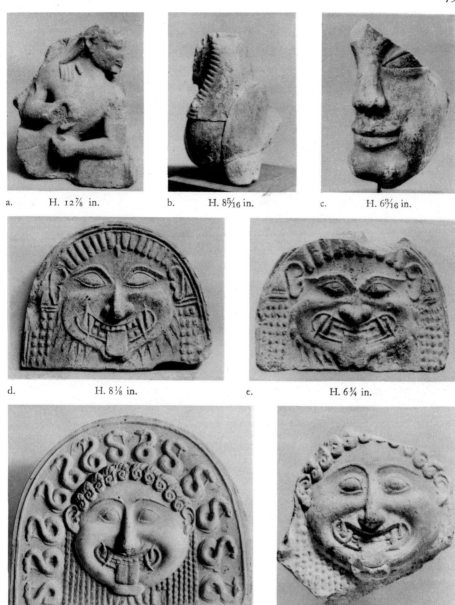

a. H. 12⅞ in. b. H. 8⁵⁄₁₆ in. c. H. 6³⁄₁₆ in.

d. H. 8⅛ in. e. H. 6¾ in.

f. H. 8¼ in. g. H. 5⅝ in.

19. TERRACOTTAS FROM ITALY AND SICILY AND A LIMESTONE SPHINX FROM GREECE

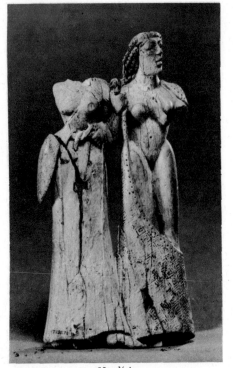

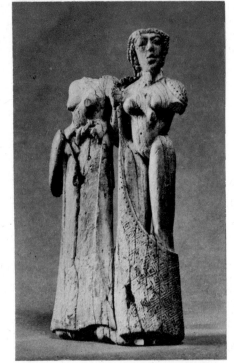

a. H. 5⅜ in. a. See left.

b. H. 1⁹⁄₁₆ in.

20. IVORY AND SILVER RELIEFS

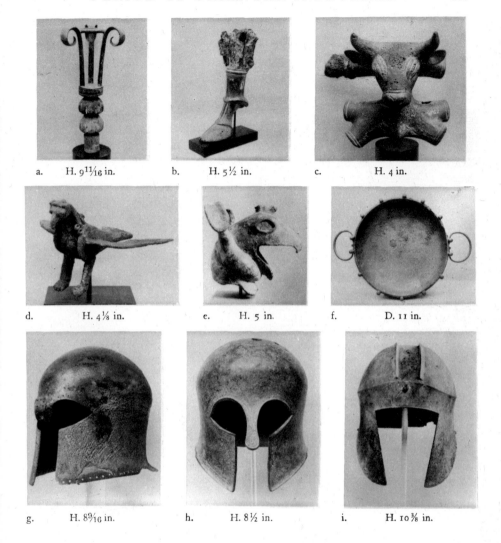

a. H. 9¹¹⁄₁₆ in. b. H. 5½ in. c. H. 4 in.

d. H. 4⅛ in. e. H. 5 in. f. D. 11 in.

g. H. 8⁹⁄₁₆ in. h. H. 8½ in. i. H. 10⅜ in.

21. BRONZE FIGURES, UTENSILS, AND HELMETS

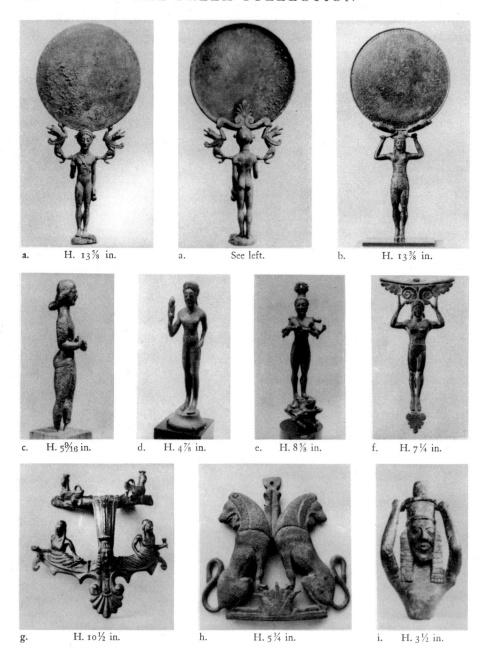

a. H. 13⅜ in. a. See left. b. H. 13⅜ in.

c. H. 5⁹⁄₁₆ in. d. H. 4⅞ in. e. H. 8⅞ in. f. H. 7¼ in.

g. H. 10½ in. h. H. 5¾ in. i. H. 3½ in.

22. BRONZE MIRRORS, STATUETTES, AND OTHER OBJECTS

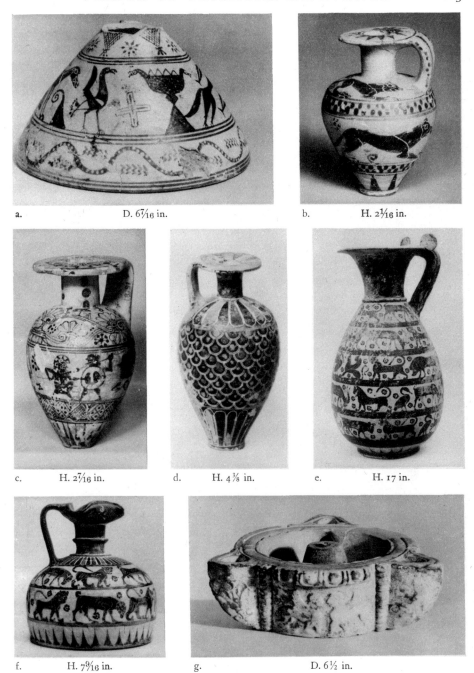

a. D. 6⁷⁄₁₆ in. b. H. 2¹⁄₁₆ in.

c. H. 2⁷⁄₁₆ in. d. H. 4⅜ in. e. H. 17 in.

f. H. 7⁹⁄₁₆ in. g. D. 6½ in.

23. POTTERY, PROTO-CORINTHIAN AND TRANSITIONAL. MARBLE LAMP

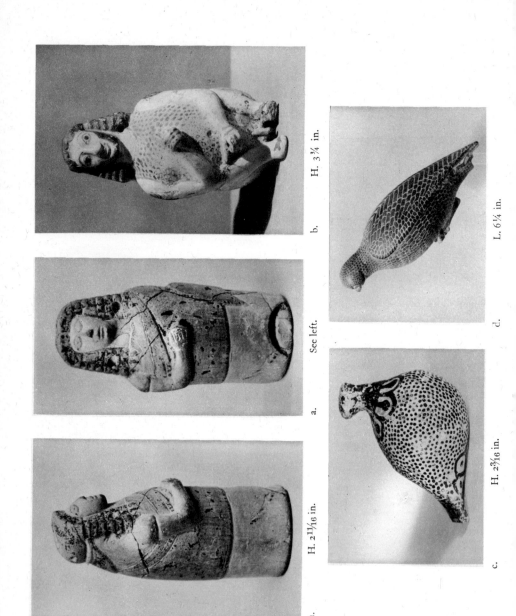

b. H. 3¾ in.

a. See left.

d. L. 6¼ in.

c. H. 2³/₁₆ in.

a. H. 2¹¹/₁₆ in.

24. PLASTIC VASES, PROTO-CORINTHIAN AND CORINTHIAN

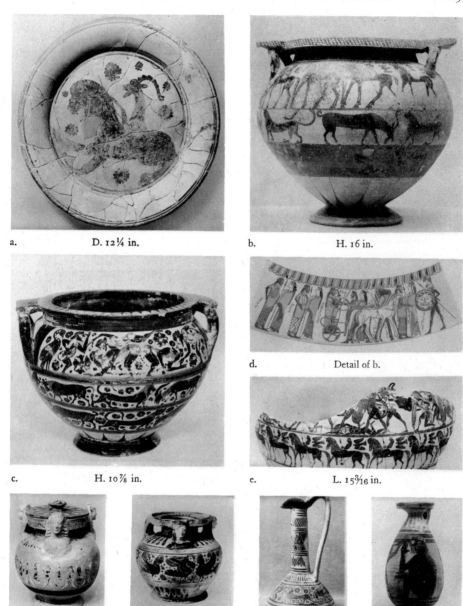

a. D. 12¼ in. b. H. 16 in.

c. H. 10⅞ in. d. Detail of b.

 e. L. 15³⁄₁₆ in.

f. H. 6¹³⁄₁₆ in. g. H. 5¾ in. h. H. 6⅛ in. i. H. 3⁵⁄₁₆ in

25. CORINTHIAN POTTERY

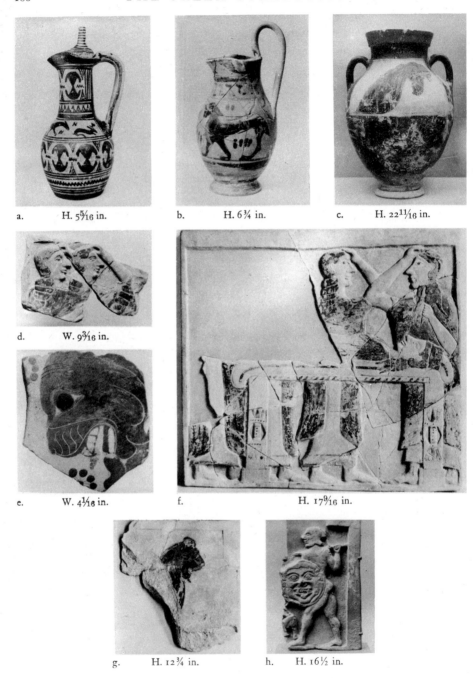

a. H. 5⅚ in. b. H. 6¾ in. c. H. 22¹¹⁄₁₆ in.

d. W. 9³⁄₁₆ in.

e. W. 4¹⁄₁₆ in. f. H. 17⁹⁄₁₆ in.

g. H. 12¾ in. h. H. 16½ in.

26. ATTIC TERRACOTTA VASES AND PLAQUES

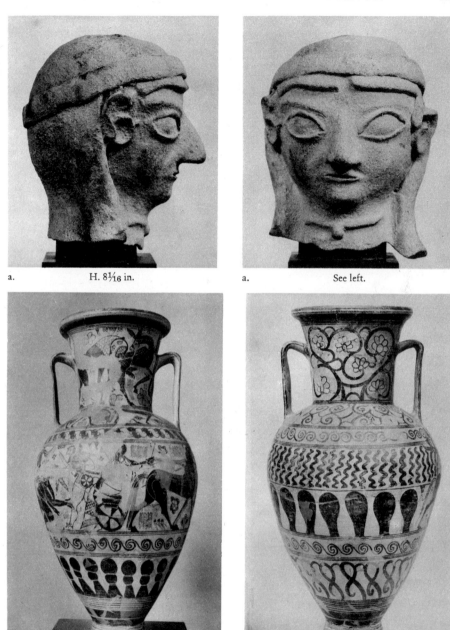

a. H. 8¹⁄₁₆ in. a. See left.

b. H. 3 ft. 6¾ in. b. See left.

27. TERRACOTTA HEAD AND EARLY ATHENIAN COLOSSAL VASE

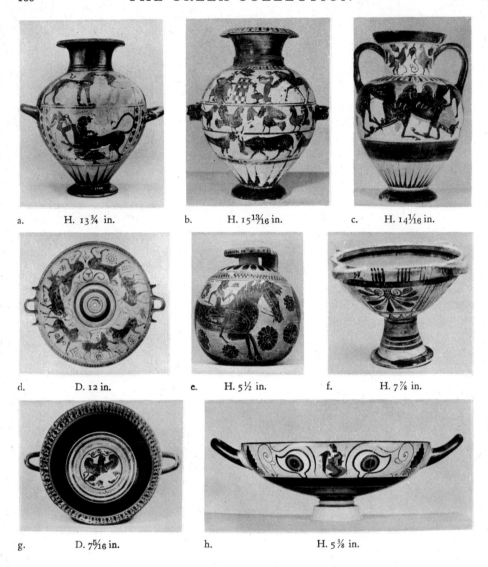

a. H. 13¾ in. b. H. 15¹³⁄₁₆ in. c. H. 14¹⁄₁₆ in.

d. D. 12 in. e. H. 5½ in. f. H. 7⅞ in.

g. D. 7⁵⁄₁₆ in. h. H. 5⅜ in.

28. ATHENIAN, BOEOTIAN, "CHALCIDIAN," AND LACONIAN POTTERY

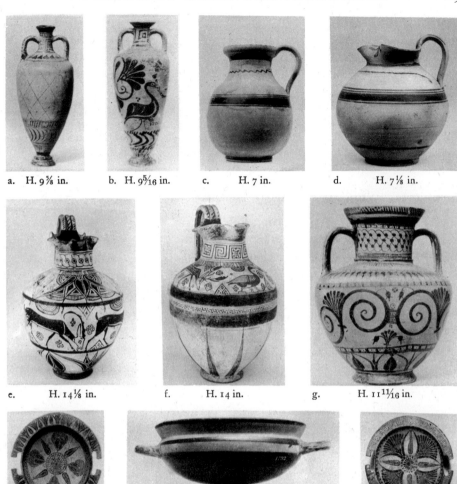

a. H. 9⅜ in. b. H. 9⁵⁄₁₆ in. c. H. 7 in. d. H. 7⅛ in.

e. H. 14⅛ in. f. H. 14 in. g. H. 11¹¹⁄₁₆ in.

h. D. 12⅛ in. i. H. 3¹⁄₁₆ in. j. D. 11¾ in.

29. EAST GREEK POTTERY

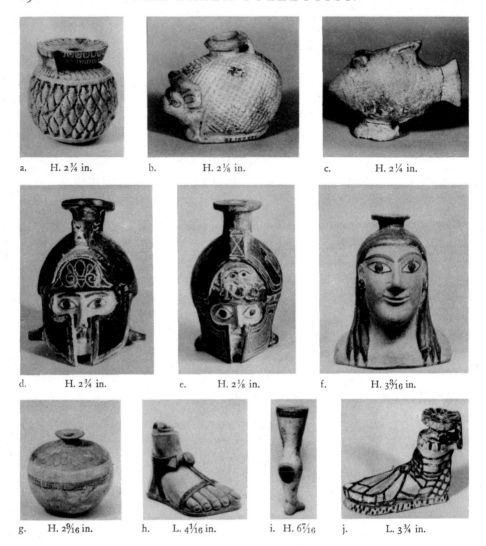

a. H. 2¾ in. b. H. 2⅛ in. c. H. 2¼ in.

d. H. 2¾ in. e. H. 2⅛ in. f. H. 3³⁄₁₆ in.

g. H. 2⁹⁄₁₆ in. h. L. 4¹⁄₁₆ in. i. H. 6⁷⁄₁₆ j. L. 3¾ in.

30. PLASTIC, FAIENCE, AND TERRACOTTA VASES, PROBABLY ALL EAST GREEK

a. L. 9⁹⁄₁₆ in. b. H. 11½ in.

c. L. 19⅝ in. d. H. 7⅝ in.

e. H. 7³⁄₁₆ in.

31. TERRACOTTA REVETMENTS FROM SARDIS, LYDIA

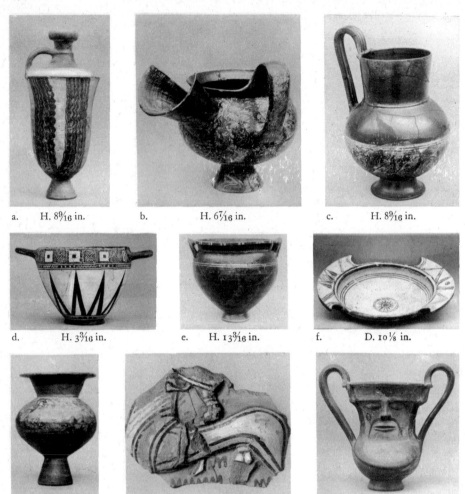

a.　　H. 8⁹⁄₁₆ in.　　b.　　　H. 6⁷⁄₁₆ in.　　c.　　　H. 8⁹⁄₁₆ in.

d.　　H. 3³⁄₁₆ in.　　e.　　H. 13³⁄₁₆ in.　　f.　　D. 10⅛ in.

g.　H. 4⅛ in.　　h.　　　W. 5⅝ in.　　i.　　H. 8⅜ in.

32. POTTERY FROM SARDIS

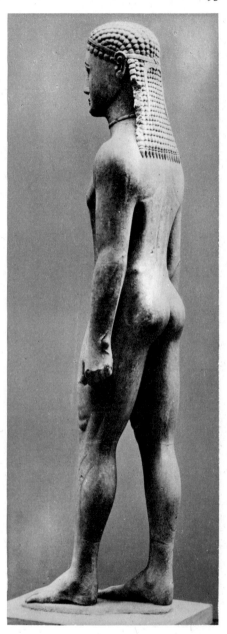

H. 6 ft. 4 in.

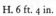 33. MARBLE STATUE OF A YOUTH (KOUROS)

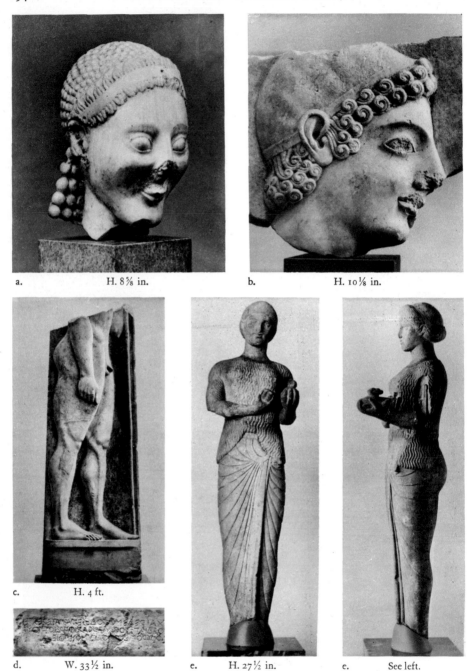

a. H. 8⅝ in. b. H. 10⅛ in.

c. H. 4 ft.

d. W. 33½ in. e. H. 27½ in. e. See left.

34. MARBLE SCULPTURES AND AN INSCRIPTION FROM A GRAVE MONUMENT

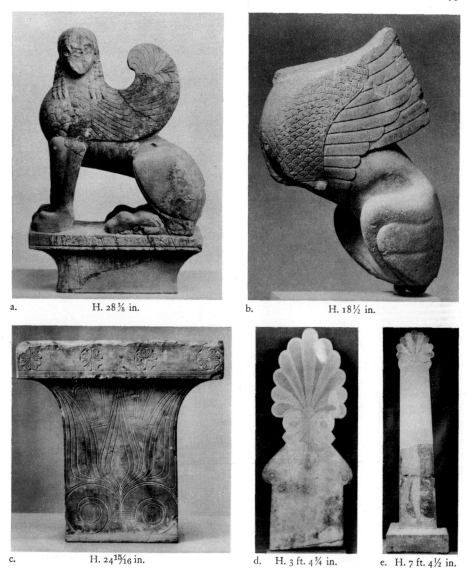

a.　　　　　H. 28⅜ in.　　　　　b.　　　　　H. 18½ in.

c.　　　　H. 24¹⁵⁄₁₆ in.　　　　d.　　H. 3 ft. 4¾ in.　　　e.　H. 7 ft. 4½ in.

35. MARBLE AND LIMESTONE SEPULCHRAL OR VOTIVE MONUMENTS

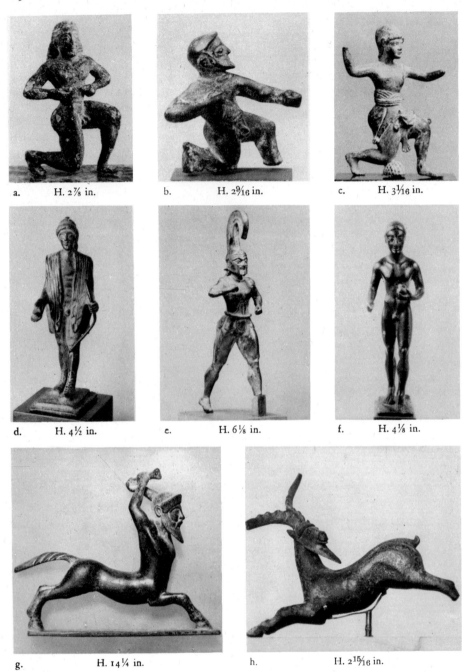

a. H. 2⅞ in. b. H. 2⁹⁄₁₆ in. c. H. 3¹⁄₁₆ in.

d. H. 4½ in. e. H. 6⅛ in. f. H. 4⅛ in.

g. H. 14¼ in. h. H. 2¹⁵⁄₁₆ in.

36. ARCHAIC BRONZE STATUETTES

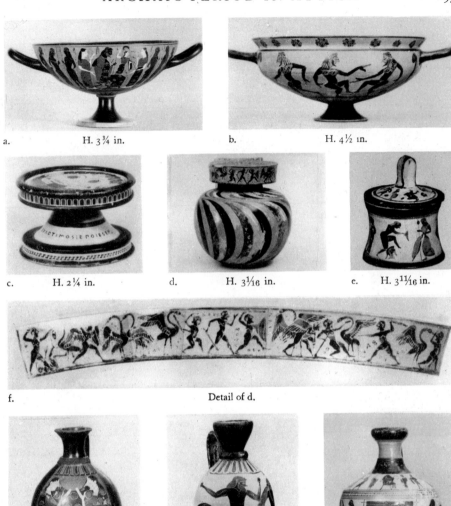

a. H. 3¾ in. b. H. 4½ in.

c. H. 2¼ in. d. H. 3¹⁄₁₆ in. e. H. 3¹¹⁄₁₆ in.

f. Detail of d.

g. H. 6⅞ in. h. H. 10⅝ in. i. H. 6¾ in.

37. BLACK-FIGURED POTTERY, ABOUT 590–530 B.C.

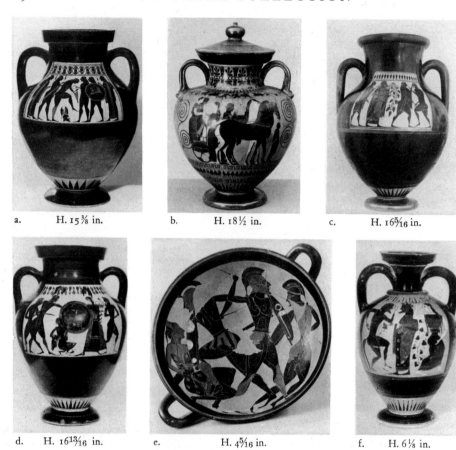

a. H. 15⅜ in. b. H. 18½ in. c. H. 16⁵⁄₁₆ in.

d. H. 16¹³⁄₁₆ in. e. H. 4⁵⁄₁₆ in. f. H. 6⅛ in.

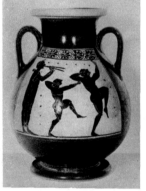
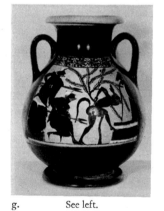
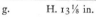

g. H. 13⅛ in. g. See left.

38. BLACK-FIGURED POTTERY, SECOND AND THIRD QUARTERS OF THE VI CENTURY B.C.

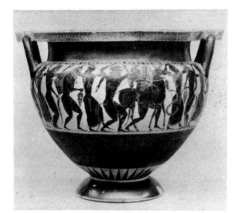

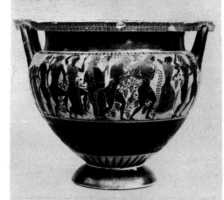

a. H. 22 in.

a. See left.

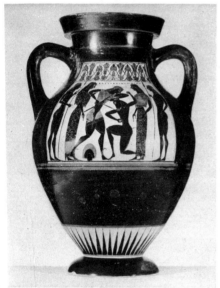

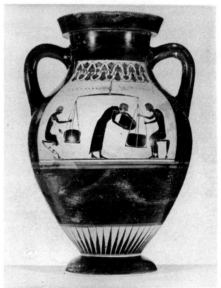

b. H. 11⅞ in.

b. See left.

39. A KRATER BY LYDOS AND AN AMPHORA BY THE TALEIDES PAINTER

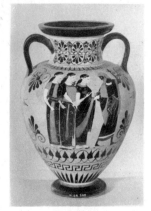

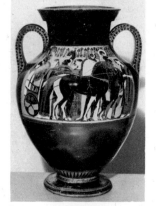

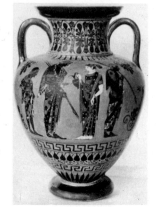

a. H. 14¾ in. b. H. 20⅚₆ in. c. H. 14¹³⁄₁₆ in.

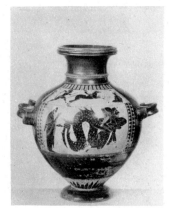

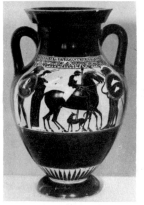

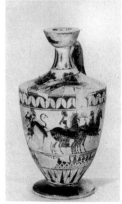

d. H. 13⅛ in. e. H. 21⁹⁄₁₆ in. f. H. 6¾ in.

40. BLACK-FIGURED POTTERY, SECOND HALF OF THE VI CENTURY B.C.

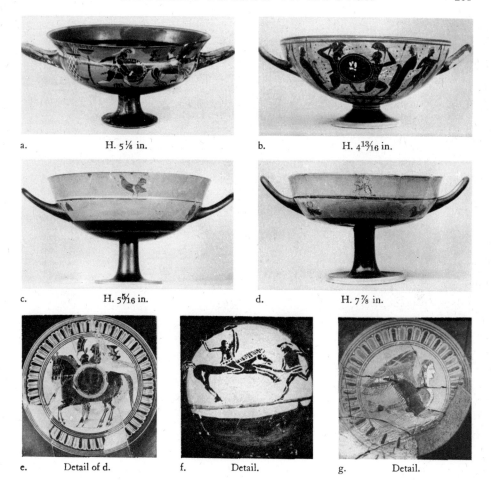

a. H. 5⅛ in. b. H. 4¹³⁄₁₆ in.

c. H. 5⁵⁄₁₆ in. d. H. 7⅞ in.

e. Detail of d. f. Detail. g. Detail.

41. BLACK-FIGURED KYLIKES, SECOND AND THIRD QUARTERS OF THE VI CENTURY B.C.

a. Detail. b. Detail.

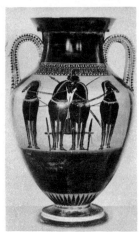

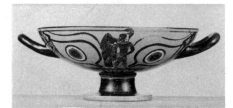

c. H. 5¹⁄₁₆ in. d. H. 4¹³⁄₁₆ in.

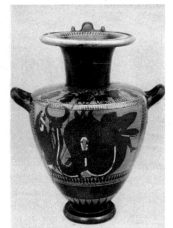

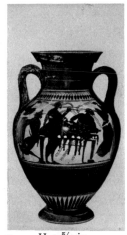

e. H. 20⅛ in. f. H. 18³⁄₁₆ in. g. H. 15⁵⁄₁₆ in.

42. BLACK-FIGURED POTTERY, SECOND HALF OF THE VI CENTURY B.C.

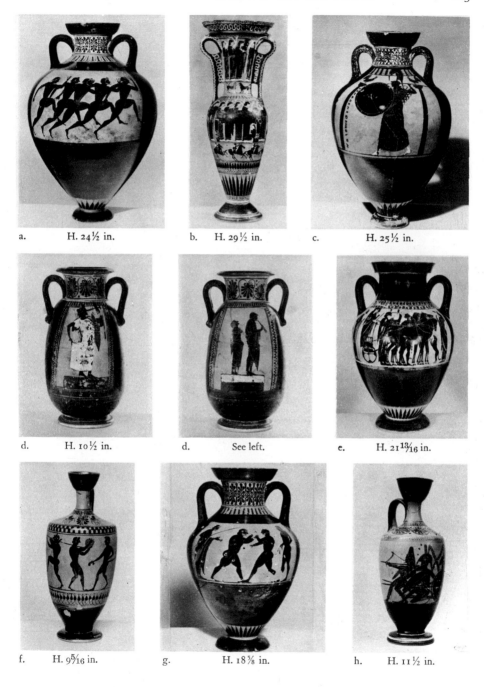

a. H. 24½ in.

b. H. 29½ in.

c. H. 25½ in.

d. H. 10½ in.

d. See left.

e. H. 21¹³⁄₁₆ in.

f. H. 9⁵⁄₁₆ in.

g. H. 18⅞ in.

h. H. 11½ in.

43. BLACK-FIGURED POTTERY, LAST QUARTER OF THE VI CENTURY B.C.

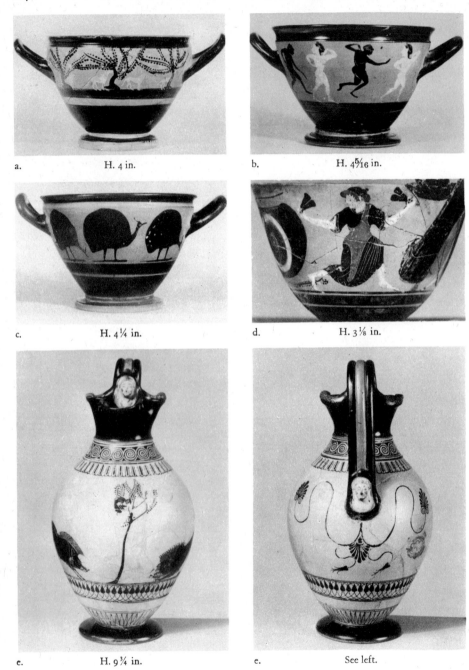

a. H. 4 in.

b. H. 4⁵⁄₁₆ in.

c. H. 4¼ in.

d. H. 3⅛ in.

e. H. 9¾ in.

e. See left.

44. BLACK-FIGURED POTTERY, LAST QUARTER OF THE VI CENTURY B.C.

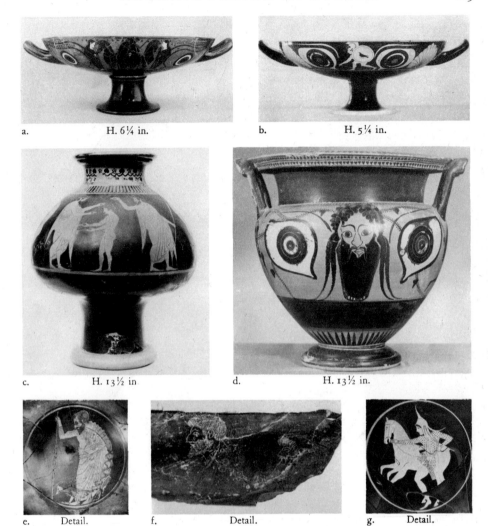

a.　　　H. 6¼ in.

b.　　　H. 5¼ in.

c.　　H. 13½ in.

d.　　H. 13½ in.

e.　Detail.

f.　　Detail.

g.　Detail.

45. POTTERY, LAST QUARTER OF VI CENTURY, AND A GREEK GRAFFITO FROM PERSEPOLIS

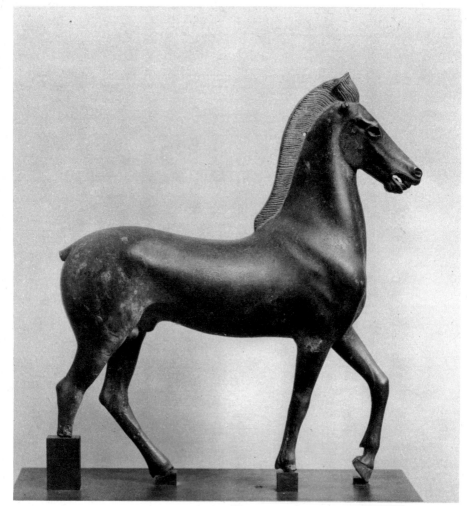

H. 15¹³⁄₁₆ in.

46. BRONZE STATUETTE OF A HORSE, PERHAPS FROM A CHARIOT GROUP

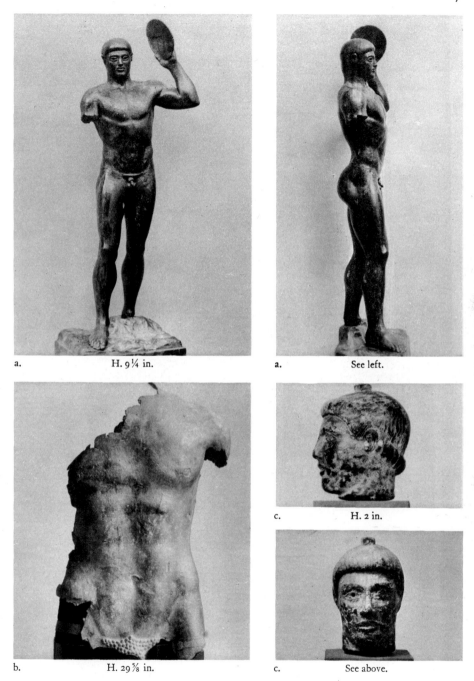

a. H. 9¼ in.

a. See left.

c. H. 2 in.

b. H. 29⅝ in.

c. See above.

47. BRONZE STATUETTE, PART OF A BRONZE STATUE, AND A BRONZE HEAD

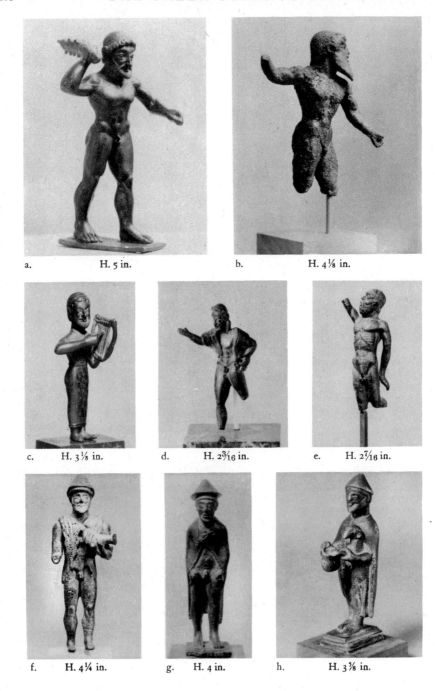

a. H. 5 in. b. H. 4⅛ in.

c. H. 3⅛ in. d. H. 2³⁄₁₆ in. e. H. 2⁷⁄₁₆ in.

f. H. 4¼ in. g. H. 4 in. h. H. 3⅞ in.

48. BRONZE STATUETTES

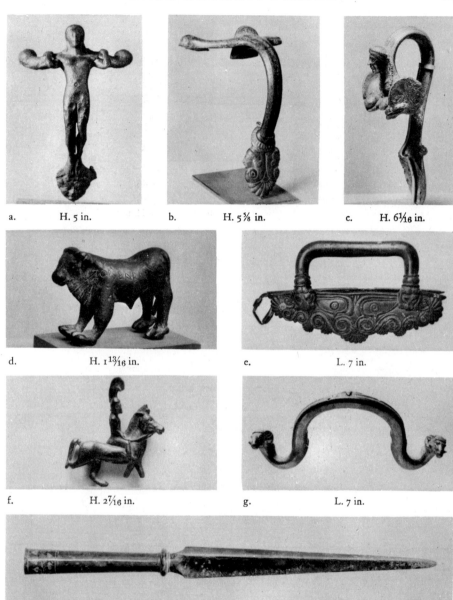

a. H. 5 in. b. H. 5⅞ in. c. H. 6¹⁄₁₆ in.

d. H. 1¹³⁄₁₆ in. e. L. 7 in.

f. H. 2⁷⁄₁₆ in. g. L. 7 in.

h. L. 16⅝ in.

49. BRONZE HANDLES, STATUETTES, AND A SPEAR BUTT

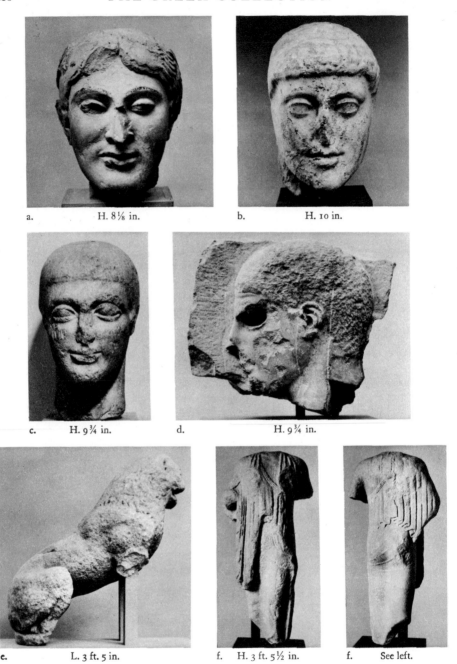

a. H. 8 ⅛ in. b. H. 10 in.

c. H. 9 ¾ in. d. H. 9 ¾ in.

e. L. 3 ft. 5 in. f. H. 3 ft. 5 ½ in. f. See left.

50. TERRACOTTA AND MARBLE SCULPTURES

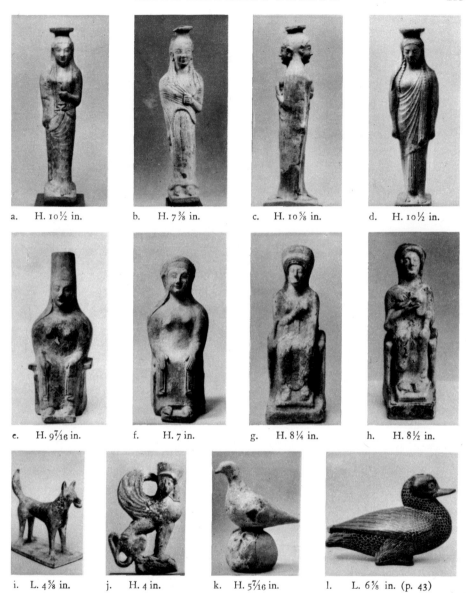

a. H. 10½ in. b. H. 7⅜ in. c. H. 10⅜ in. d. H. 10½ in.

e. H. 9⁷⁄₁₆ in. f. H. 7 in. g. H. 8¼ in. h. H. 8½ in.

i. L. 4⅝ in. j. H. 4 in. k. H. 5⁷⁄₁₆ in. l. L. 6⅝ in. (p. 43)

51. TERRACOTTA STATUETTES AND PLASTIC VASES

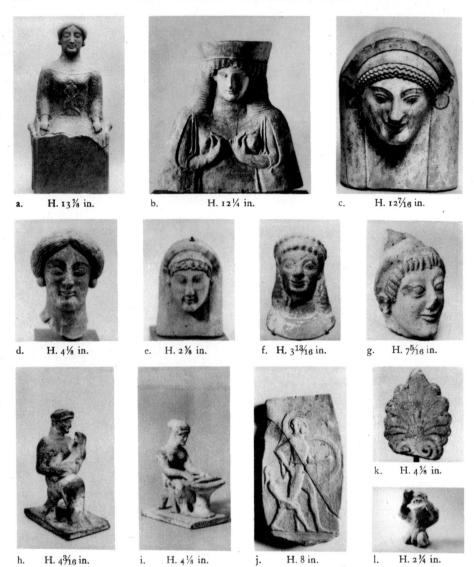

a.　H. 13⅜ in.　　b.　　H. 12¼ in.　　c.　　H. 12⁷⁄₁₆ in.

d.　H. 4⅛ in.　　e.　H. 2⅜ in.　　f.　H. 3¹³⁄₁₆ in.　　g.　　H. 7⁵⁄₁₆ in.

k.　　H. 4⅜ in.

h.　H. 4³⁄₁₆ in.　　i.　　H. 4⅛ in.　　j.　　H. 8 in.　　l.　　H. 2¾ in.

52. TERRACOTTAS

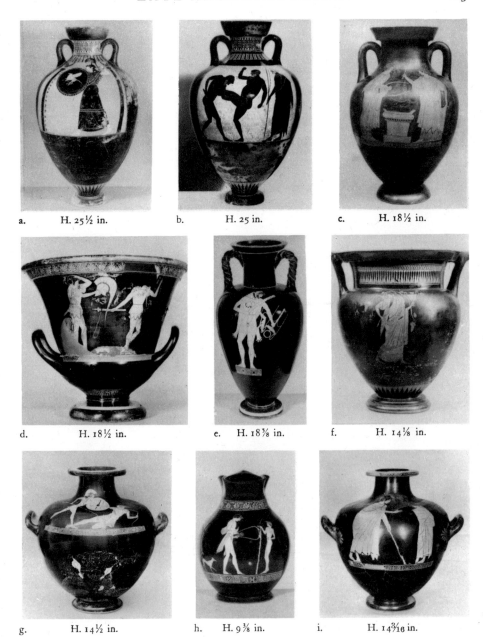

a. H. 25½ in. b. H. 25 in. c. H. 18½ in.

d. H. 18½ in. e. H. 18⅜ in. f. H. 14⅛ in.

g. H. 14½ in. h. H. 9⅜ in. i. H. 14¾₁₆ in.

53. ATTIC BLACK-FIGURED AND RED-FIGURED POTTERY, EARLY V CENTURY B.C.

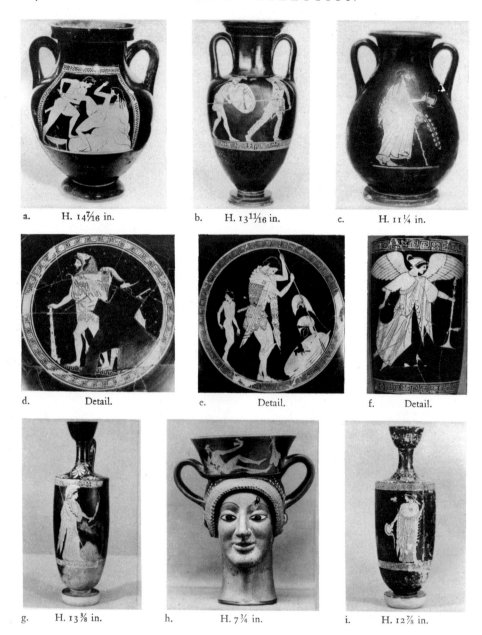

a. H. 14⁷⁄₁₆ in. b. H. 13¹¹⁄₁₆ in. c. H. 11¼ in.

d. Detail. e. Detail. f. Detail.

g. H. 13⅜ in. h. H. 7¾ in. i. H. 12⅞ in.

54. ATTIC RED-FIGURED POTTERY, EARLY V CENTURY B.C.

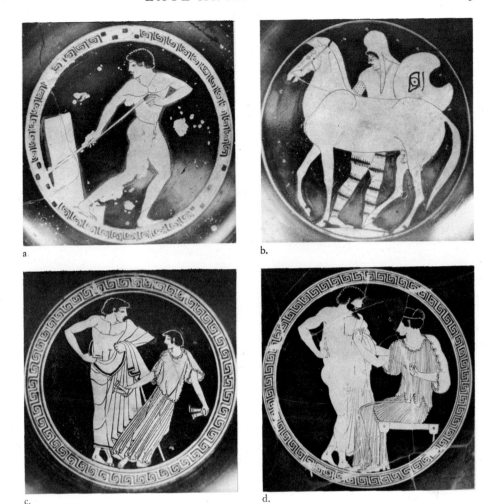

a.

b.

c.

d.

55. DETAILS OF ATTIC RED-FIGURED POTTERY, EARLY V CENTURY B.C.

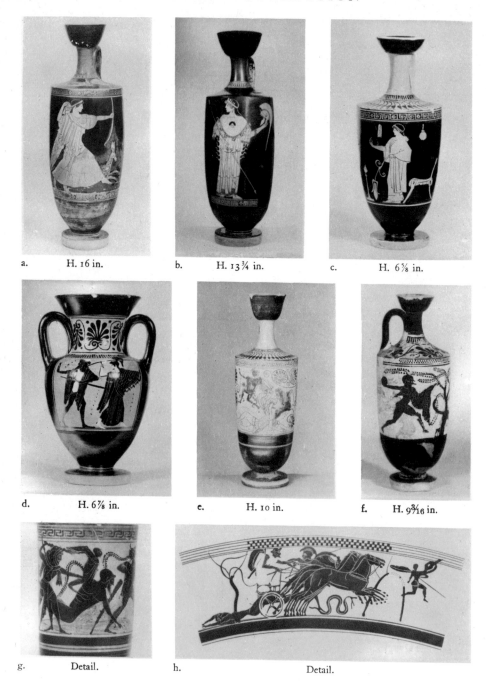

a. H. 16 in. b. H. 13¾ in. c. H. 6⅞ in.

d. H. 6⅞ in. e. H. 10 in. f. H. 9³⁄₁₆ in.

g. Detail. h. Detail.

56. ATTIC POTTERY, EARLY V CENTURY B.C

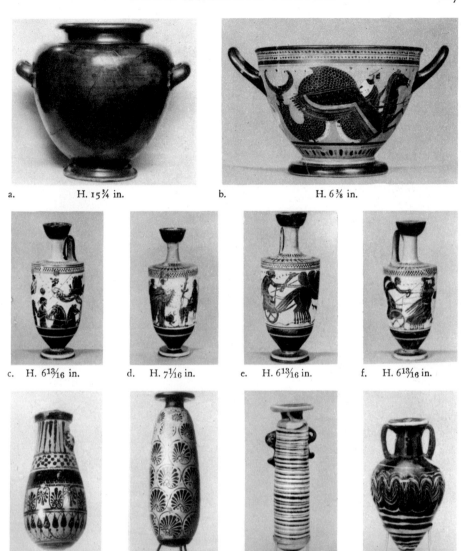

a. H. 15¾ in. b. H. 6⅜ in.

c. H. 6¹³⁄₁₆ in. d. H. 7¹⁄₁₆ in. e. H. 6¹³⁄₁₆ in. f. H. 6¹³⁄₁₆ in.

g. H. 3⁹⁄₁₆ in. h. H. 5 in. i. H. 4 in. j. H. 3¾ in.

57. ATTIC POTTERY AND GLASS VASES

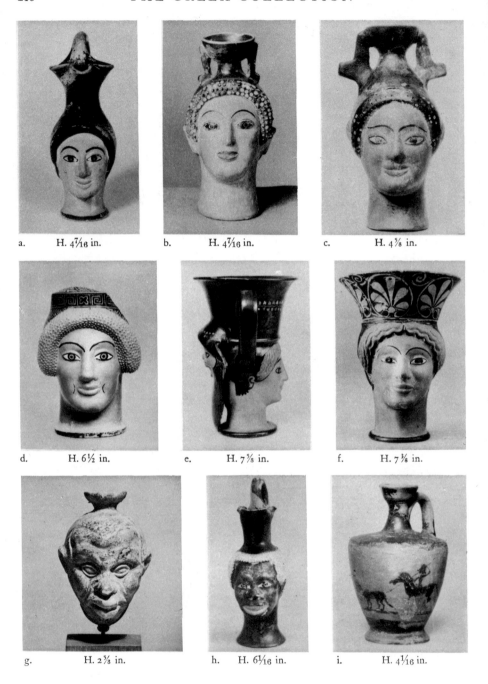

a. H. 4⁷⁄₁₆ in. b. H. 4⁷⁄₁₆ in. c. H. 4⅜ in.

d. H. 6½ in. e. H. 7⅝ in. f. H. 7⅜ in.

g. H. 2⅜ in. h. H. 6¹⁄₁₆ in. i. H. 4¹⁄₁₆ in.

58. ATTIC PLASTIC VASES. BOEOTIAN JUG

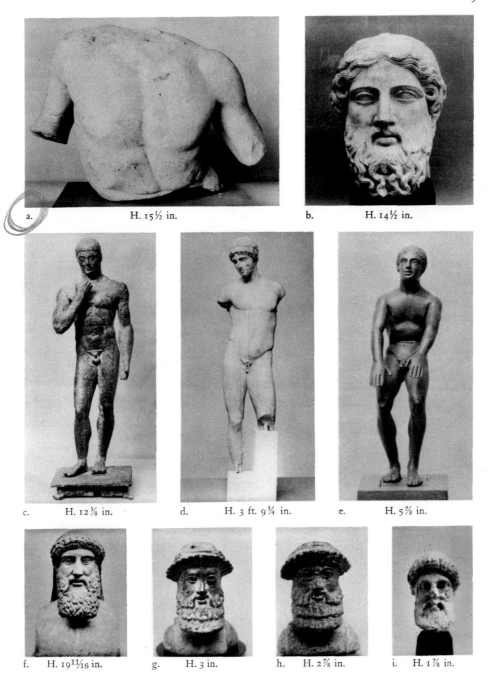

a. H. 15½ in. b. H. 14½ in.

c. H. 12⅜ in. d. H. 3 ft. 9¾ in. e. H. 5⅞ in.

f. H. 19¹¹⁄₁₆ in. g. H. 3 in. h. H. 2⅞ in. i. H. 1⅞ in.

59. MARBLE AND BRONZE SCULPTURES

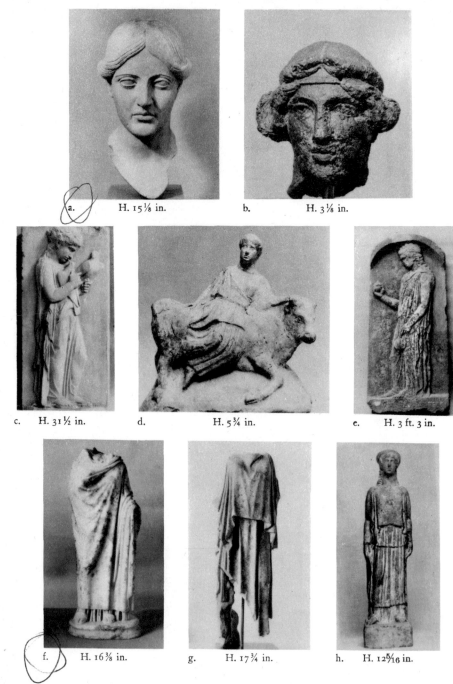

a. H. 15⅛ in. b. H. 3⅛ in.

c. H. 31½ in. d. H. 5¾ in. e. H. 3 ft. 3 in.

f. H. 16⅜ in. g. H. 17¾ in. h. H. 12⁵⁄₁₆ in.

60. MARBLE, BRONZE, AND TERRACOTTA SCULPTURES

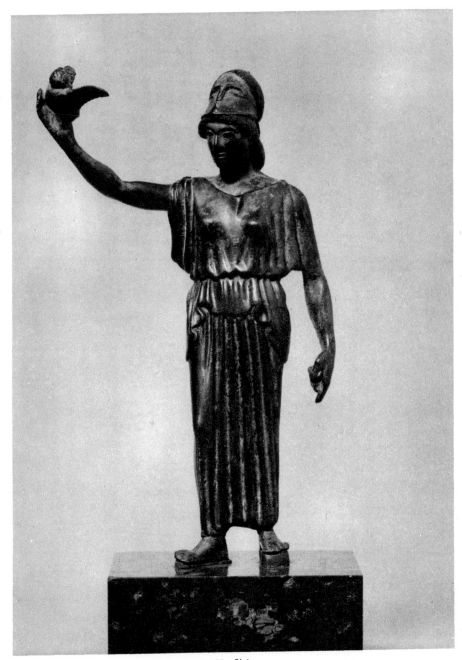

H. 5⅞ in.

61. BRONZE STATUETTE OF ATHENA, ABOUT 460 B.C.

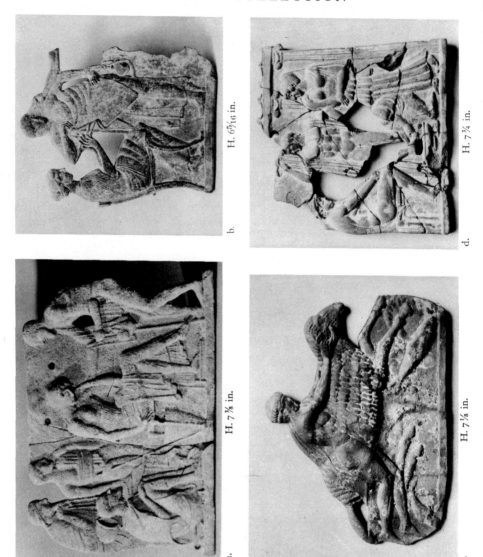

H. 6⅝₁₆ in. b.

H. 7¾ in. d.

H. ⅞ in. a.

H. 7⅛ in. c.

62. MELIAN TERRACOTTA RELIEFS

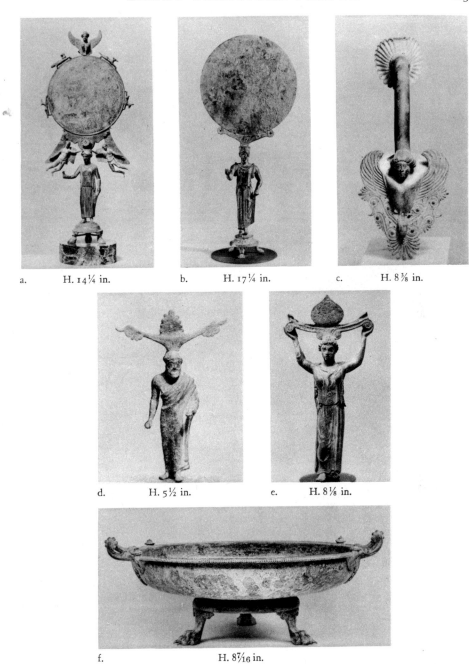

a. H. 14¼ in. b. H. 17¼ in. c. H. 8⅜ in.

d. H. 5½ in. e. H. 8⅛ in.

f. H. 8⁷⁄₁₆ in.

63. BRONZE MIRRORS AND HANDLES AND A BRONZE FOOT BATH

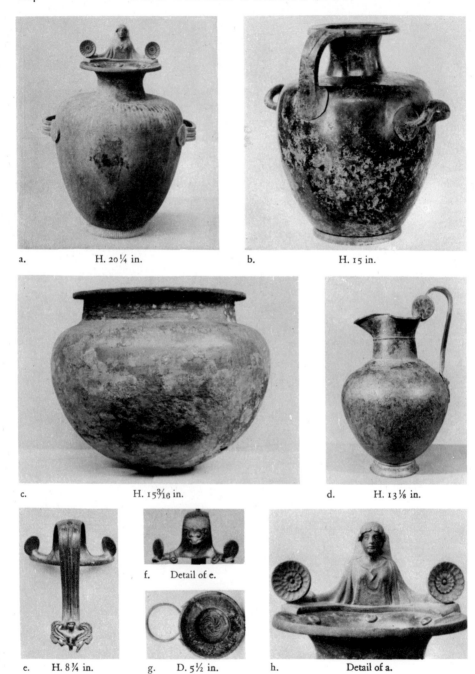

a. H. 20¼ in. b. H. 15 in.

c. H. 15³⁄₁₆ in. d. H. 13⅛ in.

e. H. 8¾ in. f. Detail of e.

g. D. 5½ in. h. Detail of a.

64. BRONZE VASES, HANDLES, AND A STRAINER

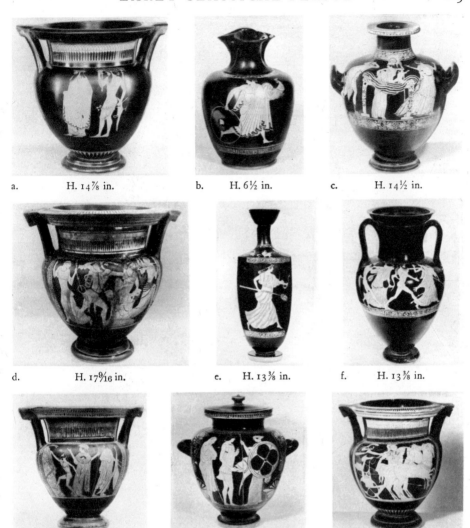

a. H. 14⅞ in. b. H. 6½ in. c. H. 14½ in.

d. H. 17⁹⁄₁₆ in. e. H. 13⅜ in. f. H. 13⅜ in.

g. H. 11⅜ in. h. H. 16 in. i. H. 17¾ in.

65. ATTIC RED-FIGURED POTTERY

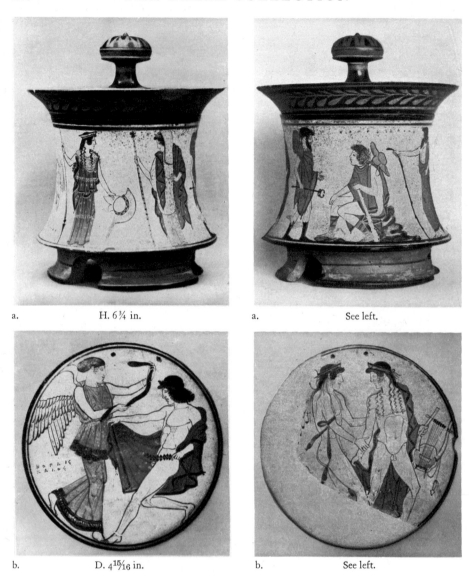

a. H. 6¾ in. a. See left.

b. D. 4¹⁵⁄₁₆ in. b. See left.

66. ATTIC WHITE-GROUND POTTERY

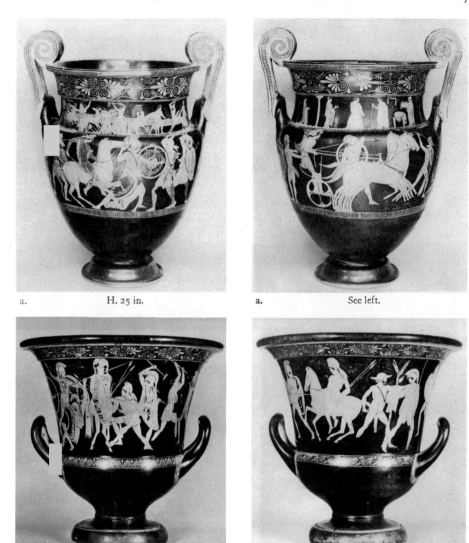

a. H. 25 in. a. See left.

b. H. 22 in. b. See left.

67. ATTIC RED-FIGURED KRATERS, OR MIXING BOWLS

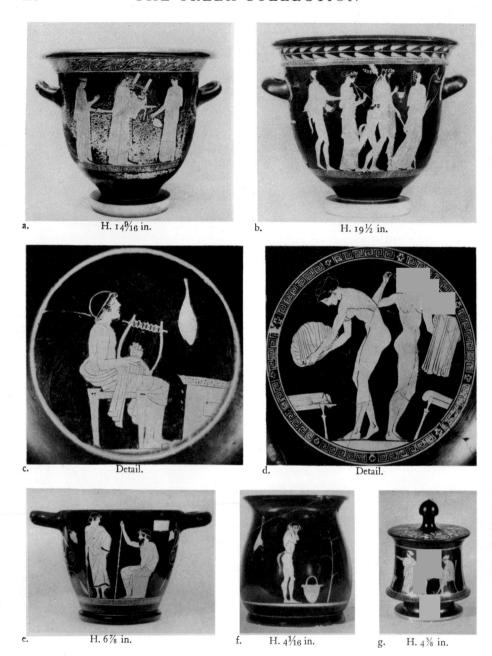

a.　H. 14⁹⁄₁₆ in.

b.　H. 19½ in.

c.　Detail.

d.　Detail.

e.　H. 6⅞ in.

f.　H. 4¹⁄₁₆ in.

g.　H. 4⅜ in.

68. ATTIC RED-FIGURED POTTERY

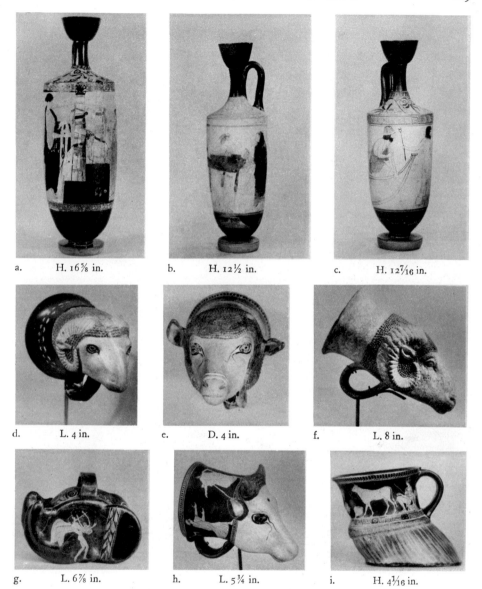

a. H. 16⅝ in. b. H. 12½ in. c. H. 12⁷⁄₁₆ in.

d. L. 4 in. e. D. 4 in. f. L. 8 in.

g. L. 6⅞ in. h. L. 5¾ in. i. H. 4¹⁄₁₆ in.

69. ATTIC WHITE-GROUND LEKYTHOI AND PLASTIC VASES

a. H. 21½ in.

b. H. 15⅜ in.

c. H. 22½ in.

d. H. 14⅝ in.

70. MARBLE SCULPTURES

a. H. 13½ in.

b. H. 11½ in.

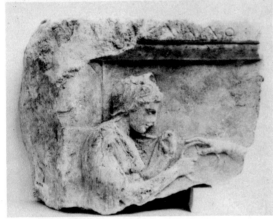

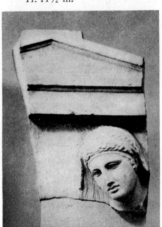

c. H. 9³⁄₁₆ in.

d. H. 26⅞ in.

71. MARBLE SCULPTURES

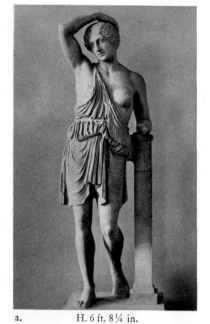

a. H. 6 ft. 8 ¼ in.

b. H. 4 ft. 11 ½ in.

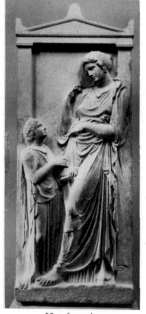

c. H. 5 ft. 10 in.

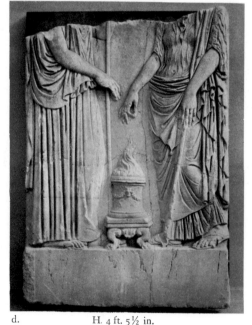

d. H. 4 ft. 5 ½ in.

72. MARBLE SCULPTURES

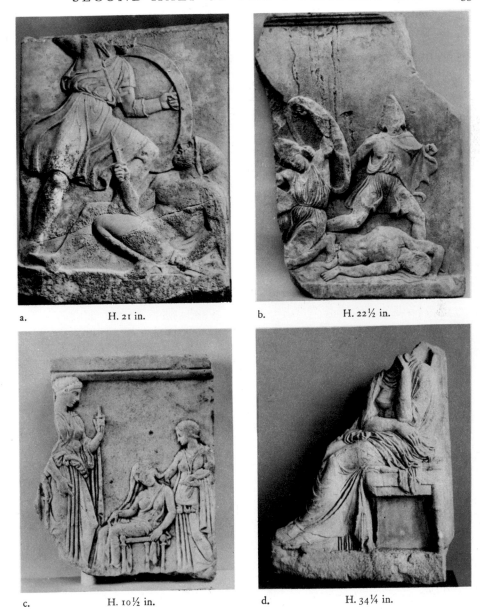

a. H. 21 in.

b. H. 22½ in.

c. H. 10½ in.

d. H. 34¼ in.

73. MARBLE SEPULCHRAL AND VOTIVE RELIEFS

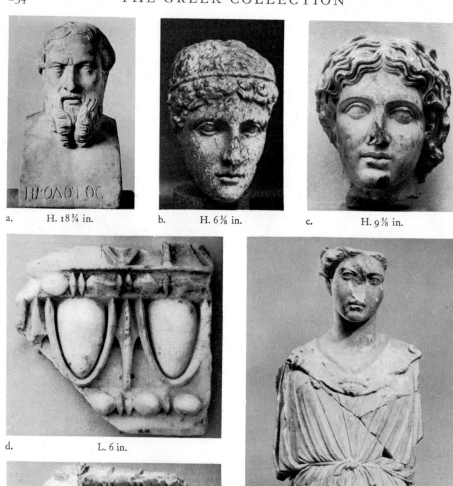

a.　　　H. 18¾ in.　　　　b.　　　H. 6⅜ in.　　　　c.　　　H. 9⅜ in.

d.　　　L. 6 in.

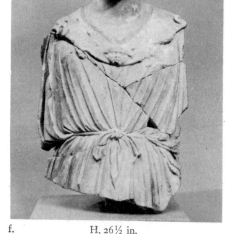

e.　　　L. 8 in.　　　　　f.　　　H. 26½ in.

74. MARBLE SCULPTURES AND ARCHITECTURAL ORNAMENTS

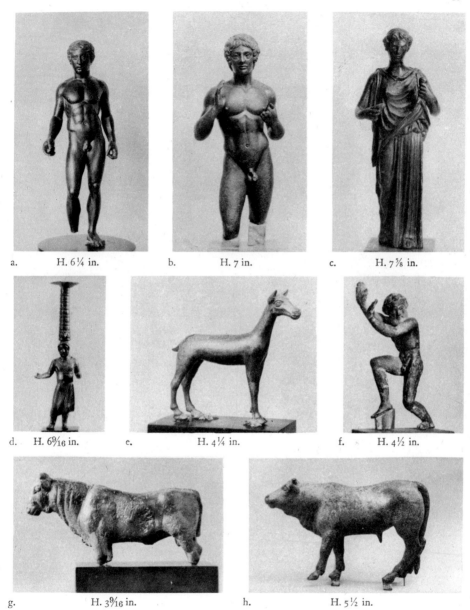

a. H. 6¼ in. b. H. 7 in. c. H. 7⅞ in.

d. H. 6⁹⁄₁₆ in. e. H. 4¼ in. f. H. 4½ in.

g. H. 3⁹⁄₁₆ in. h. H. 5½ in.

75. BRONZE STATUETTES

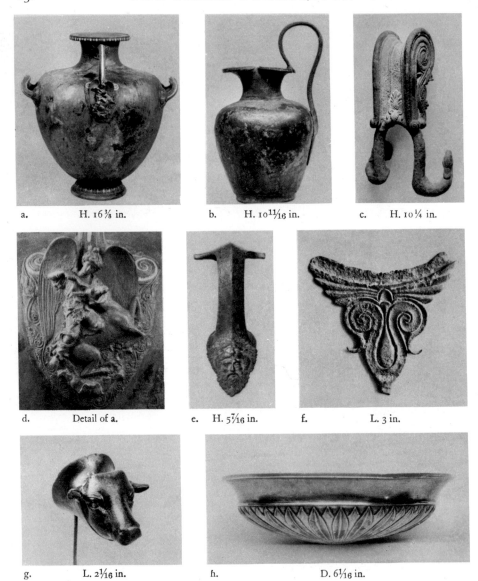

a. H. 16⅜ in. b. H. 10¹¹⁄₁₆ in. c. H. 10¼ in.

d. Detail of a. e. H. 5⁷⁄₁₆ in. f. L. 3 in.

g. L. 2¹⁄₁₆ in. h. D. 6¹⁄₁₆ in.

76. BRONZE AND SILVER VASES AND HANDLES

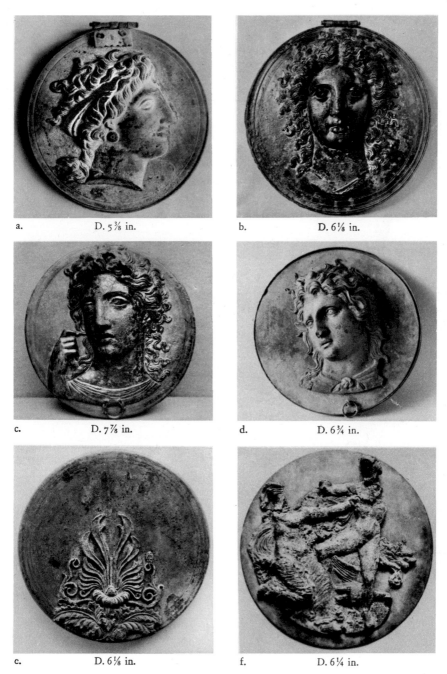

a. D. 5⅜ in. b. D. 6⅛ in.

c. D. 7⅞ in. d. D. 6¾ in.

e. D. 6⅛ in. f. D. 6¼ in.

77. BRONZE MIRRORS

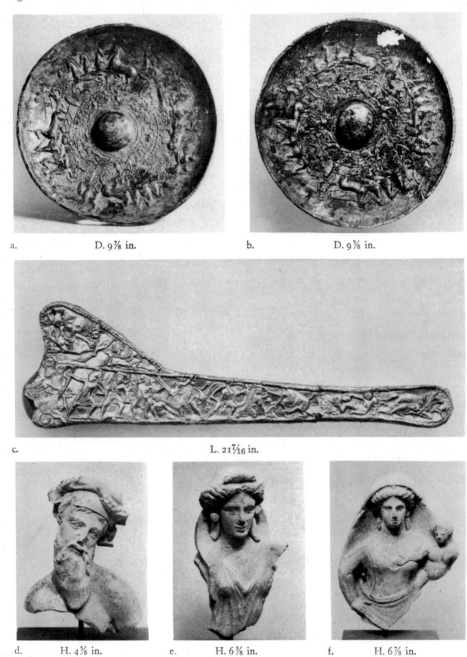

a. D. 9⅞ in. b. D. 9⅝ in.

c. L. 21⁷⁄₁₆ in.

d. H. 4⅜ in. e. H. 6⅜ in. f. H. 6⅞ in.

78. SILVER LIBATION BOWLS, A GOLD PLATE FROM A SWORD SHEATH, AND TERRACOTTAS

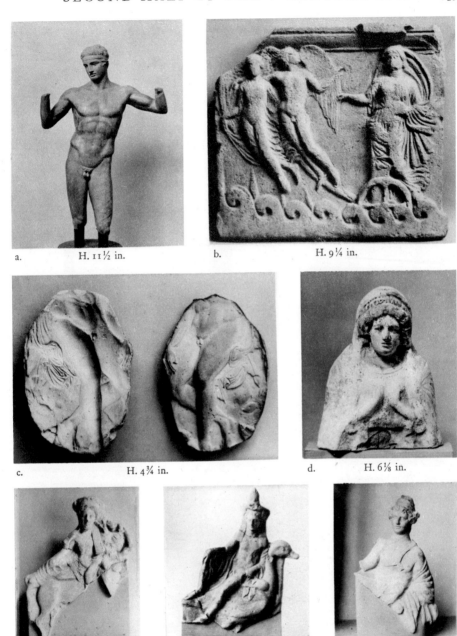

a. H. 11½ in. b. H. 9¼ in.

c. H. 4¾ in. d. H. 6⅛ in.

e. L. 14½ in. f. H. 11⅜ in. g. H. 11½ in.

79. TERRACOTTAS

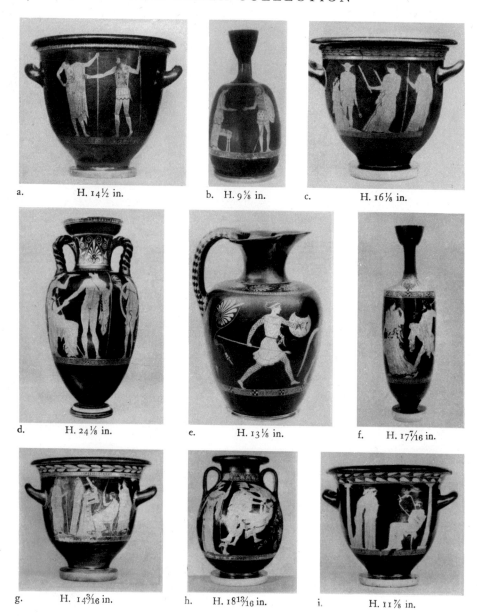

a. H. 14½ in.

b. H. 9⅝ in.

c. H. 16⅛ in.

d. H. 24⅛ in.

e. H. 13⅛ in.

f. H. 17⁷⁄₁₆ in.

g. H. 14⁹⁄₁₆ in.

h. H. 18¹³⁄₁₆ in.

i. H. 11⅞ in.

80. ATTIC RED-FIGURED POTTERY

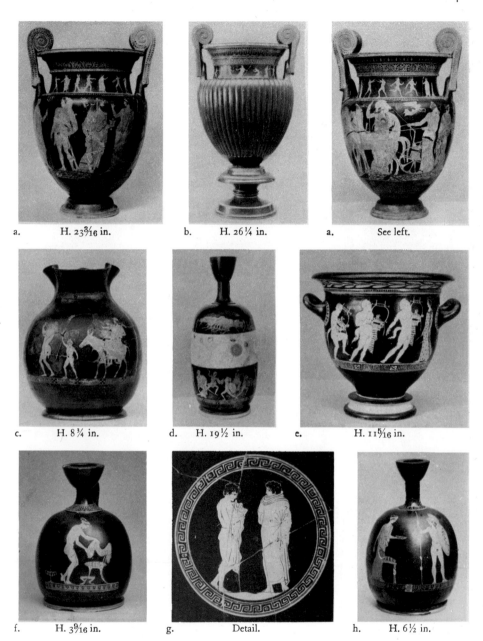

a. H. 23 3/16 in.

b. H. 26 1/4 in.

a. See left.

c. H. 8 3/4 in.

d. H. 19 1/2 in.

e. H. 11 5/16 in.

f. H. 3 9/16 in.

g. Detail.

h. H. 6 1/2 in.

81. ATTIC RED-FIGURED POTTERY

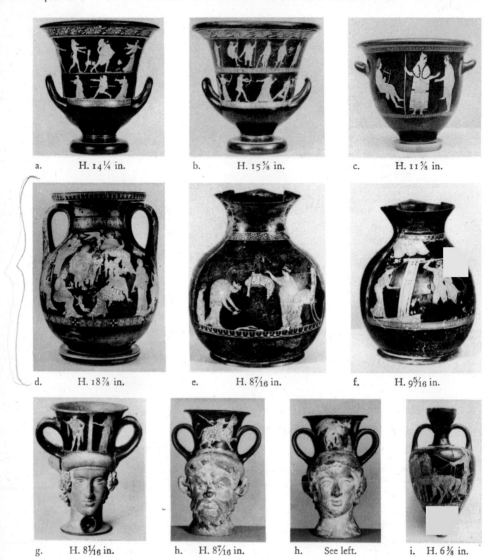

a. H. 14¼ in. b. H. 15⅝ in. c. H. 11⅞ in.

d. H. 18⅞ in. e. H. 8⁷⁄₁₆ in. f. H. 9⁵⁄₁₆ in.

g. H. 8¹⁄₁₆ in. h. H. 8⁷⁄₁₆ in. h. See left. i. H. 6⅜ in.

82. ATTIC RED-FIGURED VASES

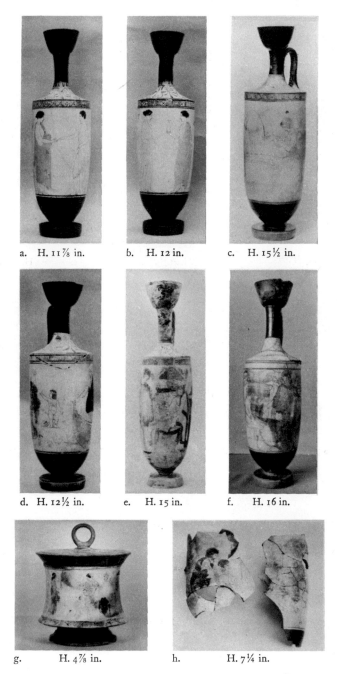

a.　H. 11⅞ in.　　b.　H. 12 in.　　c.　H. 15½ in.

d. H. 12½ in.　　e.　H. 15 in.　　f.　H. 16 in.

g.　　H. 4⅞ in.　　h.　　H. 7¼ in.

83. ATTIC WHITE-GROUND POTTERY

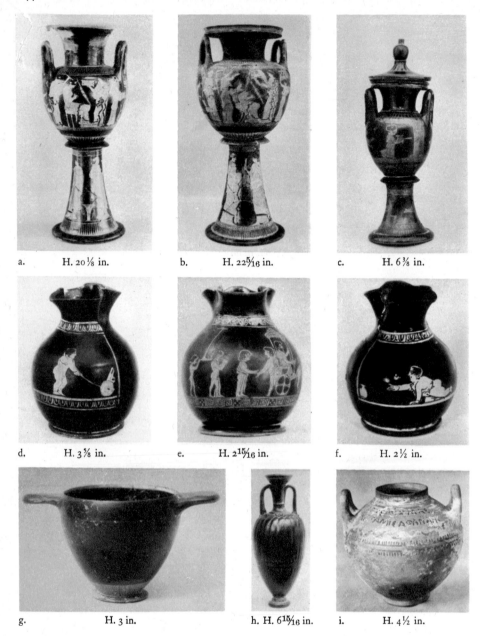

a. H. 20⅛ in. b. H. 22⁵⁄₁₆ in. c. H. 6⅜ in.

d. H. 3⅜ in. e. H. 2¹⁵⁄₁₆ in. f. H. 2½ in.

g. H. 3 in. h. H. 6¹⁵⁄₁₆ in. i. H. 4½ in.

84. ATTIC RED-FIGURED POTTERY AND A VASE WITH INSCRIPTION, POSSIBLY RHODIAN

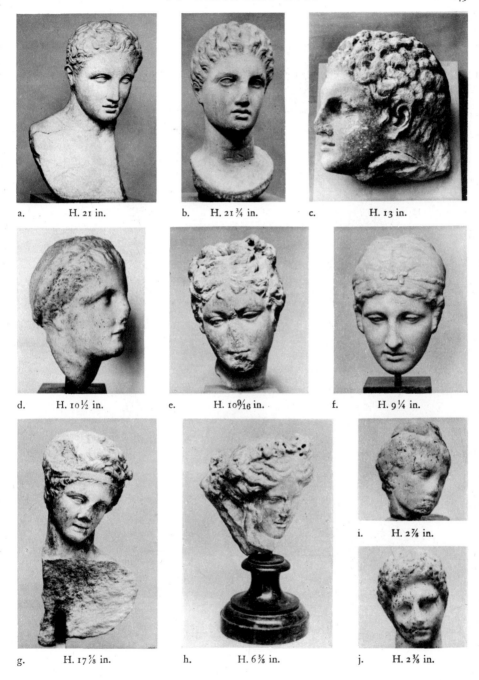

a. H. 21 in. b. H. 21 ¾ in. c. H. 13 in.

d. H. 10 ½ in. e. H. 10 9/16 in. f. H. 9 ¼ in.

i. H. 2 ⅞ in.

g. H. 17 ⅞ in. h. H. 6 ⅜ in. j. H. 2 ⅜ in.

85. MARBLE SCULPTURES

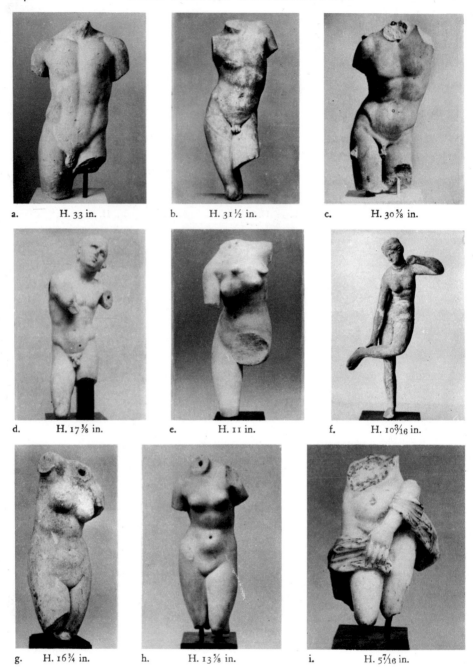

a. H. 33 in. b. H. 31½ in. c. H. 30⅜ in.

d. H. 17⅞ in. e. H. 11 in. f. H. 10³⁄₁₆ in.

g. H. 16¾ in. h. H. 13⅞ in. i. H. 5⁷⁄₁₆ in.

86. MARBLE SCULPTURES AND TERRACOTTA STATUETTES

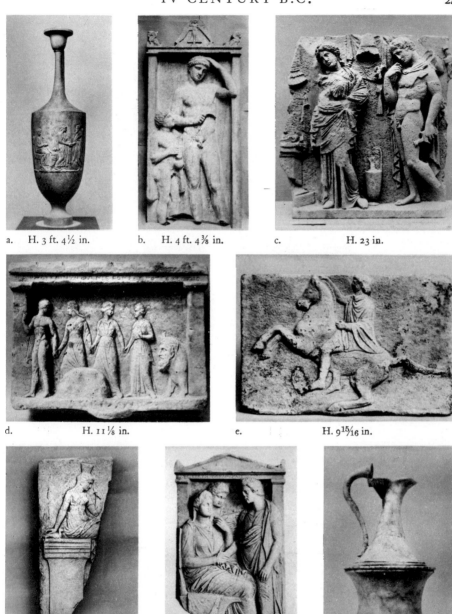

a. H. 3 ft. 4½ in. b. H. 4 ft. 4⅜ in. c. H. 23 in.

d. H. 11⅛ in. e. H. 9¹⁵⁄₁₆ in.

f. H. 14¼ in. g. H. 3 ft. 8¾ in. h. H. 11¹⁄₁₆ in.

87. SEPULCHRAL AND VOTIVE RELIEFS AND VASES

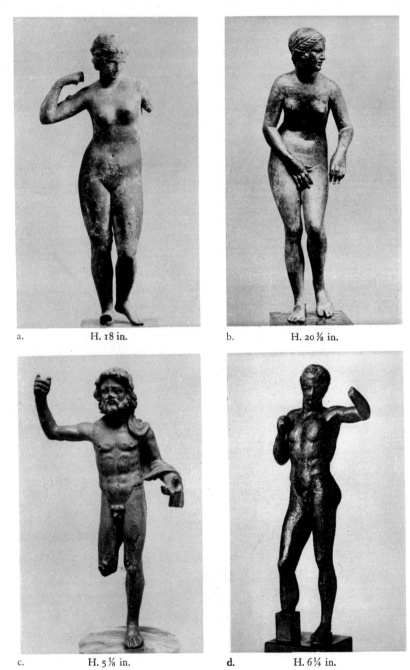

a. H. 18 in. b. H. 20⅜ in.

c. H. 5⅜ in. d. H. 6¼ in.

88. BRONZE STATUETTES

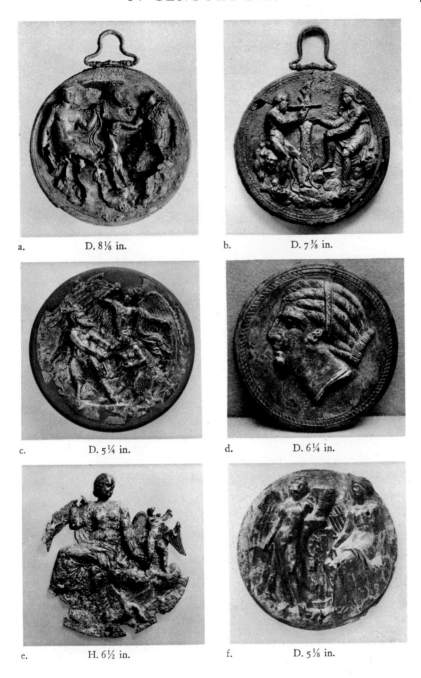

a. D. 8 1/8 in. b. D. 7 3/8 in.

c. D. 5 1/4 in. d. D. 6 1/4 in.

e. H. 6 1/2 in. f. D. 5 1/8 in.

89. BRONZE MIRRORS

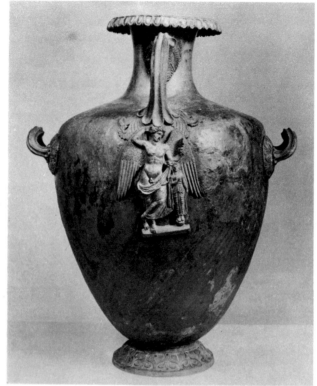

a. H. 19¾ in.

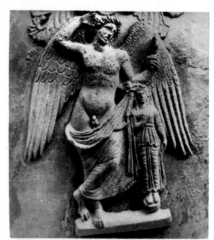

b. H. 5½ in. c. Detail of a.

90. BRONZE HYDRIA, OR WATER JAR, AND A RELIEF

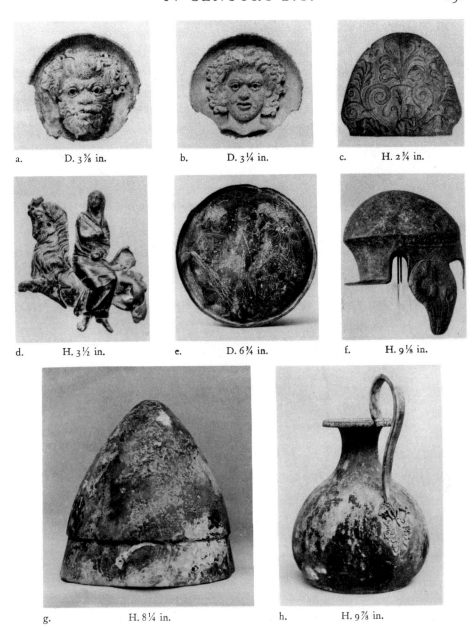

a. D. 3⅝ in. b. D. 3¼ in. c. H. 2¾ in.

d. H. 3½ in. e. D. 6¾ in. f. H. 9⅛ in.

g. H. 8¼ in. h. H. 9⅞ in.

91. BRONZE OBJECTS: A MIRROR, HELMETS, AND A VASE

a.　　H. 12 in.　　　　b.　　H. 9⁵⁄₁₆ in.　　　　c.　　H. 7⅜ in.

d.　　H. 9¾ in.　　　　e.　　H. 4¹¹⁄₁₆ in.　　　　f.　　H. 7¼ in.

g.　　H. 10¼ in.　　　　h.　　H. 4⅞ in.　　　　i.　　H. 5½ in.

92. TERRACOTTA STATUETTES

a. H. 4¾ in. b. H. 4⅛ in. c. H. 4¾ in.

d. H. 3½ in. e. H. 3¹³⁄₁₆ in. f. H. 4⅛ in.

g. H. 7⅛ in. h. H. 8½ in. i. H. 7 in.

93. TERRACOTTA STATUETTES OF ACTORS, ANTEFIXES, AND A TERRACOTTA GROUP

a. H. 13¹⁵⁄₁₆ in. b. H. 14¹⁄₁₆ in. c. H. 13¾ in.

d. H. 9¾ in. e. H. 9¼ in. f. H. 8⅞ in.

g. H. 6⅞ in. h. H. 4⅛ in. i. H. 4⅛ in.

94. ATHENIAN AND BOEOTIAN VASES

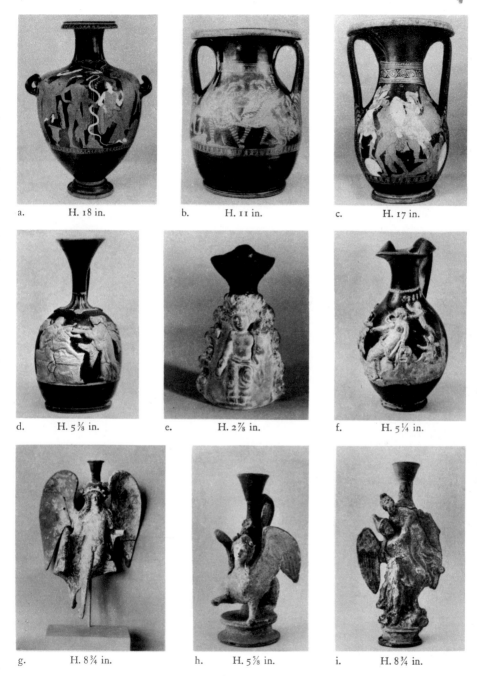

a. H. 18 in. b. H. 11 in. c. H. 17 in.

d. H. 5⅜ in. e. H. 2⅞ in. f. H. 5¼ in.

g. H. 8¾ in. h. H. 5⅝ in. i. H. 8¾ in.

95. ATHENIAN RED-FIGURED POTTERY AND VASES WITH APPLIED RELIEFS

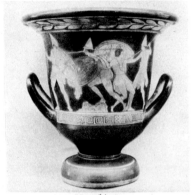

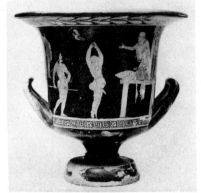

a. H. 15⅟₁₆ in. b. H. 12⅟₁₆ in.

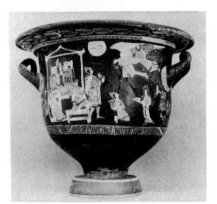

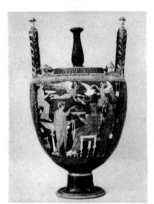

c. H. 19⅝ in. d. H. 15⅟₁₆ in.

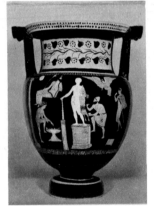

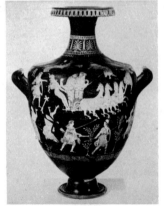

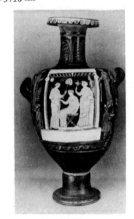

e. H. 20¼ in. f. H. 24¾ in. g. H. 27½ in.

96. SOUTH ITALIAN RED-FIGURED VASES

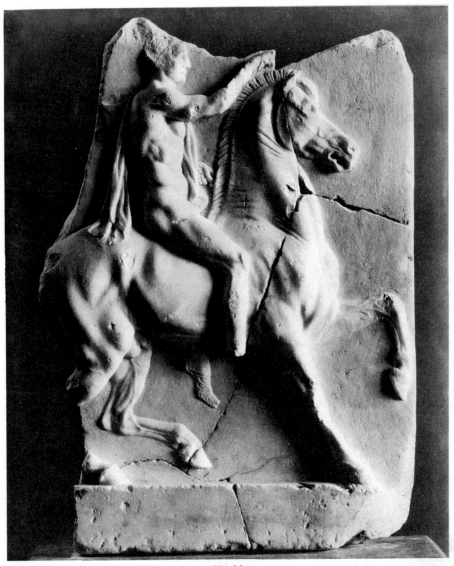

H. 18 in.

97. MARBLE RELIEF

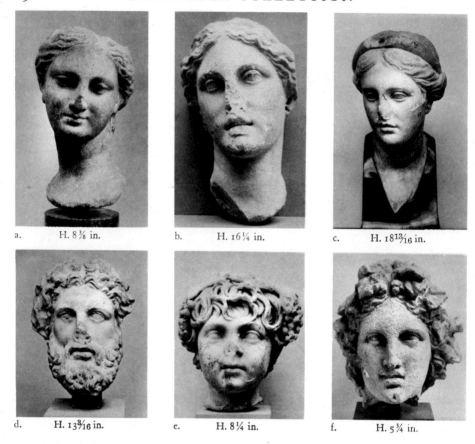

a. H. 8⅜ in. b. H. 16¼ in. c. H. 18¹³⁄₁₆ in.

d. H. 13³⁄₁₆ in. e. H. 8¼ in. f. H. 5¾ in.

98. MARBLE AND LIMESTONE HEADS

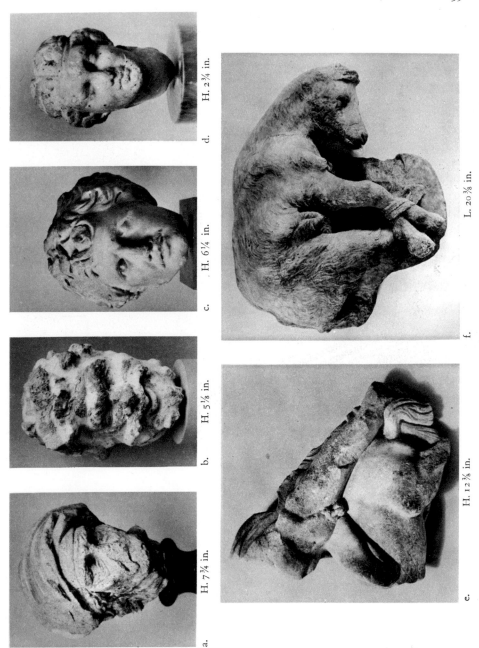

H. 2¾ in. d.

H. 6¼ in. c.

H. 5⅛ in. b.

H. 7¾ in. a.

L. 20⅜ in. f.

H. 12⅝ in. e.

99. MARBLE SCULPTURES

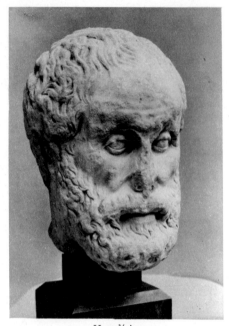

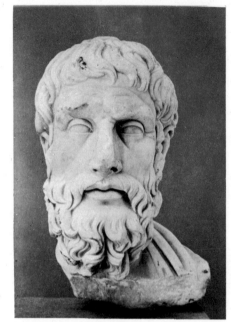

a. H. 12¾ in.

b. H. 15⅞ in.

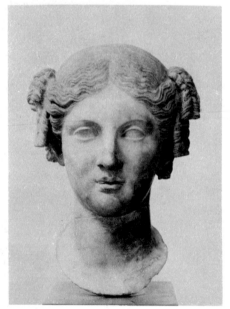

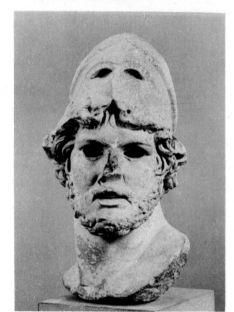

c. H. 11⅛ in.

d. H. 18⁵⁄₁₆ in.

100. MARBLE PORTRAITS

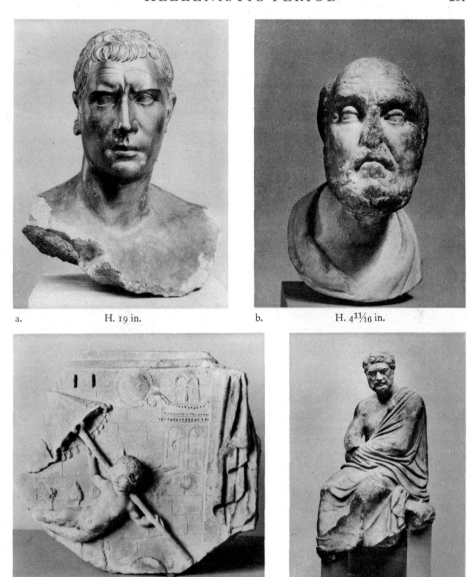

a. H. 19 in. b. H. 4$\frac{11}{16}$ in.

c. H. 12$\frac{3}{8}$ in. d. H. 21$\frac{7}{16}$ in.

101. MARBLE AND DIABASE SCULPTURES

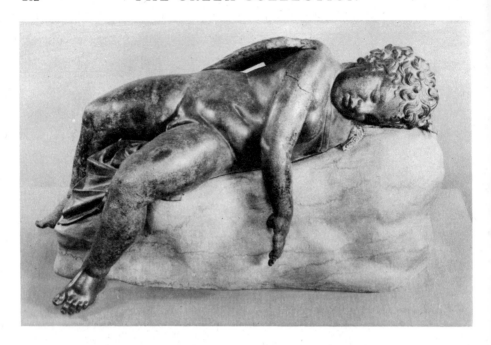

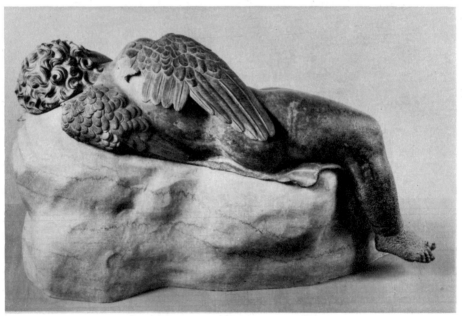

L. 33 9/16 in.

102. BRONZE STATUE OF A SLEEPING EROS

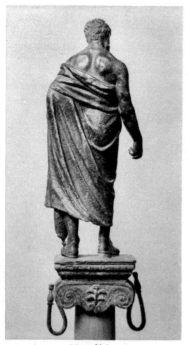

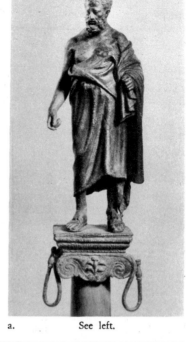

a. H. 13⅝ in.

a. See left.

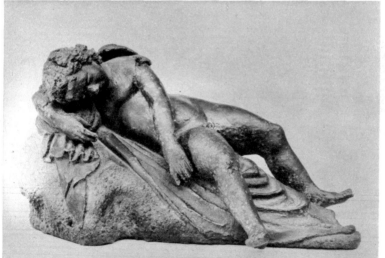

b. L. 8¼ in.

103. BRONZE STATUETTES

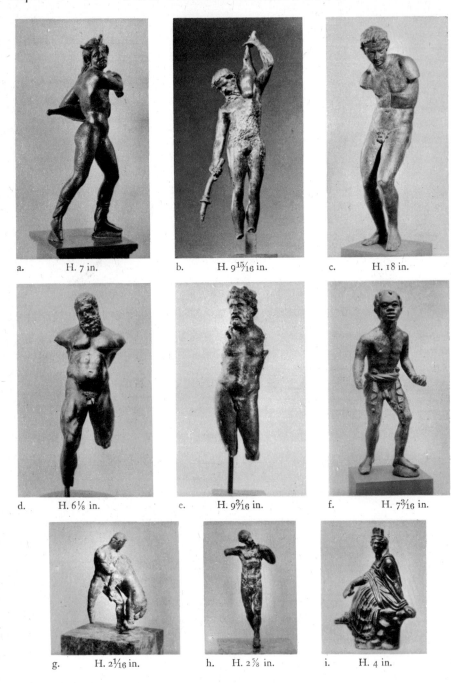

a. H. 7 in. b. H. 9¹⁵⁄₁₆ in. c. H. 18 in.

d. H. 6⅛ in. e. H. 9³⁄₁₆ in. f. H. 7³⁄₁₆ in.

g. H. 2¹⁄₁₆ in. h. H. 2⅝ in. i. H. 4 in.

104. BRONZE STATUETTES

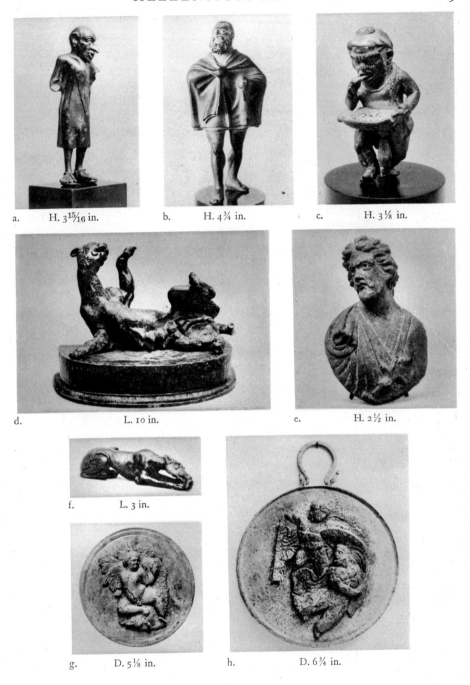

a. H. 3¹⁵⁄₁₆ in. b. H. 4¾ in. c. H. 3⅛ in.

d. L. 10 in. e. H. 2½ in.

f. L. 3 in.

g. D. 5⅛ in. h. D. 6¾ in.

105. BRONZE STATUETTES, A BUST, AND RELIEFS

a. D. 6½ in.

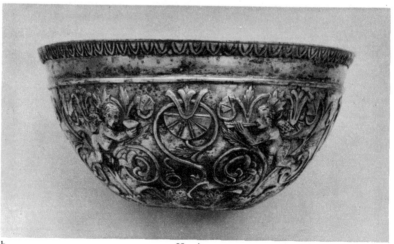

b. H. 3 in.

106. BRONZE MIRROR WITH SILVER-GILT FRAME AND A SILVER BOWL

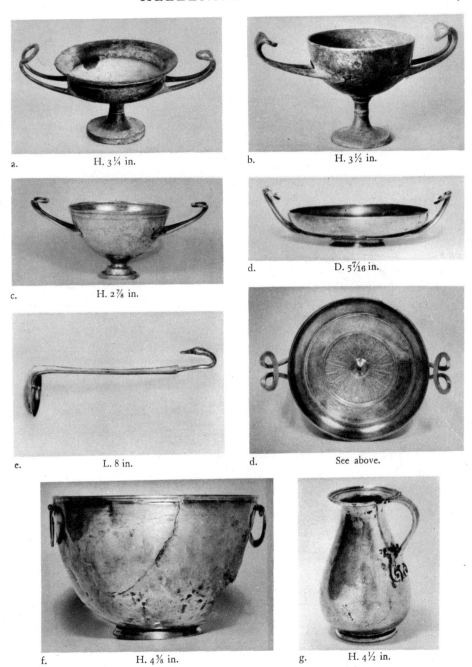

a. H. 3¼ in.

b. H. 3½ in.

c. H. 2⅞ in.

d. D. 5⁷⁄₁₆ in.

e. L. 8 in.

d. See above.

f. H. 4⅜ in.

g. H. 4½ in.

107. BRONZE AND SILVER VASES AND A SILVER LADLE

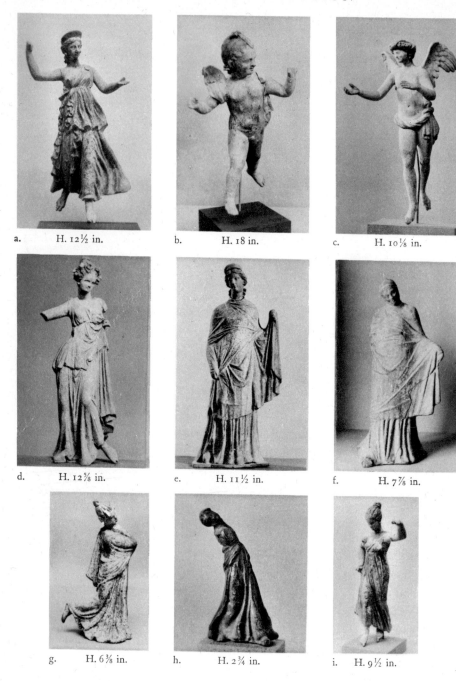

a. H. 12½ in. b. H. 18 in. c. H. 10⅛ in.

d. H. 12⅝ in. e. H. 11½ in. f. H. 7⅞ in.

g. H. 6⅜ in. h. H. 2¾ in. i. H. 9½ in.

108. TERRACOTTA STATUETTES

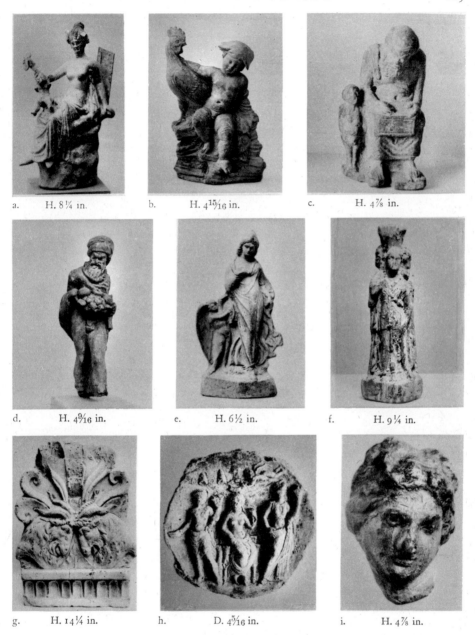

a.　H. 8¼ in.　　　b.　H. 4¹⁵⁄₁₆ in.　　　c.　H. 4⅞ in.

d.　H. 4⁹⁄₁₆ in.　　　e.　H. 6½ in.　　　f.　H. 9¼ in.

g.　H. 14¼ in.　　　h.　D. 4⁵⁄₁₆ in.　　　i.　H. 4⅞ in.

109. TERRACOTTA AND WOOD STATUETTES, AN ANTEFIX, PLASTER RELIEF, AND WAX HEAD

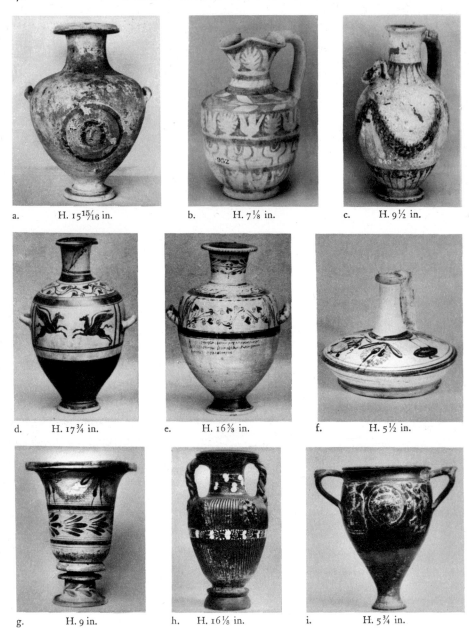

a.　　H. 15¹⁵⁄₁₆ in.　　b.　　H. 7⅛ in.　　c.　　H. 9½ in.

d.　　H. 17¾ in.　　e.　　H. 16⅞ in.　　f.　　H. 5½ in.

g.　　H. 9 in.　　h.　　H. 16⅛ in.　　i.　　H. 5¾ in.

110. TERRACOTTA VASES WITH PAINTED AND RELIEF DECORATIONS

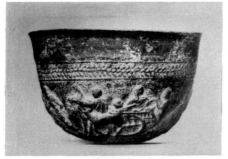

a. H. 3¼ in.

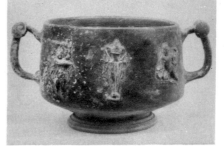

b. H. 3⅛ in.

c. Drawing of a.

d. H. 3¹¹⁄₁₆ in.

e. H. 2⅛ in.

f. H. 2⅜ in.

III. TERRACOTTA CUPS, "MEGARIAN" AND "PERGAMENE" WARE

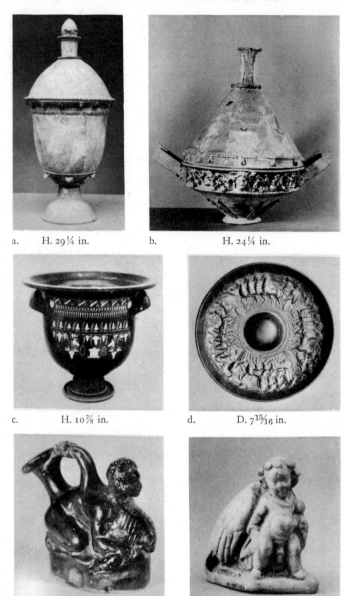

a.　　H. 29¼ in.　　　　b.　　　　H. 24¼ in.

c.　　H. 10⅞ in.　　　　d.　　　　D. 7¹⁵⁄₁₆ in.

e.　　H. 3⁵⁄₁₆ in.　　　　f.　　　　H. 3³⁄₁₆ in.

112. SOUTH ITALIAN POTTERY WITH PAINTED AND RELIEF DECORATIONS

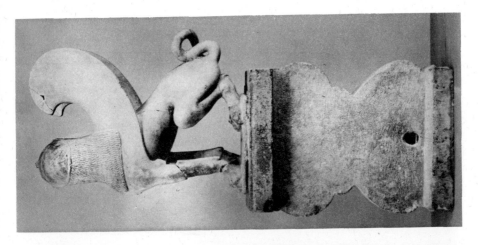

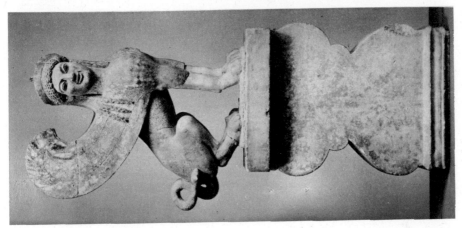

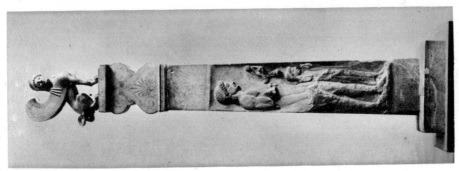

H. 13 ft. 10¹¹⁄₁₆ in.

113. ATHENIAN MARBLE GRAVESTONE, ABOUT 540 B.C.

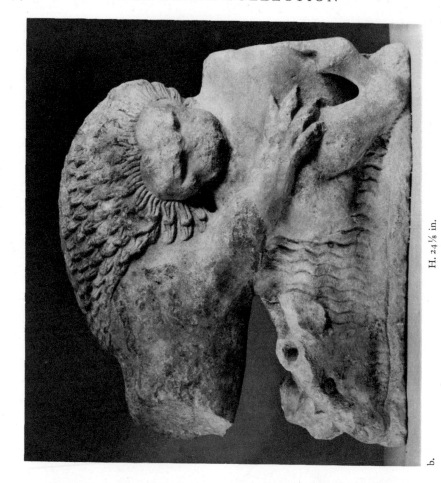

H. 24⅛ in.

b.

H. 4 ft. 7⁵⁄₁₆ in.

a.

114. MARBLE FRAGMENTS: ATHENIAN GRAVESTONE AND A GROUP, 535-525 B.C.

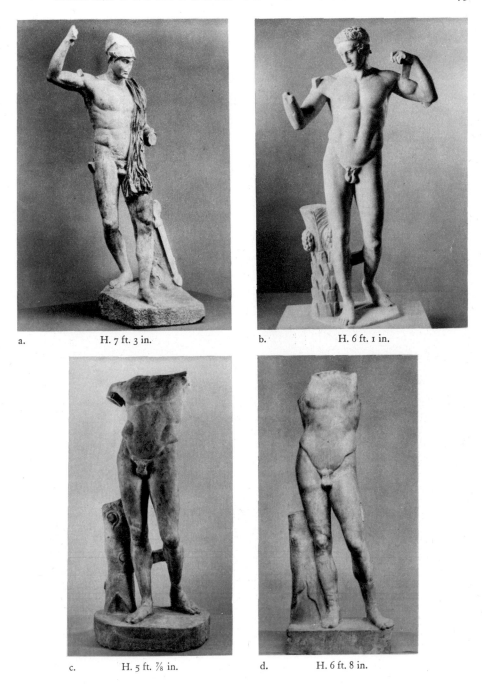

a.　　　　H. 7 ft. 3 in.　　　　b.　　　　H. 6 ft. 1 in.

c.　　　　H. 5 ft. ⅞ in.　　　　d.　　　　H. 6 ft. 8 in.

115. MARBLE STATUES, ROMAN COPIES OF V AND IV CENTURY GREEK WORKS

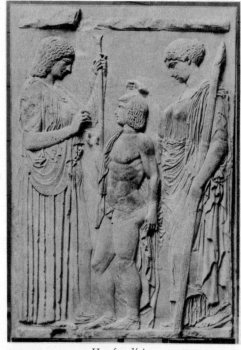

a. H. 7 ft. 5⅜ in.

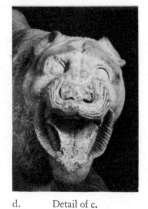

b. H. 4 ft. 8⁵⁄₁₆ in.

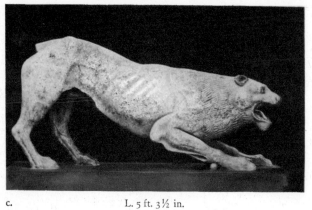

c. L. 5 ft. 3½ in.

d. Detail of c.

116. MARBLE RELIEFS AND A LION

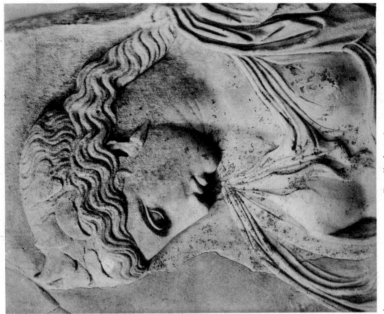

Detail of 115 b.

b.

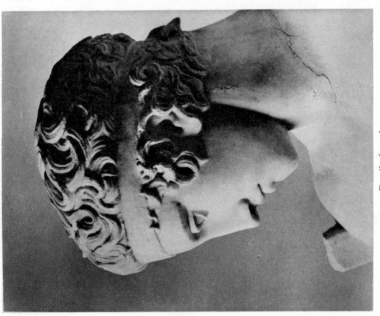

Detail of 114 b.

a.

117. HEADS FROM SCULPTURES SHOWN ON THE TWO PRECEDING PLATES

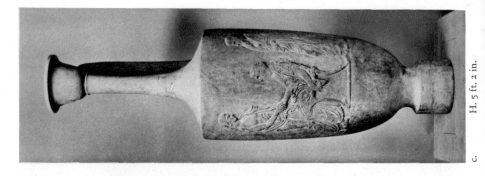

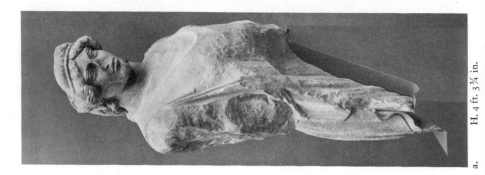

H. 5 ft. 2 in.

H. 5 ft. 2¼ in.

H. 4 ft. 3¾ in.

c.

b.

a.

118. MARBLE STATUE OF ATHENA AND TWO MARBLE GRAVE MONUMENTS

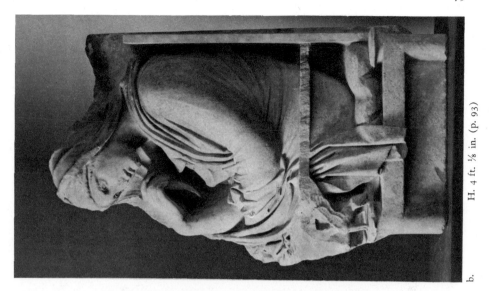

H. 4 ft. ⅛ in. (p. 93)

b.

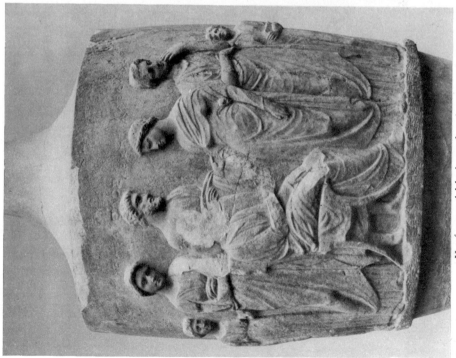

H. of restored lekythos 5 ft. 3 in.

a.

119. DETAIL OF LEKYTHOS AND A GRAVE MONUMENT. ATTIC, ABOUT 370 AND 400 B.C.

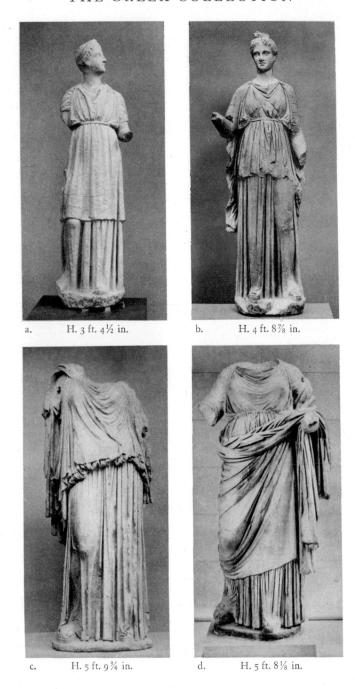

a. H. 3 ft. 4½ in. b. H. 4 ft. 8⅞ in.

c. H. 5 ft. 9¾ in. d. H. 5 ft. 8⅛ in.

120. MARBLE STATUES

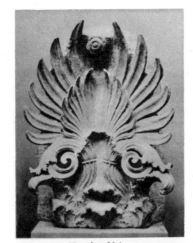
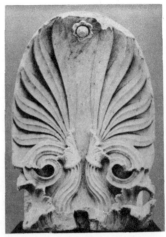

a. H. 3 ft. 5¼ in. b. H. 34½ in.

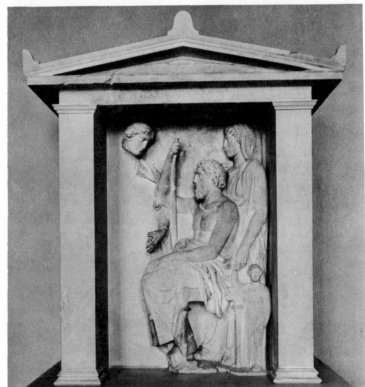

c. H. of relief 5 ft. 7⅜ in.

121. AKROTERIA FROM GRAVESTONES AND A RELIEF WITH ALIEN PEDIMENT

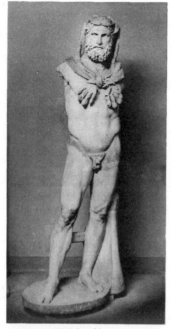

a. H. 8 ft. 1¼ in. b. H. 4 ft. 1¾ in.

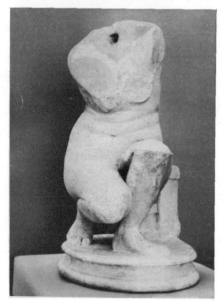

c. H. 3 ft. 6¼ in. d. H. 3 ft. 3⅜ in.

122. MARBLE STATUES

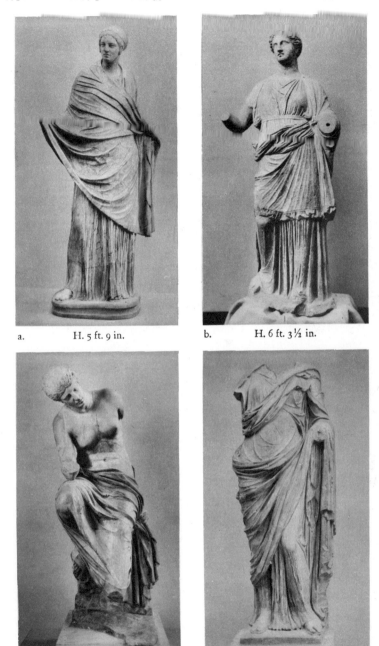

a. H. 5 ft. 9 in. b. H. 6 ft. 3½ in.

c. H. 5 ft. 6 in. d. H. 5 ft. 4¹⁵⁄₁₆ in.

123. MARBLE STATUES

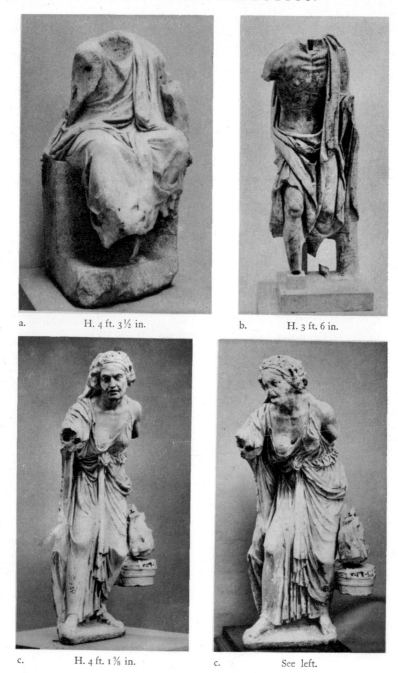

a.　　　　H. 4 ft. 3½ in.　　　　　b.　　　　H. 3 ft. 6 in.

c.　　　　H. 4 ft. 1⅞ in.　　　　　c.　　　　See left.

124. MARBLE STATUES

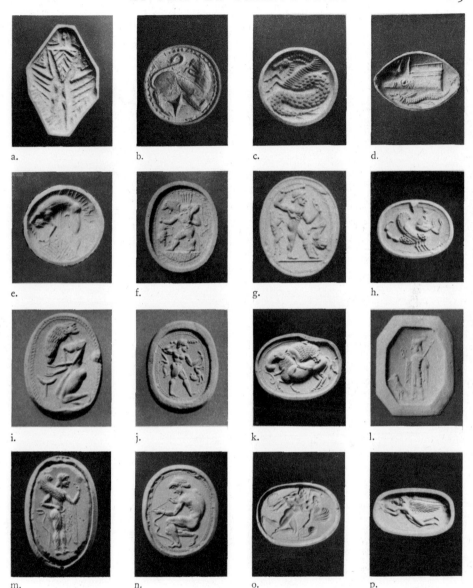

a. b. c. d.

e. f. g. h.

i. j. k. l.

m. n. o. p.

125. PLASTER IMPRESSIONS OF ENGRAVED SEALSTONES, GEOMETRIC AND ARCHAIC

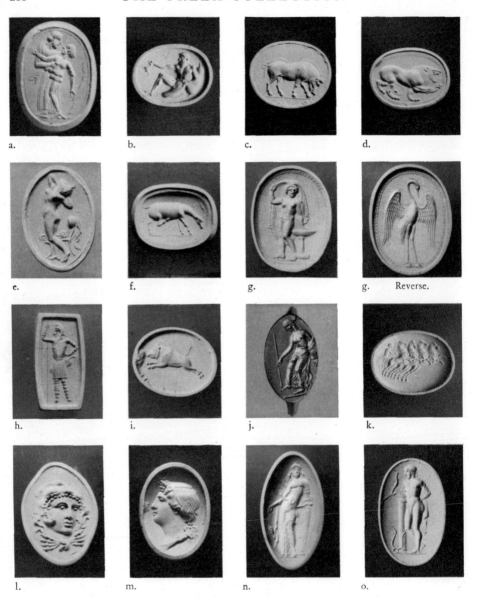

a. b. c. d.

e. f. g. g. Reverse.

h. i. j. k.

l. m. n. o.

126. PLASTER IMPRESSIONS OF ENGRAVED SEALSTONES, V–I CENTURIES B.C.

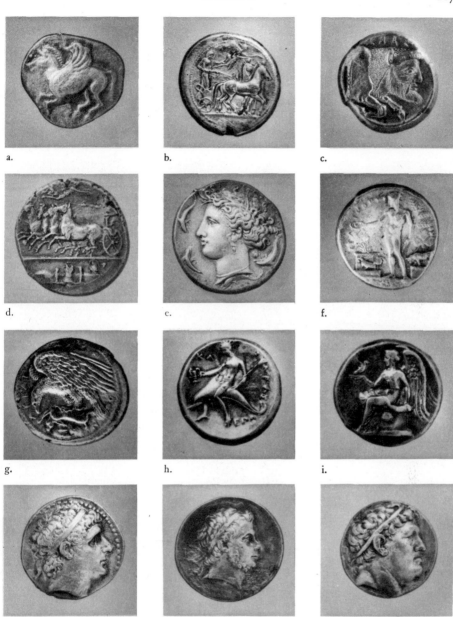

a.

b.

c.

d.

e.

f.

g.

h.

i.

j.

k.

l.

127. SILVER COINS, VI–II CENTURIES B.C.

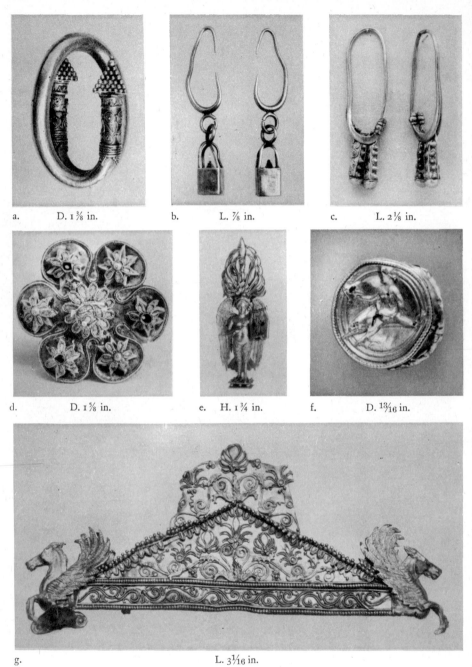

a. D. 1⅜ in. b. L. ⅞ in. c. L. 2⅛ in.

d. D. 1⅝ in. e. H. 1¾ in. f. D. 1¹³⁄₁₆ in.

g. L. 3¹⁄₁₆ in.

128. ELECTRUM AND GOLD ORNAMENTS, VII–IV CENTURIES B.C.

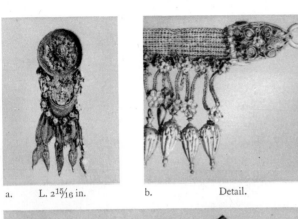
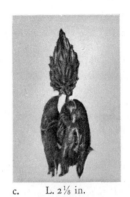

a. L. 2$\frac{15}{16}$ in. b. Detail. c. L. 2$\frac{1}{8}$ in.

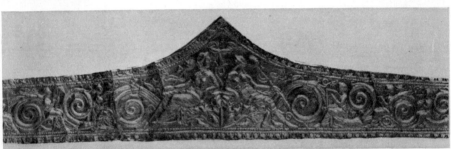

d. Detail.

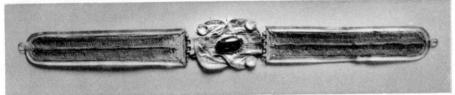

e. L. 8$\frac{1}{8}$ in.

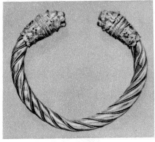
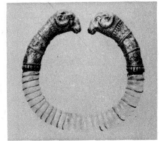

f. D. 3$\frac{1}{8}$ in. g. D. 3$\frac{1}{16}$ in.

129. GOLD ORNAMENTS, IV–III CENTURIES B.C.

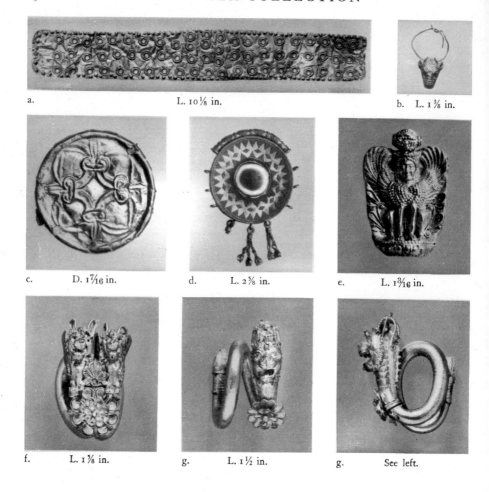

a.　　　　　　　　L. 10⅛ in.　　　　　　　b.　L. 1⅜ in.

c.　　D. 1⁷⁄₁₆ in.　　　d.　　L. 2⅝ in.　　　e.　　L. 1³⁄₁₆ in.

f.　　L. 1⅛ in.　　　g.　　L. 1½ in.　　　g.　　See left.

130. GOLD ORNAMENTS FROM CYPRUS, ABOUT 1400–400 B.C.

NOTES
ABBREVIATED REFERENCES

NOTES

PREHISTORIC PERIOD

1 ⟿ E.g., 26.31.503, 504, 507.

2 ⟿ 46.111.1. Gift of Alexander Boyd Hawes, 1946.

3 ⟿ 17.230.56.

4 ⟿ 36.122. Anonymous gift, 1936.

5 ⟿ E.g., 11.186.15: *Bull.*, 1912, pp.29 f., fig. 1. 30.119.8, 48, 62, 69.

6 ⟿ 26.31.438.

7 ⟿ 11.186.1, from Knossos: Evans, *P. of M.*, I, p.72, fig. 40; *Bull.*, 1912, p.30, fig. 2.

8 ⟿ 14.89.4, from Pseira: *Bull.*, 1915, pp.8, 9, fig. 2.

9 ⟿ 11.186.11: *Bull.*, 1912, pp. 32 f., fig. 9.

10 ⟿ 11.186.13: *Bull.*, 1912, p. 33, fig. 11.

11 ⟿ x280.

12 ⟿ 11.186.14: *Bull.*, 1912, pp. 33 f., fig. 12.

13 ⟿ 22.139.76: *Bull.*, 1924, p. 97; Binns and Frazer, *AJA*, 1929, p.6.

14 ⟿ E.g., 07.232.28.

15 ⟿ 27.120.4, 5. Gift of the Greek Government, through the American School of Classical Studies. On the pottery from Zygouries see Blegen, *Zygouries*, pp.75 ff.

16 ⟿ 27.120.8–10, 12. Gift of the Greek Government, through the American School of Classical Studies.

17 ⟿ 06.1021.2: *Bull.*, 1906, p.77, fig. 1; Sambon, *Coll. Canessa*, p.5, no. 1, pl.1,1.

18 ⟿ 10.142.2: *Bull.*, 1911, p. 32.

19 ⟿ 25.78.102.

20 ⟿ 06.1021.3: Sambon, *Coll. Canessa*, p.5, no. 2, pl.1, 2.

21 ⟿ 74.51.762 (CP805): Myres, *Handbook*, no. 448. 74.51.1393

(CP2048): Myres, no. 439. 74. 51.771 (CP814): Myres, no. 446. 74.51.1288 (CP1911): Myres, no. 449.

22 ⟿ 74.51.429 (CP227): Myres, *Handbook*, no. 435.

23 ⟿ 74.51.964 (CP1403): Myres, *Handbook*, no. 436; S. A. Immerwahr, *AJA*, 1945, pp. 544 ff., figs. 8–10. 74.51.966 (CP1405): Myres, *Handbook*, no. 437; S. A. Immerwahr, *AJA*, 1945, pp.549 ff., figs. 11, 12 (see also the fragments with birds and floral ornaments, figs. 1–4).

24 ⟿ 35.11.3: *Bull.*, 1935, pp. 10–12, and 1944–45, pp.238 f. 45.11.4, 18.

25 ⟿ 47.100.1.

26 ⟿ L2498.1–3.

27 ⟿ 26.31.490: *Bull.*, 1944–45, pp.238, 240. 24.150.9: *Bull.*, 1924, p.292. 46.111.4.

28 ⟿ 22.15; 36.11.7: *Bull.*, 1937, p.17. 35.11.16-19: *Bull.*, 1936, p.68.

29 ⟿ 74.51.1711 (CP2786): Myres, *Handbook*, no. 2018; Swindler, *AJA*, 1941, p.87.

30 ⟿ 36.11.6: *Bull.*, 1937, p.17, fig. 1, and 1944–45, pp.238, 241.

31 ⟿ 39.11.1: *Bull.*, 1939, pp. 216 f., fig. 1, and 1944–45, pp. 238, 241.

32 ⟿ 35.11.22, 23: *Bull.*, 1936, p.91.

33 ⟿ E.g.: 26.31.429, 430; 24.150.4, from Vasiliki: *Bull.*, 1924, p.292. 24.150.7, from Haghia Photia: *Bull.*, 1924, p.292. 26.31.431: Evans, *P. of M.*, I, p.177, fig. 126. 24.150.1, from Mochlos: *Bull.*, 1924, p. 292. 14.89.13, from Gournia: *Bull.*, 1915, p.10.

34 ⟿ 07.286.126: *Bull.*, 1908, p. 22, figs. 1, 28.

35 ⟿ 07.286.128a,b.

36 ⟿ 46.11.1: Segall, *Katalog*

der Goldschmiedearbeiten (Benaki Museum, Athens), p.212, no. 1b.

37 ⟿ Knife blades, e.g., 26.31. 469, from the Dictaean Cave. Chisels, e.g., 26.31.479, from Crete: *Daily Life*, p.118. Tweezers, e.g., 26.31.468, from the Dictaean Cave. Awls, e.g., 07. 232.2, from Gournia. Needles, e.g., 26.31.476, from the Dictaean Cave. Weaving hook, 26. 31.475, from the Dictaean Cave: *Daily Life*, p.118. Fish hook, 24. 150.10, probably from Psychro: *Bull.*, 1924, p.292. Bronze axe heads, e.g., 20.207: *Bull.*, 1923, p.76; Childe, *Antiquity*, 1937, pp.95 f. 40.11.4: *Bull.*, 1941, p.18. Gold axe head, 44.11.11, said to have been found in Crete (for similar axes found at Arkalochori cf. *Arch. Anz.*, 1934, cols. 190, 252). Spear heads, e.g., 26.31.484, from Crete. Daggers, e.g., 26.31.485: Evans, *P. of M.*, I, p.195, fig. 142b.

38 ⟿ 26.31.393.

39 ⟿ E.g., 26.31.398.

40 ⟿ 26.31.499: Evans, *P. of M.*, I, pp.718 ff., fig. 541; Lamb, *Bronzes*, p.7, pl.3.

41 ⟿ 74.51.5684 (CB451): Myres, *Handbook*, no. 4704; *Bronze Cat.*, no. 1180; Lamb, *Bronzes*, no. 33, pl.10b; Riis, *Acta Arch.*, 1939, p.5, no. 1, pp. 6 ff.

42 ⟿ 74.51.5685 (CB452): Myres, *Handbook*, no. 4703; *Bronze Cat.*, no. 620.

43 ⟿ 26.31.427, from Mochlos (?).

44 ⟿ 26.31.418, 502, 508, 509, from Mochlos.

45 ⟿ 26.31.417, from Milatos, near Neapolis. 25.78.22.

46 ⟿ 39.11.2: *Bull.*, 1939, pp. 216 f., fig. 2.

47 ⟿ 26.31.392.

48 ⚬⚬⚬ 26.31.53, 88, 163: *Bull.,* 1922, p.88, fig. 1.

49 ⚬⚬⚬ Cf., e.g., 26.31.120, 125, 134: *Bull.,* 1922, pp.88 f., fig. 2.

50 ⚬⚬⚬ 26.31.122, 146, 149, 156,

175: *Bull.,* 1922, p.89, fig. 3.

51 ⚬⚬⚬ 26.31.67: Richter in *Encyclopedia Britannica,* 14th ed. (1929), x, p.97, pl.1, no. 29.

52 ⚬⚬⚬ 26.31.242, 240, 278; 14. 104.3: *Bull.,* 1915, p.212; *Cat.*

of *Gems,* no. 6. 07.286.123: *Cat. of Gems,* no. 7.

53 ⚬⚬⚬ 26.31.383: Richter in *Encyclopedia Britannica,* 14th ed. (1929), x, p.97, pl.2, no. 13.

54 ⚬⚬⚬ 26.31.357.

GEOMETRIC PERIOD

1 ⚬⚬⚬ 17.190.2072: C. Smith, *J. P. Morgan Coll.,* pp.32 f., no. 80; Hampe, *Frühe gr. Sagenbilder,* p.32, no. 3a, pl.30; *Master Bronzes,* no. 62; *Bull.,* 1944–45, pp.239, 242.

2 ⚬⚬⚬ 36.11.8: *Bull.,* 1937, pp. 37 f., figs. 1–3; 1944–45, pp.239, 243; Richter, *Kouroi,* p.41, figs. 5–7.

3 ⚬⚬⚬ 42.11.42: *Bull.,* 1944–45, pp.239, 243; Richter, *AJA,* 1944, pp.1 ff.

4 ⚬⚬⚬ 47.11.7. Once in the Tyszkiewicz collection, more recently in that of Professor V. Simkhovitch. Similar pieces are in the Musée Rodin and in the Fitzwilliam Museum. On such pendants see especially Furtwängler, *Olympia,* iv, pp.60 f., pl.23, nos. 410–417; Carapanos, *Dodona,* pl.52, no. 17; Makrides, Ἐφ. Ἀρχ., 1937, part 2, pp. 518 f., nos. 23–30, pls.3, 6.

5 ⚬⚬⚬ 26.31.491.

6 ⚬⚬⚬ 26.31.494.

7 ⚬⚬⚬ 21.88.24: *Bull.,* 1923, p.75; *Master Bronzes,* no. 63; Richter, *Animals,* pp.15, 55, fig. 49.

8 ⚬⚬⚬ 35.11.14: *Bull.,* 1935, p. 255, and 1944–45, pp.239, 243; *Master Bronzes,* no. 64.

9 ⚬⚬⚬ 26.31.492, from Crete. 46. 111.5.

10 ⚬⚬⚬ 31.11.8: *Bull.,* 1932, pp. 213 f., and 1944–45, pp.239, 240.

11 ⚬⚬⚬ L1930.4, 5, 10, 20, 46: Halbherr, *AJA,* 1901, p.390, pl.12, no. 3, fig. 19; Dohan, *M. M. Studies,* 1930–31, pp.210,

211, figs. 1, 2, 4, 6, 7. All are lent to the Museum by the Archaeological Institute of America.

12 ⚬⚬⚬ 14.130.14, 15: *Bull.,* 1915, pp.70 ff., figs. 1, 2; Richter, *AJA,* 1915, pp.385 ff., pls.17–23; Richter, *Furniture,* pp.22, 66, figs. 57, 171; Zschietzschmann, *Ath. Mitt.,* 1928, p.38, nos. 11, 12; J. M. Cook, *BSA,* 1934–35, p.206; Hampe, *Frühe Gr. Sagenbilder,* p.47, fig. 21, a; R. S. Young, *Hesperia,* sup. ii, pp. 59, 173, 182.

13 ⚬⚬⚬ 34.11.2: *Bull.,* 1934, pp. 169 ff., figs. 1–3; J. M. Cook, *BSA,* 1934–35, pp.171, n.5, 192, n.4, 195, n.3; R. S. Young, *Hesperia,* sup. ii, p.172.

14 ⚬⚬⚬ 74.51.965 (CP1404): Myres, *Handbook,* no. 1701; R. S. Young, *Hesperia,* sup. ii, pp.85 (there wrongly called Myres, *Handbook,* 1702), 97, 196, n.1; N. M. Kondoleon, Ἐφ. Ἀρχ. 1945–1947 (published in 1949), pp.11 ff., fig. 4. This vase used to be classed as Athenian but has lately been identified as Cycladic by Mr. Kondoleon.

15 ⚬⚬⚬ 10.210.6: *Bull.,* 1911, pp. 30,35, fig. 10. 11.212.6.

16 ⚬⚬⚬ 10.210.7, 8: *Bull.,* 1911, pp.30 f., figs. 6, 7; R. S. Young, *Hesperia,* sup. ii, pp.172, 219, n. 2, 220, 221; J. M. Cook, *BSA,* 1934–35, pp.179 f., pl.47.

17 ⚬⚬⚬ 21.88.18: *Bull.,* 1923, p. 176, fig. 1; J. M. Cook, *BSA,* 1934–35, p.184, pl.50; R. S. Young, *Hesperia,* sup. ii, pp. 137, 198, 219, n.3, 220, 221.

18 ⚬⚬⚬ 35.11.12: *Bull.,* 1936, p. 43.

19 ⚬⚬⚬ 48.11.5: *Bull.,* 1949–50, p.91.

20 ⚬⚬⚬ 30.118.1–65: *Bull.,* 1931, p.23. On the vases from Hymettos, cf.: Blegen, *AJA,* 1934, pp. 10 ff.; Carpenter, *AJA,* 1938, pp. 61, 69; R. S. Young, *Hesperia,* 1938, p.415, and sup. ii, 1939, p.203.

21 ⚬⚬⚬ 36.11.3, 9: *Bull.,* 1937, pp. 9 f., figs. 1, 2.

22 ⚬⚬⚬ 74.51.592 (CP537): Myres, *Handbook,* no. 1710; H. A. Thompson, *Hesperia,* iii, 1934, p.442, n.2.

23 ⚬⚬⚬ E.g., 26.199.288, 287.

24 ⚬⚬⚬ 24.97.22, 23: *Bull.,* 1925, p.16.

25 ⚬⚬⚬ 47.14.

26 ⚬⚬⚬ 22.139.88; 23.198: *Bull.,* 1924, p.98.

27 ⚬⚬⚬ 37.11.18: *Bull.,* 1938, p. 51, fig. 2.

28 ⚬⚬⚬ 24.97.105: Alexander, *Early Greek Art* (M.M.A. Picture Book), fig. 6a.

29 ⚬⚬⚬ L1930.3: Halbherr, *AJA,* 1894, p.543; 1901, p.383, fig. 12.

30 ⚬⚬⚬ 22.139.18: *Bull.,* 1924, p.72.

31 ⚬⚬⚬ 74.51.5304 (CB36): Myres, *Handbook,* no. 4706; *Bronze Cat.,* no. 1423.

32 ⚬⚬⚬ 74.51.5686 (CB507): Myres, *Handbook,* no. 4713; *Bronze Cat.,* no. 1430.

33 ⚬⚬⚬ See Froehner, *Coll. Gréau,* passim.

PERIOD OF ORIENTAL INFLUENCE

1 ⟷ 35.11.20: *Bull.*, 1936, pp. 235 ff., figs. 1, 2; Casson, *Manchester Guardian Weekly*, Dec. 18, 1936, p.495; C. Picard, *Revue des études grecques*, 1937, pp.111, 159.

2 ⟷ L1930.11: Halbherr, *AJA*, 1894, p.544, and 1901, p.386, pl.10; Dohan, *M. M. Studies*, 1930–31, pp.215 f., fig. 15. These objects and the two following are lent by the Archaeological Institute of America.

3 ⟷ L1930.22, 23: Halbherr, *AJA*, 1901, pl.12,1; Dohan, *M. M. Studies*, 1930–31, pp. 213, fig. 10, 215.

4 ⟷ L1930.30: Halbherr, *AJA*, 1901, p.391, fig. 21; Dohan, *M. M. Studies*, 1930–31, pp.219, fig. 27, 221.

5 ⟷ 26.31.450, 454.

6 ⟷ 46.111.6: Dohan, *M. M. Studies*, 1930–31, pp.216 f., fig. 16; Jenkins, *Dedalica*, p.25, pl.1, 5.

7 ⟷ 36.11.5: *Bull.*, 1937, p.17. 39.11.5: *Bull.*, 1940, p.108, fig. 2.

8 ⟷ 22.139.56: E. D. Van Buren, *Archaic Fictile Revetments in Sicily and Magna Graecia*, p.148, no. 53; *Bull.*, 1925, p.14, fig. 1.

9 ⟷ 13.227.11.

10 ⟷ 22.139.57: Orsi, *Notizie d. sc.*, 1902, p.128, fig. 3, no. 3; *Bull.*, 1925, p.15, fig. 3.

11 ⟷ 24.97.1: *Bull.*, 1925, p.16. The identification as Troilos was made by D. von Bothmer. The lower piece shows only part of a horse's leg.

12 ⟷ 10.210.44: E. D. Van Buren, *Archaic Fictile Revetments in Sicily and Magna Graecia*, pp.140 f., pl.14, fig. 55. 26.60.73: *Bull.*, 1928, p.82.

13 ⟷ 39.11.9: *Bull.*, 1940, pp. 107 f., fig. 1; Alexander, *AJA*, 1940, p.293, fig. 1.

14 ⟷ 10.210.46: *Bull.*, 1940, pp. 107 f.

15 ⟷ 24.97.2: *Bull.*, 1924, p.294, fig. 5.

16 ⟷ 14.146.3a,b: *Bull.*, 1915, pp.208 f., fig. 1, and 1942–43, pp.81 ff., figs. 4, 5.

17 ⟷ 42.11.33: *Bull.*, 1942–43, pp.84 ff., figs. 9–12.

18 ⟷ 35.11.15: *Bull.*, 1936, p. 116, and 1942–43, pp.83 f., 86, fig. 8; Richter, *AJA*, 1936, p.304.

19 ⟷ 26.13: Richter and Hall, *AJA*, 1944, pp.324, 331, 336, figs. 9, 10; Richter, *Gravestones*, pp.19 f., figs. 33, 34.

20 ⟷ 06.1072: Beazley, *JHS*, 1940, pp.40, 42, fig. 21, pl.7.

21 ⟷ 17.190.73: Richter, *AJA*, 1945, pp.261 ff; Matz, *Marburger Winckelmann-Programm*, 1948, pp.3 ff.

22 ⟷ 27.122.23: *Bull.*, 1929, pp. 201 f., fig. 2. The technical analysis here given is by Murray Pease and L. Heinrich. Compare Walters, *Catalogue of Silver Plate in the British Museum*, nos. 2–4.

23 ⟷ 74.51.5682 (CB449): Myres, *Handbook*, no. 4962; *Bronze Cat.*, no. 1273.

24 ⟷ 74.51.5574 (CB331): Myres, *Handbook*, no. 4756; *Bronze Cat.*, no. 1189; Riis, *Acta Arch.*, 1939, p.19, no. 9.

25 ⟷ 74.51.5622 (CB382): Myres, *Handbook*, no. 4762; *Bronze Cat.*, no. 1182; Riis, *Acta Arch.*, 1939, p.19, no. 9.

26 ⟷ 74.51.5571 (CB328): Myres, *Handbook*, no. 4765; *Bronze Cat.*, no. 4; Langlotz in *Corolla Ludwig Curtius*, p.61, n. 7.

27 ⟷ 74.51.5617 (CB377): Myres, *Handbook*, no. 4917; *Bronze Cat.*, no. 538.

28 ⟷ 21.88.21: *Bull.*, 1923, p. 75.

29 ⟷ 39.11.12: *Bull.*, 1939, pp. 286 f., figs. 2, 3; Richter, *AJA*, 1940, p.181, figs. 1–3.

30 ⟷ 47.11.8. Formerly in the collection of Sir Cecil Harcourt-Smith (Sotheby, Sale Catalogue, June 18, 1930, no. 172, pl.12), more recently in that of Professor V. Simkhovitch.

31 ⟷ 06.1093: *Bull.*, 1907, p.20; *Bronze Cat.*, no. 15.

32 ⟷ L52: *Bronze Cat.*, no. 14; Richter, *Animals*, fig. 51; Jantzen, *Bronzewerkstätten*, pp.3, no. 2, 21, 73, no. 14; Markman, *The Horse*, p.111. The object has been on loan since 1907, by Junius S. Morgan.

33 ⟷ 01.16.1 (GR391): *Bronze Cat.*, no. 13; Richter, *Animals*, p.45.

34 ⟷ 38.11.3: *Bull.*, 1938, pp. 130 ff., figs. 1, 2; Richter, *AJA*, 1938, pp.337 ff., figs. 1–7; Beazley, *Proceedings of the Royal Irish Academy*, XLV, section C, no. 5, 1939, p.39, n. 29.

35 ⟷ 74.51.5680 (CB447): Myres, *Handbook*, no. 5013; *Bronze Cat.*, no. 28; Richter, *AJA*, 1938, p.337.

36 ⟷ 23.160.31: *Bull.*, 1924, p. 70; Langlotz, *Bildhauerschulen*, p.91, pl.53c.

37 ⟷ 41.11.5: *Catalogue Chevalier M.; Vente du 2 juin 1896*, no. 150, pl.3; *Bull.*, 1942, pp. 150 f.; Richter, *AJA*, 1942, pp. 319 ff.

38 ⟷ 46.11.6.

39 ⟷ 06.1104: *Bronze Cat.*, no. 25; Langlotz, *Bildhauerschulen*, pp.87, no. 19, 91; Richter, *AJA*, 1942, p.324, n. 21.

40 ⟷ 29.100.488: *Bull.*, 1930, p.75; Kukahn, *Der Griechische Helm*, p.66, no. 39.

41 ⟷ 07.286.105: *Bronze Cat.*, no. 1530; Kukahn, *Der Griechische Helm*, p.71, no. 64. 19. 192.35: *Bull.*, 1921, p.36; Kukahn, *Der Griechische Helm*, pp. 72 f., no. 65.

42 ⟷ 35.11.2: *Bull.*, 1935, pp. 133 f.; Kukahn, *Der Griechische Helm*, p.55, no. 45.

43 ⟷ 24.195.1–180: *Bull.*, 1925, pp.157 f.

44 ⟷ 24.195.185–187: *Bull.*, 1925, p.158.

45 ⟷ 23.160.18: *Bull.*, 1924, p. 98, fig. 3.

46 ⟷ 19.192.74: *Bull.*, 1920, p.

255. 38.11.9: *Bull.*, 1939, pp. 98 f.

47 ⟷ 18.91: *Bull.*, 1919, pp.8 ff., fig. 3.

48 ⟷ 37.128.1: *Bull.*, 1938, p. 27.

49 ⟷ 23.44: *Bull.*, 1923, p.178.

50 ⟷ 30.11.1: *Bull.*, 1930, p. 136.

51 ⟷ 47.100.2. From the Brummer collection. *Bull.*, 1949–50, p.92.

52 ⟷ 41.162.22: Pease, *C.V.*, Gallatin Coll., pl.34, 1.

53 ⟷ 96.18.38 (GR519). 22.139. 9: *Bull.*, 1923, p.177; Payne, *Necr.*, p.277, no. 138, and *Protokor. V.*, pp.17, 24, no. 31, pl.31, 1.

54 ⟷ X22.13 (GR512): Payne, *Necr.*, p.274, no. 75.

55 ⟷ 41.162.79: Payne, *Necr.*, p.342, xvi; Pease, *C.V.*, Gallatin Coll., pl.34, 5.

56 ⟷ 06.1021.17: Payne, *Necr.*, p.289, no. 528.

57 ⟷ 06.1021.18: Payne, *Necr.*, p.300, no. 774.

58 ⟷ X22.14 (GR502): Payne, *Necr.*, p.78, n. 4.

59 ⟷ 74.51.1414 (CP2083): *Cesnola Atlas*, II, 1106.

60 ⟷ 21.88.169: *Bull.*, 1924, p. 99; Payne, *Necr.*, p.296, no. 700; Amyx, *Univ. of Cal. Pub.*, I, no. 9, p.211. 25.78.46: *Bull.*, 1927, p.17; Payne, *Necr.*, p.292, no. 646.

61 ⟷ 13.225.10: *Bull.*, 1914, pp. 234 f.; Payne, *Necr.*, p.299, no. 750.

62 ⟷ 27.116: *Bull.*, 1928, pp. 48, 49, figs. 1, 2; Payne, *Necr.*, pp.103, 135, 163, no. 17, 318, no. 1187, 114, n.6, 160, n.5, pl. 33, 5.

63 ⟷ 12.229.9: *Bull.*, 1913, pp. 155 f., fig. 4; Payne, *Necr.*, p. 318, no. 1195.

64 ⟷ 41.11.1: *Bull.*, 1941, pp. 187 ff.; Richter, *AJA*, 1942, p. 268.

65 ⟷ 06.1021.26: Richter, *Furniture*, p.68, fig. 179; Payne,

Necr., pp.117, 313, no. 1046.

66 ⟷ X22.20 (GR501): Payne, *Necr.*, pp.137, 188, 319, no. 1200; Lunsingh Scheurleer, *Grieksche Ceramiek*, p.64.

67 ⟷ 38.11.8: *Bull.*, 1939, p.99.

68 ⟷ 06.1021.24: Payne, *Necr.*, pp.188, 326, no. 1401.

69 ⟷ 35.11.21: *Bull.*, 1936, pp. 104 f., figs. 1, 2; Amyx, *Univ. of Cal. Pub.*, I, no. 9, pp.208, 214, pl.32c, d. 21.88.63: *Bull.*, 1923, p.177; Payne, *Necr.*, p. 322, no. 1305; Amyx, *Univ. of Cal. Pub.*, I, no. 9, pl.31c. 51.364 (CP54): Myres, *Handbook*, no. 1724; Payne, *Necr.*, pp.236, 322, no. 1309; Milne, *AJA*, 1942, pp. 218 ff.; Amyx, *Univ. of Cal. Pub.*, I, no. 9, p. 214, pl.31 f.; *Bull.*, 1942, pp. 36 f.

70 ⟷ 06.1021.32: Payne, *Necr.*, pp.155, 236, 332, no. 1503; Amyx, *Univ. of Cal. Pub.*, I, no. 9, p.215.

71 ⟷ 06.1021.25: Sambon, *Coll. Canessa*, no. 143. 23.72.2: Richter, *Animals*, fig. 153. 41. 162.31: Pease, *C.V.*, Gallatin Coll., pl.34, 2. 21.88.8: *Bull.*, 1923, p.178.

72 ⟷ 12.198.1: *Bull.*, 1913, pp. 155 f., fig. 6; J. M. Cook, *BSA*, 1934–35, p.188, n.4; R. S. Young, *Hesperia*, sup. II, pp.60, 70.

73 ⟷ 11.210.1: *Bull.*, 1912, pp. 68 ff.; Richter, *JHS*, 1912, pp. 370 ff., and Casson, 1922, p.218; Pfuhl, *M.u.Z.*, figs. 86, 87; Jacobsthal, *Ornamente*, pl.48; Beazley, *ABS*, p.9, pl.2; Beazley and Ashmole, *Sculpture and Painting*, p.10, fig. 21; J. M. Cook, *BSA*, 1934–35, pp.192 ff.; R. S. Young, *AJA*, 1942, pp.51, 56 f., and *Hesperia*, sup. II, pp. 108, 130, 132–135, 137, 149, 160, 166, 213, 218, 220, 221; Dugas, *Revue des études anciennes*, 1943, p.23, n.2. Dugas suggested that Herakles's opponent is not Nessos but Acheloos. But the part of the head where a horn might have been is missing and, in any case, as Sir John Beazley pointed out to me, the creature's tail is not that of a bull but of a horse.

74 ⟷ 38.11.10: *Bull.*, 1939, pp. 98 ff.; Beazley, *Hesperia*, 1944, p.38, n.3.

75 ⟷ 22.139.7: *Bull.*, 1923, pp. 178 f.; Richter and Milne, fig. 1.

76 ⟷ 26.164.28: Butler, *Sardis*, I, p.121, ill. 125; Beazley, *Hesperia*, 1944, p.42, n.8.

77 ⟷ 21.88.81: *Bull.*, 1923, p. 177, fig. 2; Smith, *Univ. of Cal. Pub. in Class. Arch.* I, no. 3, p.88.

78 ⟷ 25.78.104.

79 ⟷ 26.60.17: *Bull.*, 1927, p. 17, fig. 1; Payne, *Necr.*, pp.154, 308, no. 913.

80 ⟷ 07.156.7: D. von Bothmer, *AJA*, 1944, p.163, n.23.

81 ⟷ 74.51.1331 (CP1968): Myres, *Handbook*, no. 1729; Payne, *Necr.*, p.126, no. 2.

82 ⟷ 45.11.2: *Bull.*, 1944–45, pp.169 ff.

83 ⟷ 22.139.77: *Bull.*, 1924, p. 99; Lane, *BSA*, 1933–34, p.130.

84 ⟷ 14.30.26: Chase, *AJA*, 1921, pp.111 ff., pl.4; Lane, *BSA*, 1933–34, pp.150 f.

85 ⟷ 06.1021.22: Payne, *Necr.*, p.202, no. 20; Sambon, *Coll. Canessa*, p.55, no. 211, pl.13.

86 ⟷ 21.88.91: *Bull.*, 1923, p. 178, fig. 6.

87 ⟷ 06.1021.16: A. D. Ure, *M. M. Studies*, 1932–33, pp.18, 23, no. 4, figs. 6, 7. X248.7. 51.11.9: *Bull.*, 1951, p.108.

88 ⟷ 06.1021.28: Sambon, *Coll. Canessa*, p.7, no. 8.

89 ⟷ 98.8.25 (GR535): Furtwängler, *Kleine Schriften*, II, 1921, 13, 16; Rumpf, *Ath. Mitt.*, 1921, p.163, and *Chalkidische Vasen*, pl.182, no. 263; Pfuhl, *M.u.Z.*, p.205. 96.18.64, 65 (GR536, 537): Rumpf, *Ath. Mitt.*, 1921, pp.161 f., pl.6a, and *Chalkidische Vasen*, pl.177, nos. 245, 246.

90 ⟷ 46.11.5: Sotheby, Sale Catalogue, May 14, 1946, no. 103; *Bull.*, 1946–47, pp. 131 ff.

91 ⟷ 21.169.2: *Bull.*, 1923, p. 177, 179, fig. 7; Rumpf, *Jahrbuch*, 1933, p.73, no. 11. 19.

192.10: *Bull.*, 1920, pp.254 f.

92 ∽ 19.192.12, 13: Galerie Georges Petit, Sale Catalogue, *Collection Pozzi*, June 25–27, 1919, p.32, no. 440; *Bull.*, 1920, pp.254, 255, figs. 1, 2.

93 ∽ 23.160.35; 26.60.22 (foot restored): *Bull.*, 1924, p.97; J. M. Cook, *BSA*, 1933–34, pp.26 ff., 49, no. 22.

94 ∽ 74.51.528 (CP431): Myres, *Handbook*, no. 1726; J. M. Cook, *BSA*, 1933–34, p.47, no. 11.

95 ∽ 17.230.38–41: *Bull.*, 1923, p.179. 74.51.360 (CP45): Myres, *Handbook*, no. 1713.

96 ∽ 48.11.6: *Bull.*, 1949–50, pp.93 f. The foot is restored.

97 ∽ 37.11.4: *Bull.*, 1937, pp. 175 f., fig. 1.

98 ∽ 21.169.1: *Bull.*, 1922, pp. 215 f.; Rumpf, *Jahrbuch*, 1933, p.55, n.2.

99 ∽ 14.30.7.

100 ∽ E.g., 74.51.1374, 1372: Myres, *Handbook*, nos. 1732, 1731.

101 ∽ 26.211.1–13.

102 ∽ 33.11.1, 2: *Bull.*, 1934, p. 81.

103 ∽ 29.62. 41.162.121: Pease, *C.V.*, Gallatin Coll., pl. 33, 9.

104 ∽ 41.162.122: Pease, *C.V.*, Gallatin Coll., pl.33, 10.

105 ∽ 41.162.220: Gallatin, *C.V.*, Gallatin Coll., pl.2, 12.

106 ∽ 41.162.38, 74: Pease, *C.V.*, Gallatin Coll., pl.33, 5, 4. 21.88.170: *Bull.*, 1924, p.294. 06.1021.31: Sambon, *Coll. Canessa*, p.44, no. 145; Maximova, *Les Vases Plastiques*, p. 156, n.2.

107 ∽ 39.11.7: *Bull.*, 1939, pp. 286 f., fig. 1; Richter, *AJA*, 1940, pp.181 ff.

108 ∽ 26.164.3.

109 ∽ 24.97.4: *Bull.*, 1924, p. 294. 41.162.195: Gallatin, *C.V.*, Gallatin Coll., pl.30, 5.

110 ∽ 41.162.26: Pease, *C.V.*, Gallatin Coll., pl.33, 6. On the varying color of terracotta, cf. E. R. Price, *East Greek Pottery*,

p.37. Reduction in the kiln would also turn a pinkish color into grey.

111 ∽ 13.225.11: *Bull.*, 1914, p.235; C. M. Robertson, *JHS*, 1938, p.42, no. 6a.

112 ∽ E.g., 11.216; 26.199.1, 8, 9.

113 ∽ 26.164.32: Butler, *Sardis*, I, pp.77 f., ill. 74, and Shear, X, pp.9 ff., pl.2.

114 ∽ 26.164.16: Butler, *Sardis*, I, p.77, ill. 73; Shear, *AJA*, 1923, pp.140 f., fig. 6, and *Sardis*, X, pp.19 ff, pl.5.

115 ∽ Butler and others, *Sardis*, passim; Chase, *AJA*, 1914, pp. 432 ff., and 1921, pp.111 ff. The pottery from Sardis is to be published by Chase and Hanfmann in a volume of *Sardis*.

116 ∽ 26.59.2–6.

117 ∽ 16.75.6

118 ∽ 26.199.21a: Hanfmann, *AJA*, 1945, pp.570 ff., fig. 1.

119 ∽ See Froehner, *Coll. Gréau*, passim.

THE ARCHAIC PERIOD IN ATTICA

1 ∽ 32.11.1: *Bull.*, 1932, pp. 218 ff., figs. 1–4; Richter, *AJA*, 1932, p.381, pl.a, *M. M. Studies*, 1934–36, pp.21 ff., figs. 1–14, in Brunn-Bruckmann, *Denk.*, nos. 751–5, and *Kouroi*, no. 1, pp.63 ff.

2 ∽ 21.88.16: *Bull.*, 1922, pp. 148 ff.; Richter in Brunn-Bruckmann, *Denk.*, no. 721, and *Kouroi*, no. 52, pp.132 f.

3 ∽ 07.286.110: *Bull.*, 1908, pp. 2 ff., fig. 3.

4 ∽ 24.97.87: *Bull.*, 1926, p. 126 f., fig. 4; Richter, *Gravestones*, pp.14 ff., figs. 30–32, 38; Richter and Hall, *AJA*, 1944, pp. 324, 335.

5 ∽ 17.230.6: *Bull.*, 1921, p.14; Dinsmoor, *AJA*, 1922, pp.261 ff.; Richter, *Gravestones*, pp.31 ff., figs. 39–42, 60b.

6 ∽ 43.11.6: Richter and Hall, *AJA*, 1944, pp.324, 335; Richter,

Gravestones, pp.37 f., figs. 52–54.

7 ∽ 12.158: Richter, *Gravestones*, pp.43 ff., fig. 62.

8 ∽ 16.174.6: *Bull.*, 1925, p. 269, fig. 1, and 1926, p.58; Richter, *Gravestones*, pp.43 ff., fig. 65.

9 ∽ 42.11.36: Richter, *Gravestones*, pp.62 f., fig. 71.

10 ∽ 44.11.5: Richter, *Gravestones*, pp.81 ff., fig. 16.

11 ∽ 21.88.179: Richter, *AJA*, 1941, pp.161 ff., and *Gravestones*, pp.87 ff., figs. 19, 91, 92; *Bull.*, 1943–44, p.239; Richter and Hall, *AJA*, 1944, pp.324, 336, fig. 6.

12 ∽ 15.167: *Bull.*, 1916, p.124, fig. 1; Richter and Hall, *AJA*, 1944, pp.322, 324, 336, fig. 7; Richter, *Gravestones*, pp.104 ff., figs. 23, 104.

13 ∽ 15.167.1: *Bull.*, 1916, p. 124; Richter, *Gravestones*, pp. 105 ff., figs. 22, 103; Richter and Hall, *AJA*, 1944, pp.324, 336.

14 ∽ 08.258.6: *Bull.*, 1909, pp. 44, 78; *Bronze Cat.*, no. 16.

15 ∽ 26.31.493.

16 ∽ 12.229.4: *Bull.*, 1913, pp. 268 f., fig. 7; *Bronze Cat.*, no. 62. Etruscan (?)

17 ∽ 07.286.91: *Bull.*, 1908, pp.89 f., fig. 2; *Bronze Cat.*, no. 60.

18 ∽ 07.286.92: *Bull.*, 1908, pp.89 f., fig. 4; *Bronze Cat.*, no. 17; Richter, *Kouroi*, no. 143.

19 ∽ 45.11.7: *Bull.*, 1945–46, pp.249 ff.

20 ∽ 17.190.2070: *Master Bronzes*, no. 70. Part of the branch is missing.

21 ∽ 20.181: *Bull.*, 1921, p.36; Richter, *Animals*, pp.26, 69, fig.

126, pl.41; *Master Bronzes*, no. 75.

22 ⟿ x22.6 (GR541): Richter and Milne, fig. 92; Haspels, *ABL*, pp.5, 25, 194, no. 1, pl.8, 1.

23 ⟿ 39.11.10: *Bull.*, 1940, pp. 36 f., fig. 1.

24 ⟿ 07.286.43, 41: Haspels, *ABL*, p.42; Richter and Milne, fig. 94.

25 ⟿ 22.139.22: *Bull.*, 1925, p. 297; Greifenhagen, *Eine attische schwarzfigurige Vasengattung*, p.10, pl.1; Payne, *Necr.*, pp. 194 ff., no. 8; Richter and Milne, fig. 152.

26 ⟿ 06.1097: Richter and Milne, fig. 160.

27 ⟿ 47.11.5: Millin, *Monumens inédits*, 11, 1806, pp.15 ff.; Hoppin, *Bf*, pp.344 f. and the references there cited; Tillyard, *Hope Vases*, no. 13; Beazley, *JHS*, 1932, pp.198 f.; Sotheby, Sale Catalogue, Dec. 2, 1946, no. 48; *Bull.*, 1946–47, pp. 221 ff.

28 ⟿ 31.11.4: *Bull.*, 1931, pp. 289 ff., figs. 1–3; Beazley, *JHS*, 1932, p.200; Richter and Milne, fig. 189.

29 ⟿ 26.49: Richter, *AJA*, 1932, pp.272 ff.; Beazley, *BSA*, 1931–32, p.21, *JHS*, 1932, pp.172, 196, 201, and *AJA*, 1935, p. 485; Richter and Milne, fig. 103.

30 ⟿ 31.11.10: *Bull.*, 1931, pp. 291 ff., figs. 4, 5, and 1932, pp. 70 f., figs. 1, 2; Bieber, *Entwicklungsgeschichte*, p.24, pl.1; Richter and Milne, fig. 93; Haspels, *ABL*, pp.12, 14, 99. Now attributed to the Amasis Painter (Beazley, in a letter).

31 ⟿ 41.162.32: Gallatin, *C.V.*, Gallatin Coll., pl.2, nos. 9, 11.

32 ⟿ 06.1021.164: Sambon, *Coll. Canessa*, no. 217; Richter and Milne, fig. 137.

33 ⟿ 17.230.14: Tillyard, *Hope Vases*, pp.30 f., no. 15; Beazley, *ABF*, p.30, no. 18, and *BSA*, 1931–32, p.1; Technau, *Exekias*, no. 17; Bloesch, *Formen*, p.viii.

34 ⟿ 41.162.143: Beazley, *BSA*, 1931–32, p.6, no. 26; Pease, *C.V.*, Gallatin Coll., pl.35, 2a,b.

35 ⟿ 06.1021.69: Beazley, *ABF*, p.33, no. 14; Kraiker, *Ath. Mitt.*, 1934, pp.13, 22; Richter and Milne, fig. 3.

36 ⟿ 18.145.15: Richter and Milne, fig. 9. Foot restored.

37 ⟿ 25.78.6: *Bull.*, 1925, p. 298, fig. 2; Kraiker, *Ath. Mitt.*, 1934, p.6, n.2, no. 11; Rumpf, *Sakonides*, p.24, no. 19, pl.32.

38 ⟿ 31.11.11: Beazley, *BSA*, 1931–32, p.18, and 'Εφ. 'Αρχ., 1937, pp.15 f.; *Bull.*, 1932, pp. 74 ff., figs. 1–6; Richter, *M. M. Studies*, 1932–33, pp.169 ff.; Richter and Milne, figs. 43–44; Rumpf, *Sakonides*, pp.8 ff., no. 91; Brommer, *Jahrbuch*, 1937, p.202, no. 5.

39 ⟿ 17.230.8.

40 ⟿ 98.8.11 (GR549): Beazley, *BSA*, 1931–32, p.14, no. 42; Richter and Milne, fig. 13.

41 ⟿ 41.162.184: Pease, *C.V.*, Gallatin Coll., pl.32, 1a, b; Beazley, *BSA*, 1931–32, p.14, no. 38.

42 ⟿ 98.8.14 (GR533). The attribution by Beazley has not yet been published.

43 ⟿ 06.1021.48: Sambon, *Coll. Canessa*, p.15, no. 46; Richter and Milne, fig. 77.

44 ⟿ 41.85. 06.1021.68: Sambon, *Coll. Canessa*, no. 221.

45 ⟿ 12.234.1: *Bull.*, 1913, pp. 155 f., fig. 8; Beazley, *M. M. Studies*, 1934–36, pp.102(5), 112(76); Richter and Milne, fig. 155. 06.1021.159: Sambon, *Coll. Canessa*, no. 38; Richter and Milne, fig. 159. 25.78.33: Beazley, *JHS*, 1934, p.89. 12. 234.3: Richter and Milne, fig. 153. 12.234.2. 01.8.6 (GR521): Beazley, *M. M. Studies*, 1934–36, pp.93 ff.

46 ⟿ 41.162.41: Pease, *C.V.*, Gallatin Coll., pl.33, 14; Beazley, *JHS*, 1942, p.99.

47 ⟿ 18.74.2: *Bull.*, 1919, pp. 8 ff., fig. 2.

48 ⟿ 06.1021.155: Sambon, *Coll. Canessa*, p.57, no. 215; Hoppin, *Bf*, p.424; Beazley, *JHS*, 1932, p.182; Richter and Milne, fig. 154.

49 ⟿ 27.122.30: *Bull.*, 1938, pp. 52 ff., figs. 1, 2.

50 ⟿ 25.78.4: *Bull.*, 1925, p. 298, fig. 5; Beazley, *JHS*, 1932, pp.169, n.12, 175, 177 f., 179 f., pl.8, and *M. M. Studies*, 1934–36, p.114, no. 82; Rumpf, *Sakonides*, p.23, no. 10.

51 ⟿ 29.131.6: *Bull.*, 1930, pp. 136 f., fig. 6; Beazley, *JHS*, 1932, p.190; Hafner, *Viergespanne*, pp.5 ff., no. 21.

52 ⟿ 18.74.2. 98.8.16 (GR 542). The attribution was made by Beazley.

53 ⟿ 17.230.5: Beazley, *JHS*, 1932, pp.188, 204, fig. 20, and *ABF*, pl.1, 3; Brommer, *Jahrbuch*, 1937, p.202, no. 6, figs. 5, 6.

54 ⟿ x248.16.

55 ⟿ 06.1021.161: Sambon, *Coll. Canessa*, p.13, no. 35; P. N. Ure, *JHS*, 1932, pp.65 f., no. 93.

56 ⟿ 09.221.39: *Bull.*, 1910, p.145. 12.198.2. 12.234.4: *Bull.*, 1913, pp.155 f., fig. 3. 98.8.31 (GR550).

57 ⟿ 44.11.1: Bloesch, *Formen*, p.8; *Bull.*, 1944–45, pp.110 ff.; Milne, *AJA*, 1945, pp.528 ff.

58 ⟿ 16.70: *Bull.*, 1916, p.254, fig. 3; Richter and Milne, figs. 78, 79. 41.162.2, 193: Gallatin, *C.V.*, Gallatin Coll., pl.3, 1–4.

59 ⟿ 12.198.4: Beazley, *ARV*, p.948.

60 ⟿ 06.1021.67: Sambon, *Coll. Canessa*, no. 52, pl.3; Richter and Milne, figs. 6, 7; Hafner, *Viergespanne*, p.11, no. 114.

61 ⟿ 14.136: *Bull.*, 1915, pp. 26, 98, fig. 3; Hoppin, *Bf*, p.212; Richter and Milne, fig. 161; Hafner, *Viergespanne*, pp.9, no. 85, 29; Bloesch, *Formen*, p.24.

62 ⟿ 26.60.29: *Bull.*, 1927, p. 18; Richter and Milne, fig. 4.

63 ⟿ 49.11.1: D. von Bothmer, *JHS*, 1951, pp.40 ff.

64 ⟿ 27.228: *Bull.*, 1928, pp. 54 ff., figs. 1–3; Zschietzschmann, *Ath. Mitt.*, 1928, p.42, no. 69; Richter and Milne, p.6, fig. 40.

65 ⟿ 14.130.12: Von Brauchitsch, *Die panathenäischen Preisamphoren*, pp.20, no. 15,

36, no. 41; *Bull.*, 1915, pp.100 f., fig. 4; Beazley, *JHS*, 1927, p.87, n.55, and *AJA*, 1943, p.443, no. 6; Gardiner, *Athletics*, pp.134, fig. 89, 137; Richter and Milne, fig. 24; Smets, *Groupes chronologiques*, p.89, no. 12. 07.286. 80: Beazley, *ABF*, p.28, pl.16, 1, and *AJA*, 1943, p.444; Smets, *Groupes chronologiques*, p.93, no. 57.

66 ↝ 06.1021.51: Beazley, *JHS*, 1927, p.86, no. 43 bis.

67 ↝ 06.1021.60: Sambon, *Coll. Canessa*, p.61, no. 224; Richter and Milne, fig. 95; Haspels, *ABL*, p.55.

68 ↝ 26.60.76: *Bull.*, 1928, pp. 108, fig. 3, 112; Haspels, *ABL*, p.61.

69 ↝ 07.286.72: Richter and Milne, fig. 32; Beazley, *JHS*, 1936, p.89; D. von Bothmer, *JHS*, 1951, p.46, pl.22.

70 ↝ 06.1021.47: Sambon, *Coll. Canessa*, p.17, no. 55; Beazley, *JHS*, 1927, p.87, n.55, and *V. Pol.*, p.11, n.4; Richter and Milne, fig. 115; Robinson and Fluck, p.110, no. 100.

71 ↝ 21.88.93: *Bull.*, 1923, pp. 253 ff.; Richter and Milne, fig. 184.

72 ↝ 41.162.23, 68, 125: Gallatin, *C.V.*, Gallatin Coll., pl.8, nos. 4, 2, 6.

73 ↝ 46.11.7: *Burlington F. A. Club Exh.*, 1904, p.115, no. 62, pls.97, 98; E. Strong, *Melchett Coll.*, 1928, no. 44, pl.40; Sotheby, Sale Catalogue, May 14, 1946, p.11, no. 88; *Bull.*, 1946–47, pp.255 ff. The vase was cleaned in this Museum.

74 ↝ 41.162.8: Pease, *C.V.*, Gallatin Coll., pl.46, 1a–c; Kraiker, *Ath. Mitt.*, 1930, pp. 172 f.; Beazley, *ARV*, p.54, no. 6; Richter, *ARVS*, p.50, figs. 39, 40.

75 ↝ 06.1021.101: Sambon, *Coll. Canessa*, no. 226.

76 ↝ 41.162.112: Pease, *C.V.*, Gallatin Coll., pls.47, 4, 61, 7; Kraiker, *Jahrbuch*, 1929, pp. 191 f., no. 58; Beazley, *ARV*, p. 49, no. 61; Richter, *ARVS*, pp. 50, 177, fig. 11.

77 ↝ 07.286.47: Furtwängler and Reichhold, II, pp.178 ff., figs. 60, 65, pl.93, 2; Beazley, *VA*, p.22, and *ARV*, p.77; Hoppin, *Rf*, II, p.10, no. 2; Pfuhl, *M.u.Z.*, I, pp.419 ff., sections 450 f., and III, p.97, nos. 340 ff.; Richter and Hall, no. 10; Richter, *ARVS*, p.52, fig. 38.

78 ↝ 45.11.17: Herzfeld, *Archaeological History of Iran*, pp. 73 ff., pl.10, and *Iran in the Ancient East*, p.251, pl.72; Richter, *AJA*, 1946, p.28, fig. 26.

79 ↝ 20.253: Richter and Milne, fig. 143; Richter and Hall, no. 4; Robinson and Fluck, p.138, no. 163; Beazley, *ARV*, p.54, no. 4; Richter, *ARVS*, p.51.

80 ↝ 10.210.18: Beazley, *VA*, pp.7 ff., no. 4, fig. 3, *JHS*, 1927, p.64, and *Campana Fragments*, p.33, no. 3; Richter and Milne, fig. 87; Richter and Hall, no. 3; Robinson and Fluck, pp.102, no. 73, 104, no. 77; Beazley, *ARV*, p.35, no. 6; Richter, *ARVS*, p.49, fig. 35.

81 ↝ 14.146.1: *Bull.*, 1915, pp. 99 f., fig. 2; H. R. W. Smith, *Univ. of Cal. Pub.*, I, no. 1, pp. 9 ff., pls.2, 3, figs. b–d; Richter and Hall, no. 1; Bloesch, *Formen*, pp.42 f., 46; Beazley, *ARV*, p.9, no. 9; Richter, *ARVS*, p.47, figs. 10, 15, 16.

82 ↝ 14.146.2: *Bull.*, 1915, pp. 98, fig. 1, 100; Beazley, *VA*, p. 6, and *ARV*, p.11; Hoppin, *Rf*, p.400, no. 3; Richter and Milne, fig. 162; Richter and Hall, no. 2; Richter, *ARVS*, p.47.

LATE ARCHAIC PERIOD

1 ↝ 23.69: *Bull.*, 1923, pp. 89 ff.; Richter, *Animals*, figs. 62, 63, and in Brunn-Bruckmann, *Denk.*, no. 726; Curtius, *Die Antike*, 1927, pp.162 ff.; *Master Bronzes*, no. 81; Markman, *The Horse*, pp.16, 59, 60, 62, 63, 65, 112, 117, 165 f., 168, fig. 31.

2 ↝ 07.286.87: *Bull.*, 1908, pp. 31 ff.; *Bronze Cat.*, no. 78; Richter in Brunn-Bruckmann, *Denk.*, no. 723; *Master Bronzes*, no. 82.

3 ↝ 20.194: *Bull.*, 1923, pp. 32 ff.; Homann-Wedeking, *Ath. Mitt.*, 1935–36, pp.201 ff., 212, pls.77–79.

4 ↝ 28.77: *Bull.*, 1928, pp. 266 ff., figs. 1–3; *Master Bronzes*, no. 71.

5 ↝ 21.88.52: *Bull.*, 1923, pp.

73, 75, fig. 6; Langlotz, *Bildhauerschulen*, p.100, pl.55b.

6 ↝ 21.88.23: *Bull.*, 1923, p.74.

7 ↝ 43.11.1: Richter, *AJA*, 1944, pp.5 ff., figs. 16–18.

8 ↝ 24.97.20: *Bull.*, 1924, pp. 294 f., fig. 2; Langlotz, *Bildhauerschulen*, p.150, pl.93b; Jantzen, *Bronzewerkstätten*, p. 55. For a similar attachment, cf. Bruns, *Antike Bronzen*, pp. 30 f.

9 ↝ 45.162: *Bull.*, 1945–46, pp. 249 ff.

10 ↝ 43.11.3: Richter, *AJA*, 1944, p.5, figs. 11–15; *Bull.*, 1945–46, p.249.

11 ↝ 08.258.7: *Bull.*, 1909, pp. 78, 81, and 1945–46, p.250;

Bronze Cat., no. 58; *Master Bronzes*, no. 68.

12 ↝ 08.258.5: *Bull.*, 1909, pp. 78–81; *Bronze Cat.*, no. 59.

13 ↝ 23.46: *Bull.*, 1923, pp. 73 ff.; Jantzen, *Bronzewerkstätten*, pp.27, no. 22, 72, no. 7.

14 ↝ 20.210: *Bull.*, 1923, pp. 74 f., fig. 4.

15 ↝ 07.286.103: *Bronze Cat.*, no. 45. 22.139.34. 07.286.101, 102: *Bronze Cat.*, nos. 52, 53.

16 ↝ 74.51.5681 (CB448): Myres, *Handbook*, no. 5012; *Bronze Cat.*, no. 66.

17 ↝ 46.12: Milne, *AJA*, 1944, p.35, figs. 5, 6.

18 ↝ 74.51.5453, 5455 (CB187, 189): *Bronze Cat.*, nos. 723,

724; Milne, *AJA*, 1944, pp.35, figs. 7, 8, 45, nos. 80, 81.

19 ⟷ 22.139.34: *Bull.*, 1924, p. 295.

20 ⟷ 38.11.7: *Bull.*, 1939, pp. 146 ff., fig. 3; Richter, *AJA*, 1939, pp.189, 194 ff., figs. 4, 5; Tod, *JHS*, 1942, p.66.

21 ⟷ 26.60.1: Richter, *AJA*, 1928, pp.1 ff.; Homann-Wedeking, *Ath. Mitt.*, 1935–36, p.212.

22 ⟷ 19.192.11: *Bull.*, 1921, p. 9, fig. 1; Langlotz, *Bildhauerschulen*, pl.80.

23 ⟷ 12.59: *Bull.*, 1913, p.174; Blümel, *Arch. Anz.*, 1937, pp. 56 f., fig. 5; Richter, *Gravestones*, p.122, n.8.

24 ⟷ 07.306: Loewy, *Arch. epig. Mitt. aus Oest.*, 1887, pp. 159 f., fig. 13, pl. 6, 1; *Bull.*, 1908, pp.4 f., fig. 4.

25 ⟷ 47.100.3: *Bull.*, 1948, p. 150, 4 ill.; Richter, *AJA*, 1948, pp.331 ff., pls.32, 33.

26 ⟷ 30.11.6: Albizzati, in *Antike Plastik*, pp.1 ff.; *Bull.*, 1930, pp.242 ff.

27 ⟷ 35.11.7, 6, 4: *Bull.*, 1935, pp.178 f., figs. 2, 3. 34.11.1: *Bull.*, 1934, p.126. 26.31.453. 41.162.3: Pease, *C.V.*, Gallatin Coll., pl.33, 13.

28 ⟷ 36.11.2: *Bull.*, 1936, pp. 133 ff. 06.1115: Richter, *Sculpture and Sculptors*, 2nd ed., p.60, fig. 63.

29 ⟷ 89.2.2134.

30 ⟷ X189.

31 ⟷ 06.1145, 1146: *Bull.*, 1907, p.5; Richter, *Animals*, figs. 144, 120.

32 ⟷ 26.164.5, 20: Butler, *Sardis*, 1, p.118.

33 ⟷ 47.11.6.

34 ⟷ 18.145.31: *Bull.*, 1922, p. 113, fig. 1.

35 ⟷ 26.31.457.

36 ⟷ 47.11.4. From the collection of Professor A. Furtwängler.

37 ⟷ 36.11.4: *Bull.*, 1937, p.17, fig. 2.

38 ⟷ 23.258: *Bull.*, 1924, pp. 127 f., fig. 4. 06.1141. 26.199. 154; 26.164.8, 24, 21. Butler, *Sardis*, 1, pp.81 f., 118. 89.2. 2130. On these protomes cf. H. R. W. Smith, *Hesperia*, sup. VIII, pp.353 ff.

39 ⟷ 11.212.14.

40 ⟷ L1930.1: Halbherr, *AJA*, 1901, p.390, pl.12, no. 4; *Öst. Jahr.*, 1909, p.64, fig. 45; Dohan, *M. M. Studies*, 1931–32, p.209, fig. 39.

41 ⟷ 26.60.9–13.

42 ⟷ 07.286.79: Beazley, *Der Kleophrades Maler*, p.29, no. 84, and *ARV*, p.129, no. 98; Smets, *Groupes chronologiques*, p.92, no. 45.

43 ⟷ 16.71: Beazley, *Der Kleophrades Maler*, p.29, no. 85, and *ARV*, p.129, no. 99; Smets, *Groupes chronologiques*, p.92, no. 48.

44 ⟷ 13.233: Beazley, *Der Kleophrades Maler*, pp.13, 14, 23, no. 11, pl.29, 3, 4, and *ARV*, p.122, no. 11; Richter and Hall, pp.36 f., no. 13; Richter, *ARVS*, pp.67, 68.

45 ⟷ 08.258.58: Beazley, *Der Kleophrades Maler*, pp.11, 14, 17, 25, no. 29, pl.19, and *ARV*, p.123, no. 32; Richter and Hall, no. 12; Richter, *ARVS*, p.67, fig. 47.

46 ⟷ 10.210.19: Beazley, *Der Berliner Maler*, pp.12, 14, 15, 20, no. 129, pl.22, 1, and *ARV*, p. 140, no. 132; Richter and Hall, no. 14; Richter, *ARVS*, p.69, figs. 17, 26.

47 ⟷ 22.139.32: Beazley, *Der Berliner Maler*, p.20, no. 174, *ARV*, p.142, no. 179, and *Potter and Painter*, p.31; Richter and Milne, fig. 119; Richter and Hall, no. 15; Richter, *ARVS*, pp. 69 f., fig. 48.

48 ⟷ 41.162.139: Pease, *C.V.*, Gallatin Coll., pl.58, 5; Beazley, *ARV*, p.142, no. 174; Richter, *ARVS*, p.70.

49 ⟷ 41.162.17: Beazley, *ARV*, p.135, no. 65; Pease, *C.V.*, Gallatin Coll., pl.51, 2; Richter, *ARVS*, p.70. 07.286.69: Beaz-

ley, *Der Berliner Maler*, p.17, no. 50, pl.15, 2, and *ARV*, p.135, no. 56; Richter and Milne, fig. 18; Richter and Hall, no. 16; Richter, *ARVS*, p.69.

50 ⟷ 07.286.73: Richter and Milne, p.26; Beazley, *ARV*, p. 170, no. 15; Richter and Hall, no. 20; Richter, *ARVS*, p.72, fig. 49.

51 ⟷ 06.1021.99: Richter and Hall, no. 17; Beazley, *ARV*, p. 146, no. 3; Richter, *ARVS*, p.70.

52 ⟷ 07.286.78: Richter and Hall, no. 19; Beazley, *ARV*, p. 154, no. 9; Richter, *ARVS*, p. 71.

53 ⟷ 01.8.8 (GR578): Richter and Hall, no. 22; Beazley, *ARV*, p.175, no. 14; Richter, *ARVS*, p.72, fig. 50.

54 ⟷ 41.162.101: Pease, *C.V.*, Gallatin Coll., pl.51, 1; Beazley, *ARV*, p.163, no. 3; Richter, *ARVS*, p.73, fig. 51.

55 ⟷ 21.88.1; 20.244; 11.212.7. Richter and Hall, nos. 25–27; Beazley, *ARV*, pp.167, 165, nos. 32, 8, 37; Richter, *ARVS*, p.72.

56 ⟷ 06.1021.117: Richter and Hall, no. 35; Schoppa, *Darstellung der Perser*, pp.30, 2, 50.

57 ⟷ 12.231.2: Richter and Hall, no. 39; Beazley, *ARV*, p. 215, no. 28; Richter, *ARVS*, pp. 77 f., fig. 59.

58 ⟷ 41.162.1: Gallatin, *C.V.*, Gallatin Coll., pls.10–12; Beazley, *ARV*, p.299, no. 1; Richter *ARVS*, p.86, fig. 58.

59 ⟷ 12.234.5: Beazley, *JHS*, 1929, pp.56 ff., and *ARV*, p.254, no. 137; Richter and Hall, no. 43; Richter, *ARVS*, p.79, fig. 18.

60 ⟷ 29.131.4: Richter and Hall, no. 42; Beazley, *ARV*, p. 253, no. 132; Richter, *ARVS*, p. 79.

61 ⟷ 28.57.12: Richter and Hall, no. 40; Beazley, *ARV*, p. 255, no. 156; Richter, *ARVS*, p. 79.

62 ⟷ 09.221.43; 25.189.1. Richter and Hall, nos. 41, 48; Beazley, *ARV*, pp.255, 256, nos. 155, 160; Richter, *ARVS*, pp.

79 f., figs. 61, 60; Brett, *Trans. Inter. Numis. Congress*, 1936, p. 24, n.1, fig. 3.

63 ∞ 96.9.37 (GR577): Richter and Hall, no. 49; Beazley, *ARV*, p.253, no. 117; Richter, *ARVS*, p.80; Bloesch, *Formen*, pp. 128 f., no. 10.

64 ∞ 27.74: Richter and Hall, no. 51; Beazley, *ARV*, p.267, no. 10; Richter and Milne, fig. 156; Bieber, *AJA*, 1941, pp. 529 ff.; Richter, *ARVS*, p.87, fig. 62.

65 ∞ 96.9.191 (GR1120): Richter and Hall, no. 56; Beazley, *ARV*, p.314, no. 229; Richter, *ARVS*, p.81.

66 ∞ 20.246; 06.1152; 08.258. 57; 12.231.1; 96.18.70 (GR573); 41.162.130. Richter and Hall, nos. 52–55, 57; Beazley, *ARV*, pp.304, 306–308, 310, 317, nos. 42, 83, 102, 112, 144, 193; Robinson and Fluck, pp.84, 155, 158, 159, 178, nos. 29, 189, 242; Richter, *ARVS*, pp.81 f.; Pease, *C.V.*, Gallatin Coll., pls. 47, 6, 50, 1.

67 ∞ 22.139.82: Richter and Hall, no. 60; Beazley, *ARV*, p. 290, no. 154.

68 ∞ 09.221.47, 48; 06.1021. 172, 170. Richter and Hall, nos. 5, 8, 6; Beazley, *ARV*, pp.61, no. 44, 108, no. 3, 115, no. 37, 114, no. 15; Richter, *ARVS*, pp.51, 53; Robinson and Fluck, p.104, no. 78; Richter and Milne, figs. 186, 163.

69 ∞ 18.145.28; 16.174.41; 14. 105.9; 16.174.42; 96.9.36 (GR 575). Richter and Hall, nos. 38, 36, 37, 62, 61; Beazley, *ARV*, pp.87, no. 9, 229, no. 40, 227, no. 8, 232, no. 41, 233, no. 72; Richter, *ARVS*, pp.51, 85, 86; Robinson and Fluck, p.163, no. 211.

70 ∞ 13.227.16: Richter and Hall, no. 28; Beazley, *ARV*, p. 206, no. 15; Richter, *ARVS*, p. 73, fig. 52.

71 ∞ 41.162.27: Gallatin, *C.V.*, Gallatin Coll., pl.18, 1; Beazley, *ARV*, p.206, no. 18; Richter, *ARVS*, p.73.

72 ∞ 27.122.6; 25.78.2. Richter and Hall, nos. 29, 30; Beazley, *ARV*, p.207, nos. 14, 13; Richter, *ARVS*, p.74, fig. 55.

73 ∞ 07.286.67: Richter and Hall, no. 31; Beazley, *ARV*, p. 435, no. 69; Robinson and Fluck, p.121, no. 121; Richter, *ARVS*, p.74.

74 ∞ 41.162.18: Pease, *C.V.*, Gallatin Coll., pls.58, 4, 61, 3; Beazley, *ARV*, p.434, no. 57; Richter, *ARVS*, p.74, fig. 54.

75 ∞ 06.1021.114: Richter and Hall, no. 32; Beazley, *ARV*, p. 432, no. 29; Richter, *ARVS*, p. 74.

76 ∞ 41.162.117: Gallatin, *C.V.*, Gallatin Coll., pl.26, 8; Beazley, *ARV*, p.435, no. 79; Richter, *ARVS*, p.74.

77 ∞ 06.1021.90: Richter and Hall, no. 34; Beazley, *ARV*, p. 473, no. 83; Richter, *ARVS*, p. 75, fig. 56.

78 ∞ 41.162.178: Pease, *C.V.*, Gallatin Coll., pl.39, 2; Richter, *ARVS*, p.75; Haspels, *ABL*, p. 240, no. 155.

79 ∞ 06.1070: Beazley, *ARV*, p. 203, no. 2; Haspels, *ABL*, pp. 111, 235, no. 71; Woodward, *Perseus*, pp.64 f., fig. 19; Richter, *ARVS*, p.75.

80 ∞ 25.70.2: *Bull.*, 1925, p. 300, fig. 4; Haspels, *ABL*, p. 51, n.4, p.233, no. 15; Richter, *ARVS*, p.75.

81 ∞ 41.162.29, 34, 35, 30: Pease, *C.V.*, Gallatin Coll., pls. 44, 1a–d, 2a–c, 45, 1a–c, 2a, b; Haspels, *ABL*, pp.96, 97, n.4 and 7, 98, 99, 120, no. 3, 121–124, 225, nos. 3, 5, 226, nos. 6, 10, pl.32, 1a–d, 35, 1; *Bull.*, 1942, pp.56, 57, 59; Richter, *ARVS*, pp.75 f.; Beazley, *JHS*, 1942, p. 99.

82 ∞ 23.160.87: *Bull.*, 1930, pp. 136 f., fig. 4; Haspels, *ABL*, p. 228, no. 143; Richter, *ARVS*, p. 76.

83 ∞ 46.129.1: *Bull.*, 1949–50, p.95.

84 ∞ 08.258.29: Haspels, *ABL*, pp.93, 223, no. 2.

85 ∞ 07.286.68: Haspels, *ABL*, pp.149, n.2, 255, no. 30, pl.45, 4a, b. 08.258.28: Haspels, *ABL*, pp.153, 157, 258, no. 105; Beazley, *ARV*, p.478, no. 5. 41.162. 146: Pease, *C.V.*, Gallatin Coll., pl.43, 2a, b; Haspels, *ABL*, pp. 257, no. 72, 149. 39.94.2. Gift of the Misses Cross.

86 ∞ 17.230.9: Richter and Milne, fig. 170; Haspels, *ABL*, p.250, no. 22; Richter, *ARVS*, p.75. 06.1021.49: Gardiner, *Athletics*, p.218, no. 200; Haspels, *ABL*, pp.144, 251, no. 43; Richter, *ARVS*, p.75.

87 ∞ 34.11.6: Richter, *ARVS*, p. 75.

88 ∞ 06.1021.79: Haspels, *ABL*, pp.79, n.13, 83, 84, 214, no. 180, pl.25, 5.

89 ∞ 41.162.97: Pease, *C.V.*, Gallatin Coll., pl.42, 1; Beazley, *V. Pol.*, p.80, note to p.34.

90 ∞ 21.80: Haspels, *ABL*, pp. 102, no. 6, 103; Robinson and Fluck, p.119; Richter and Milne, fig. 109; Beazley, *ARV*, p.69, no. 27.

91 ∞ 25.78.65: *Bull.*, 1927, p. 18.

92 ∞ 10.210.15: Richter and Milne, fig. 68.

93 ∞ 23.160.62: *Bull.*, 1925, pp. 128, fig. 3, 132; Beazley, *JHS*, 1929, pp.45 f., no. 3, and *ARV*, p. 895, no. 4. 23.160.34: Richter and Milne, fig. 107. 41.162. 28: Gallatin, *C.V.*, Gallatin Coll., pl.30, 1.

94 ∞ 00.11.1 (GR570): Richter and Milne, fig. 134.

95 ∞ 27.122.21.

96 ∞ 23.160.33: *Bull.*, 1924, p. 128, fig. 3; Richter and Milne, fig. 108.

97 ∞ 06.1021.205: Beazley, *JHS*, 1929, pp.43 ff., no. 13, pl. 4, 3; Richter and Milne, fig. 187; Beazley, *ARV*, p.896, no. 16.

98 ∞ 41.162.14: Gallatin, *C.V.*, Gallatin Coll., pl.29, 3, 4.

99 ∞ 30.11.10: *Bull.*, 1930, p. 281, fig. 3; Beazley, *ARV*, p. 899, no. 5.

100 ⚔ 22.139.81: Beazley, *ARV*, p.57, no. 4.

101 ⚔ 07.286.50: Richter and Hall, no. 9; Beazley, *ARV*, p. 90, no. 2.

102 ⚔ 22.139.80: Richter and Hall, no. 45; Beazley, *ARV*, p. 250, no. 61.

103 ⚔ 07.156.8: Beazley, *ARV*, p.264, no. 5.

104 ⚔ 22.139.82: Richter and Hall, no. 60; Beazley, *ARV*, p. 290, no. 154.

105 ⚔ 14.105.7: Beazley, *ARV*, p.242, no. 59.

106 ⚔ 06.1133: Richter and

Hall, no. 63; Beazley, *ARV*, p. 235, no. 37.

107 ⚔ 07.286.49: Richter and Hall, no. 58; Beazley, *ARV*, p. 313, no. 226.

108 ⚔ 19.192.32: Beazley, *ARV*, p.157, no. 64.

109 ⚔ See Froehner, *Coll. Gréau*, passim.

EARLY CLASSICAL PERIOD

1 ⚔ 19.192.38: F. H. Robinson, *Memoirs of the American Academy in Rome*, 1929, p. 166, pl. 9, fig. 4.

2 ⚔ 26.60.2: *Bull.*, 1926, pp. 255 f., fig. 2; Amelung, *Jahrbuch*, 1927, p.151, pl.21, 3; Modona, *Historia*, 1929, pp.429 ff.; Blümel, *Berlin Cat., Römische Kopien*, IV, p.14.

3 ⚔ 03.12.4 (GR1070): Bieber in *Einzelaufnahmen*, no. 4709.

4 ⚔ 97.22.13 (GR44): *Bronze Cat.*, no. 235. 19.192.1: *Bull.*, 1921, p.37. 19.192.69.

5 ⚔ 13.231.2: *Bull.*, 1914, pp. 64 f., fig. 9; Curtius, *Röm. Mitt.*, Ergänzungsheft, I, 1931, Zeus u. Hermes, pp.48, 52, 53, 77; V. H. Poulsen, *Acta Arch.*, 1940, p.15, fig. 10.

6 ⚔ 30.11.13: *Bull.*, 1931, pp. 95–97, figs. 1–4; V. Poulsen, *Berytus*, 1939–40, p.8, and *Acta Arch.*, 1937, p.122, no. 2.

7 ⚔ 24.97.31: *Bull.*, 1925, pp. 107 f., fig. 3; Ingholt, *Rapport préliminaire*, 1934, p.27; Blümel, *Berlin Cat., Römische Kopien*, IV, p.29 (with bibliography for this type); Rumpf, *Miscellanea Academica Berolinensia*, 1950, p.43.

8 ⚔ 27.45: *Bull.*, 1927, pp. 101 ff., figs. 1, 2; Richter in *Einzelaufnahmen*, no. 3007.

9 ⚔ 11.141: *Bull.*, 1911, p.211, fig. 2; Richter in Brunn-Bruckmann, *Denk.*, no. 728; Diepolder, *Grabreliefs*, p.8, pl.1, 1.

10 ⚔ 06.1151: *Bull.*, 1907, pp. 5, 8.

11 ⚔ 06.1156: D. M. Robinson, *AJA*, 1932, p.132.

12 ⚔ 23.73.2: *Bull.*, 1923, p. 212.

13 ⚔ 30.11.9: *Bull.*, 1930, pp. 279 ff.; Jacobsthal, *Die Melischen Reliefs*, no. 88, pl.50; Buschor in Furtwängler and Reichhold, III, p.127, fig. 60; Richter, *AJA*, 1932, p.205.

14 ⚔ 25.78.26: *Bull.*, 1926, pp. 80 ff., fig. 1; Jacobsthal, *Die Melischen Reliefs*, no. 95, pl.54; Furtwängler and Reichhold, III, p.127, fig. 59.

15 ⚔ 12.229.20: *Bull.*, 1913, pp. 175, 177, fig. 4; Jacobsthal, *Die Melischen Reliefs*, no. 101, pl. 58.

16 ⚔ 31.11.9: *Bull.*, 1932, pp. 44 ff., figs. 1, 2; Jacobsthal, *JHS*, 1939, pp.66 f., pl.7b.

17 ⚔ 12.229.17: *Bull.*, 1913, pp. 175, 177, fig. 5. For better preserved examples of this composition see Quagliati, *Ausonia*, 1908, pp.138 ff., figs. 18, 19.

18 ⚔ 20.218: *Bull.*, 1923, p.214.

19 ⚔ 20.216: *Bull.*, 1923, p.214.

20 ⚔ 26.31.459, 460.

21 ⚔ 08.258.10: *Bronze Cat.*, no. 79; Richter in Brunn-Bruckmann, *Denk.*, pl.724; Jantzen, *Bronzewerkstätten*, pp.2, 55.

22 ⚔ 08.258.11: *Bronze Cat.*, no. 81; *Master Bronzes*, no. 87; C. Young, *AJA*, 1926, pp.427 ff., fig. 1.

23 ⚔ 29.48.

24 ⚔ 17.190.2071: C. Smith, *Coll. of J. P. Morgan*, p.22, no. 56, pl.29; Richter, *Animals*, pp. 12, 30, 45, 46.

25 ⚔ 06.1059: *Bronze Cat.*, no. 751.

26 ⚔ 06.1144: *Bronze Cat.*, no. 86.

27 ⚔ 06.1098: *Bronze Cat.*, no. 77.

28 ⚔ 50.11.1: The feet are bent out of position. Conze, *Festschrift für Benndorf*, 1898, pp. 176 f., pl.9; Reinach, *Répertoire de la statuaire grecque et romaine*, III, 1920, p.85, no. 3; Forsdyke, *British Museum Quarterly*, VIII, 1933–34, pp.110 f., pl.36; Neugebauer, *Die Antike*, II, 1935, pp.39 ff., pls.1–3; Langlotz, *Phidiasprobleme*, 1948, p. 74, pl.22, no. 3; D. K. Hill, *Catalogue of Classical Bronze Sculpture in the Walters Art Gallery*, p.86, no. 185; *Bull.*, 1950, pp. 58 f.

29 ⚔ 38.11.5: *Bull.*, 1939, pp. 23 ff.; Milne, *AJA*, 1944, pp. 26 ff.

30 ⚔ 45.11.3.

31 ⚔ 26.50: Langlotz, *Bildhauerschulen*, p.76, pl.34; Richter in *Antike Plastik*, pp.183 ff.; Lamb, *Bronzes*, p.163, pl.59a; D. M. Robinson, *AJA*, 1942, pp. 178, figs. 7–10, 182, 185.

32 ⚔ 26.255.2: *Bull.*, 1927, p. 20, fig. 6.

33 ⚔ 06.1078: *Bronze* Cat., no. 525.

34 ⚔ 23.160.26: *Bull.*, 1924, p. 69.

35 ⚔ 38.11.11a–c: *Bull.*, 1939, pp.145 f., figs. 1, 2; Richter, *AJA*, 1939, pp.189 ff., figs. 1–3, D. M. Robinson, 1942, pp. 188 ff., n.55, and M. J. Milne, 1944, pp.33, 34.

36 ⚔ 09.221.12: *Bronze Cat.*, no. 80.

37 ⟶ 14.105.3: *Bull.*, 1915, pp. 210 f.

38 ⟶ 16.72: Beazley, *Der Pan Maler*, p.21, no. 8, pl.25, 3, and *ARV*, p.362, no. 8; Richter and Hall, no. 64; Richter, *ARVS*, p. 95.

39 ⟶ 20.245: Beazley, *Der Pan Maler*, pp.17, n.38, 22, no. 18, pl.28, 2, and *ARV*, p.363, no. 23; Richter and Hall, no. 66; Richter, *ARVS*, p.95.

40 ⟶ 23.160.55: Beazley, *Der Pan Maler*, pp.14, 25, no. 63, pl. 18, 2, and *ARV*, p.367, no. 76; Richter and Hall, no. 65; Richter, *ARVS*, p.95.

41 ⟶ x22.25 (GR585): Beazley, *Der Pan Maler*, p.25, no.67, and *ARV*, p.367, no. 84; Richter and Hall, no. 67; Richter, *ARVS*, p. 96.

42 ⟶ 06.1021.152: Richter and Hall, no. 69; Beazley, *ARV*, p. 370, no. 11; Richter, *ARVS*, p. 96.

43 ⟶ 41.162.86: Pease, *C.V.*, Gallatin Coll., pl.57, 1a, b; Beazley, *ARV*, p.371, no. 20; Richter, *ARVS*, p.96.

44 ⟶ 41.162.60: Gallatin, *C.V.*, Gallatin Coll., pl.23, 3, 4; Beazley, *ARV*, p.373, no. 5; Richter, *ARVS*, p.96.

45 ⟶ 15.27: Richter and Hall, no. 70; Beazley, *ARV*, p.378, no. 9; Richter, *ARVS*, p.96.

46 ⟶ 25.28: Richter and Hall, no. 71; Beazley, *ARV*, p.386, no. 39; Richter, *ARVS*, p.97.

47 ⟶ 06.1021.144: Richter and Hall, no. 72; Beazley, *ARV*, p. 385, no. 9.

48 ⟶ 41.162.69: Gallatin, *C.V.*, Gallatin Coll., pl.23, 1, 2; Beazley, *ARV*, p.385, no. 22; Richter, *ARVS*, p.97.

49 ⟶ 07.286.36: Richter and Hall, no. 73; Beazley, *ARV*, p. 588, no. 112; Swindler, *AJA*, 1915, pp.414 f., pls.29, 30; Richter and Milne, fig. 141; Diepolder, *Der Penthesileia Maler*, pp. 13 f., 15, pls.11, 2, 12, 1; Richter, *ARVS*, p.98, fig. 73.

50 ⟶ 28.167: Richter and Hall, no. 74; Beazley, *ARV*, p.588, no. 14; Diepolder, *Der Pen-thesileia Maler*, pp.16, 17, pl.19; Richter, *ARVS*, p.98, fig. 69.

51 ⟶ 96.18.76 (GR597): Richter and Hall, no. 75; Richter and Milne, fig. 157; Beazley, *ARV*, p.587, no. 98; Richter, *ARVS*, p.98.

52 ⟶ 06.1079: Richter and Milne, fig. 174; Richter and Hall, no. 77; Beazley, *ARV*, p. 588, no. 105; Richter, *ARVS*, p. 98.

53 ⟶ 41.162.9: Gallatin, *C.V.*, Gallatin Coll., pls. 19, 20; Beazley, *ARV*, p.584, no. 25; Diepolder, *Der Penthesileia Maler*, p.19, pl.31, 1; Richter, *ARVS*, p. 98, fig. 70.

54 ⟶ 06.1021.167: Richter and Hall, no. 78; Beazley, *ARV*, p. 597, no. 4; Richter, *ARVS*, p. 100.

55 ⟶ 26.60.79: Richter and Hall, no. 79; Beazley, *ARV*, p. 589, no. 1; Richter, *ARVS*, p. 100.

56 ⟶ 39.11.8: *Bull.*, 1940, pp. 37 f.; Beazley, *ARV*, p.606, no. 21; Richter, *AJA*, 1940, pp. 183 ff., figs. 6, 7, and *ARVS*, p. 100, fig. 72.

57 ⟶ 41.162.98: Pease, *C.V.*, Gallatin Coll., pl.56, 1; Webster, *Der Niobidenmaler*. pp.10, 14, 22, no. 50; Beazley, *ARV*, p. 423, no. 65; Richter, *ARVS*, p. 101, fig. 75.

58 ⟶ 99.13.2 (GR579): Richter and Hall, no. 97; Beazley, *ARV*, p.422, no. 50; Richter, *ARVS*, p. 101; Webster, *Der Niobiden-maler*, pp.11, 22, no. 37.

59 ⟶ 07.286.66: Richter and Hall, no. 127; Beazley, *ARV*, p. 426; Robinson and Fluck, pp. 81, no. 18, 107, no. 91; Richter, *ARVS*, p.101.

60 ⟶ 07.286.84: Richter and Hall, no. 98; Beazley, *ARV*, p. 427, no. 1; Hauser in Furtwäng-ler and Reichhold, II, pp.297 ff., pls.116, 117; Richter, *ARVS*, pp. 102 f.

61 ⟶ 07.286.86: Richter and Hall, no. 99; Beazley, *ARV*, p. 429, no. 3; Hauser in Furtwäng-ler and Reichhold, II, pp. 304 ff., pls.118, 119; Richter, *ARVS*, pp. 103 f., fig. 31.

62 ⟶ 24.97.96: Richter and Hall, no. 100; Beazley, *ARV*, p. 402, no. 16; Richter and Milne, fig. 60; Richter, *ARVS*, p.105.

63 ⟶ 06.1021.176: Richter and Hall, no. 101; Beazley, *ARV*, p. 402, no. 28; Richter and Milne, fig. 66; Richter, *ARVS*, p.105.

64 ⟶ 06.1021.190, 192: Richter and Hall, nos. 102, 103; Beazley, *ARV*, p.409, nos. 27, 26; Richter and Milne, figs. 83, 84; Richter, *ARVS*, p.105.

65 ⟶ 07.286.85: Richter and Hall, no. 109; Beazley, *ARV*, p. 410, no. 1; Richter, *ARVS*, p. 106, fig. 78.

66 ⟶ 22.139.72: Richter and Hall, no. 106; Beazley, *ARV*, p. 521, no. 1; Robinson and Fluck, p.75, no. 9; Bloesch, *Formen*, pp. 140 f., no. 116; Richter, *ARVS*, p.106, fig. 86.

67 ⟶ 17.230.10: Richter and Hall, no. 105; Beazley, *ARV*, p. 524, no. 25; Richter, *ARVS*, p. 107.

68 ⟶ 06.1021.177: Richter and Hall, no. 107; Beazley, *ARV*, p. 531, no. 95; Richter, *ARVS*, p. 107, fig. 87.

69 ⟶ 06.1101: Richter and Milne, fig. 131; Beazley, *ARV*, p. 525, no. 3; Richter, *ARVS*, p. 107.

70 ⟶ 46.11.3: *Bull.*, 1949–50, p.95. Attributed to the Painter of Louvre CA1694 by D. von Both-mer.

71 ⟶ 41.162.5: Pease, *C.V.*, Gallatin Coll., pls.50, 2a, b, 61, 1; Beazley, *ARV*, p.524, no. 3; Richter, *ARVS*, p.107, fig. 85.

72 ⟶ 23.160.54: Richter and Hall, no. 59; Beazley, *ARV*, p. 289, no. 152; Richter, *ARVS*, p. 84, fig. 65.

73 ⟶ 06.1117: Richter and Hall, no. 96; Richter and Milne, fig. 139. The attribution to the Hiketes Group is by Beazley.

74 ⟶ 26.60.77: Richter and Hall, no. 85; Beazley, *ARV*, p. 321, no. 83; Richter, *ARVS*, p. 108. 41.162.19: Gallatin, *C.V.*, Gallatin Coll., pls.16, 2, 17, 1, 2; Beazley, *ARV*, p.321, no. 77; Richter, *ARVS*, p.108, fig. 77.

75 ⟶ 09.221.41: Richter and Hall, no. 33; Beazley, *ARV*, p. 437, no. 5; Robinson and Fluck, p.97, no. 69; Richter, *ARVS*, p. 109. 41.162.21: Gallatin, *C.V.*, Gallatin Coll., pl.15, 1–4; Beazley, *ARV*, p.437, no. 1; Richter, *ARVS*, p.109.

76 ⟶ 17.230.37; 18.74.1; 41. 162.20. Richter and Hall, nos. 82, 83; Beazley, *ARV*, p.326, nos. 1, 2, 8; Richter, *ARVS*, pp. 110 f.; Richter and Milne, fig. 65; Gallatin, *C.V.*, Gallatin Coll., pl.14, 1–3.

77 ⟶ 07.286.74; 34.11.7; 06. 1021.149. Richter and Hall, nos. 87–89; Beazley, *ARV*, pp.346, 347, nos. 1, 22, 2; Richter, *ARVS*, p.110, and *AJA*, 1935, pp.182 ff., figs. 1, 2; Bieber, *Theater*, p.19, fig. 24.

78 ⟶ 07.286.70: Richter and Hall, no. 81; Beazley, *ARV*, p. 336, no. 13; Richter, *ARVS*, p. 110.

79 ⟶ 29.131.7: Richter and

Hall, no. 80; Beazley, *ARV*, p. 336, no. 2; Richter, *ARVS*, pp. 29, 34, 110.

80 ⟶ 41.162.155, 134, 140, 145; 35.54; 24.97.37. Gallatin, *C.V.*, Gallatin Coll., pls.18, 2, 4, 26, 7; Beazley, *ARV*, pp.329, no. 13, 442, no. 9, 509, no. 9, 510, no. 58, 496, no. 56, 482, no. 1, and *JHS*, 1927, pp.231 f., fig. 6; Richter, *ARVS*, pp. 109, 114; Pease, *C.V.*, Gallatin Coll., pls. 52, 1a, b, 59, 1; Richter and Hall, no. 93.

81 ⟶ 07.286.64; 39.11.6. *Bull.*, 1940, pp.38 f., fig. 5; Richter, *AJA*, 1940, p.185, figs. 8, 9.

82 ⟶ 06.1021.203: Richter and Milne, fig. 180.

83 ⟶ 41.162.33: Gallatin, *C.V.*, Gallatin Coll., pl.29, 1, 2; Beazley, *ARV*, p.568, no. 4.

84 ⟶ 40.11.12: *Bull.*, 1941, pp. 122 f.

85 ⟶ 38.11.2: *Bull.*, 1938, pp.

225 f., figs. 1–4; Richter, *AJA*, 1939, p.6, figs. 4, 5, and *ARVS*, p.111, fig. 80. Now thought to be Brygan by Beazley.

86 ⟶ 07.286.40: Fairbanks, *Lekythoi*, II, p.257, no. 16b, pl. 38, 2; Pfuhl, *M.u.Z.*, fig. 539; Beazley, *ARV*, p.561, no. 107.

87 ⟶ 21.88.17: Beazley, *ARV*, p.561, no. 111; Richter, *ARVS*, pp. 112 f., fig. 81.

88 ⟶ 35.11.5: Beazley, *ARV*, p. 580, no. 1; Richter, *ARVS*, p. 114, fig. 83.

89 ⟶ 41.162.102: Gallatin, *C.V.*, Gallatin Coll., pl.27, nos. 7, 9; Beazley, *ARV*, p.468, no. 8.

90 ⟶ 06.1021.294: Sambon, *Coll. Canessa*, p.21, no. 76. "Very like the Inscription Painter and probably from his own hand" (Beazley).

91 ⟶ 07.286.44: Fairbanks, *Lekythoi*, II, p.244, no. 43a, pl. 32, 1; Beazley, *ARV*, p.446, no. 54; Richter, *ARVS*, p.109.

SECOND HALF OF THE V CENTURY B.C.

1 ⟶ 07.286.108: *Bull.*, 1908, pp. 5 f., fig. 5.

2 ⟶ 08.258.44: *Bull.*, 1909, pp. 62 f., fig. 2.

3 ⟶ 13.229.2: *Bull.*, 1914, pp. 63 f., fig. 7.

4 ⟶ 26.31.428.

5 ⟶ 11.210.2: *Bull.*, 1912, pp. 47 ff.; Hyde, *Olympic Victor Monuments*, p.145, pl.15; Chase, *Greek and Roman Sculpture in American Museums*, pp.67 f., fig. 75; Schmidt in *Corolla Ludwig Curtius*, p.78, n.33; Thassilo von Scheffer, *Die Kultur der Griechen*, pl.198.

6 ⟶ 07.286.116: *Bull.*, 1908, p. 7, fig. 7; Blümel, *Winckelmannsprogramm*, no. 90, p.21, no. 4, pl.1, 4; Amelung in *Einzelaufnahmen*, nos. 2038, 2039.

7 ⟶ 14.130.5: *Bull.*, 1915, pp. 25, 27, fig. 5.

8 ⟶ 12.232.2: *Bull.*, 1913, p. 175.

9 ⟶ 91.8: *Bull.*, 1919, pp.171 ff.

10 ⟶ 32.11.4: *Bull.*, 1933, pp. 2 ff., and 1935, pp.66 ff.; Richter, *AJA*, 1933, p.4, figs. 5, 6.

11 ⟶ 32.11.3: *Bull.*, 1921, p.20, and 1933, p.33.

12 ⟶ 24.97.15: *Bull.*, 1926, p. 128; Schweitzer, *Jahrbuch*, 1931, p.198.

13 ⟶ 36.11.1: *Bull.*, 1936, pp. 108 ff., figs. 1, 2; Richter, *AJA*, 1936, pp.301 ff., figs. 1, 2.

14 ⟶ 30.11.3: *Bull.*, 1930, pp. 218 f.; Richter, *M. M. Studies*, 1930–31, pp.147 ff.

15 ⟶ 48.11.4: Stackelberg, *Gräber der Hellenen*, pl.1, no. 3; Matz, *Arch. Ztg.*, 1874, p.29; Michaelis, *Ancient Marbles in Great Britain*, p.492, no. 37; Conze, *Die attischen Grabreliefs*, I, no.572, pls.114, 115; F. Poulsen in *Einzelaufnahmen*, nos. 3080 f.; Diepolder, *Grabreliefs*, p.36; *Bull.*, 1948–1949, pp.162 f.

16 ⟶ 07.286.109: *Bull.*, 1908, p.6.

17 ⟶ 40.11.23: *Bull.*, 1941, pp. 67 ff., 170; Richter, *Art in*

America, 1941, pp.57 ff., figs. 1, 2.

18 ⟶ 29.47: *Bull.*, 1929, pp. 254 ff., figs. 1–3.

19 ⟶ 24.97.98: *Bull.*, 1930, pp. 168 ff.

20 ⟶ 24.97.99: *Bull.*, April sup., 1926, pp.8 f., fig. 2.

21 ⟶ 24.97.92.

22 ⟶ 24.62: *Bull.*, 1924, p.309.

23 ⟶ 12.19. Gift of Marcus T. Reynolds, 1912.

24 ⟶ 26.60.5: *Bull.*, 1926, pp. 176 f., fig. 1; West, *M. M. Studies*, 1930–31, pp.174 ff., fig. 1; Meritt and West, *The Athenian Assessment of 425 B.C.*, p. 17, pl.2; Meritt, Wade-Gery, McGregor, *The Athenian Tribute Lists*, I, p.112, no. 21, fig. 157.

25 ⟶ 74.51.5679 (CB453): Myres, *Handbook*, no. 5014; *Bronze Cat.*, no. 87.

26 ⟶ 97.22.11 (GR42): *Bronze Cat.*, no. 89; *Master Bronzes*, no. 90.

27 ⌐ 23.160.51: *Bull.*, 1924, pp.295 f., fig. 6.

28 ⌐ 27.122.20: *Bull.*, 1930, p. 135.

29 ⌐ 27.122.12: *Bull.*, 1928, p. 80, fig. 2.

30 ⌐ 06.1091: *Bronze Cat.*, no. 97. 20.37.4: *Bull.*, 1921, pp. 34 f., fig. 5.

31 ⌐ 07.286.106: *Bull.*, 1908, pp.89 f., fig. 3; *Bronze Cat.*, no. 96.

32 ⌐ 14.147.1: *Bull.*, 1916, p. 129; Richter, *Animals*, fig. 96.

33 ⌐ 37.11.6: *Bull.*, 1937, pp. 255 ff., figs. 1, 2; Richter, *AJA*, 1937, pp.532 ff., figs. 1–4; Züchner, *Griechische Klappspiegel*, p.192.

34 ⌐ 96.18.10, 11 (GR104, 105): *Bronze Cat.*, nos. 91, 92.

35 ⌐ 08.258.4: *Bronze Cat.*, no. 93.

36 ⌐ 23.160.25: *Bull.*, 1924, p. 69, fig. 2.

37 ⌐ 06.1061: *Bronze Cat.*, no. 757; Züchner, *Griechische Klappspiegel*, p.78, κs 124.

38 ⌐ 07.255: *Bull.*, 1908, pp. 68 f., fig. 2; *Bronze Cat.*, no. 758; Züchner, *Griechische Klappspiegel*, p.74, κs 106.

39 ⌐ 07.256: *Bull.*, 1908, pp. 67, 68, fig. 1; *Bronze Cat.*, no. 759; Züchner, *Griechische Klappspiegel*, p. 70, κs 100.

40 ⌐ 06.1228: *Bronze Cat.*, no. 760. The interpretation of the woman as Auge is M. J. Milne's suggestion.

41 ⌐ 07.257: *Bull.*, 1908, p.66; *Bronze Cat.*, no. 761; Möbius, *Ornamente d. gr. Grabstelen*, p. 60, n.13; Züchner, *Griechische Klappspiegel*, p.92, κs 157.

42 ⌐ 25.78.44: *Bull.*, 1927, p. 20, fig. 7; Züchner, *Griechische Klappspiegel*, p.73, κs 105.

43 ⌐ 74.51.5418 (CB150): *Bronze Cat.*, no. 747; Myres, *Handbook*, no. 4801; Jantzen, *Bronzewerkstätten*, p.68, no. 46.

44 ⌐ 39.11.4: *Bull.*, 1940, pp. 8 ff., figs. 1, 2; Richter, *AJA*, 1941, pp.363 ff. 47.11.9.

45 ⌐ 21.88.34: *Bull.*, 1923, p. 124.

46 ⌐ 30.11.12: Boroffka, *Bull. of Bachstitz Gallery*, 1929, p.36; *Bull.*, 1931, pp.44 ff.; Richter, *M. M. Studies*, 1932–33, pp. 109 ff., figs. 1–29; Schefold, *Eurasia*, XII, 1937, pp.26, n.7, 28, 41, figs. 33–35.

47 ⌐ 32.11.2: *Bull.*, 1932, pp. 250 ff.; Richter, *AJA*, 1933, p. 51.

48 ⌐ 20.217, 219, 222. *Bull.*, 1923, p.214.

49 ⌐ 25.78.74; 25.78.84; 10. 210.69.

50 ⌐ 10.210.59.

51 ⌐ 10.210.76; 10.210.75.

52 ⌐ 10.210.43: Jastrow, *Opuscula archaeologica*, II, 1, 1938, pp.6 f., pl.1.

53 ⌐ 11.211: *Bull.*, 1912, p.97, fig. 6; D. K. Hill, *Hesperia*, XII, 1943, p.110, fig. 11.

54 ⌐ 26.199.67: Richter, *M. M. Studies*, 1928–29, p.26, fig. 3.

55 ⌐ 07.286.81: Richter and Hall, no. 118; Beazley, *ARV*, p.637, no. 49; Pfuhl, *M.u.Z.*, II, fig. 496, ¶566; Robinson and Fluck, p.115, no. 107a; Richter, *ARVS*, p.118.

56 ⌐ 12.236.2; 25.189.2. Richter and Hall, nos. 119, 120; Beazley, *ARV*, pp.145, 635, no. 19, 648; Richter, *ARVS*, p.118; *Bull.*, 1927, p.18, fig. 5.

57 ⌐ 12.236.1: Richter and Hall, no. 121; Beazley, *ARV*, p.635, no. 20; *Bull.*, 1913, p. 157; Richter, *ARVS*, p.118.

58 ⌐ 17.230.13: Richter and Hall, no. 113; Beazley, *ARV*, p. 640, no. 86; Richter, *ARVS*, pp. 119 f. The mouth is restored.

59 ⌐ 06.1171; 07.286.42; 08. 258.16–18. Richter and Hall, nos. 114–117; Beazley, *ARV*, pp. 644, 645, nos. 152–154, 176, 178; Fairbanks, *Lekythoi*, I, p. 226, no. 48a, pl.10, I, and II, pp. 260, no. 14a, pl.39, 252, no. 48b, c, pl.35, 1, 2; Robinson and Fluck, p.98, no. 70; Richter, *ARVS*, pp.119 f.; *Bull.*, 1909, pp. 101 ff., figs. 4, 5.

60 ⌐ 17.230.35: Richter and Hall, no. 122; Beazley, *ARV*, p. 656, no. 66; Richter, *ARVS*, p. 122.

61 ⌐ 41.162.142: Pease, *C.V.*, Gallatin Coll., pl.55, 1a, b; Beazley, *ARV*, p.653, no. 9; Richter, *ARVS*, p.122.

62 ⌐ 28.57.23: *Bull.*, 1931, pp. 245 ff., figs. 1–3; Nilsson, *Archiv für Religionswissenschaft*, 1935, p.137, no. 14; Richter and Hall, no. 124; Beazley, *ARV*, p.651, no. 1; Richter, *ARVS*, pp.123, 132.

63 ⌐ 09.221.44: Fairbanks, *Lekythoi*, II, p.15, no. 20, pl.4; Beazley, *AWL*, p.21, pl.7, 3, and *ARV*, p.782, no. 71; Richter, *ARVS*, p.122.

64 ⌐ 34.32.2: *Bull.*, 1934, p. 70. Attributed to the Painter of Munich 2335 by Beazley in 1946.

65 ⌐ 23.160.43: *Bull.*, 1925, p. 50.

66 ⌐ 10.210.11: *Bull.*, 1911, pp. 32, 36, fig. 5; Fairbanks, *Lekythoi*, II, p.245, no. 19a, pl. 33, 1; Beazley, *ARV*, p.764, no. 31; Richter, *ARVS*, p.138, fig. 88.

67 ⌐ 06.1021.189: *Bull.*, 1906, p.75, fig. 5; Richter and Hall, no. 108; Beazley, *ARV*, p.661, no. 9; Richter and Milne, fig. 126; Von Mercklin, *Röm. Mitt.*, 1923–24, p.108; Richter, *ARVS*, p.124, fig. 88.

68 ⌐ 23.160.80: *Bull.*, 1925, p. 264, fig. 6; Richter and Hall, no. 110; Beazley, *ARV*, p.666, no. 1; Richter, *ARVS*, p.125, fig. 90.

69 ⌐ 24.97.30: *Bull.*, 1925, p. 130, fig. 7; Richter and Milne, fig. 61; Richter and Hall, no. 131; Beazley, *ARV*, p.668, no. 2; Richter, *ARVS*, p.125, fig. 93.

70 ⌐ 21.88.73: *Bull.*, 1923, pp. 253 ff.; Richter and Hall, no. 126; Robinson and Fluck, p.156, no. 196; Beazley, *ARV*, p.678, no. 16; Richter, *ARVS*, p.128.

71 ⌐ 45.11.1: *Bull.*, 1945–46, pp.126 ff.; Libertini, *Boll. d'Arte*, 1933, pp.554 ff.; Beazley, *ARV*, p.680, no. 49; Richter, *ARVS*, p.128, fig. 96.

72 ⟷ 06.1021.116: Richter and Milne, fig. 22; Richter and Hall, no. 130; Beazley, *ARV*, p. 690, no. 1; Richter, *ARVS*, p.128.

73 ⟷ 08.258.21: *Bull.*, 1909, p. 103; Jacobsthal, *M. M. Studies*, 1934–36, pp.117 ff., figs. 6–10; Friedländer, *Arch. Anz.*, 1935, cols. 20 ff.; Beazley, *ARV*, p. 717, no. 1; Richter, *ARVS*, pp. 130 f., 170, n.72.

74 ⟷ 41.83: *Bull.*, 1941, pp. 202 ff., figs. 3, 4.

75 ⟷ 12.229.14: *Bull.*, 1913, pp.157 f.; Richter and Hall, no. 136; Richter, *ARVS*, pp.131 f., fig. 100.

76 ⟷ 19.192.44: *Bull.*, 1921, p. 14; Richter and Hall, no. 157; Richter and Milne, fig. 30.

77 ⟷ 27.122.8: *Bull.*, 1929, pp. 107 ff.; Richter and Hall, no. 154; Richter and Milne, fig. 53; Beazley, *ARV*, p.797, no. 2; Richter, *ARVS*, pp.144 f., fig. 112.

78 ⟷ 24.97.25: *Bull.*, 1925, pp. 261 f., figs. 1–3; Richter and Hall, no. 128; Richter and Milne, fig. 54; Beazley, *ARV*, p.688; Richter, *ARVS*, p.130, fig. 107.

79 ⟷ 25.78.66: *Bull.*, 1927, pp. 57 f., figs. 2, 4; Richter and Hall, no. 155; Messerschmidt, *Röm. Mitt.*, 1932, pp.129 ff., 135, figs. 3, 7b; Richter and Milne, fig. 62; Beazley, *ARV*, p. 797, no. 7; Bieber, *Theater*, p.8, fig. 9, and *AJA*, 1941, p.531, fig. 2; Richter, *ARVS*, p.145.

80 ⟷ 07.286.65: Richter and Hall, no. 137; Richter and Milne, fig. 48; Beazley, *ARV*, p. 766, no. 9; Richter, *ARVS*, p. 132.

81 ⟷ 41.162.137, 141: Hoppin, *C.V.*, Gallatin Coll., pl.24, 1–3; Beazley, *ARV*, p.768, nos. 35, 47; Richter, *ARVS*, p.132.

82 ⟷ 08.258.22: *Bull.*, 1909, p. 105, fig. 8; Hauser in Furtwängler and Reichhold, pl.120, 1; Pfuhl, *M.u.Z.*, fig. 566; Brommer, *Jahrbuch*, 1937, pp.208, no. 30, 216; Richter and Hall, no. 140; Beazley, *ARV*, p.725, no. 9; Richter, *ARVS*, p.133.

83 ⟷ 30.11.8: *Bull.*, 1930, p.

281, fig. 2; Richter and Milne, fig. 100; Richter and Hall, no. 141; Beazley, *ARV*, p.724, no. 4; Richter, *ARVS*, pp.133 f., fig. 102.

84 ⟷ 31.11.13: *Bull.*, 1932, pp. 103 ff., figs. 1–7; Richter, *AJA*, 1932, p.96, figs. 6, 7, and *ARVS*, p.134; Richter and Hall, no. 139; Beazley, *AWL*, p.8, pl.7, 1, and *ARV*, p.725, no. 7. Since the publication of Richter and Hall in 1936 a new study of the inscribed names of the Greeks and Amazons has led D. von Bothmer to suggest a number of changes. He will publish them in his forthcoming monograph on Amazons.

85 ⟷ 09.221.38.

86 ⟷ X22.42 (GR1218): Beazley, *ARV*, p.799, no. 13; Richter, *ARVS*, p.146, fig. 110. In 1946 Beazley changed his attribution from Aison to the Eretria Painter. 22.139.31. Attributed to the Eretria Painter by Beazley in 1946.

87 ⟷ 40.11.2: *Bull.*, 1940, pp. 157 ff., figs. 1, 2; Beazley, *ARV*, p.737; Richter, *AJA*, 1940, pp. 428 ff., figs. 1–3, 1942, p.221, and *ARVS*, p.136, fig. 104. Only the first letter of the name beginning with B is certain. Instead of Beroie, as previously conjectured, Beazley suggests Bentho.

88 ⟷ 27.122.9: *Bull.*, 1928, pp. 108, fig. 2, 111 f.; Beazley, *JHS*, 1929, pp.72 ff., fig. 25, and *ARV*, p.800, no. 19; Richter and Hall, no. 151; Richter, *ARVS*, p.146.

89 ⟷ 16.73; 07.286.35. *Bull.*, 1916, p.255, fig. 4; Richter and Hall, nos. 144, 145; Beazley, *ARV*, pp.742, 743, nos. 1, 5; Herbig, *Ath. Mitt.*, 1929, pp. 168 f., pl.7; Richter and Milne, fig. 73; D. M. Robinson, *AJA*, 1936, pp.516 ff., nos. 2, 3; Richter, *ARVS*, p.137.

90 ⟷ 08.258.24: Richter and Hall, no. 149; Beazley, *ARV*, p. 754, no. 27; Richter, *ARVS*, p. 137, fig. 106.

91 ⟷ 41.162.89: Gallatin, *C.V.*, Gallatin Coll., pl.24, 8; Beazley, *ARV*, p.755, no. 47; Richter, *ARVS*, p.137.

92 ⟷ 37.11.19: *Bull.*, 1939, pp. 231 f., fig. 2; Richter, *AJA*, 1942, p.268, *Greek Painting*, p. 15, and *ARVS*, pp. 135 f. "Mr. H. Immerwahr argues in *Transactions of the American Philological Association*, LXXVII, 1946, pp.247 ff., that the situation in this scene is like that of Aristophanes' *Ekklesiazousai*, 960 ff. —a man serenading his sweetheart—but this seems improbable. Timidity is not a characteristic of hetairai in fifth century vase-painting" (M. J. Milne).

93 ⟷ 37.11.23: *Bull.*, 1938, pp. 262 ff., figs. 1–3; Richter, *AJA*, 1939, pp.1 ff., figs. 1–3, and *Greek Painting*, p.17; Beazley, *ARV*, p.832, no. 6; Richter, *ARVS*, pp.147 f., fig. 114.

94 ⟷ X22.59 (GR1243): Richter and Hall, no. 159; Beazley, *ARV*, p.832, no. 7; Robinson and Fluck, p.113, no. 103a; Richter, *ARVS*, pp.134, 148.

95 ⟷ 09.221.40: *Bull.*, 1910, pp. 143, 145, fig. 7; Richter and Hall, no. 161; Richter and Milne, fig. 145; Beazley, *ARV*, p.840, no. 86; Richter, *ARVS*, p. 149.

96 ⟷ 21.88.64.

97 ⟷ 41.162.70: Klein, *Child Life*, pp.7, 46, n.62, pl.7d; Pease, *C.V.*, Gallatin Coll., pl.60, 7.

98 ⟷ 06.1021.202: Richter and Milne, fig. 120; Klein, *Child Life*, pp.26, n.317, 14, n.184.

99 ⟷ 06.1021.196: Klein, *Child Life*, pp.12, n.142, 27, n. 325, 38, n. 432; Richter and Hall, no. 164; Beazley, *ARV*, p. 837, no. 42.

100 ⟷ 24.97.34: *Bull.*, 1925, p. 131, fig. 9; Deubner, *Jahrbuch*, 1927, pp.177 ff., figs. 7–9, and *Att. Feste*, pp.104 ff., pl.11, 2–4; Nilsson, *Sitz. d. Bayer. Ak. d. Wiss.*, 1930, pp.8, 9, 11; Bieber, *AJA*, 1942, p.153, and *Hesperia*, sup. VIII, 1949, pp.34 ff., pl. 5, 1a, b.

101 ⟷ 23.73.1: *Bull.*, 1923, p. 127; Klein, *Child Life*, p.16, n. 201.

102 ⟷ 15.25: *Bull.*, 1915, pp. 122 ff., fig. 1; Klein, *Child Life*, pl.17d, p.15, n.200; Richter and

Milne, fig. 75; D. M. Robinson, *AJA*, 1936, p.519, no. 4.

103 ⟐ 06.1021.135: Fairbanks, *Lekythoi*, II, p.185, no. 52; Buschor, *Münch. Jahr.*, 1925, p. 186; Beazley, *ARV*, p.829, no. 19; Richter, *ARVS*, p.153.

104 ⟐ 23.160.42: *Bull.*, 1925, p.48; Beazley, *ARV*, p.813, no. 6.

105 ⟐ 06.1021.130, 133: Fairbanks, *Lekythoi*, II, p.88, no. 13, pl.13, 3, p.73, no. 5, pl.11, 2; Beazley, *ARV*, p.815, nos. 27,

23; Buschor, *Münch. Jahr.*, 1925, p.185.

106 ⟐ 06.1169: Fairbanks, *Lekythoi*, II, p.178, no. 34, pl. 27, 2 (where wrong accession number is given); Buschor, *Münch. Jahr.*, 1925, p.187; Beazley, *ARV*, p.820, no. 3; Richter, *ARVS*, p.153, fig. 116 (with wrong caption).

107 ⟐ 41.162.12: Gallatin, *C.V.*, Gallatin Coll., pls. 28, no. 1, 28a; Richter, *ARVS*, p.153, fig. 117. Attributed by Beazley in

1946 to "a member of Group R." 07.286.45: Fairbanks, *Lekythoi*, II, p.169, no. 15, pl. 26; Beazley, *ARV*, p.828, no. 8; Richter, *ARVS*, p.153, figs. 118, 119.

108 ⟐ 24.97.82.

109 ⟐ 26.31.443: Richter and Milne, fig. 176.

110 ⟐ 06.1116: Shear, *AJP*, 1908, pp.461 ff.; Robinson and Fluck, pp.31, n.73, 114, n.106; Tarbell, *Class. Phil.*, 1917, pp. 190 f.

IV CENTURY B.C.

1 ⟐ 15.143: *Bull.*, 1916, pp. 82 ff.; Hyde, *Olympic Victor Monuments*, p.168, pl.20.

2 ⟐ 11.91.1: *Bull.*, 1911, p.211, fig. 1; Lawrence, *BSA*, 1923–25, p.67, pl.8, 1.

3 ⟐ 10.142.1: *Bull.*, 1910, pp. 276 ff., figs. 2–4.

4 ⟐ 09.195: *Bull.*, 1910, p.237.

5 ⟐ 26.60.37: Richter, *Sculpture and Sculptors*, 2nd ed., p. 185, fig. 537; *Bull.*, 1927, p. 143, fig. 2.

6 ⟐ 42.201.12.

7 ⟐ 08.258.43: *Bull.*, 1909, p. 63.

8 ⟐ 11.212.4: *Bull.*, 1912, p.95.

9 ⟐ 08.258.39: *Bull.*, 1909, pp. 62, 64, fig. 1.

10 ⟐ 25.179: *Bull.*, 1926, pp. 82 f., fig. 3.

11 ⟐ 14.130.11: *Bull.*, 1915, p. 26, fig. 4.

12 ⟐ 17.230.21: *Bull.*, 1921, p. 11, fig. 3.

13 ⟐ 13.229.1: *Bull.*, 1914, p. 64, fig. 7.

14 ⟐ 24.97.14: *Bull.*, 1925, p. 106, fig. 2; Libertini, *Röm. Mitt.*, 1923–24, pp.440 ff., pl.9; Klein, *Praxiteles*, p.239, fig. 38; Rizzo, *Prassitele*, p.41, pls.66, 67.

15 ⟐ 17.230.3: *Bull.*, 1921, pp. 11 f., fig. 4; Richter in Brunn-Bruckmann, *Denk.*, no. 527, figs. 1–3.

16 ⟐ 42.201.8: *Bull.*, 1943–44, p.84.

17 ⟐ 45.127.

18 ⟐ 09.221.8: *Bull.*, 1910, p. 236, fig. 3.

19 ⟐ 20.49.1: *Bull.*, 1921, p.12.

20 ⟐ 23.160.20: *Bull.*, 1924, p. 127, fig. 3.

21 ⟐ 08.258.41: *Bull.*, 1909, pp.62 f., 65, fig. 4; Diepolder, *Grabreliefs*, pp.40, 42.

22 ⟐ 06.287: *Bull.*, 1906, pp. 120 ff.

23 ⟐ 12.159: *Bull.*, 1913, pp. 173 f., fig. 1.

24 ⟐ 29.54: *Bull.*, 1929, pp. 301 ff.; Klumbach, *Tarentiner Grabkunst*, pp.11, no. 44, 64, pl. 9; Wuilleumier, *Tarente*, pp. 301 f., pl.14, 1.

25 ⟐ 12.229.1: *Bull.*, 1913, p. 174.

26 ⟐ 10.210.27: *Bull.*, 1911, pp. 22 f., fig. 3.

27 ⟐ 25.78.59: *Bull.*, 1926, pp. 259 f., fig. 3.

28 ⟐ 24.228: *Bull.*, 1926, pp. 83 f., fig. 5.

29 ⟐ 11.13.1.

30 ⟐ 26.59.1: *Bull.*, April sup., 1926, pp.7, fig. 1, 10 f.; Butler, *Sardis*, I, pp.52 f., ill. 46, II, pp.65 ff., figs. 73–76, pls.b, c, and *Atlas*, pls.8–11.

31 ⟐ 35.122: *Bull.*, 1933, p.13, and 1936, pp.30 ff., figs. 1, 2; S. Reinach, *Rev. arch.*, 1898, pp.

371 ff., pl.20; Richter, *AJA*, 1933, pp.48 ff., pls.7a, 8a.

32 ⟐ 12.173: *Bull.*, 1913, p.268, fig. 6; *Bronze Cat.*, no. 121.

33 ⟐ 17.230.4: *Bull.*, 1921, pp. 32 f., fig. 1; Klein, *Praxiteles*, p. 52, fig. 2; *Burlington F. A. Club Exh.*, 1904, pp.51 f., no. 56, pl. 54; *Master Bronzes*, no. 92; Süsserot, *Gr. Plastik*, pp.145 ff., pl.31, 1.

34 ⟐ 06.1058: *Bull.*, 1907, pp. 18 ff., fig. 4; *Bronze Cat.*, no. 110.

35 ⟐ 44.11.9: *Bull.*, 1945–46, pp.184 ff.; Richter, *AJA*, 1946, pp.361 ff., pl.22.

36 ⟐ 07.259: *Bull.*, 1908, pp. 69 f., fig. 3; *Bronze Cat.*, no. 765; Züchner, *Griechische Klappspiegel*, p.46, κs60.

37 ⟐ 14.130.4: *Bull.*, 1915, pp. 209 ff., fig. 6; Züchner, *Griechische Klappspiegel*, p.89 f., κs150.

38 ⟐ 06.1129: *Bronze Cat.*, no. 766.

39 ⟐ 07.258: *Bull.*, 1908, p.70, fig. 4; *Bronze Cat.*, no. 767; Züchner, *Griechische Klappspiegel*, p.82, κs132.

40 ⟐ 22.139.86.

41 ⟐ 07.286.88: *Bull.*, 1908, p. 90, no. 8; *Bronze Cat.*, no. 107.

42 ⟐ 17.190.2073: Furtwängler and Reichhold, II, pp.42 f., fig. 18; C. Smith, *J. P. Morgan Coll.*, no. 59, pl.32; Züchner, *Griechische Klappspiegel*, pp. 99 f., κs164.

43 ⁓ 07.286.89: *Bull.*, 1908, p. 90, no. 9; *Bronze Cat.*, no. 106; Richter, *AJA*, 1946, p.363, no. 3, pl.25, fig. 10; Züchner, *Griechische Klappspiegel*, p.195.

44 ⁓ 25.78.88: *Bull.*, 1927, p. 21, fig. 10.

45 ⁓ 09.221.18a, b: *Bull.*, 1910, pp.98 f.; *Bronze Cat.*, nos. 108, 109.

46 ⁓ 06.1127, 1128: *Bull.*, 1907, p.20, fig. 7; *Bronze Cat.*, nos. 111, 112.

47 ⁓ 09.221.10: *Bull.*, 1910, pp. 97 f., fig. 4; *Bronze Cat.*, no. 505.

48 ⁓ 08.258.14: *Bull.*, 1909, p. 81; *Bronze Cat.*, no. 1540.

49 ⁓ 17.230.26: *Bull.*, 1921, p. 36.

50 ⁓ 12.229.19: *Bull.*, 1913, pp.176 ff., fig. 7.

51 ⁓ 11.140.2: *Bull.*, 1911, pp. 214 ff., fig. 7.

52 ⁓ 07.286.18, 4: Klein, *Child Life*, pp.18, n.252, 19, n.266, pl.20c; *Daily Life*, pp.47, 50, fig. 62. 13.225.15: *Bull.*, 1914, p.236. Head and right arm ancient but alien.

53 ⁓ 06.1066: *Bull.*, 1907, p.7. 10.210.38: *Bull.*, 1910, p.276. 38.11.1: *Bull.*, 1938, p.51, fig. 4.

54 ⁓ E.g., 08.258.35: *Bull.*, 1909, pp.129 f., fig. 5.

55 ⁓ 30.117: *Bull.*, 1931, pp. 18 ff.

56 ⁓ 17.190.2061: Klein, *Child Life*, p.2, n.16, pl.3a.

57 ⁓ 17.190.2063.

58 ⁓ 13.225.13, 14, 16, 18–28: *Bull.*, 1914, pp.235 f.; *Daily Life*, pp.20 f.; Bieber, *Theater*, pp.85 ff., figs. 122–135.

59 ⁓ 35.11.1: *Bull.*, 1935, p. 165, figs. 1, 2.

60 ⁓ 10.210.45: D. M. Robinson, *AJA*, 1923, p.19, fig. 25.

61 ⁓ 10.210.52: D. M. Robinson, *AJA*, 1923, pp.19, 21, fig. 25.

62 ⁓ 44.11.12, 13: Gabrici, *Mon. Linc.*, 1913, p.682, nos. 1, 3; *Bull.*, 1944–45, pp.168 ff.; Beazley, *ARV*, p.852, nos. 2, 4;

Richter, *ARVS*, p.151, fig. 122.

63 ⁓ 17.46.1: Gabrici, *Mon. Linc.*, 1913, p.682, fig. 234, no. 2; Richter and Hall, no. 165; Beazley, *ARV*, p.852, no. 1; Richter and Milne, fig. 23; Richter, *ARVS*, p.151.

64 ⁓ E.g., 06.1021.199, 200: Sambon, *Coll. Canessa*, pp. 39, no. 115, 71 f., no. 247, pls. 8, 17; Richter and Milne, fig. 102. 42.201.2: *Bull.*, 1943–44, p.1.

65 ⁓ 42.201.3. For such omphaloi see Nilsson, *Archiv für Religionswissenschaft*, 1935, p.92, n.3.

66 ⁓ 08.258.20: *Bull.*, 1909, p. 103; Richter and Hall, no. 166; Schefold, *Ath. Mitt.*, 1934, p. 138, pl.13, no. 2; Götze, *Röm. Mitt.*, 1938, p.228, pl.36, 1; Richter, *ARVS*, p.159.

67 ⁓ 21.88.162: *Bull.*, 1925, pp. 130 f., fig. 8; Richter and Hall, no. 167; Richter, *ARVS*, p.159, fig. 121. 26.60.75: Schefold, *Untersuchungen*, pp.24, no. 191, 92, 97, fig. 3, pl.11, 1; Richter, *ARVS*, p.162; Bieber, *Hesperia*, 1949, sup.8, pp.32 f., pl.4, 2.

68 ⁓ 25.190: Schefold, *Kertscher Vasen*, pp.5, 6, 10, 14, 22, pl. 10, and *Untersuchungen*, pp. 37, no. 327, 66, 97, 104 f., 127, 130, 141, 151, 154; Deubner, *Att. Feste*, p.103, pl.9, 4; Richter and Milne, fig. 121; Richter and Hall, no. 169; Richter, *ARVS*, p.161, fig. 123; Bieber, *Hesperia*, 1949, sup.8, pp.31 ff., pl.4, 1.

69 ⁓ 06.1021.181: *Bull.*, 1905–06, pp.79 f., fig. 7; Richter, *AJA*, 1907, pp.417 ff., fig. 5, and *ARVS*, p.161, fig. 125; Schefold, *Kertscher Vasen*, pp.13, 22, pl. 9a, b, and *Untersuchungen*, p. 61, no. 593; Richter and Milne, fig. 177; Richter and Hall, no. 170; Bieber, *Hesperia*, sup.8, pp. 31 f., pl.4, 3a, b.

70 ⁓ 24.97.5: *Bull.*, 1925, p. 131; Schefold, *Kertscher Vasen*, pp.9, 13, 22, pl.11, and *Untersuchungen*, p.24, no. 190; Richter and Hall, no. 171; Beazley, *JHS*, 1939, p.41; Richter, *ARVS*, p.160, fig. 124.

71 ⁓ 22.139.26: Richter and Hall, no. 173; Walton, *Harvard*

Theological Review, 1938, p.72, n.20; Richter, *ARVS*, pp.161 f.

72 ⁓ 06.1021.179: Schoppa, *Darstellung der Perser*, p.41, no. 32; Schefold, *Untersuchungen*, p.57, no. 546, fig. 6; Richter and Milne, fig. 39.

73 ⁓ 06.1021.184: Schefold, *Untersuchungen*, pp.24, no. 189, 89; Richter and Milne, fig. 86; Richter and Hall, no. 168; Hahland, *Vasen um Meidias*, pp. 7, n.16, 18.

74 ⁓ 06.1021.195: Sambon, *Coll. Canessa*, 1904, p.39, no. 113; Schefold, *Untersuchungen*, pp.57, no. 547, 118, 159 III, pl.38a, b.

75 ⁓ 06.1021.183: Sambon, *Coll. Canessa*, pp.37 f., no. 111; Deubner, *Att. Feste*, p.246.

76 ⁓ 23.74: *Bull.*, 1923, pp. 253 ff., fig. 6.

77 ⁓ 37.11.2: *Bull.*, 1937, pp. 90 f., fig. 2.

78 ⁓ 49.11.2: *Bull.*, 1949–50, p.95.

79 ⁓ x22.44 (GRI220). On such Boeotian vases see Ure, *Arch. Anz.*, 1933, col. 37; Lullies, *Ath. Mitt.*, 1940, pp.1 ff.

80 ⁓ 06.1021.232: Sambon, *Coll. Canessa*, p.76, no. 262; Shepard, *The Fish-tailed Monster in Greek and Etruscan Art*, p.40; Beazley, *JHS*, 1943, p.68.

81 ⁓ x22.45 (GRI221).

82 ⁓ 28.57.9: Richter, *ARVS*, p.163.

83 ⁓ 44.11.10: *Bull.*, 1944–45, pp.170 f.; Richter, *ARVS*, p. 163.

84 ⁓ 26.60.64: *Bull.*, 1929, pp. 201, fig. 1, 203.

85 ⁓ 06.1021.180: Sambon, *Coll. Canessa*, p.45, no. 151, pl. 12; *Bull.*, 1906, p.80, fig. 8.

86 ⁓ 06.1021.207: Sambon, *Coll. Canessa*, p.45, no. 152, pl. 12.

87 ⁓ 41.162.42: Gallatin, *C.V.*, Gallatin Coll., pl.30, 2.

88 ⁓ 96.18.57 (GR610): Trendall, *Frühitaliotische Vasen*, pp. 9, n.8, 12, n.14, 31, no. 14.

89 ⁓ 21.88.75: *Bull.*, 1923, p.

256; Beazley, *V. Pol.*, pp.72 ff., n.4; Moon, *Papers of the British School at Rome*, XI, 1929, p.38; Trendall, *Frühitaliotische Vasen*, pp.16, 34, no. 138. 11.212. 12: *Bull.*, 1912, p.97, fig. 5; Trendall, *Frühitaliotische Vasen*, pp. 15, 35, no. 167, pl.11c; Beazley, *JHS*, 1939, p.5. 12. 235.4: *Bull.*, 1913, p.158; Beazley, *V. Pol.*, p.76, n.3; Trendall, *Frühitaliotische Vasen*, pp.15, 35, no. 165, pls.19, 11b. 91. 1.466.

90 ⟋ 24.97.104. Said to have been found near Taranto. *Bull.*, 1927, pp.56 f., fig. 1; Whatmough, *Harvard Studies in Classical Philology*, 1928, pp. 1 ff., fig. 1; Messerschmidt, *Röm. Mitt.*, 1932, pp.134 ff., figs. 4, 7a; Trendall, *Frühitaliotische Vasen*, pp.25 f., no. b75, 41, no. 75, pl.28b; Bieber, *Theater*, pp.281 f., fig. 381.

91 ⟋ 41.162.50: Pease, *C.V.*,

Gallatin Coll., pl.64, no. 1.

92 ⟋ 16.140. Said to have been found at Lentini, Sicily. *Bull.*, 1916, pp.255 ff., figs. 6, 7; Messerschmidt, *Röm Mitt.*, 1932, pp. 138 ff., figs. 5, 7c; Bieber, *Theater*, pp.145 f., figs. 200, 201; Trendall, *Frühitaliotische Vasen*, pp.27, no. b88, 41, no. 88; Richter, *Greek Painting*, p.18.

93 ⟋ 13.232.3: *Bull.*, 1914, pp. 234 f., fig. 3; Klein, *Child Life*, pl.23a, p.21, n.276.

94 ⟋ 10.210.17a, b: *Bull.*, 1911, p.36; Richter, *Furniture*, p.70, fig. 189.

95 ⟋ 11.210.3. Said to be from Taranto. *Monumenti dell' Inst.*, VI, 1860, pl.42b, and *Annali*, 1860, p.317; *Bull.*, 1912, pp. 95 f., fig. 2.

96 ⟋ 07.128.1. Gift of Matilda W. Bruce, 1907.

97 ⟋ 17.46.2.

98 ⟋ 50.11.4: *Bull.*, 1951, pp. 156 ff.

99 ⟋ 52.11.2. "Near the group of Naples 1959" (A. D. Trendall).

100 ⟋ 17.120.241. Bequest of Isaac D. Fletcher, 1917; 96. 18.42 (GR640). Said to be from Naples.

101 ⟋ 06.1021.227: Sambon, *Coll. Canessa*, 1904, p.40, no. 120, pl.10; Richter, *Furniture*, p.43, fig. 120, and *Gr. Ptg.*, p.18; Beazley, *JHS*, 1943, p.92, no. 19.

102 ⟋ 06.1021.231: Sambon, *Coll. Canessa*, 1904, p.40, no. 121, pl.10; Beazley, *JHS*, 1943, p.91, no. 7.

103 ⟋ 01.8.12 (GR998). Said to be from Capua. *Sale Catalogue of the de Morgan Collection of Greek Art*, 1901, p.75, no. 389.

104 ⟋ Froehner, *Coll. Gréau*, passim.

HELLENISTIC PERIOD

1 ⟋ 07.286.111: *Bull.*, 1908, pp. 1, 6, 7, fig. 1, 61; Richter, *Animals*, pp.18, 61, fig. 79, in Brunn-Bruckmann, *Denk.*, pl. 729, 1, *AJA*, 1932, pp.284 f., and 1933, p.51; Johnson, *AJA*, 1932, pp.276 ff.; F. Poulsen, 'Εφ. 'Αρχ., 1937, pp.188 ff., fig. 3.

2 ⟋ 45.11.5.

3 ⟋ 21.88.13: *Bull.*, 1924, p. 240, fig. 1; *Einzelaufnahmen*, pl.3507.

4 ⟋ 13.227.2: *Bull.*, 1914, p.64.

5 ⟋ 14.130.6: *Bull.*, 1915, p.25, fig. 3.

6 ⟋ 26.60.46.

7 ⟋ 15.146: *Bull.*, 1916, pp. 41 f., fig. 3.

8 ⟋ 25.78.57.

9 ⟋ 23.160.5.

10 ⟋ 10.210.25: *Bull.*, 1910, p. 275.

11 ⟋ 14.105.1: *Bull.*, 1915, pp. 25, 27, fig. 6.

12 ⟋ 19.192.89: *Bull.*, 1924, p. 193.

13 ⟋ 23.160.9: *Bull.*, 1926, pp. 256 f., fig. 1.

14 ⟋ 24.97.90: *Bull.*, 1926, pp. 81, 83, fig. 4.

15 ⟋ 14.130.10: *Bull.*, 1915, p. 26.

16 ⟋ 28.57.1: *Bull.*, 1930, p. 169.

17 ⟋ 07.286.114: *Bull.*, 1908, p.7.

18 ⟋ 11.88.71.

19 ⟋ 12.229.3: *Bull.*, 1913, p. 174.

20 ⟋ 11.90: *Bull.*, 1911, pp. 150 ff.; Delbrueck, *Ant. Porträts*, p.38, no. 25, pl.25; Brunn-Arndt, *Gr. u. röm. Porträts*, nos. 1124, 5; Schefold, *Bildnisse*, pp. 118, 119, 210.

21 ⟋ 26.269: *Bull.*, 1927, pp. 142 ff., figs. 3, 4.

22 ⟋ 03.12.2 (GR1068): *Bull.*, 1906, p.82, no. 17; Bieber in *Einzelaufnahmen*, nos. 4727–9.

23 ⟋ 03.12.8 (GR1057.2): *Bull.*, 1906, p.82, no. 11; Bieber in *Einzelaufnahmen*, nos. 4724–6.

24 ⟋ 24.97.32: *Bull.*, 1930, pp.

166 ff., fig. 1; Suhr, *Sculp. Portr. of Gr. Statesmen*, pp.33 f.; Bieber in *Einzelaufnahmen*, nos. 4735–7.

25 ⟋ 16.172.

26 ⟋ 24.73: *Bull.*, 1925, p.104, fig. 1; Richter, *AJA*, 1925, pp. 152 ff., figs. 1, 2.

27 ⟋ 24.243: *Bull.*, 1925, pp. 104 f., fig. 4; Richter, *AJA*, 1925, pp.152 ff., figs. 3, 4. The restored bust was removed in 1951.

28 ⟋ 10.151: *Bull.*, 1911, pp. 91, 94, fig. 6; Richter, *Animals*, pp.27, 70, pl.43, fig. 134.

29 ⟋ 43.11.4: *Bull.*, 1943–44, pp.118 ff.; Richter, *AJA*, 1943, pp.365 ff., figs. 1–7; Picard, *Rev. arch.*, 1947, pp.213 ff., figs. 13–15.

30 ⟋ 13.225.2: *Bull.*, 1914, pp. 90 f., fig. 2; *Master Bronzes*, no. 95; *Bronze Cat.*, no. 132; Richter, *AJA*, 1943, p.370, fig. 9.

31 ⟋ 10.231.1: *Bull.*, 1911, pp. 130 ff.; Delbrueck, *Ant. Porträts*, pp.38 f., no. 26, fig. 13a, b, pl.26; *Bronze Cat.*, no. 120; Lippold, *Gr. Porträtstatuen*, p.

82; Brunn-Arndt, *Gr. u. röm. Porträts*, no. 1123; Schefold, *Bildnisse*, pp.124, no. 4, 125, 211, fig. 4; *I. Gr.*, II–III, 2nd ed., 1489.30 ff.

32 ↭ 15.57: *Bull.*, 1915, pp. 236 f.; *Master Bronzes*, no. 93.

33 ↭ 41.11.6: *Bull.*, 1942–43, pp.102 f.

34 ↭ 29.73: *Bull.*, 1930, pp. 40 ff., figs. 1–3.

35 ↭ 09.221.22: *Bull.*, 1910, pp. 96 f., fig. 2; *Bronze Cat.*, no. 130.

36 ↭ 09.221.23: *Bull.*, 1910, pp. 96 f., fig. 3; *Bronze Cat.*, no. 129.

37 ↭ 18.145.10: *Bull.*, 1921, pp. 33 ff., fig. 3; Beardsley, *The Negro in Gr. and Rom. Civ.*, pp. 96 f., no. 213, fig. 19.

38 ↭ 07.286.90: *Bull.*, 1908, p. 91, no. 13, fig. 6; *Bronze Cat.*, no. 251.

39 ↭ 26.60.65: *Bull.*, 1928, p. 80, fig. 5.

40 ↭ 18.145.21: *Bull.*, 1921, p. 37.

41 ↭ 13.227.8: *Bull.*, 1914, p. 92, fig. 4; *Bronze Cat.*, no. 259.

42 ↭ 12.229.6: *Bronze Cat.*, no. 127; *Master Bronzes*, no. 94; Bieber, *Theater*, pp.419 f., figs. 554a–c.

43 ↭ 07.286.96: *Bull.*, 1908, pp. 90 f., no. 12, fig. 5; *Bronze Cat.*, no. 128.

44 ↭ 97.22.9 (GR38): *Bronze Cat.*, no. 275.

45 ↭ 07.261: *Bull.*, 1908, pp. 58 f.; *Bronze Cat.*, no. 403; Richter, *Animals*, fig. 34; *Master Bronzes*, no. 96.

46 ↭ 36.11.12: *Bull.*, 1937, pp. 90 f., fig. 1.

47 ↭ 06.1060: *Bronze Cat.*, no. 775; Züchner, *Griechische Klappspiegel*, p.30, KS32.

48 ↭ 40.11.19: *Bull.*, 1941, pp. 168 f.; Richter, *AJA*, 1942, p. 134. The mirror on which the relief is mounted is ancient but alien.

49 ↭ 22.50.1: *Bull.*, 1922, pp. 133 f., fig. 1; Richter and Alex-ander, *AJA*, 1947, pp.221 ff., pls.42–47.

50 ↭ 07.286.97, 130: *Bull.*, 1908, p.90, no. 10, and 1909, p. 81, fig. 5; *Bronze Cat.*, nos. 596, 595; Zahn, *Gallerie Bachstitz*, II, 1921, p.41, no. 95, pl.33. 21. 88.68: *Bull.*, 1923, p.73. 16.62: *Daily Life*, p.30, fig. 33; Segall, *Katalog der Goldschmiedearbei-ten* (Benaki Museum, Athens), no. 39.

51 ↭ 08.258.50–55: *Mon. Linc.*, IX, 1899, pp.697, 766 f., pl.9 (=pl.29); *Bull.*, 1909, pp. 44, 129.

52 ↭ 22.40.2: *Bull.*, 1922, p. 134, fig. 2; Trever, *Greco-Bac-trian Art*, pp.70 f., fig. 6.

53 ↭ 06.1077.

54 ↭ 28.55: Richter, *M. M. Studies*, 1928–29, p.26.

55 ↭ 24.97.84: *Bull.*, 1928, p. 81, fig. 9.

56 ↭ 22.139.38: *Bull.*, 1924, p. 127, fig. 2.

57 ↭ 22.139.5: *Bull.*, 1923, p. 214, fig. 4.

58 ↭ 13.227.12: *Bull.*, 1914, p. 236. 11.212.18.

59 ↭ 13.227.13, 14: *Bull.*, 1914, p.236. 12.232.11, 12: *Bull.*, 1913, p.177; Klein, *Child Life*, p.33, n.380.

60 ↭ 11.212.20: *Daily Life*, p. 79, fig. 98. 19.192.6: *Bull.*, 1920, p.109, and 1921, p.14; *Daily Life*, p.79, fig. 99. 12.232. 13.

61 ↭ 06.1087: Klein, *Child Life*, p.11, n.121, pl.7f.

62 ↭ 06.1069.

63 ↭ 23.259: *Bull.*, 1924, p. 127, fig. 1; Klein, *Child Life*, p. 29, n.346, pl.28c.

64 ↭ 12.229.21: *Bull.*, 1913, p. 177.

65 ↭ 09.221.36: *Bull.*, 1910, pp.146, 155, fig. 10.

66 ↭ 07.286.30.

67 ↭ 09.221.33; 07.286.27.

68 ↭ 11.140.1: *Bull.*, 1911, pp. 214 f., fig. 9.

69 ↭ 39.11.3: *Bull.*, 1939, p. 272.

70 ↭ 41.11.3: *Bull.*, 1941, pp. 202 ff., fig. 2. Alexander, *AJA*, 1942, p.267.

71 ↭ 31.11.15–17: *Bull.*, 1932, pp.197 f.

72 ↭ 31.11.16–17.

73 ↭ 90.9.67 (GR690): Mer-riam, *AJA*, 1885, p.19, pl.1; Six, *Ant. Denk.*, III, p.34, pl.34a; Richter, *Gr. Ptg.*, p.19.

74 ↭ 74.51.544 (CP456): Myres, *Handbook*, no. 943.

75 ↭ 74.51.432 (CP233): Myres, *Handbook*, no. 952.

76 ↭ Cf., e.g., 06.1021.248: Sambon, *Coll. Canessa*, p.49, no. 175.

77 ↭ Cf., e.g., 24.97.120; 27. 122.10; 28.57.21; 29.131.2; 30. 11.4. *Bull.*, 1929, pp.326 f., and 1931, pp.123 f.; Richter, *M. M. Studies*, 1929–30, pp.188 ff., 198 f., 194 ff., 1932–33, pp.45 ff., and *Gr. Ptg.*, p.19; Libertini, *Centuripe*, pp.166 f., no. 34, pls. 47, no. 2, 60.

78 ↭ E.g., 90.9.7 (GR676): Swindler, *Ancient Ptg.*, p.355, fig. 562.

79 ↭ 74.51.441 (CP249): Zahn, *Priene*, p.400; Leroux, *Lagynos*, p.32, no. 48; Myres, *Handbook*, no. 960.

80 ↭ 47.11.1. Probably from Greece. *Bull.*, 1949–50, p.96.

81 ↭ E.g., 91.1.446. Bequest of Edward C. Moore, 1891. 41. 162.229: Gallatin, *C.V.*, Gallatin Coll., pl.32, no. 11.

82 ↭ 51.11.2: Heydemann, *Jahrbuch*, 1886, pp.286 f.; Ken-ner, *C.V.*, Vienna, Collection F. V. Matsch, pp.25 f., pl.18.

83 ↭ 90.9.1 (GR661): Merriam, *AJA*, 1885, p.19, pl.1.

84 ↭ 09.221.46a–s: *Bull.*, 1910, pp.142, 145.

85 ↭ 31.11.2: *Daily Life*, pp. 18 f., fig. 21. Weitzmann, *Hes-peria*, 1949, pp.186 f.

86 ↭ 41.162.91: Pease, *C.V.*, Gallatin Coll., pl.62, 13a–c.

87 ↭ 45.16.1. Anonymous gift.

88 ↭ 98.8.23 (GR1111): Pagen-stecher, *Exped. Ernst von Sieg-lin*, II, 3, p.66, figs. 79, 80.

17.194.1825: Froehner, *Coll. Gréau*, p.271, no. 74, pl.339, 4.

89 ☙ 98.8.26 (GR1141).

90 ☙ 17.194.1846: Froehner, *Coll. Gréau*, p.269, no. 62, pl. 338, 5.

91 ☙ 06.1021.270: Sambon, *Coll. Canessa*, p.74, no. 255, pl. 17.

92 ☙ 17.194.2040: Froehner, *Coll. Gréau*, p.269, no. 64, pl. 338, 4.

93 ☙ 17.194.2027. Said to be from Asia Minor. Froehner, *Coll. Gréau*, p.269, no. 63, pl. 338, 7.

94 ☙ 96.18.144; 01.8.13; 23.

160.12: x248.17. Richter, *AJA*, 1941, pp.384 f.

95 ☙ 08.258.26: *Bull.*, 1909, p. 105; Bielefeld, *Ein attischer Tonrelief*, 1937, p.5, no. 9, fig. 3; Richter, *AJA*, 1941, pp.383 ff.

96 ☙ 06.1021.277: Sambon, *Coll. Canessa*, p.48, no. 170. 41.162.105: Pease, *C.V.*, Gallatin Coll., pl.64, no. 8; Richter, *AJA*, 1941, pp.385 f., fig. 30.

97 ☙ 26.255.1: *Bull.*, 1927, p. 20, fig. 8.

98 ☙ 12.232.22: *Bull.*, 1913, p. 158.

99 ☙ 06.1021.268: Sambon, *Coll. Canessa*, p.74, no. 253.

100 ☙ 41.162.45: Gallatin, *C.V.*, Gallatin Coll., pl.30, no. 7.

101 ☙ 07.286.131. Said to be from Puzzuoli.

102 ☙ 06.1021.266: Sambon, *Coll. Canessa*, p.74, no. 254.

103 ☙ 04.17.1–6 (GR2273–8): Merriam, *AJA*, 1885, p.18, and 1887, pp.263–266, pl.17; A. J. Reinach, *Mon. Piot*, 1910, pp. 52–56, nos. 7–10, 2154, 6, 7 (p.56, no. 10, which is GR2275, is referred to as no. 2154); Pagenstecher, *Necropolis*, pp. 43–56, nos. 19, 32, 46, 52, 54, 63; Swindler, *Ancient Ptg.*, pp. 344 f., fig. 551.

LARGE SCULPTURES OF VARIOUS PERIODS

1 ☙ 11.185: *Bull.*, 1913, pp. 94 ff., 1922, p.68, 1940, pp. 178 ff., figs. 1–4, and 1943–44, pp.233 ff.; Richter in *Ant. Denk.*, IV, pp.43 ff., pls.19, 20; Richter, *Gravestones*, pp.64 ff., figs. 73–79, and *AJA*, 1941, pp. 159 ff. figs. 1–6; Richter and Hall, *AJA*, 1944, pp.322 ff., 328, 335, figs. 1, 5, pl.7.

2 ☙ 38.11.13: *Bull.*, 1944–45, p. 4, and 1943–44, pp.233 ff., pls. 2, 3; Richter and Hall, *AJA*, 1944, pp.324, 325, 335, figs. 2, 3, pls.8, 9, 11; Richter, *Gravestones*, pp.53 ff., figs. 66, 67, and *Gr. Ptg.*, p.4.

3 ☙ 42.11.35: *Bull.*, 1945–46, pp.93 ff. The part belonging to it mentioned below is published in the *Eph. Arch.*, 1862, col. 49, no. 4, pl.1, γ'. I owe its discovery in the Ephemeris to D. von Bothmer, and the subsequent locating of it in the National Museum (in an inaccessible storeroom) to the kind efforts of Mr. and Mrs. Karouzos and Mr. Yalouris.

4 ☙ 42.11.43: Richter in Brunn-Bruckmann, *Denk.*, pls. 763–765; *Bull.*, 1942–43, pp.206 ff., figs. 1–9.

5 ☙ 14.130.9: *Bull.*, 1935, pp. 216 ff.; Richter, ᾿Εφ. ᾿Αρχ., 1937, pp.20 ff., pls. 1–4.

6 ☙ 25.116: *Bull.*, 1929, pp. 26 ff., figs. 1–3; Richter, *M. M. Studies*, 1929, pp.187 ff.; Cur-

tius, *Röm. Mitt.*, 1934, pp.305 ff., figs. 1–4.

7 ☙ 25.78.56: *Bull.*, 1933, pp. 214 ff., figs. 1–3; Richter, *AJA*, 1935, pp.46 ff., pls.12–15.

8 ☙ 03.12.8 (GR1057.1): *Bull.*, 1906, p.82, no. 11; Bieber in *Einzelaufnahmen*, nos. 4710, 11.

9 ☙ 08.258.42: *Bull.*, 1909, p. 44; Diepolder, *Grabreliefs*, pp. 14 f., pl.7.

10 ☙ 47.11.2: *Bull.*, 1946–47, pp.179 ff.

11 ☙ 35.11.3: *Bull.*, 1936, pp. 9 ff., and 1938, pp.276; Richter, *AJA*, 1936, pp.11 ff., figs. 1, 2.

12 ☙ 09.221.3: *Bull.*, 1910, pp. 40, 210, 212; Schröder in Brunn-Bruckmann, *Denk.*, pl. 643; Klein, *Jahrbuch*, 1918, pp. 36 f., fig. 17; Rambo, *Lion in Greek Art*, p.28; Richter, *Animals*, figs. 20, 25.

13 ☙ 03.12.15 (GR1064.1): *Bull.*, 1906, p.82, no. 3; Bieber in *Einzelaufnahmen*, nos. 4831, 2.

14 ☙ 03.12.12 (GR1061): *Bull.*, 1906, p.82, no. 4; Bieber in *Einzelaufnahmen*, nos. 4712, 13.

15 ☙ 06.311: *Notizie d. sc.*, 1903, p.60; *Bull.*, 1906, pp. 147 ff.; Mariani, *Boll. Comm.*, 1907, pp.29 ff., pl.5.

16 ☙ 03.12.17 (GR1066): *Bull.*,

1906, pp.80 ff., no. 1; Bieber in *Einzelaufnahmen*, nos. 4715, 16.

17 ☙ 11.100.1 and 2: *Bull.*, 1911, p.211; Diepolder, *Grabreliefs*, p.35, pl.30; Klein, *Child Life*, p.6, n.48.

18 ☙ 49.11.4: *Bull.*, 1950, pp. 57 f. Said to have been found in Athens, near the Kerameikos. Formerly in the collection of the Vicomte de Dresnay.

19 ☙ 44.11.2, 3: *Bull.*, 1944–45, pp.48 ff.; Richter, *AJA*, 1944, pp.229 ff., figs. 1–11.

20 ☙ 07.286.107: *Bull.*, 1908, pp.2, 6, fig. 2; Conze, *Grabreliefs*, no. 1539, pl.321; Möbius, *Ornamente d. gr. Grabstelen*, pp. 42, n.32, 89.

21 ☙ 20.198: *Bull.*, 1922, pp. 255 f., figs. 1, 2; Möbius, *Ornamente d. gr. Grabstelen*, pp.42, n.32, 89.

22 ☙ 11.55: *Bull.*, 1911, p.211.

23 ☙ 03.12.14 (GR1063): *Bull.*, 1906, p.82, no. 7; Bieber in *Einzelaufnahmen*, nos. 4833–6.

24 ☙ 08.258.48: *Bull.*, 1909, pp. 45 ff.; Reinach, *Mon. Piot*, 1913, pp.180 f., figs. 6, 7; Lawrence, *Later Greek Sculpture*, pp.22, 112, pl.38.

25 ☙ 09.221.4: Gatti, *Notizie d. sc.*, 1904, pp.225 f.; *Bull.*, 1910, pp.234 f., fig. 2; *Gr. Por-*

trätstatuen, p.84, fig. 21; Brunn-Arndt, *Gr. u. röm. Porträts*, nos. 1121, 2; Schefold, *Bildnisse*, pp. 146, 147, 213.

26 ↤ 09.221.1: *Bull.*, 1910, pp. 209 ff.

27 ↤ 03.12.16 (GRI065): *Bull.*, 1906, p.82, no. 2; Bieber in *Einzelaufnahmen*, nos. 4717–21.

28 ↤ 03.12.10 (GRI059.1): *Bull.*, 1906, p.82, no. 10; Bieber in *Einzelaufnahmen*, no. 4730.

29 ↤ 03.12.9 (GRI058): *Bull.*, 1906, p.82, no. 6; Bieber in *Einzelaufnahmen*, nos. 4837, 8.

30 ↤ 10.210.21: *Bull.*, 1911, pp. 21 f., fig. 2; Horn, *Röm. Mitt.*, II. Ergänzungsheft, pp.92 f., pl.

43; V. Müller, *Art Bull.*, 1938, pp.408 f., 415.

31 ↤ 09.39: *Bull.*, 1909, pp. 201, 204 ff.; Valieri, *Notizie d. sc.*, 1907, p.525, figs. 45, 46; Richter in Brunn-Bruckmann, *Denk.*, no. 730.

32 ↤ 19.192.15: *Bull.*, 1921, pp. 12 f., fig. 6.

ENGRAVED SEALSTONES

1 ↤ 41.160.479: *Evans and Beatty Coll.*, no. 3.

2 ↤ 42.11.2: *Evans and Beatty Coll.*, no. 2.

3 ↤ 42.11.1: *Evans and Beatty Coll.*, no. 4.

4 ↤ 41.160.497.

5 ↤ 42.11.3: *Evans and Beatty Coll.*, no. 5.

6 ↤ 42.11.8: *Evans and Beatty Coll.*, no. 8; *Bull.*, 1942–43, pp. 144 f., fig. 3.

7 ↤ 42.11.5: *Evans and Beatty Coll.*, no. 6; *Bull.*, 1942–43, pp. 144 f., fig. 1.

8 ↤ 42.11.7: *Evans and Beatty Coll.*, no. 9.

9 ↤ 42.11.10: *Evans and Beatty Coll.*, no. 13.

10 ↤ 42.11.11: *Evans and Beatty Coll.*, no. 12; Furtwängler, *AG*, pl.6, no. 34; Shepherd, *Sea Monsters*, p.29, pl.5, fig. 40.

11 ↤ 42.11.12: *Evans and Beatty Coll.*, no. 11; *Bull.*, 1942–43, pp.145, 147, fig. 5.

12 ↤ 42.11.13: *Evans and Beatty Coll.*, no. 14.

13 ↤ 81.6.1: *Cat. of Gems*, no. 10.

14 ↤ 37.11.7: *Bull.*, 1937, p. 176, fig. 2.

15 ↤ 10.130.729.

16 ↤ 14.40.772; 25.78.93: *Burlington F. A. Club Exh.*, 1904, p. 206, pl.110, M120; *Bull.*, 1926, p.286.

17 ↤ 31.11.14: *Bull.*, 1932, pp. 181 f.

18 ↤ 17.49: *Cat. of Gems*, no. 19.

19 ↤ 74.51.4195 (CE3): Myres, *Handbook*, no. 4195; *Cat. of Gems*, no. 13.

20 ↤ 74.51.4172 (CE1): Myres, *Handbook*, no. 4172; *Cat. of Gems*, no. 11.

21 ↤ 25.78.94: Furtwängler, *AG*, pl.7, 54; *Burlington F. A. Club Exh.*, 1904, p.207, no. 123, pl.110, M123; *Bull.*, 1926, p. 286.

22 ↤ 81.6.3: Furtwängler, *AG*, pl.6, 49; *Cat. of Gems*, no. 18, pl.4.

23 ↤ 74.51.4220 (CE14): Myres, *Handbook*, no. 4220; *Cat. of Gems*, no. 29, pl.9.

24 ↤ 42.11.15: Furtwängler, *AG*, pl.6, no. 51; *Evans and Beatty Coll.*, no. 15; *Bull.*, 1942–43, p.145, fig. 4.

25 ↤ 42.11.21: *Evans and Beatty Coll.*, no. 18.

26 ↤ 26.31.301.

27 ↤ 31.11.5: Furtwängler, *AG*, pls.9, 23, 51, 14; *Cat. of Southesk Coll.*, ed. by Lady Helena Carnegie, pl.2, b8; Beazley, *Lewes House Gems*, pp. 20 f., pl. a10; *Bull.*, 1931, pp. 267 f.

28 ↤ 74.51.4223 (CE16): Furtwängler, *AG*, pl.9, no. 22; Myres, *Handbook*, no. 4223; *Cat. of Gems*, no. 31, pl.10; Beazley, *Lewes House Gems*, p. 28, pl.3.

29 ↤ 42.11.16: *Evans and Beatty Coll.*, no. 21.

30 ↤ 41.160.481: *Evans and Beatty Coll.*, no. 19.

31 ↤ 81.6.14: *Cat. of Gems*, no. 23, pl.6.

32 ↤ 41.160.551: *Evans and Beatty Coll.*, no. 20.

33 ↤ 74.51.4173 (CE10): Myres, *Handbook*, no. 4173; *Cat. of Gems*, no. 24.

34 ↤ 74.51.4224 (CE18): Myres, *Handbook*, no. 4224; *Cat. of Gems*, no. 33, pl.12.

35 ↤ E.g., 30.8.875; 16.174.39: *Bull.*, 1921, pp.57 f., fig. 1 f. 21.88.37: *Burlington F. A. Club Exh.*, 1904, p.188, no. 34, pl. 108, M34; *Bull.*, 1922, p.193, fig. 2. 25.78.92: Furtwängler, *AG*, pl.63, no. 6; *Bull.*, 1926, p. 286. 41.160.490, 440; 24.97. 47: *Bull.*, 1925, pp.180, 182, fig. 1; Richter, *Animals*, pp.24, 67, fig. 110.

36 ↤ 74.51.4199 (CE17): Furtwängler, *AG*, pl.9, 32; Myres, *Handbook*, no. 4199; *Cat. of Gems*, no. 32.

37 ↤ 06.1124: *Bull.*, 1907, p. 123, no. 4, fig. 2; *Cat. of Gems*, no. 36, pl.14.

38 ↤ 42.11.19: *Evans and Beatty Coll.*, no. 26; *Bull.*, 1942–43, pp.145, fig. 6, 147.

39 ↤ 25.78.7: *Bull.*, 1925, p. 182, fig. 2.

40 ↤ 42.11.17: *Evans and Beatty Coll.*, no. 22; *Bull.*, 1942–43, pp.146, fig. 11, 147.

41 ↤ 41.160.492: *Evans and Beatty Coll.*, no. 24.

42 ↤ 41.160.457: *Evans and Beatty Coll.*, no. 23.

43 ↤ 11.196.1: Furtwängler, *AG*, pl.12, nos. 38, 39; *Bull.*, 1912, p.98; *Cat. of Gems*, no. 37, pl.15.

44 ↤ 74.51.4198 (CE22): Myres, *Handbook*, no. 4198; *Cat. o[*

Gems, no. 41, pl.17; Richter, *Animals,* pp.17, 60, fig. 72.

45 ↝ 42.11.24: *Evans and Beatty Coll.,* no. 28.

46 ↝ 26.31.380.

47 ↝ 47.114. Gift of Rupert L. Joseph. Sotheby, Sale Catalogue, June 1, 1939, no. 187, pl.1; *Bull.,* 1939, pp.263 f.; *AJA,* 1942, pp. 267 f.

48 ↝ 74.51.4226 (CE23): Myres, *Handbook,* no. 4226; *Cat. of Gems,* no. 44; Richter, *Animals,* pp.32, 75, fig. 165.

49 ↝ 21.88.38: Furtwängler, *AG,* pl.9, no. 55; *Burlington F. A. Club Exh.,* 1904, p.189, no. 42, pl.108, M42; *Bull.,* 1922, p.194, fig. 3; Richter, *Animals,* pp.32, 75, fig. 164.

50 ↝ 81.6.257: *Cat. of Gems,* no. 38, pl.16; Richter, *Animals,* pp.32, 75, fig. 163.

51 ↝ 07.286.117: *Cat. of Gems,* no. 47, pl.21; Alexander, *Jewelry,* p.53, no. 116.

52 ↝ 06.1123: *Bull.,* 1907, p. 123, no. 5; *Cat. of Gems,* no. 46; Alexander, *Jewelry,* p.53, no. 117.

53 ↝ 41.160.451: *Evans and Beatty Coll.,* no. 37.

54 ↝ 21.88.166: *Bull.,* 1924, p. 35, fig. 1; Alexander, *Jewelry,* p.50, no. 107.

55 ↝ 16.174.36: *Bull.,* 1921, pp. 57, 58, fig. 1d; Alexander, *Jewelry,* p.53, no. 118.

56 ↝ 42.11.25: *Evans and Beatty Coll.,* no. 35; Furtwängler, *AG,* pl.9, no. 49.

57 ↝ 42.11.18: Furtwängler, *AG,* pl.9, no. 52; *Evans and Beatty Coll.,* no. 38.

58 ↝ E.g., 41.160.433, 431: *Evans and Beatty Coll.,* nos. 31, 32.

59 ↝ E.g., 41.160.653: *Evans and Beatty Coll.,* no. 30.

60 ↝ E.g., 25.78.100: *Burlington F. A. Club Exh.,* 1904, p. 255, no. 98, pl.112, O98; *Bull.,* 1926, p.286.

61 ↝ E.g., 25.78.98: *Burlington F. A. Club Exh.,* 1904, p.255, no. 97, pl.112, O97; *Bull.,* 1926, p.286.

62 ↝ E.g., 41.160.443, 429: *Evans and Beatty Coll.,* nos. 33, 34; Richter, *Animals,* pp.24, 28, 68, 72, figs. 115, 140; *Bull.,* 1942–43, pp.146 f., fig. 9.

63 ↝ 07.286.121: *Cat. of Gems,* no. 42, pl.18.

64 ↝ 81.6.8: Furtwängler, *AG,* pl.18, no. 74; *Cat. of Gems,* no. 43.

65 ↝ 41.160.435.

66 ↝ 42.11.26: *Evans and Beatty Coll.,* no. 44.

67 ↝ 10.132.1: *Bull.,* 1910, p. 276; *Cat. of Gems,* no. 81.

68 ↝ 17.194.25–27: *Cat. of Gems,* nos. 70–72.

69 ↝ 41.160.505: *Evans and Beatty Coll.,* no. 45.

70 ↝ 41.160.445: *Evans and Beatty Coll.,* no. 46.

71 ↝ 81.6.9: *Cat. of Gems,* no. 51.

72 ↝ 41.160.645: *Evans and Beatty Coll.,* no. 48.

73 ↝ 81.6.65: *Cat. of Gems,* no. 138, pl.38.

74 ↝ 21.88.47: *Bull.,* 1922, p. 195, fig. 4.

75 ↝ 81.6.64: *Cat. of Gems,* no. 137.

76 ↝ 81.6.101: *Cat. of Gems,* no. 189, pl.50.

77 ↝ 41.160.499: *Evans and Beatty Coll.,* no. 49.

78 ↝ 81.6.120: *Cat. of Gems,* no. 212, pl.53.

79 ↝ 49.21.1. Gift of Rupert L. Joseph. Smith and Hutton, *Cat.*

of the Wyndham Cook Collection, p.27, no. 103; *Burlington F. A. Club Exh.,* 1904, pl.110, no. M87; Richter in *Studies presented to D. M. Robinson,* I, pp. 721 f.

80 ↝ 21.88.46: *Bull.,* 1922, p. 196, fig. 4; Furtwängler, *AG,* pl.43, no. 20; *Burlington F. A. Club Exh.,* 1904, p.186, no. 21, pl.108, M21.

81 ↝ 41.160.527.

82 ↝ 41.160.707.

83 ↝ 81.6.107: *Cat. of Gems,* no. 197.

84 ↝ 81.6.109: *Cat. of Gems,* no. 199.

85 ↝ 41.160.484: *Evans and Beatty Coll.,* no. 47.

86 ↝ 42.11.29: *Evans and Beatty Coll.,* no. 50.

87 ↝ 41.160.442: *Evans and Beatty Coll.,* no. 51.

88 ↝ 06.1205: *Bull.,* 1907, pp. 123 f., no. 11, fig. 3; *Cat. of Gems,* no. 83, pl.28; Shepherd, *Sea Monsters,* p.74.

89 ↝ 11.195.5: *Bull.,* 1912, p. 98; *Cat. of Gems,* no. 82, pl.27.

90 ↝ 32.142.1.

91 ↝ 06.1204: *Bull.,* 1907, p. 125, no. 15; *Cat. of Gems,* no. 320.

92 ↝ In three examples. 10.132. 2: *Bull.,* 1910, p.276; *Cat. of Gems,* no. 324. 26.60.59: *Burlington F. A. Club Exh.,* 1904, p.205, no. 115, pl.115; Christie Sale Cat. of the Cook Coll., July 14, 1925, p.14, no. 58; *Bull.,* 1928, p.82. 29.175.3. Gift of Milton Weil.

93 ↝ 25.78.96: *Compte-rendu,* 1864, p.195; *Annali,* 1874, pp. 81 f., n.7; S. Reinach, *Pierres Gravées,* p.121, pl.118; Furtwängler, *AG,* pl.65, no. 46; *Burlington F. A. Club Exh.,* 1904, pp.200 f., no. 96, pl.109, M96; *Bull.,* 1926, p.286.

JEWELRY

1 ☙ 12.229.24. From the Warren collection. *Bull.*, 1913, p.179; Alexander, *Jewelry*, 1928, p.46, fig. 99; Beazley, *JHS*, 1940, p.26, n.10.

2 ☙ 95.15.317, 318.

3 ☙ 13.43.1, said to be from Athens. Sale Cat., Estate of M. C. D. Borden, Esq., American Art Galleries, 1913, no. 521; *Bull.*, 1914, p.257, fig. 2; Alexander, *Jewelry*, 1928, fig. 43.

4 ☙ 11.140.12a, b: *Bull.*, 1911, pp.214, 216, fig. 10; Alexander, *Jewelry*, 1928, fig. 44.

5 ☙ 06.1217.1–12: *Bull.*, 1906, pp.118 ff.; Alexander, *Jewelry*, 1928, p.46, fig. 97, and 1940, figs. 7–11.

6 ☙ 37.11.8–17, said to be from near Saloniki. Formerly in the Gans collection. Zahn, *Amtliche Berichte*, xxxv, 1913–14, col. 73, and *Galerie Bachstitz*, ii, 1921, pp.25 ff., pls.22, 23; Bieber, *Griechische Kleidung*, pl.63; *Bull.*, 1937, pp.290 ff., figs. 1–7, and 1940, p.216; Alexander, *Jewelry*, 1940, figs. 3–6; *Daily Life*, p.65, fig. 78.

7 ☙ 08.258.49: *Bull.*, 1909, pp. 44, 124, 129 f., fig. 1, and 1940, p.216; Zahn, *Galerie Bachstitz*,

ii, 1921, p.27; Reinach, *Répertoire de la Statuaire Grecque et Romaine*, v, p.408, no. 7; Alexander, *Jewelry*, 1928, fig. 61.

8 ☙ 26.209.1, 2, said to be from Tarentum. *Bull.*, 1926, pp. 285 f., fig. 11; Alexander, *Jewelry*, 1928, pl.2, and 1940, fig. 1.

9 ☙ 06.1159, said to be from Patras. *Bull.*, 1907, pp.123, no. 7, 125, fig. 6; Fowler and Wheeler, *Greek Archaeology*, pp.348 f., fig. 264; Alexander, *Jewelry*, 1928, p.42, fig. 92.

10 ☙ 25.78.89: Stebbins, *The Dolphin in the Lit. and Art of Gr. and Rome*, p.127.

11 ☙ 20.241: *Bull.*, 1924, p.35, fig. 2; Alexander, *Jewelry*, 1928, p.46, fig. 98.

12 ☙ 13.225.31a, b: *Bull.*, 1914, p.258; Alexander, *Jewelry*, 1928, fig. 65.

13 ☙ 21.88.5, 6: *Bull.*, 1924, p. 35; Alexander, *Jewelry*, 1928, fig. 68.

14 ☙ 45.11.8–16.

15 ☙ 13.234.1, said to be from Tarentum. *Bull.*, 1914, pp.257 f., fig. 1; Alexander, *Jewelry*, 1928,

figs. 18–21; Zahn, *Ant. Denk.*, iv, 1929, p.79, n.3.

16 ☙ 74.51.3002: Myres, *Handbook*, no. 3002; Perrot and Chipiez, *Histoire de l'art dans l'antiquité*, iii, fig. 602.

17 ☙ 74.51.3005: Myres, *Handbook*, no. 3005.

18 ☙ 74.51.3006–3056: Myres, *Handbook*, nos. 3006–56.

19 ☙ 74.51.3149: Myres, *Handbook*, no. 3149; Alexander, *Jewelry*, 1928, p.44, no. 96.

20 ☙ 74.51.3120: Myres, *Handbook*, no. 3120.

21 ☙ 74.51.3370–3375: Myres, *Handbook*, nos. 3370–75; Perrot and Chipiez, *Histoire de l'art dans l'antiquité*, iii, fig. 570.

22 ☙ 74.51.3382: Myres, *Handbook*, no. 3382; Perrot and Chipiez, *Histoire de l'art dans l'antiquité*, iii, fig. 593.

23 ☙ 74.51.3385: Myres, *Handbook*, no. 3385; Perrot and Chipiez, *Histoire de l'art dans l'antiquité*, iii, fig. 590.

24 ☙ 74.51.3598: Myres, *Handbook*, no. 3598; Perrot and Chipiez, *Histoire de l'art dans l'antiquité*, iii, fig. 562.

REFERENCES ABBREVIATED IN THE NOTES

PERIODICALS, LEXICONS, CORPUSES

Acta Arch. Acta Archaeologica.

AJA. American Journal of Archaeology.

AJP. American Journal of Philology.

Annali. Annali dell' Instituto di corrispondenza archeologica.

Annuario. Annuario della Regia Scuola Archeologica di Atene e delle Missioni Italiene in Oriente.

Ant. Denk. Antike Denkmäler, herausgegeben vom Deutschen Archäologischen Institut.

Arch. Anz. Archäologischer Anzeiger; Beiblatt zum Jahrbuch des Deutschen Archäologischen Instituts.

Arch. Class. Archeologia Classica, Rivista dell' Istituto di Archeologia della Università di Roma.

Arch. Ztg. Archäologische Zeitung.

Ath. Mitt. Mitteilungen des Deutschen Archäologischen Instituts, Athenische Abteilung.

Bull. Com. Bullettino della Commissione archeologica comunale di Roma.

Boll. d'Arte. Bollettino d'arte del Ministero della Pubblica Istruzione.

BSA. The Annual of the British School at Athens.

Brunn-Bruckmann, *Denk.* H. Brunn and F. Bruckmann, Denkmäler griechischer und römischer Skulptur.

Bull. Bulletin of the Metropolitan Museum of Art (New York).

Class. Phil. Classical Philology.

Compte-rendu. Compte-rendu de la Commission Impériale Archéologique.

Crit. d'Arte. La Critica d'Arte; Rivista trimestrale di arti figurative per il mondo antico.

C.V. Corpus vasorum antiquorum.

Δελτ. ’Αρχ. Δελτίον ’Αρχαιολογικόν.

Einzelaufnahmen. P. Arndt, W. Amelung, G. Lippold, and F. Bruckmann, Photographische Einzelaufnahmen antiker Skulpturen.

Eph. Arch. Ephemeris Archaiologike.

’Εφ. ’Αρχ. ’Εφημερὶς ’Αρχαιολογική.

Gaz. arch. Gazette archéologique.

Hesperia. Hesperia; Journal of the American School of Classical Studies at Athens.

I.Gr. Inscriptiones Graecae.

Jahrbuch. Jahrbuch des Deutschen Archäologischen Instituts.

JHS. Journal of Hellenic Studies.

Mem. Pont. Acc. Memorie della Pontificia Accademia Romana di Archeologia.

M. M. Studies. Metropolitan Museum Studies.

Mon. Linc. Monumenti antichi, pubblicati per cura dell' Accademia nazionale dei Lincei.

Mon. Piot. Monuments et Mémoires publiés par l'Académie des inscriptions et belles-lettres (Fondation Eugène Piot).

Monumenti dell' Inst. Monumenti inediti pubblicati dell' Instituto di corrispondenza archeologica.

Münch. Jahr. Münchener Jahrbuch der bildenden Kunst.

Notizie d. sc. Notizie degli scavi di antichità, communicate alla R. Accademia dei Lincei.

Öst. Jahr. Jahreshefte des Österreichischen Archäologischen Institutes in Wien.

Rev. Arch. Revue archéologique.

Röm. Mitt. Mitteilungen des Deutschen Archäologischen Instituts, Römische Abteilung.

BOOKS

Alexander, *Jewelry.* C. Alexander, Jewelry, the Art of the Goldsmith in Classical Times, 1928.

Beazley, *ABS.* J. D. Beazley, Attic Black-Figure, a Sketch (from the Proceedings of the British Academy, XIV, 1928).

———, *ARV.* Attic Red-Figure Vase-Painters (1942).

———, *AWL.* Attic White Lekythoi, 1938.

———, *VA.* Attic Red-figured Vases in American Museums, 1918.

———, *V.Pol.* Greek Vases in Poland, 1928.

Bieber, *Entwicklungsgeschichte.* M. Bieber, Entwicklungsgeschichte der griechischen Tracht von der vorgriechischen Zeit bis zur römischen Kaiserzeit, 1934.

————, *Theater*. The History of the Greek and Roman Theater, 1939.

Bloesch, *Formen*. H. Bloesch, Formen attischer Schalen von Exekias bis zum Ende des strengen Stils, 1940.

Bronze Cat. G. M. A. Richter, Greek, Etruscan, and Roman Bronzes (M.M.A., 1915).

Cat. of Gems. G. M. A. Richter, Catalogue of Engraved Gems of the Classical Style (M.M.A., 1920).

Cesnola Atlas. L. P. di Cesnola, A Descriptive Atlas of the Cesnola Collection of Cypriote Antiquities in the Metropolitan Museum of Art, New York, 1885–1903.

Daily Life. H. McClees, The Daily Life of the Greeks and Romans, with additions by C. Alexander, 1941.

Diepolder, *Grabreliefs*. H. Diepolder, Die attischen Grabreliefs des fünften und vierten Jahrhunderts v. Chr., 1931.

Evans, *P. of M.* Sir Arthur J. Evans, The Palace of Minos, 1921–1936.

Evans and Beatty Coll. G. M. A. Richter, Ancient Gems from the Evans and Beatty Collection, 1942.

Fairbanks, *Lekythoi*. A. Fairbanks, Athenian White Lekythoi.

Froehner, *Coll. Gréau*. C. E. L. W. Froehner, Collection Julien Gréau, verrerie antique, . . . appartenant à M. John Pierpont Morgan, 1903.

Furtwängler, *Aegina*. A. Furtwängler, Aegina, das Heiligtum der Aphaia, 1906.

————, *AG*. Die Antiken Gemmen, 1900.

Furtwängler and Reichhold. A. Furtwängler and K. Reichhold, Griechische Vasenmalerei, 1904–1932.

Gardiner, *Athletics*. E. N. Gardiner, Athletics of the Ancient World, 1930.

Haspels, *ABL*. C. H. E. Haspels, Attic Black-figured Lekythoi, 1936.

Hoppin, *Bf.* J. C. Hoppin, A Handbook of Greek Black-figured Vases, with a chapter on the Red-figured Italian Vases, 1924.

————, *Rf.* A Handbook of Attic Red-figured Vases, 1919.

Ingholt, *Rapport préliminaire*. Harald Ingholt, Rapport préliminaire sur la première campagne des fouilles de Hama, 1934.

Jacobsthal, *Ornamente*. P. Jacobsthal, Ornamente griechischer Vasen, 1927.

Jantzen, *Bronzewerkstätten*. N. Jantzen, Bronzewerkstätten in Grossgriechenland und Sizilien (Jahrbuch, Ergänzungsheft 13, 1938).

Klein, *Child Life*. A. E. Klein, Child Life in Greek Art, 1932.

Lamb, *Bronzes*. W. Lamb, Greek and Roman Bronzes, 1929.

Langlotz, *Bildhauerschulen*. E. Langlotz, Fruegriechische Bildhauerschulen, 1927.

Master Bronzes. Master Bronzes Selected from Museums and Collections in America (Exhibition in Buffalo, Fine Arts Academy, February 1937).

Millin, *Monumens inédites*. A. L. Millin, Monumens antiques inédites ou nouvellement expliqués, 1802–1806.

Myres, *Handbook*. J. L. Myres, Handbook of the Cesnola Collection of Antiquities from Cyprus, 1914.

Payne, *Necr.* H. Payne, Necrocorinthia, a Study of Corinthian Art in the Archaic Period, 1931.

————, *Protokor.* V. H. Payne, Protokorintische Vasenmalerei, 1933.

Pfuhl, *M.u.Z.* E. Pfuhl, Malerei und Zeichnung der Griechen, 1923.

Richter, *Animals*. G. M. A. Richter, Animals in Greek Sculpture; A Survey, 1930.

————, *ARVS*. Attic Red-figured Vases; A Survey, 1946.

————, *Furniture*. Ancient Furniture. A History of Greek, Etruscan, and Roman Furniture, 1926.

————, *Gravestones*. Archaic Attic Gravestones, 1944.

Richter and Hall. G. M. A. Richter, Red-figured Athenian Vases in the Metropolitan Museum of Art, with 83 drawings by L. F. Hall, 1936.

Richter and Milne. G. M. A. Richter and M. J. Milne, Shapes and Names of Greek Vases, 1935.

Robinson and Fluck. D. M. Robinson and E. J. Fluck, A Study of the Greek Love-Names, 1936.

Rumpf, *Chalkidische Vasen*. A. Rumpf, Chalkidische Vasen, im Auftrage des Archäologischen Institutes des Deutschen Reiches, mit Benutzung der Vorarbeiten von G. Loeschke, 1927.

Sambon, *Coll. Canessa*. A. Sambon, Vases antiques de terre cuite, collection Canessa, 1904.

Schefold, *Bildnisse*. K. Schefold, Die Bildnisse der antiken Dichter, Redner und Denker, 1943.

————, *Untersuchungen*. K. Schefold, Untersuchungen zu den Kertscher Vasen, 1934.

Smets, *Groupes chronologiques*. A. Smets, Groupes chronologiques des amphores panathenaïques inscrites, in l'Antiquité classique, v, Fasc. 1, 1936.

Süsserot, *Gr. Plastik*. H. K. Süsserot, Griechische Plastik des vierten Jahrhunderts vor Christus, 1938.

Wuilleumier, *Tarente*. P. Wuilleumier, Tarente, des origines à la conquête romaine, 1939.

INDEX

INDEX

TWO THOUSAND COPIES
OF THIS HANDBOOK WERE PRINTED
IN AUGUST 1953
BY CASE, LOCKWOOD & BRAINARD, HARTFORD

PLATES BY
PHOTOGRAVURE AND COLOR COMPANY, NEW YORK